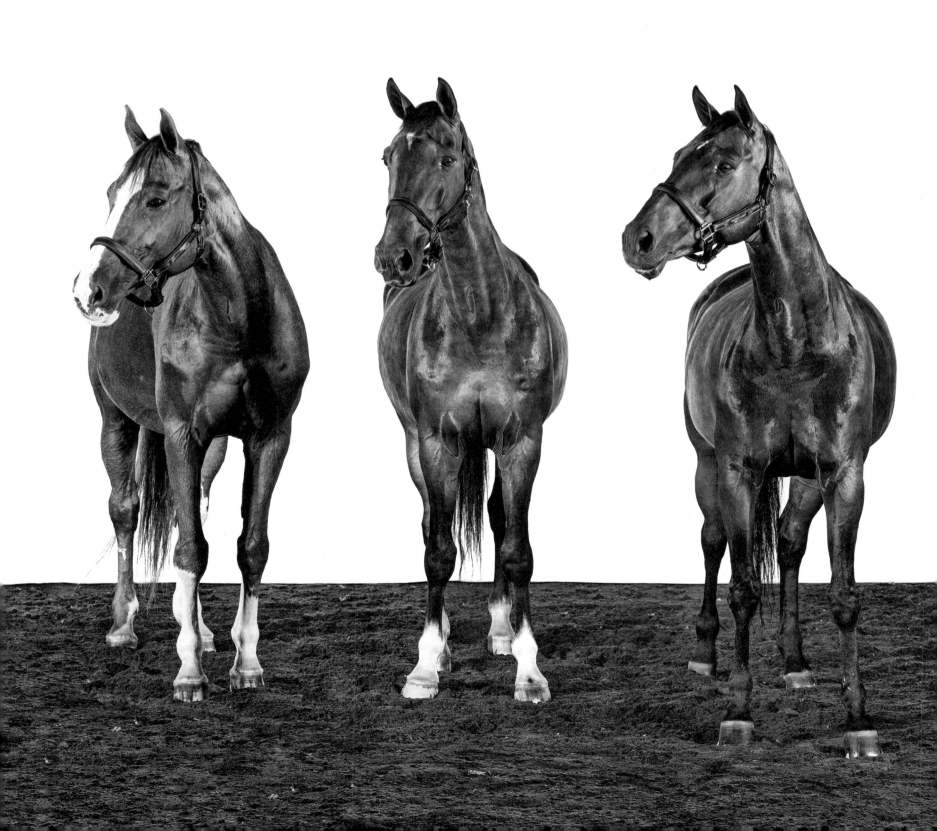

For Bruce

who makes everything possible

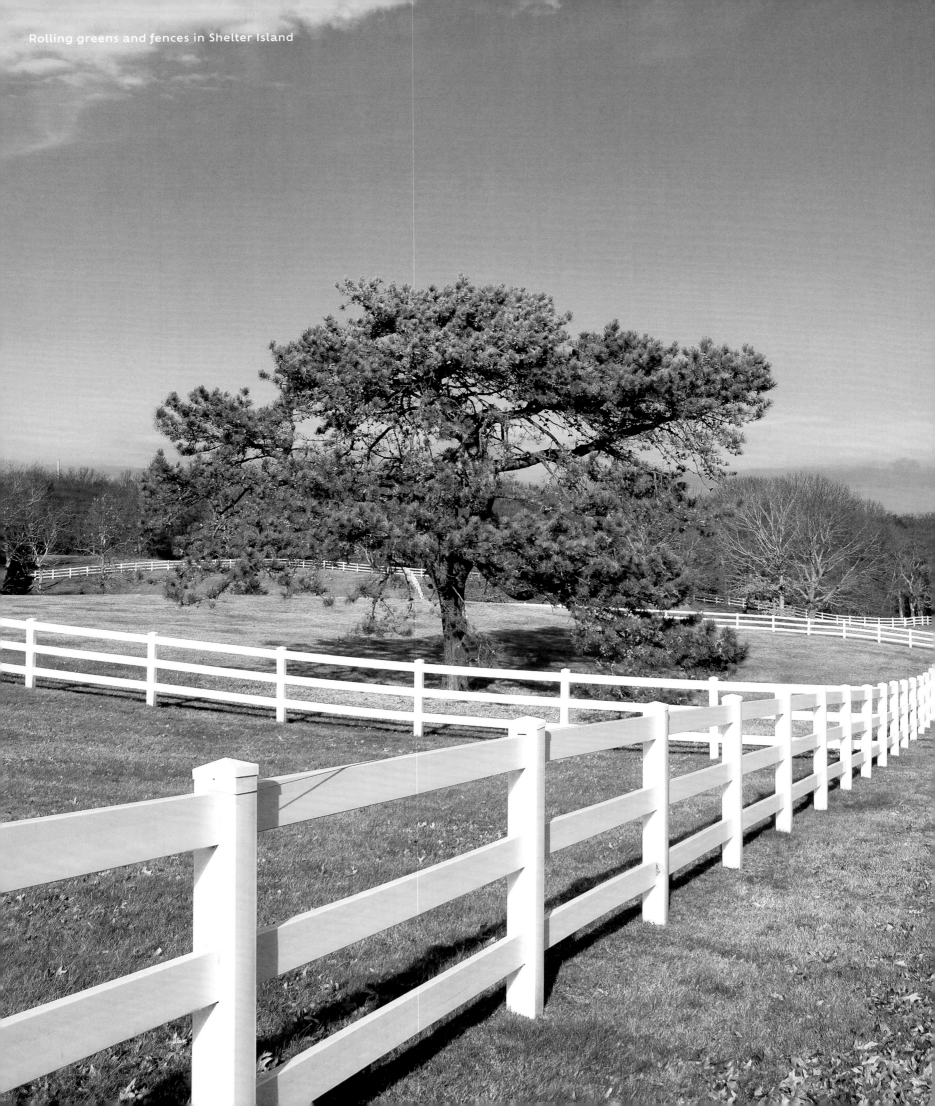

Equestrian Life
in the Hamptons

Blue Carreon

images
Publishing

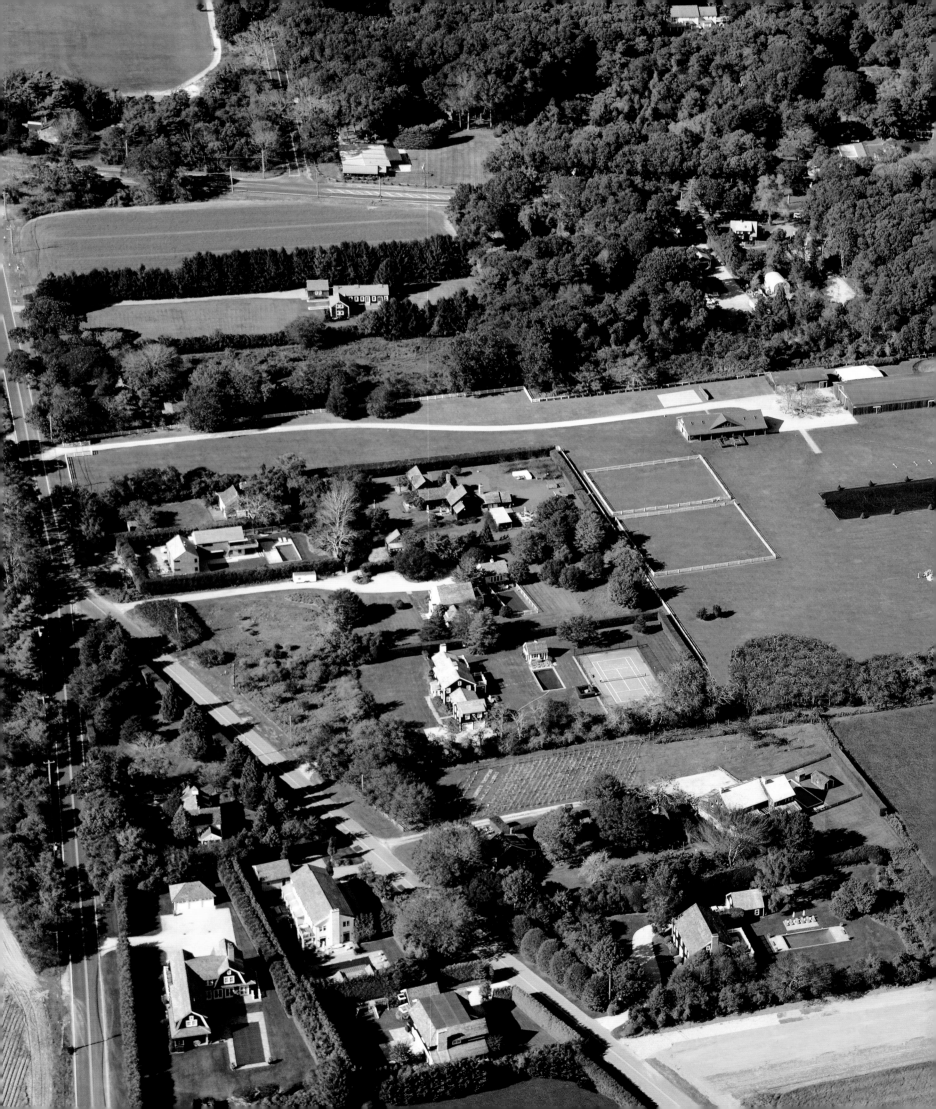

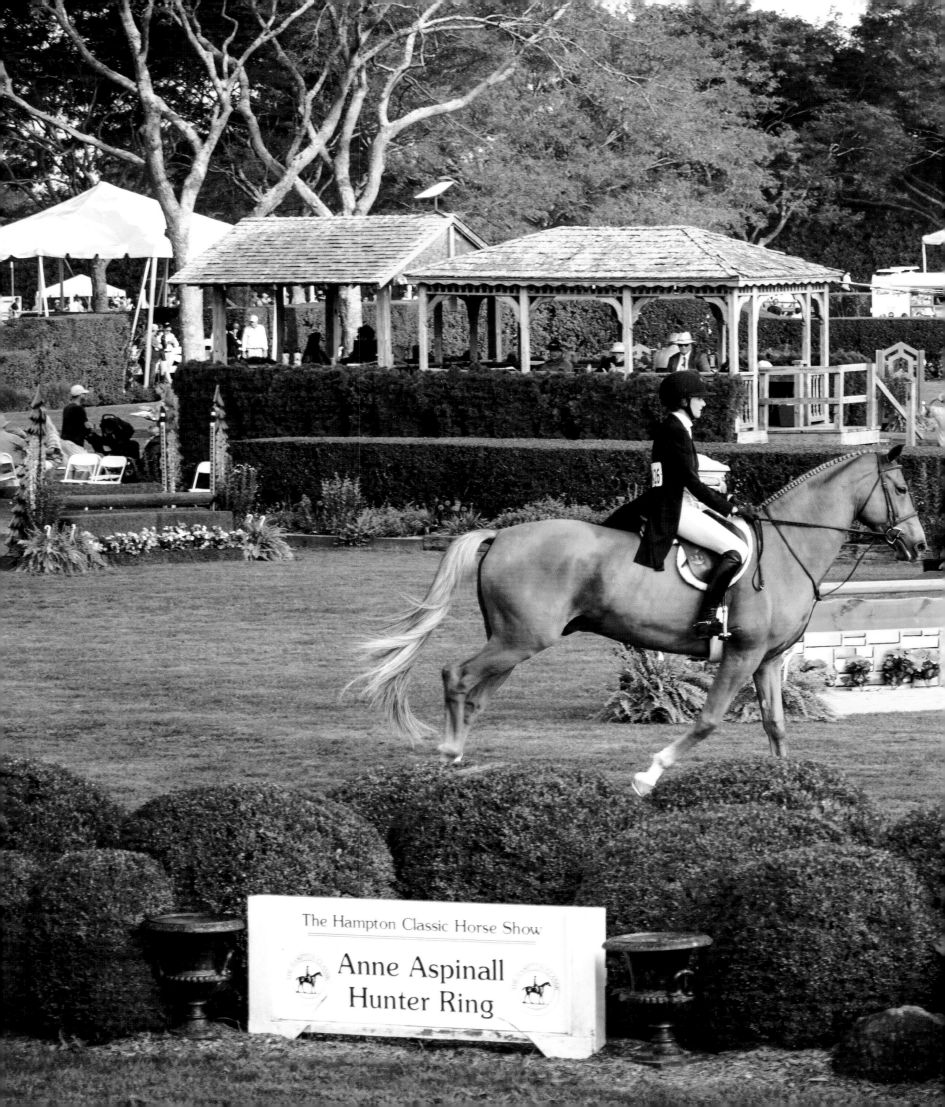

The Hampton Classic Horse Show

Anne Aspinall
Hunter Ring

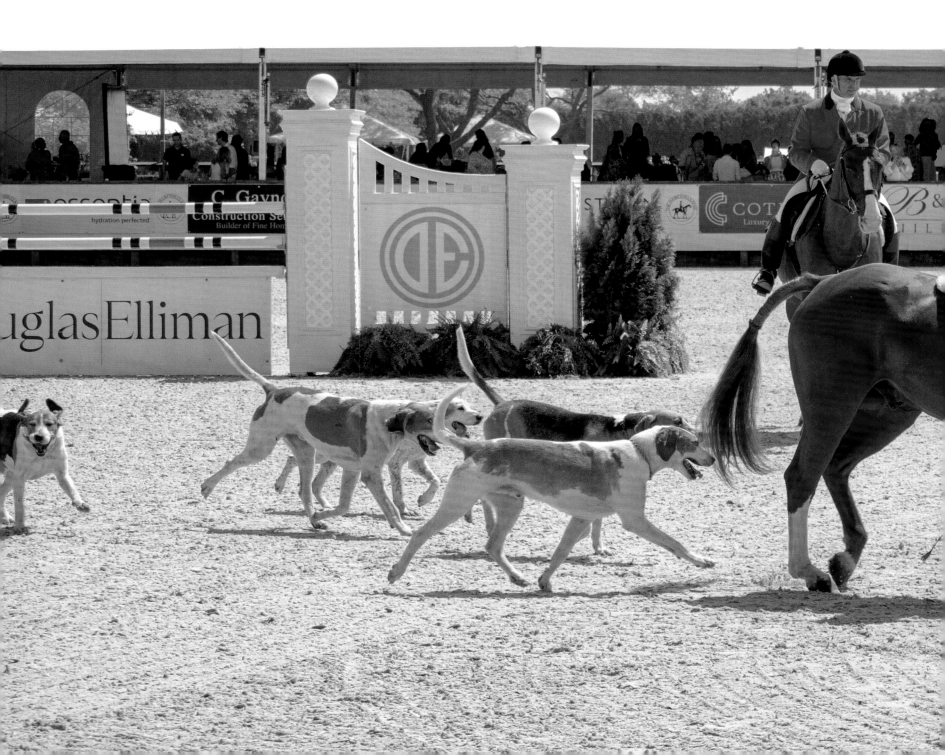

In the nearby arenas not far from the Grand Prix stadiums are other jumper and hunter rings, including the Anne Aspinall Ring, named after one of the luminaries of the equestrian community of the Hamptons. In these rings, riders try to best each other. Amateurs, professionals, young and old, and their mounts, put on a show for equine enthusiasts and for the social spectators of the sport. The hunter riders navigate courses with particular attention to maintaining a consistent cadence of their horses. The equitation entries, who are judged on their style and effortlessness, have to make sure that they are in their most beautiful and elegant forms under pressure. "The hunter class is all about the look, elegance, and poise," explains hunter and equitation judge Scott Fitton. "It is supposed to be done with ease. You are really watching the rider guiding the horse without really noticing the rider. In equitation you are looking more at the rider and the directions they are giving the horse and the aids," Scott adds. The jumpers have to find the right combination of speed and control through various hurdles. To the untrained eye, the cues a rider gives its horses may be invisible, but do not be fooled: the placement of the heel, the taps on the horse body, the distribution of body weight, the forward seat, and the clucks are all orchestrated and products of muscle memory and years of training.

Jumping courses can also seem like a maze of obstacles to novices and spectators, and sometimes even the most seasoned rider can get lost in the course. "We are almost like a schoolteacher giving a test or an exam. I don't go out there thinking I'm building a competition. I have to build it to have a nice flow—left to right, balance, steering," explained course designer Steve Stephens during a Hampton Classic Clubhouse chat. "We are setting the stage for them to compete and perform. They are competing against each other. They are not competing against the course," reinforced fellow course designer Guilherme Jorge in the same talk.

"I love the journey of competing and what has lead me to that round," describes trainer and competitive rider Laura Bowery of Sea Aire Inc of her mentality at horse shows. "In the jumpers it's about being fast but smooth. In the hunters, about making it seamless. I tell myself some confident things about myself and my horse before I go in the ring and that I have prepared for this competition. I think a lot about my horses when we are in the gate. Are they relaxed? Are they listening to me? Is there anything different I need to do in the show ring than what I did in the practice ring? At the end of the day, I love the sport and just try to give my horses the best ride possible."

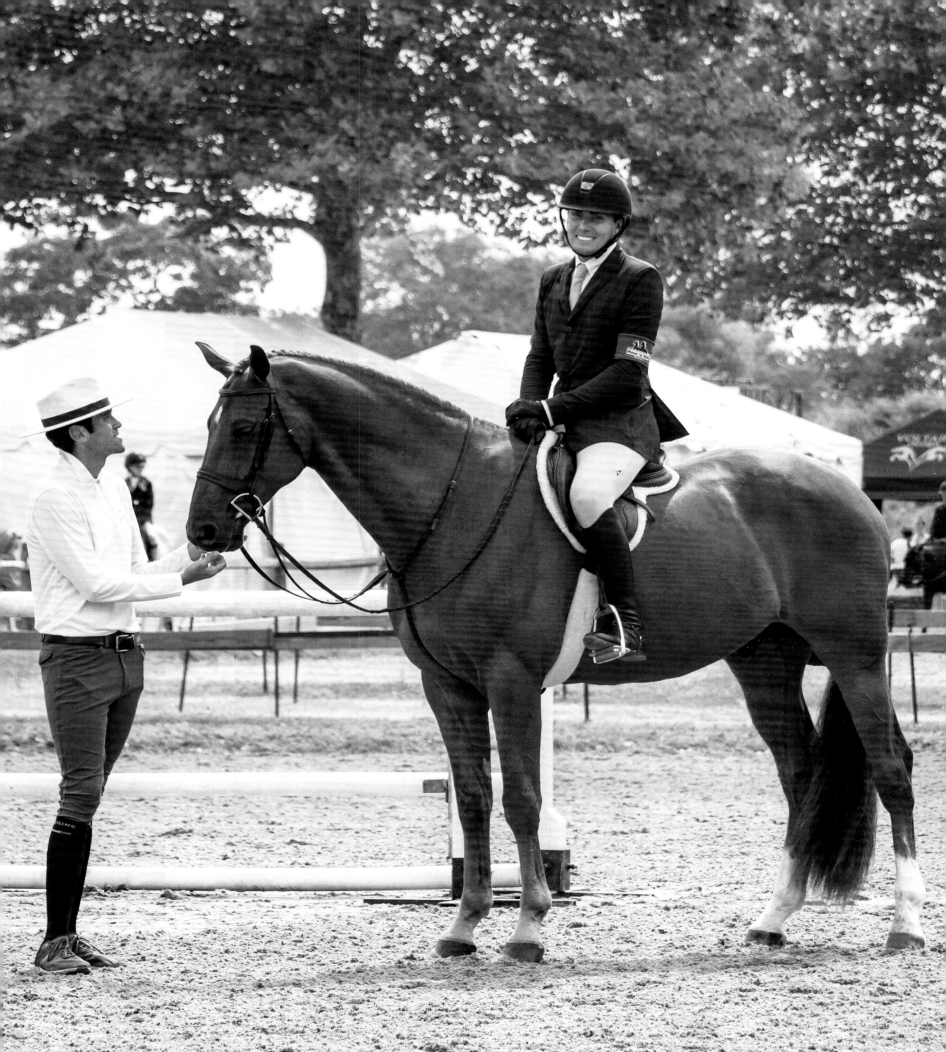

Brendan Williams and Geoffrey Hesslink
in the warm-up ring

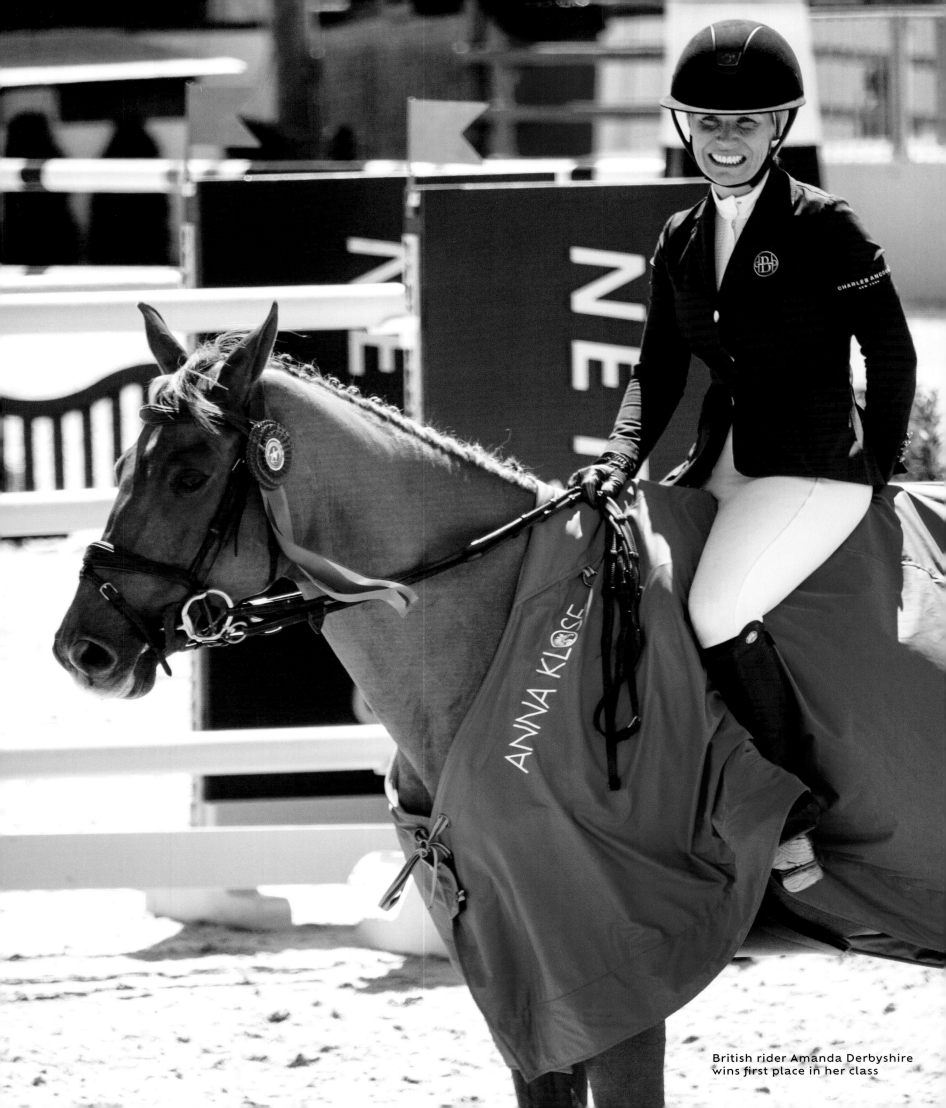

British rider Amanda Derbyshire
wins first place in her class

Among the show jumpers who travel to the East End is Great Britain's Amanda Derbyshire. "My favorite competition memories at the Hampton Classic are winning the Speed Challenge on Lady Maria BH and coming in third at the prestigious Grand Prix on Luibanta BH," Amanda recalls.

"I love the atmosphere in the Hamptons. I've been showing here since I was a kid and will continue to support the Hampton Classic," describes Wellington-based show jumper Michael Murphy. "The event is unique because it is such a great blend of the social aspect and top-level competition. It also puts a punctuation on the end of the summer season," adds show jumper Colin Sqyuia, who rides under the Philippine flag.

"The highlight over the years at the Hampton Classic for me was watching my son Jasper compete for the first time in 2021," shares top United States show jumper Georgina Bloomberg. "I was his age when I first competed at the Classic and it's a show that he knows means a lot to me, and he also understands the history and importance of the show. He took training and preparing for it very seriously and I was so proud to watch him go in there and how well her rode." She continues: "But most of all I was so proud to see how much he enjoyed it. It is very sentimental for me to see him riding at shows where I did as a child too, but the part that makes me the happiest is seeing that he enjoys the process and the journey no matter the result."

Dramatic twists worthy of movie plot lines and force majeures like hurricanes and weird weather patterns have been part of the Hampton Classic history; tents for horses and riders being dismantled just as horses are about to arrive on site due to an impending hurricane. And, of course, there is the tale of Michael Matz, who in 1989 won the Grand Prix, a week after he walked away from a tragic plane crash in Sioux City. He survived the plane crash unharmed with fellow rider (and eventual wife) D.D. Alexander, who also did very well that year, winning a $10,000 jumper class. The following year, Matz would repeat his victory and become a back-to-back winner of the Grand Prix. Michael Matz and D.D. Alexander Matz's son Alex Matz has followed in the galloping strides of his parents and has competed at the Hampton Classic on several occasions. "I hope with hard work and perseverance I can win the Hampton Classic Grand Prix a few times. Then I can give back to the show that has been so exciting to attend as competitor," Alex says.

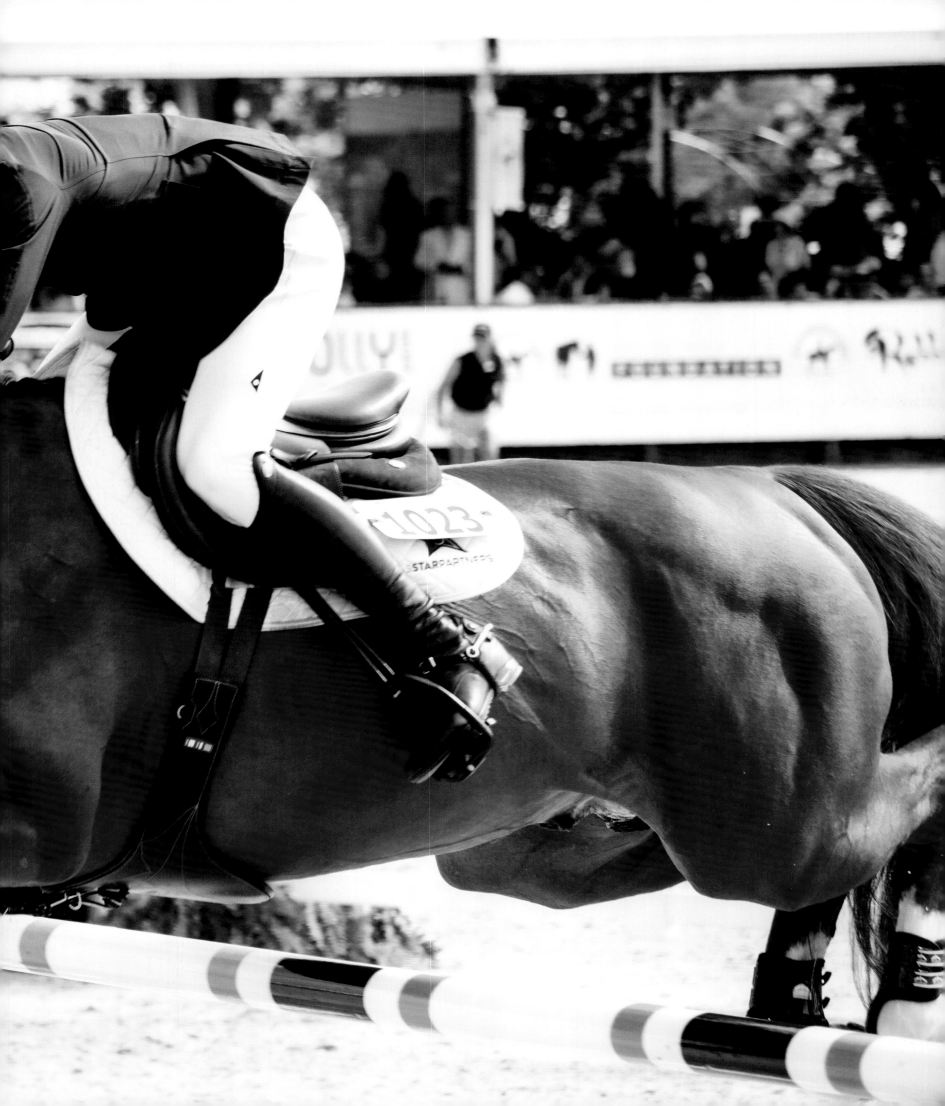

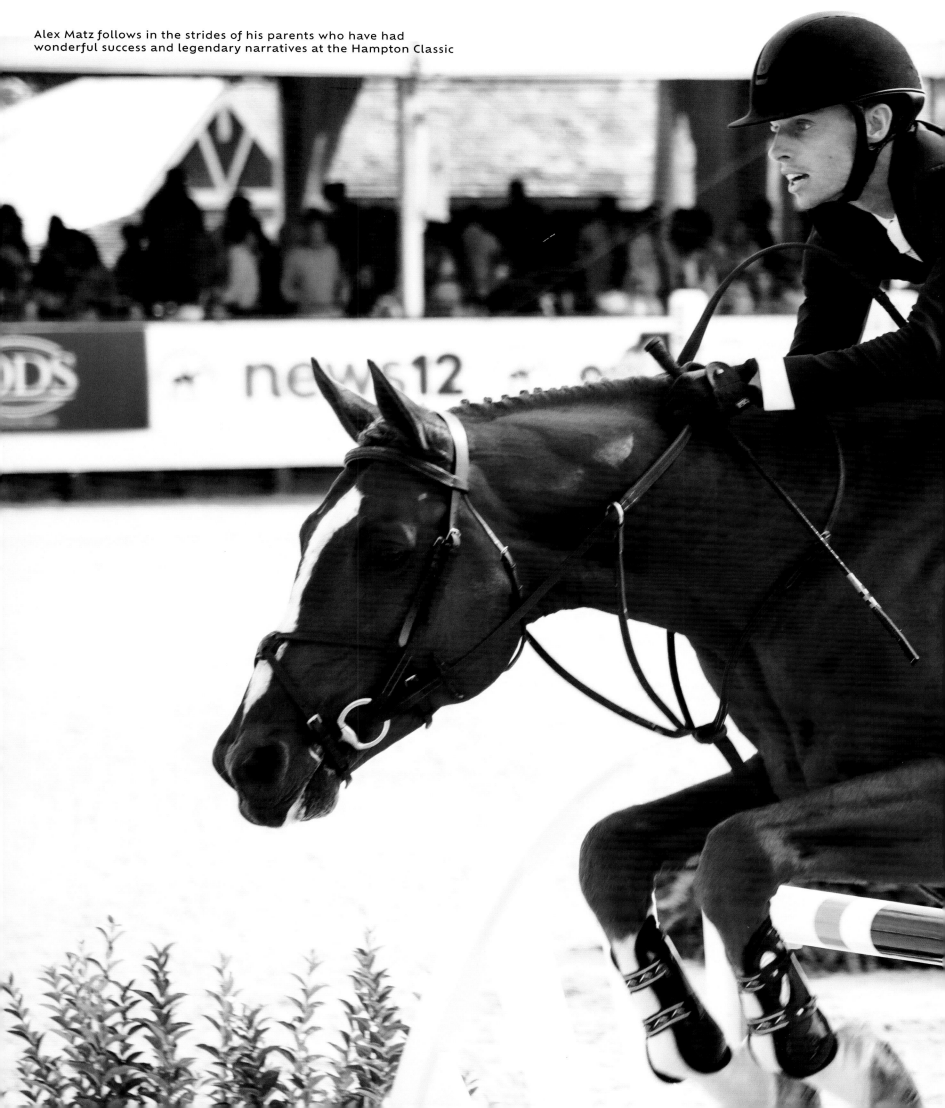

Alex Matz follows in the strides of his parents who have had
wonderful success and legendary narratives at the Hampton Classic

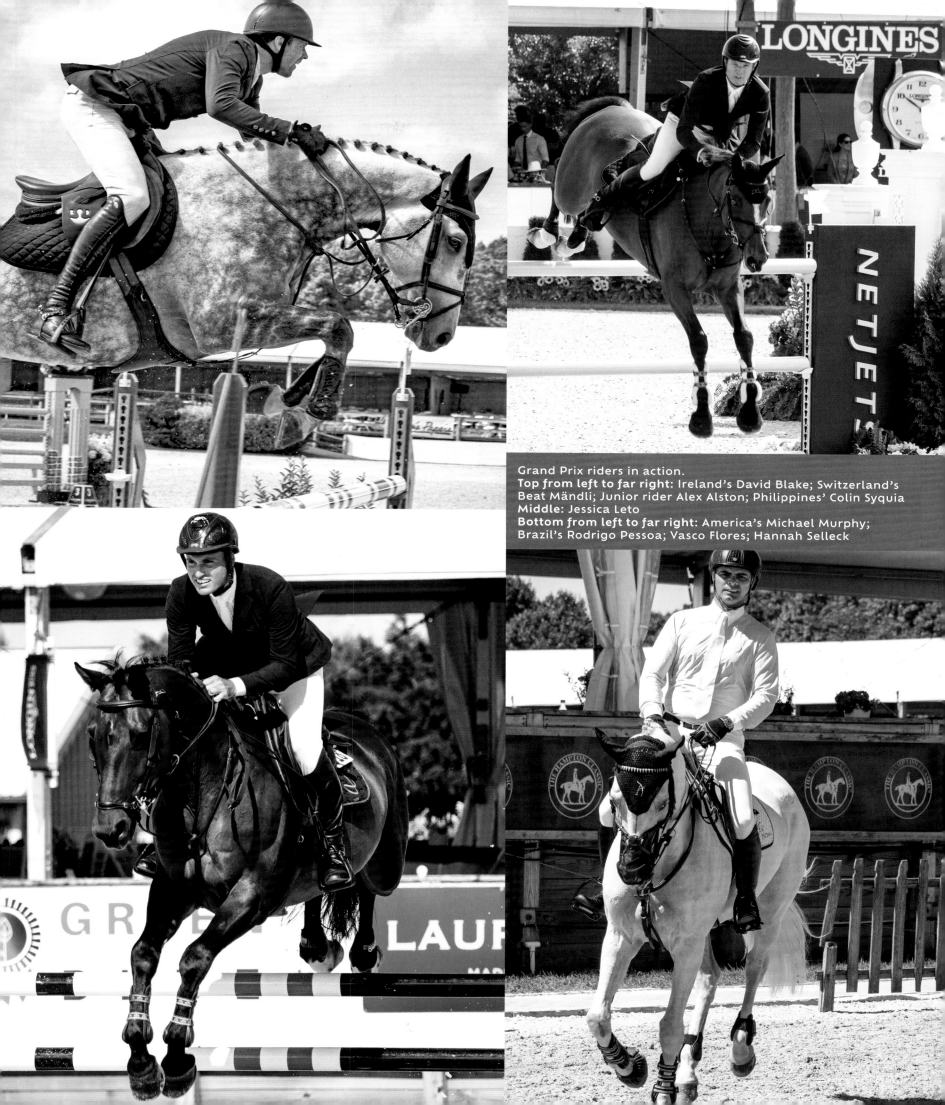

Grand Prix riders in action.
Top from left to far right: Ireland's David Blake; Switzerland's Beat Mändli; Junior rider Alex Alston; Philippines' Colin Syquia
Middle: Jessica Leto
Bottom from left to far right: America's Michael Murphy; Brazil's Rodrigo Pessoa; Vasco Flores; Hannah Selleck

Of course, it is a high-risk sport. To have your horse stop and refuse a jump at a fast gallop can propel you forward and make you lose your balance and fall off. A miscalculation of distance and/or miscommunication with the horse can each lead to spectacular and sometimes dangerous falls. Accidents can and have happened.

One of the most devastating was the fall of seasoned show jumper and Irishman Kevin Babington from his steed Shorapur during a Grand Prix qualifier class at the 2019 Hampton Classic that left him with a spinal cord injury. "It was a tricky combination. Three combinations in a row and my horse picked up one stride in the two-stride distance. Couldn't get her feet down and her feet sort of landed on the pole. And I face-planted into the ground. I did a backwards somersault and sort of landed on my Adam's apple. They had to stabilize my neck with rods," recounted Kevin Babington of his accident in a testimony he shared on YouTube. The fall left him a quadriplegic but that has not limited his involvement with the sport. He now acts as a coach and teacher to riders like his daughter Gwyneth Babington. The Kevin Babington Foundation has also been set up to provide aid to riders who have suffered spinal injuries, and the Hampton Classic is a big supporter of the foundation.

Geoffrey Hesslink, one of the country's best hunter riders, has written about his own unfortunate accident at the 2019 Hampton Classic that left him out of the sport for a year. In his essay for equine online publication *Noelle Floyd* on January 29, 2020, Geoffrey wrote, "It was a Tuesday morning, the first class in the Grand Prix ring. I walked the course, and since I had done so well on Sunday, I wanted to go for it. I left out some strides and did a few inside turns. I was doing so well, going super-fast. I made this rollback turn by the in-gate with a lot of momentum, and the horse's legs slipped out from underneath him. All four of his legs went to the left, and he fell on my leg and slid across it, basically twisting my entire leg around. Of course, my initial reaction was concern for my horse. I was so worried that he was hurt and, because of the adrenaline, wasn't feeling any pain (yet). Thankfully, he was fine ... not even a scratch! But when I tried to stand up, my leg felt like mush."

Geoffrey Hesslink was sidelined for months. Although, the pandemic of 2020 had some sort of silver lining because horse shows were put on pause. The Hampton Classic was not staged in 2020, the first time in its forty-six-year history. Geoffrey was able to recover from surgery without the nagging feeling of missing out on the horse show circuit.

"After my injury in 2019, coming back to the Hampton Classic was a big goal of mine. It was harder mentally than I ever would have imagined. I am very glad I made myself get back out there, because there is no feeling like cantering around the grass fields at the Hamptons," Geoffrey shares.

Top riders from all around the country and overseas make the pilgrimage to the Hamptons to compete at the Hampton Classic. "It is the best show in America. It is world class," says Dennis Suskind, president of the board of the Hampton Classic.

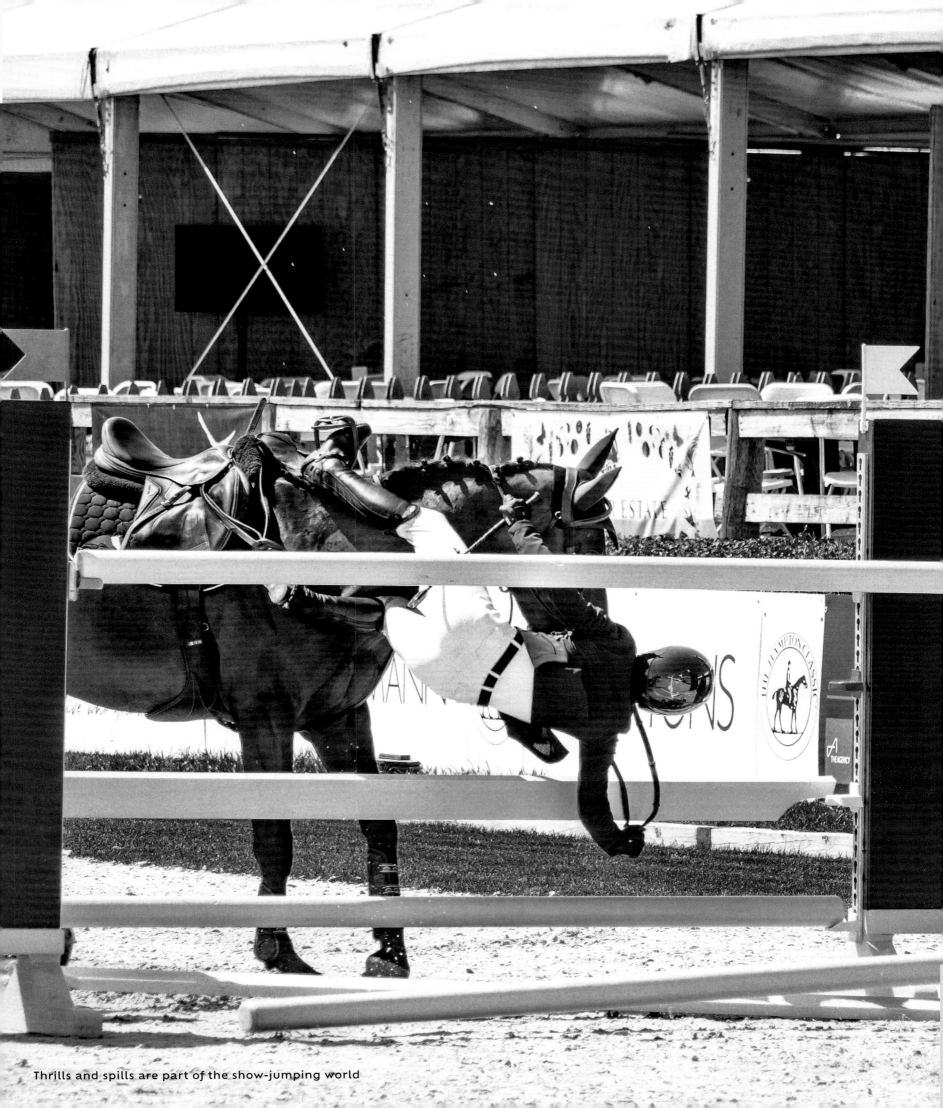

Thrills and spills are part of the show-jumping world

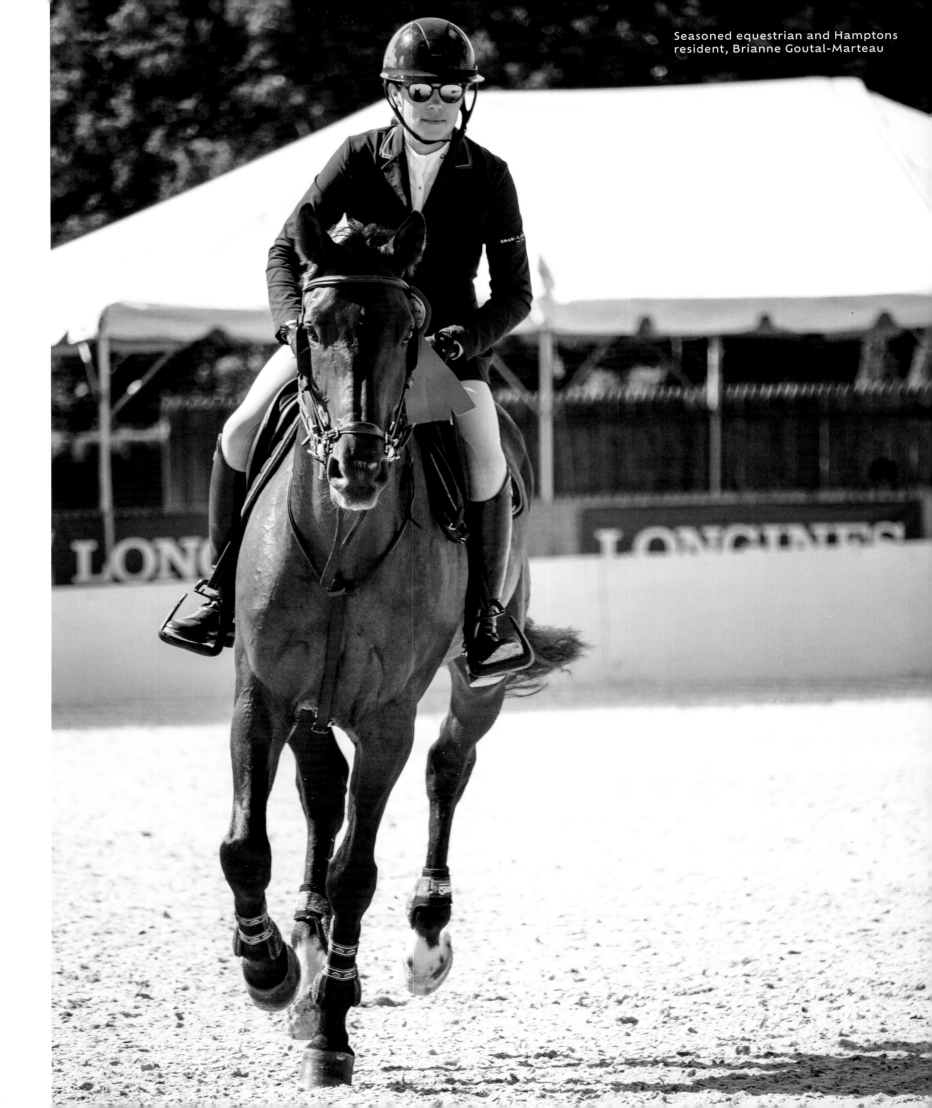

Seasoned equestrian and Hamptons resident, Brianne Goutal-Marteau

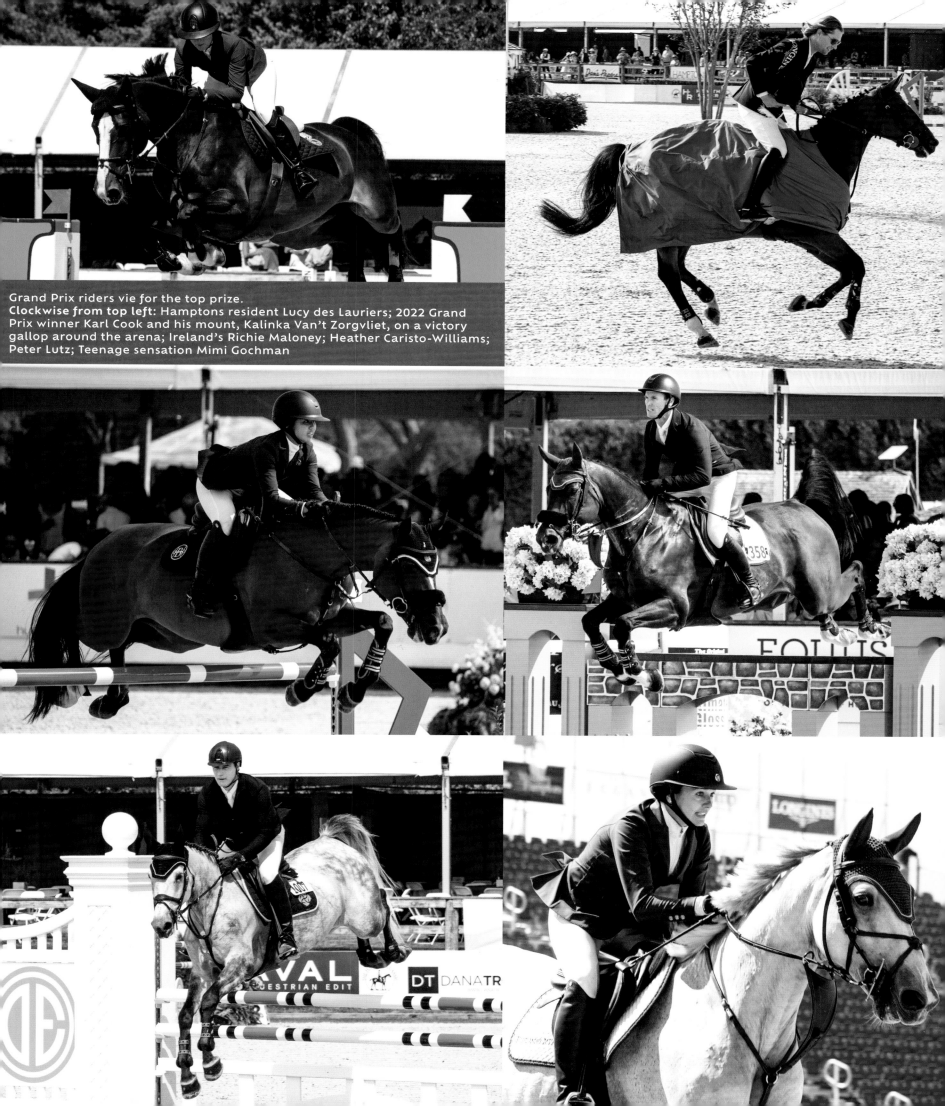

Grand Prix riders vie for the top prize.
Clockwise from top left: Hamptons resident Lucy des Lauriers; 2022 Grand Prix winner Karl Cook and his mount, Kalinka Van't Zorgvliet, on a victory gallop around the arena; Ireland's Richie Maloney; Heather Caristo-Williams; Peter Lutz; Teenage sensation Mimi Gochman

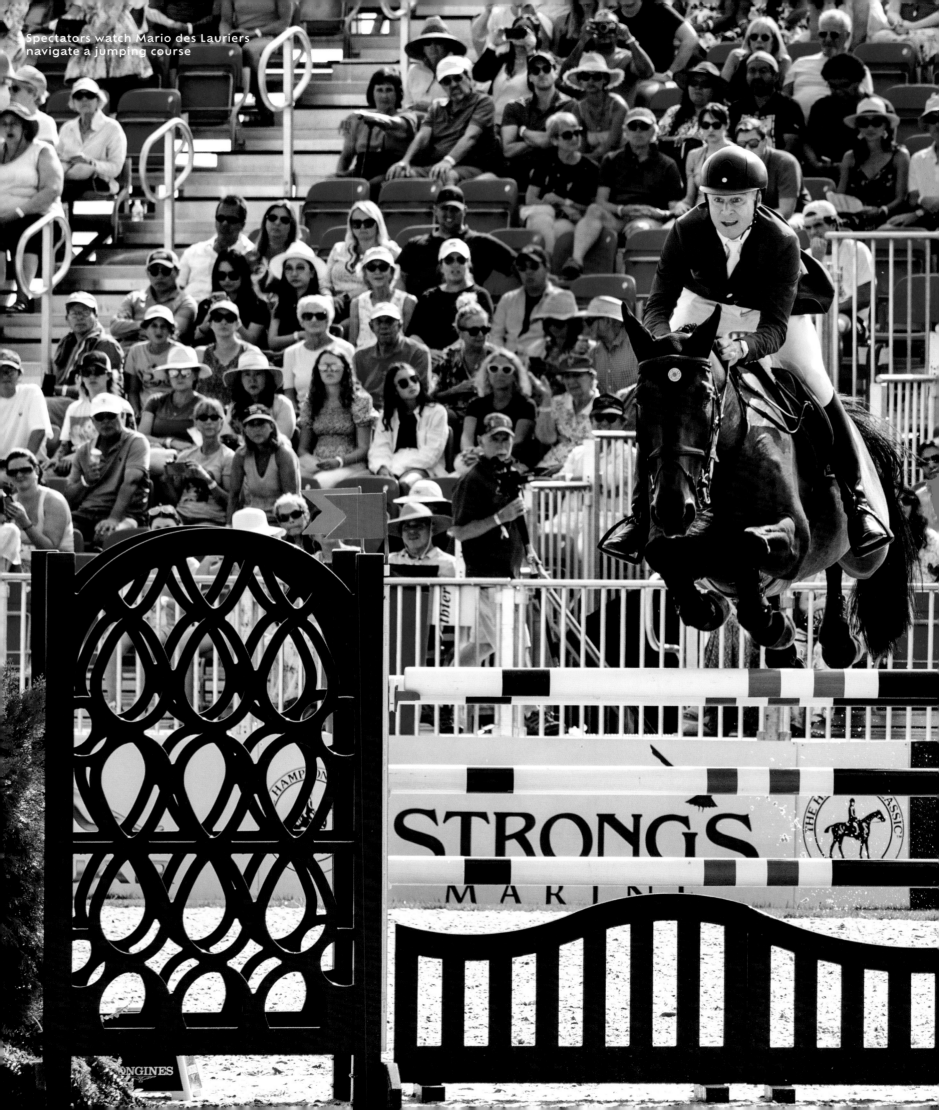

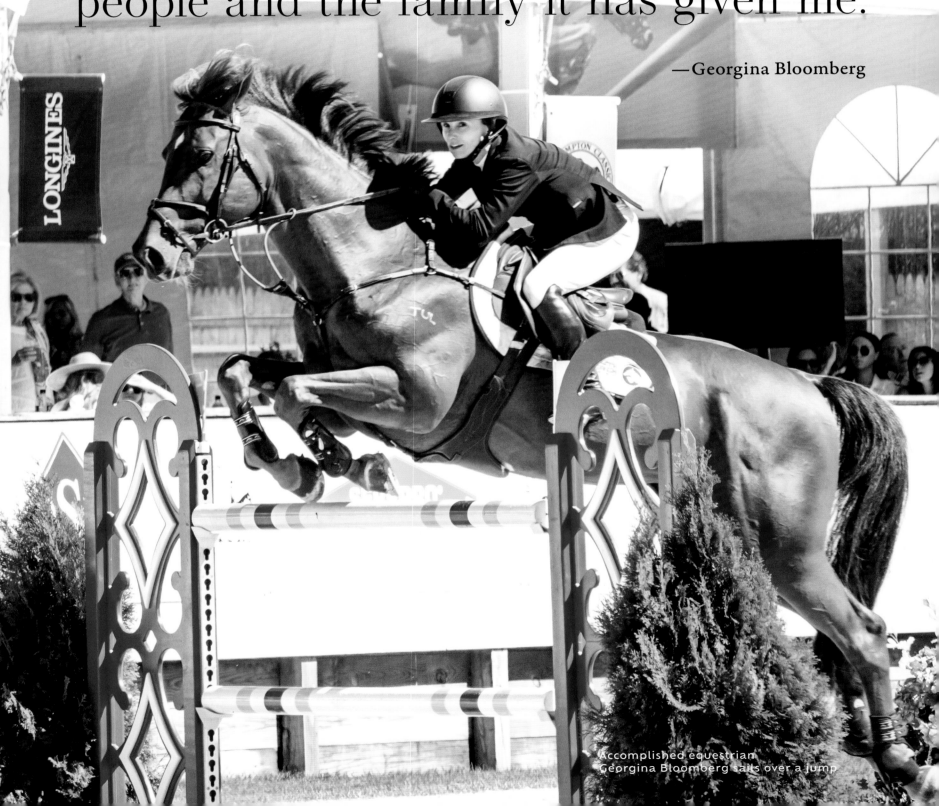

"The equestrian community has given me so much and it is important to me to give back to it in any way I can. Not only do I love the horses, but I love the people and the family it has given me."

—Georgina Bloomberg

Accomplished equestrian Georgina Bloomberg sails over a jump

risks, and I was going to beat him. I wasn't going to be slower than him today. And it worked out."

"It was a really incredible feeling," Daniel adds. "It's really special not only because it's the Hampton Classic, but because it's McLain Ward on his home turf. To beat him today is definitely going to be one that I'll remember."

McLain Ward, of course, is a United States Olympian, having won the silver medal at the 2020 Tokyo Olympics, and he has claimed the top Hampton Classic Grand Prix prize seven times. The first was in 1998 with his horse Twist du Valon and most recently in 2018 on his mare Gigi's Girl BH. "It's a nice accolade to have on one's resumé. It's always been an important Grand Prix for me but you have to look forward at what's in front of you," says McLain, and adds: "The horse is the true athlete. Some horses are better than others. Sometimes there is anxiety and nerves. Sometimes you question whether you prepared well. Sometimes you are prepared well and you don't want to let the horse down. It's a whole cluster of emotions."

To watch a show jumper is not like watching a Formula One racing car driver speed through a race. Show jumping requires the harmony of two living, breathing creatures—the rider and their mount. Everything is deliberate, studied, and approached with a combination of derring-do and confidence. The sharp turns, the lengthening of the strides, the seat positions on and off the saddle and the constant readjustment for balance at the gallop makes the sport inaccessible to those who are fearful or indecisive. It is also one of a few sports where all genders and ages compete against each other.

Sometimes it's all in the family, like in 2019, when father and daughter competitors Mario and Lucy des Lauriers bested each other at the jump-off of the $300,000 Grand Prix event. Canadian Olympian Mario des Lauriers rode his horse Bardolina to eke out a win against his daughter Lucy (who rides for the United States) by the narrowest of margins. "She and Hester make a great pair, and I know they are very quick. I did what I had to do to put a little pressure on her," remarked Mario des Lauriers of his strategy against his daughter at the press conference afterwards.

There were eight obstacles in that jump-off complete with left turns and right turns, and occasions to gallop. Mario sped through the course with a time of 42.82 seconds and no faults. Lucy approached the jump-off with incredible quickness and confidence and was clocked to win at 39.6 seconds but unfortunately she knocked down a pole at the last jump and incurred a four-point penalty. "My horse is great. I couldn't be happier. It's a family win regardless," said Lucy des Lauriers after the exhilarating jump-off.

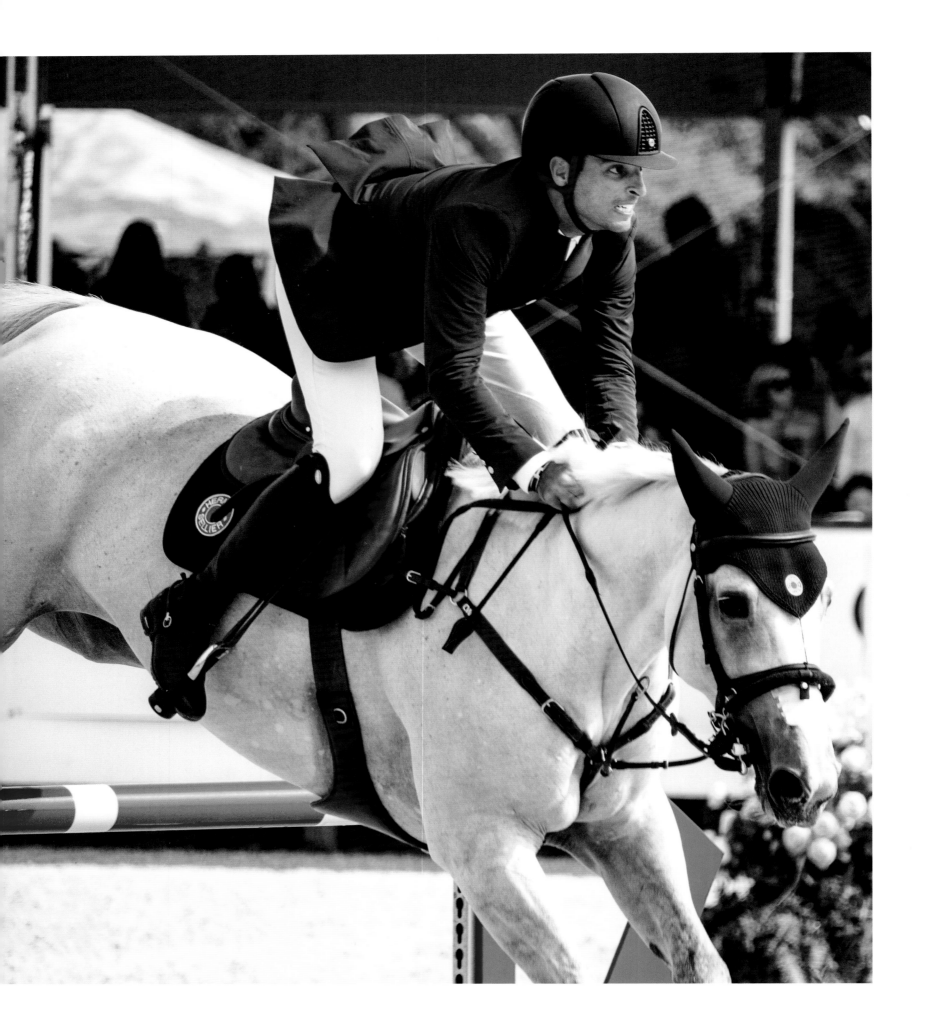

"Winning the Grand Prix in 2021 was very special. It was a fast jump-off and a great effort. Family and friends were there to see it and live the moment. It was great. Winning it in 2017 was just as special. It was my first win of this prestigious Grand Prix. That weekend was magical."

—Daniel Bluman

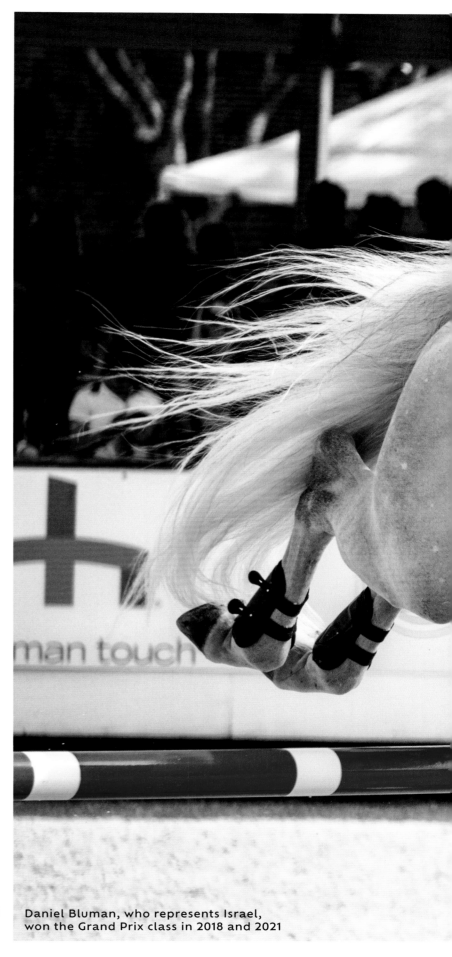

Daniel Bluman, who represents Israel, won the Grand Prix class in 2018 and 2021

Riding to Victory

Premier Show Jumping and Polo Competitions

To compete and ultimately win the Grand Prix at the Hampton Classic is to summon something out of the ordinary. For the rider, it is to be in perfect unison with your horse. For the spectator, it is to bear witness to an unshakable trust between horse and rider and quite literally a manifestation of a leap of faith.

For just under two minutes, a hush descends upon the crowd. The only sounds are coming from the heavy breathing of a horse; the crescendo of its strides and muscle exertions at the sight of a jump; the 'whoas' and 'clucks' of the rider; the gentle command to speed up with a squeeze of the legs or a tap of a crop; the hooves brushing the poles making them quiver in their cups; the millisecond when both horse and rider hold their breath as they float over a triple oxer, followed by the echoing thud upon landing. Then the rapturous applause from the spectators after a clear, victorious round.

The stakes and the excitement factor go up several notches at the jump-off. It's a heart-pounding thriller when riders and horses with clear rounds are tested on their speed, abilities to make zippy turns, riding accuracy, and their will to win. An application of geometry and mathematics is also needed. Finding the quickest way from obstacle to obstacle, creating angles on turns, and leaving strides out. And when you win and get to do a victory lap, well, that's just one for the books.

"I was watching everything McLain Ward did carefully," Daniel Bluman says of his ride to victory at the 2021 Hampton Classic Grand Prix event on his horse Gemma W. "He's a fast rider, and he loves to win this class. Then the crowd went crazy when he finished, and I had so many emotions at that point. I just said to myself that I was going to give everything—absolutely everything—I had. I was going to take all the

United States Olympian McLain Ward has won the Grand Prix event at the Hampton Classic seven times—the most wins of any rider since the competition started in 1977

Marilyn Clark looks timeless and elegant in her riding outfit

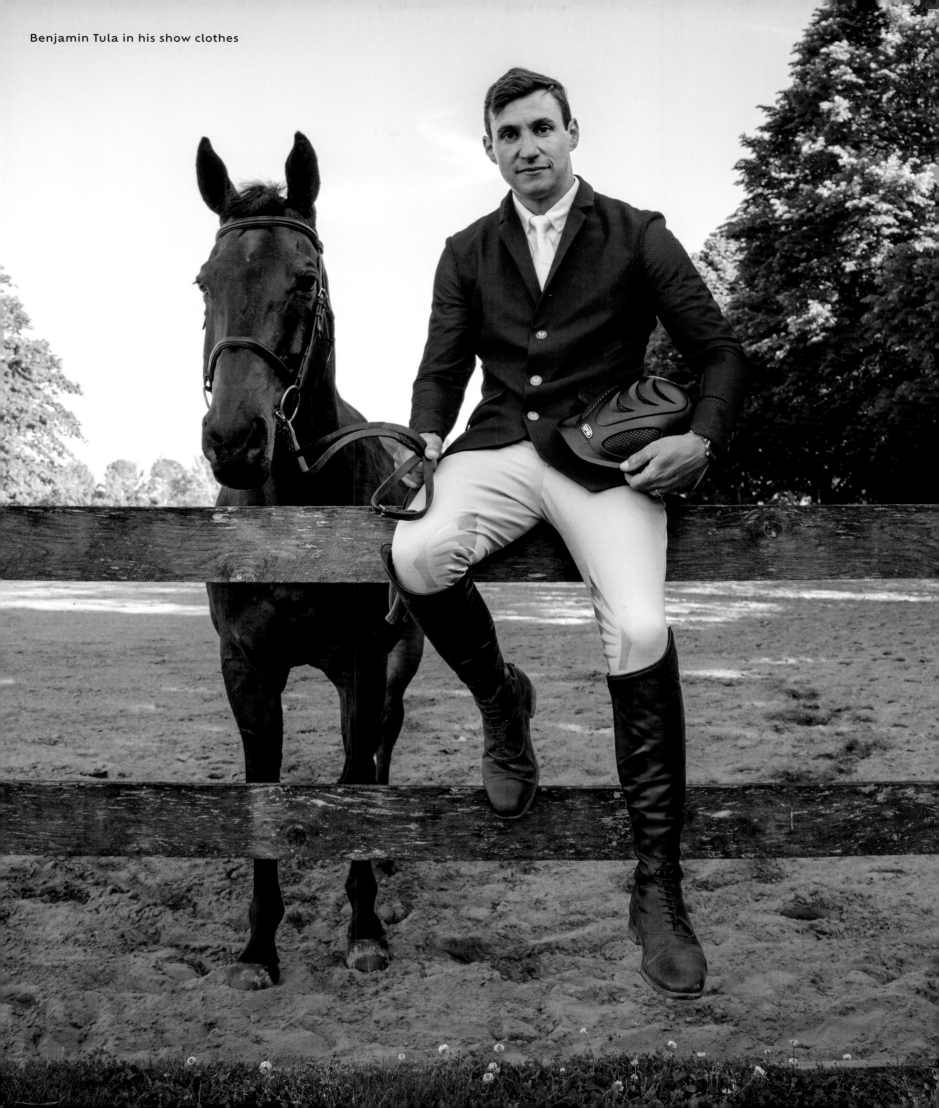

Benjamin Tula in his show clothes

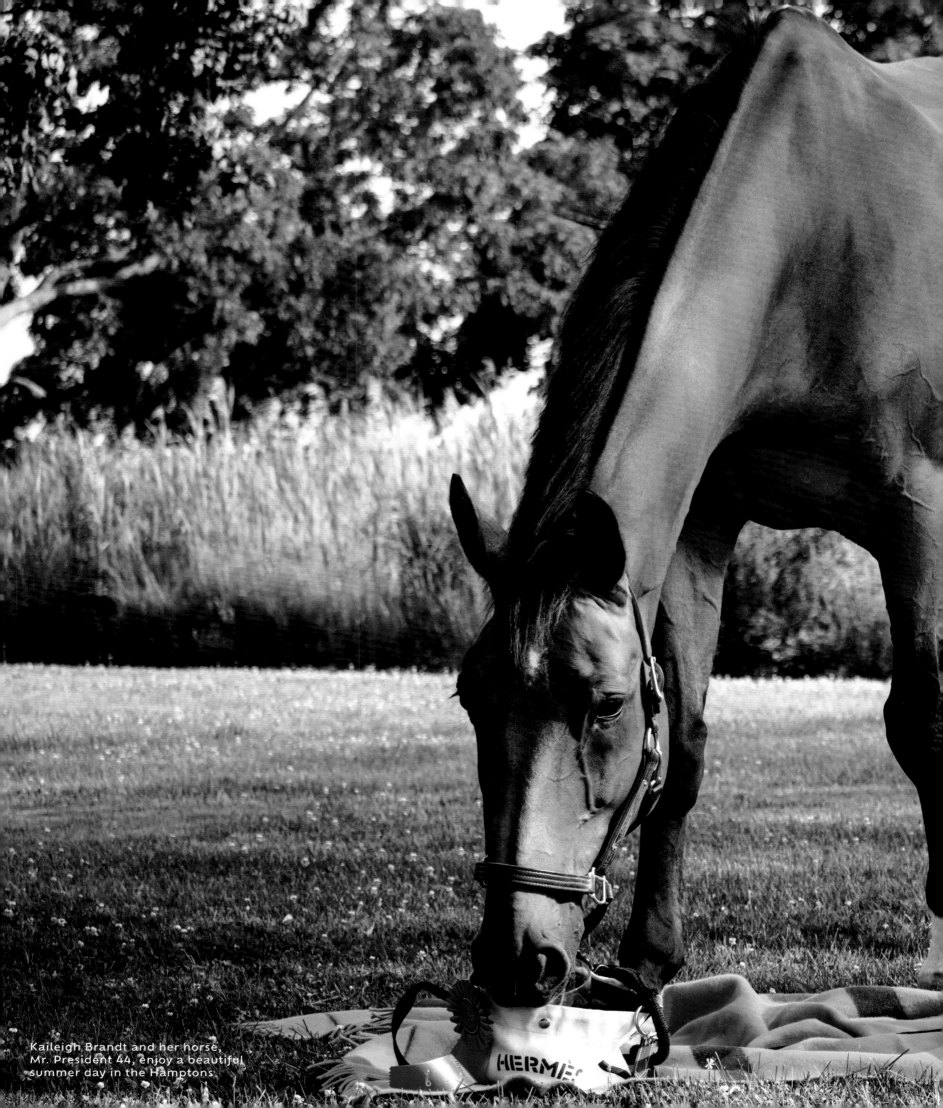

Kaileigh Brandt and her horse,
Mr. President 44, enjoy a beautiful
summer day in the Hamptons

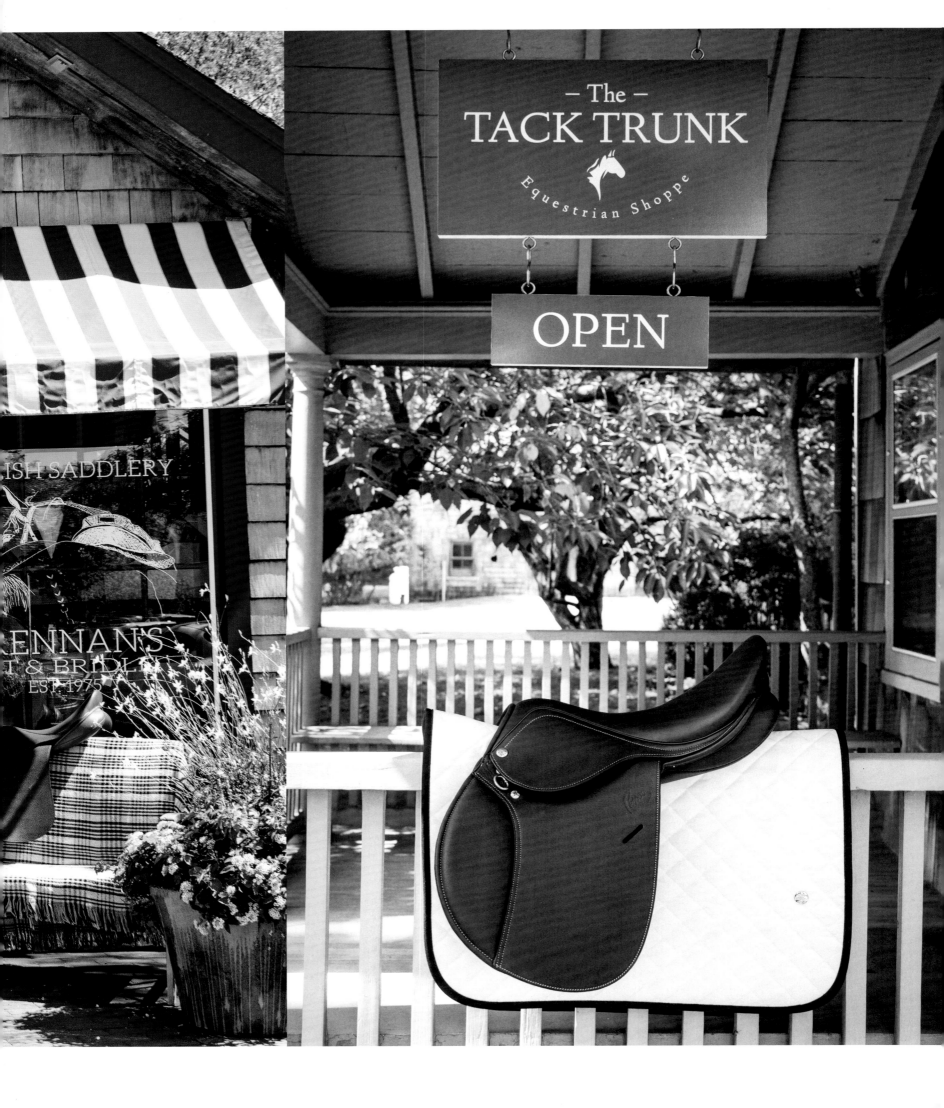

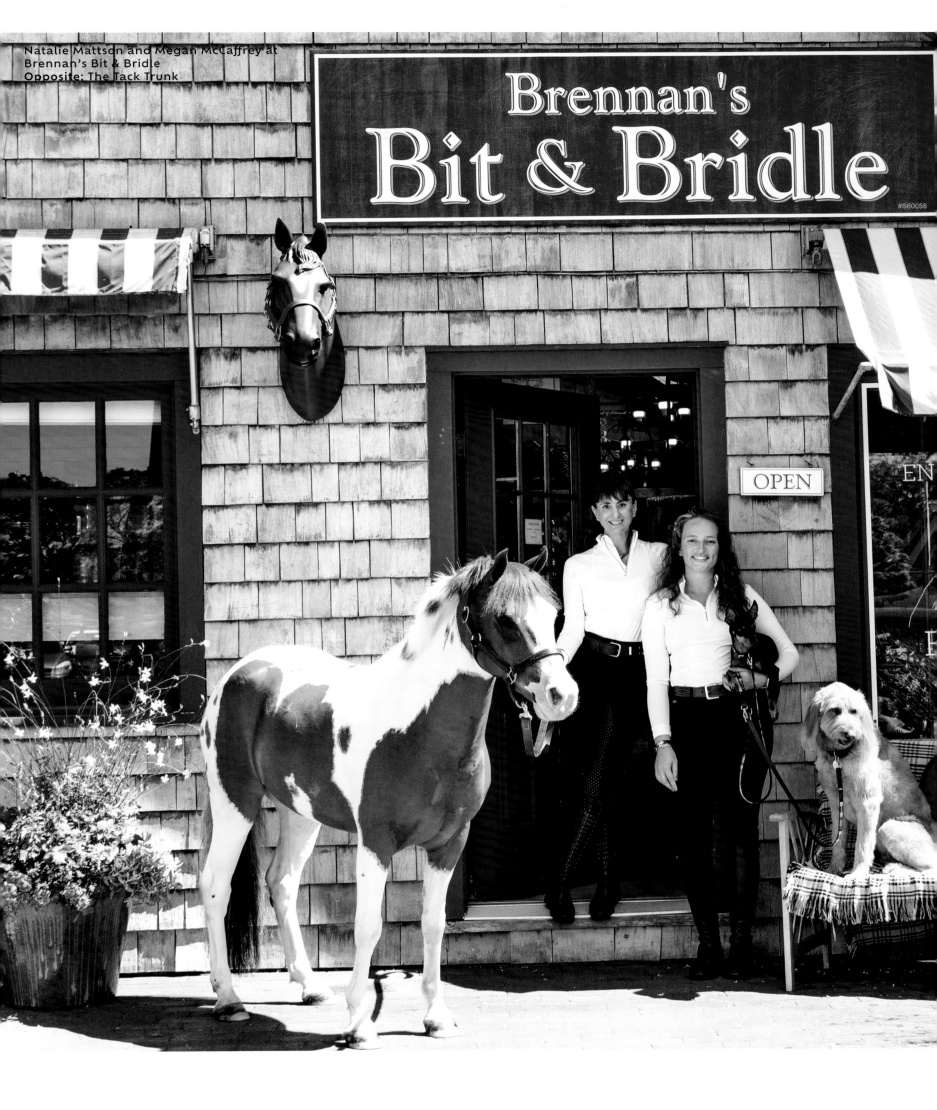

Natalie Mattson and Megan McCaffrey at
Brennan's Bit & Bridle
Opposite: The Tack Trunk

Brennan's
Bit & Bridle

OPEN

"What I love about equestrian style is that it combines polish, tailoring, and functionality. It is also, most importantly, about movement and line. It's the best of both worlds."

—Michael Kors

A collection of horse bits

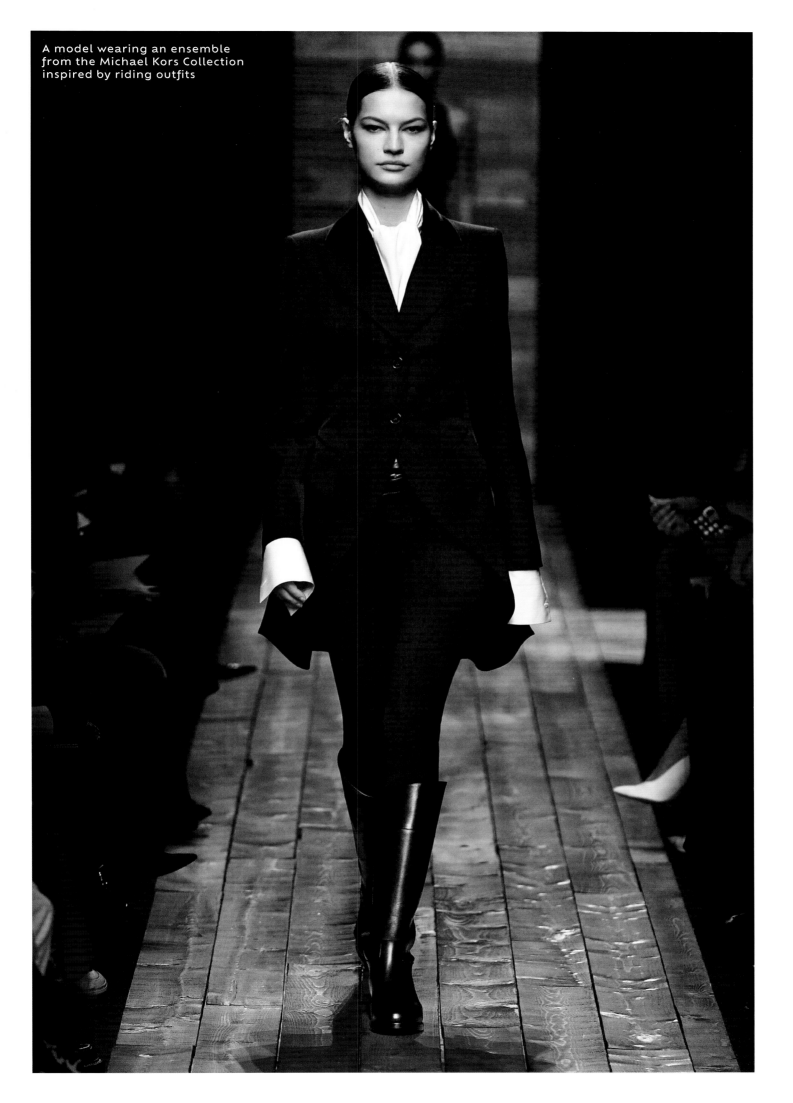

A model wearing an ensemble from the Michael Kors Collection inspired by riding outfits

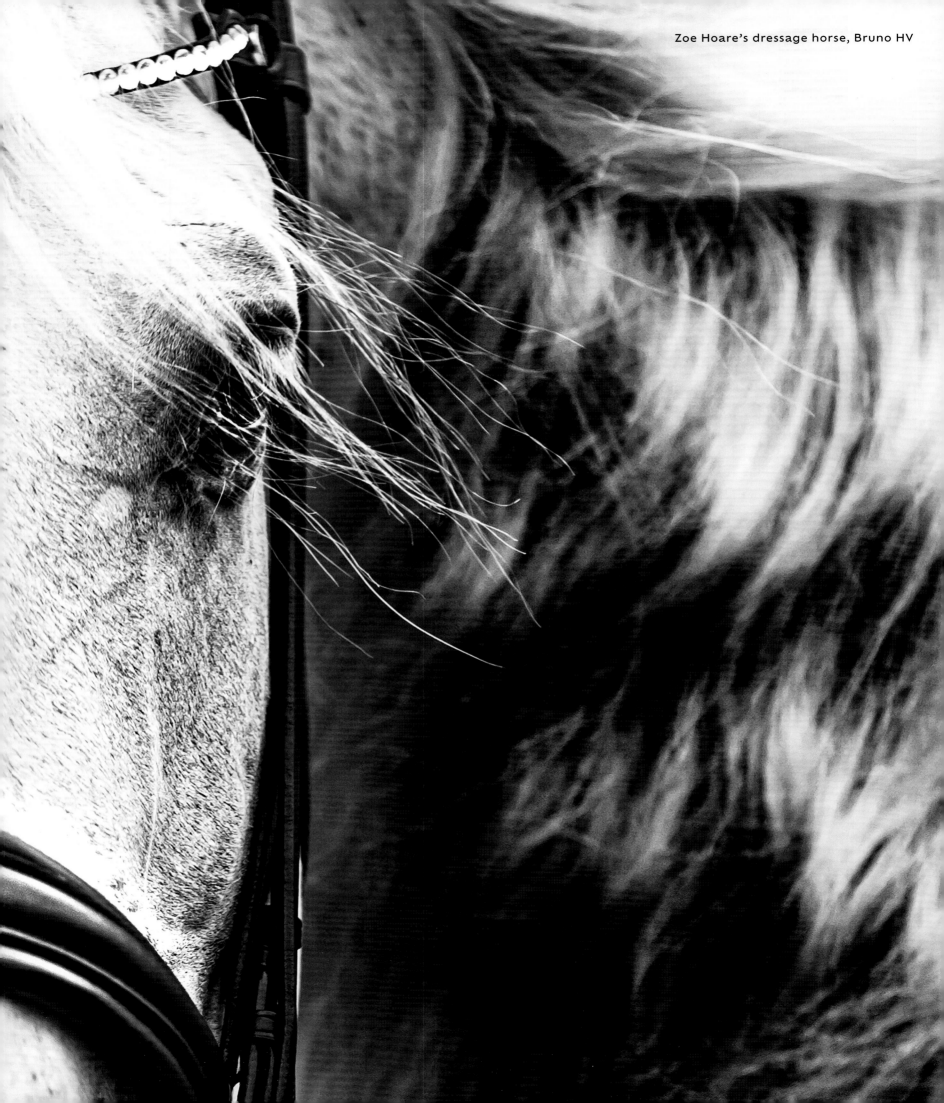

Zoe Hoare's dressage horse, Bruno HV

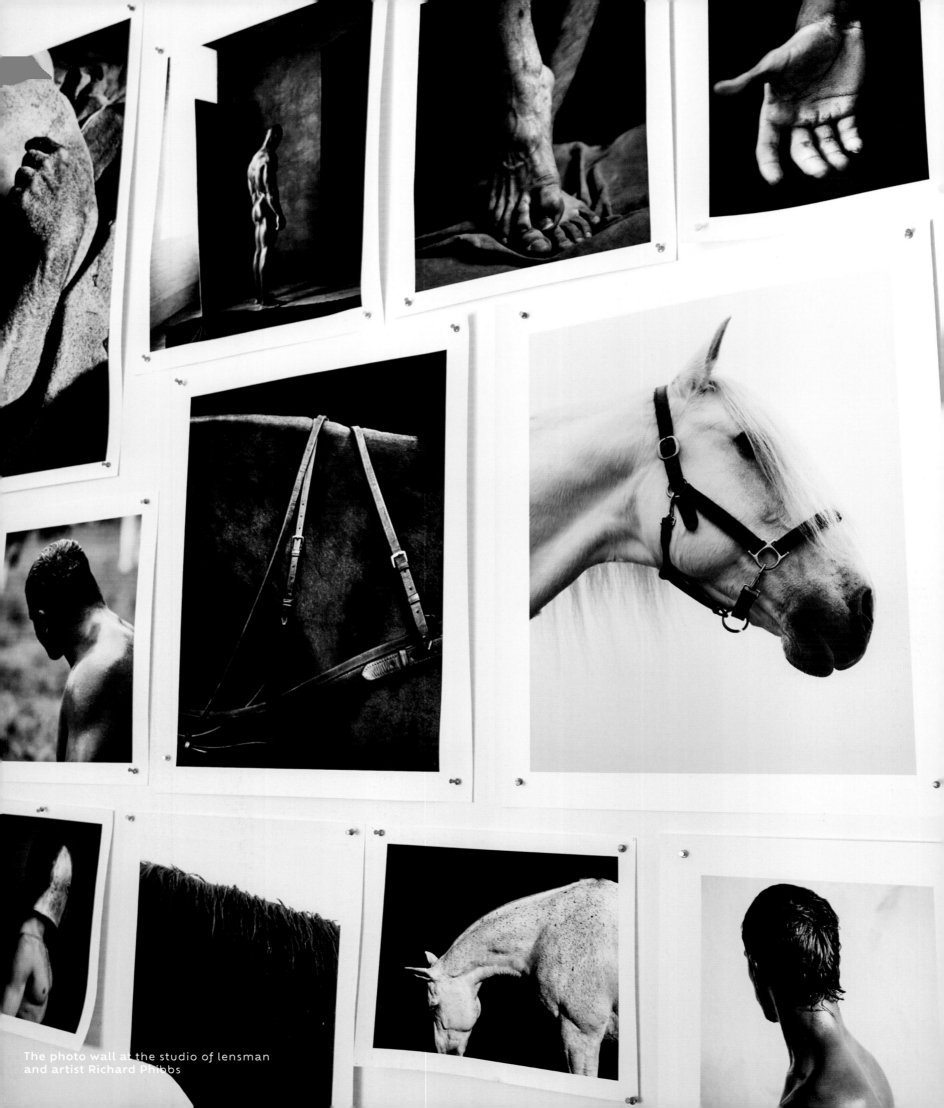

The photo wall at the studio of lensman
and artist Richard Phibbs

"I like to photograph horses because they are magic."

—Richard Phibbs

Ralph Lauren poses beside a horse near East Hampton in 1997; the designer has made equestrian sports and horsemanship an integral part of his brand identity

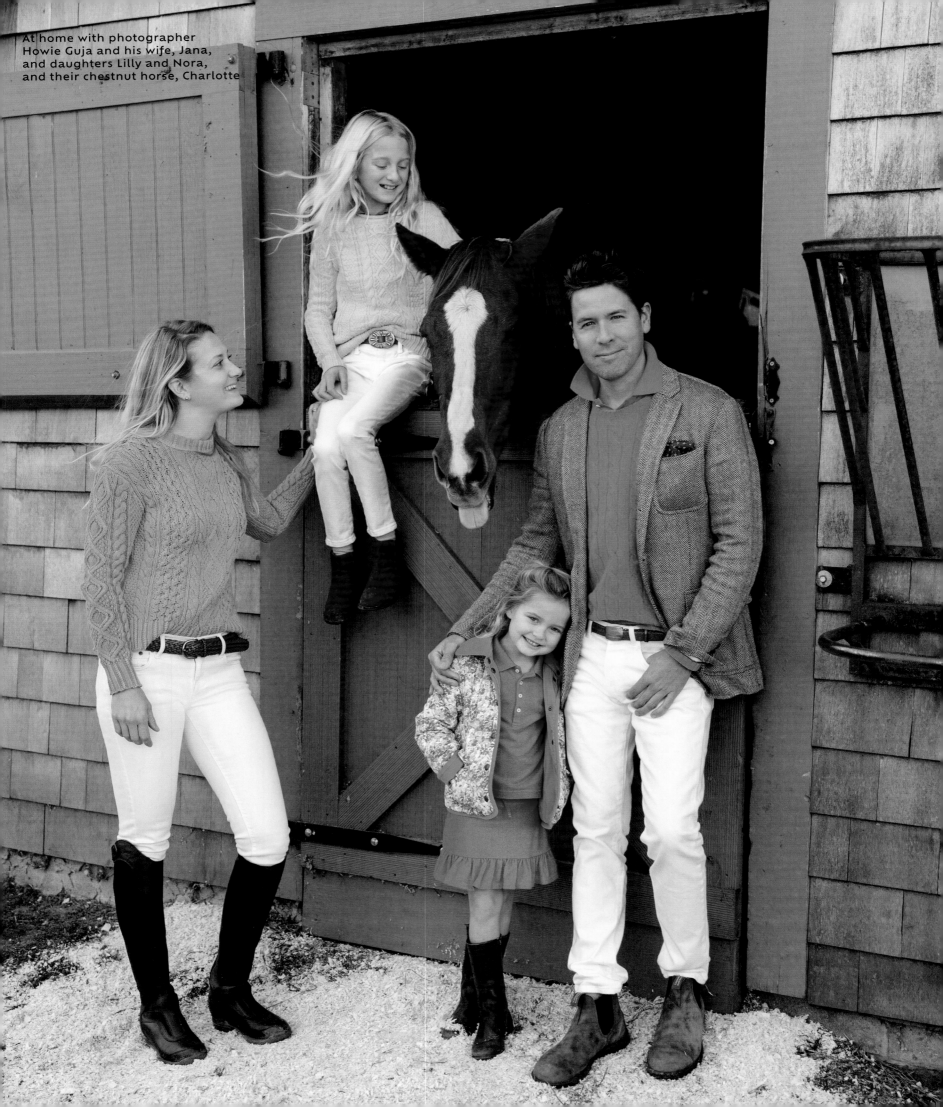

At home with photographer Howie Guja and his wife, Jana, and daughters Lilly and Nora, and their chestnut horse, Charlotte

The equestrian look has transcended the sport and has become part of the fashion landscape because it comes with the allure of a privileged life. It conjures images of wealth and the aspirational lives of the leisure class. Think Jackie Kennedy, Grace Kelly, C.Z. Guest, and Athina Onassis. Plus, it is inherently chic, what with the burnished boots, skin-tight breeches, tailored show jackets, gloves, and all.

However, the elegance of equestrian dress as we know it had a pragmatic and utilitarian genesis. The tall boots protected the rider from chafing and from scratches from wayward tree branches and brambles during hunts. The stock ties doubled as slings or tourniquets in case of riding accidents. The net veil with the top hats protected the face from mud from charging horses. And the jackets and coats, and to some extent the waistcoats, guarded against the elements.

On the other side of the English riding style is the all-American cowboy and cowgirl look with the jeans, plaid shirts, and cowboy boots and hats. These are outfits that have sartorial lives outside of ranches and rodeos.

In the Hamptons, equestrian sporting kit and tack stores like Brennan's Bit & Bridle and The Tack Trunk cater to both riders for performance outfits and show clothes *and* nonriders who want that equestrian look. Danielle Levine, the founder of equine e-commerce site Kaval, also operates pop-up retail outlets around the week of the Hampton Classic, offering horse-inspired fashions and accessories alongside technical equestrian clothes.

"Over the years, countless brands have been inspired by the horse world's formal fox-hunting look," Danielle says. "But there is another side to equestrian style—one that I think is equally iconic. The clean-faced, classic 'horse girl.' That woman is Jackie Kennedy, Liz Taylor, Audrey Hepburn, or, for that matter, cowboys on the plains, who effortlessly throw on a pair of breeches or jeans and a top to ride their horse. There is nothing more beautiful than someone in their happy place—sitting astride a 1,200-pound animal who will transport them, even for a moment, to a different world," Danielle describes.

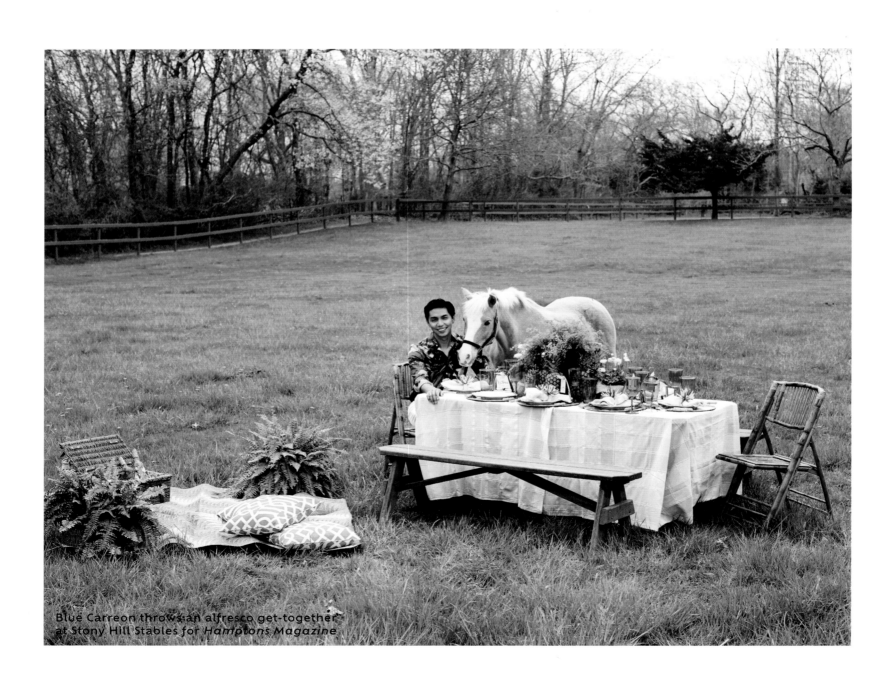

Blue Carreon throws an alfresco get-together
at Stony Hill Stables for *Hamptons Magazine*

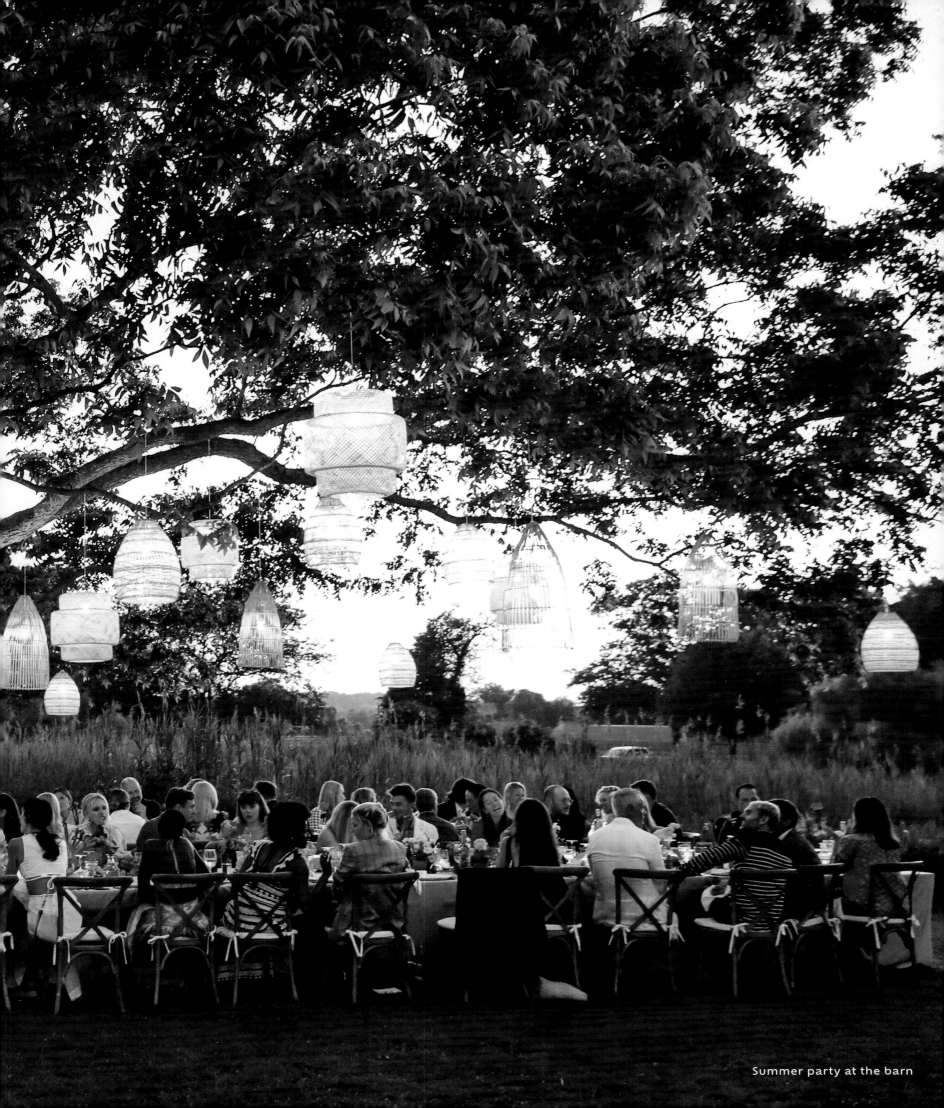

Summer party at the barn

Party barns, those restored and converted structures that tell of the East End's farming origins, have been coveted real estate features as much as heated pools and tennis courts. And arguably one of the most Hamptons-esque images is that of a summer picnic or a wedding at the barn with horses in the distance. Stephanie Riggio Bulger had her wedding to Michael Bulger at her sprawling barn MeadowView Farms surrounded by family and friends, as well as friends of the four-legged kind, which included horses, miniature ponies, and goats. Kelsey Calabro of Pinnacle Farm exchanged wedding vows with Raymond Wellen under an allée of cherry blossom trees. Her prized show horses looking out from the windows of their stalls.

In the fashion world, Gucci's horsebit motif easily comes to mind for equine-inspired design; the Italian fashion house embellishing everything from loafers and bags to ready-to-wear with the ubiquitous horsebit. Boots echoing a rider's footwear, especially the two-tone version used by hunters, have been co-opted by fashion. Jodhpurs, stirrup pants, riding jackets, velvet helmets, and top hats have also been given fashion makeovers throughout the years. And the quilted jackets, tweed coats, and scarves that we've come to associate with the country weekend and of course royalty, such as the late Queen Elizabeth II, are part of the fashion vernacular.

Most recently, fashion has been having quite the love affair with horses. For the opening of its haute couture spring/summer 2022 collection, Chanel sent Princess Charlotte Casiraghi of Monaco down the runway astride her mount. Actress Jennifer Lawrence has starred in Dior advertisements with black and gray horses. Dior, of course, has one of its best-selling bags, a small purse that borrows its shape from the horse saddle. And Burberry, Chloé, Loewe, and Gucci have all run with campaigns that featured models of the human and equine form.

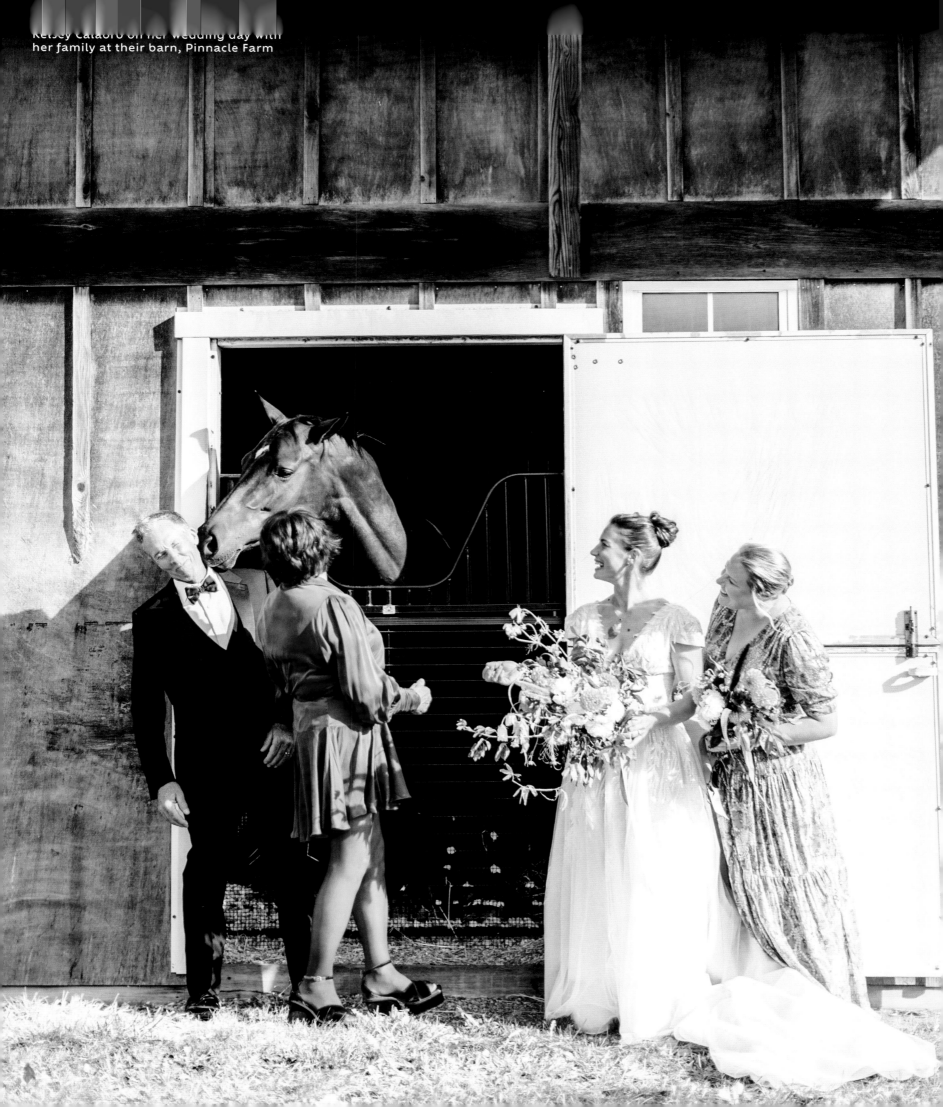

Kelsey Calabro on her wedding day with her family at their barn, Pinnacle Farm

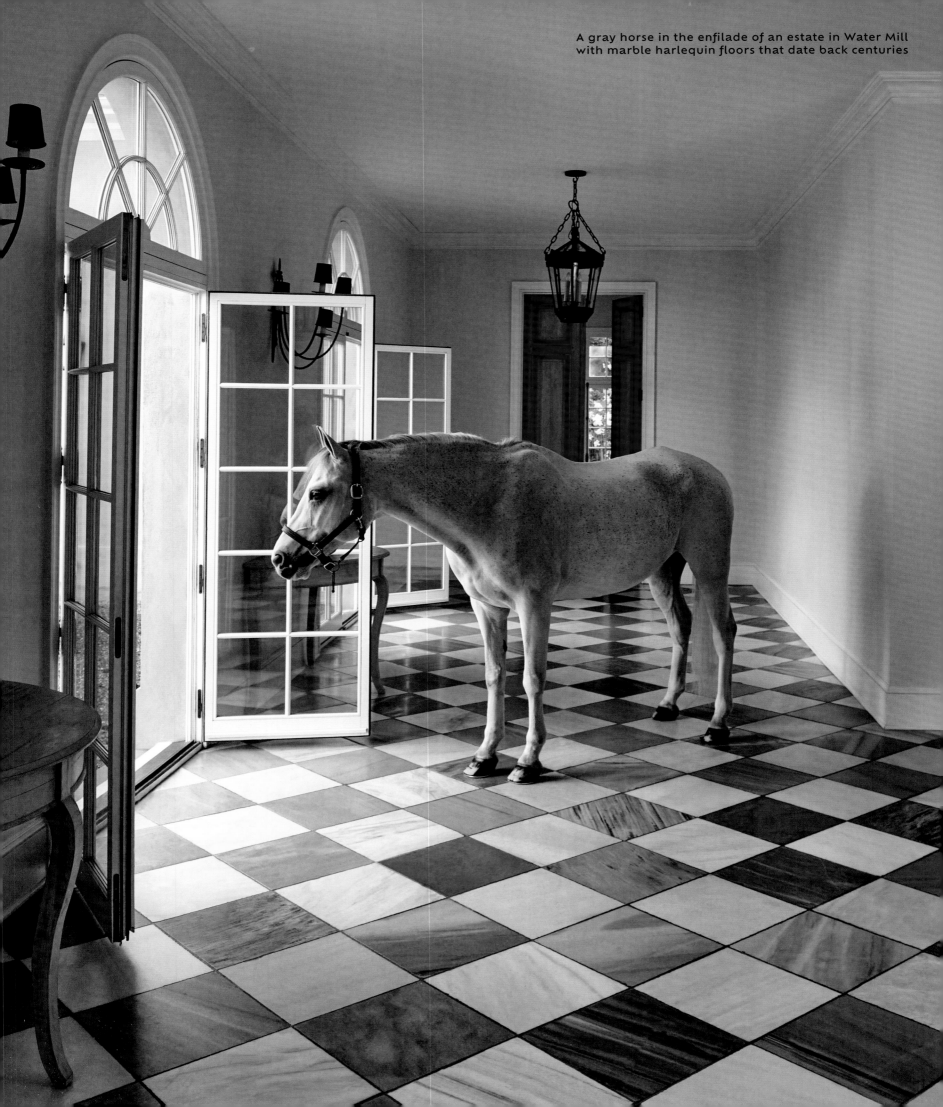

A gray horse in the enfilade of an estate in Water Mill with marble harlequin floors that date back centuries

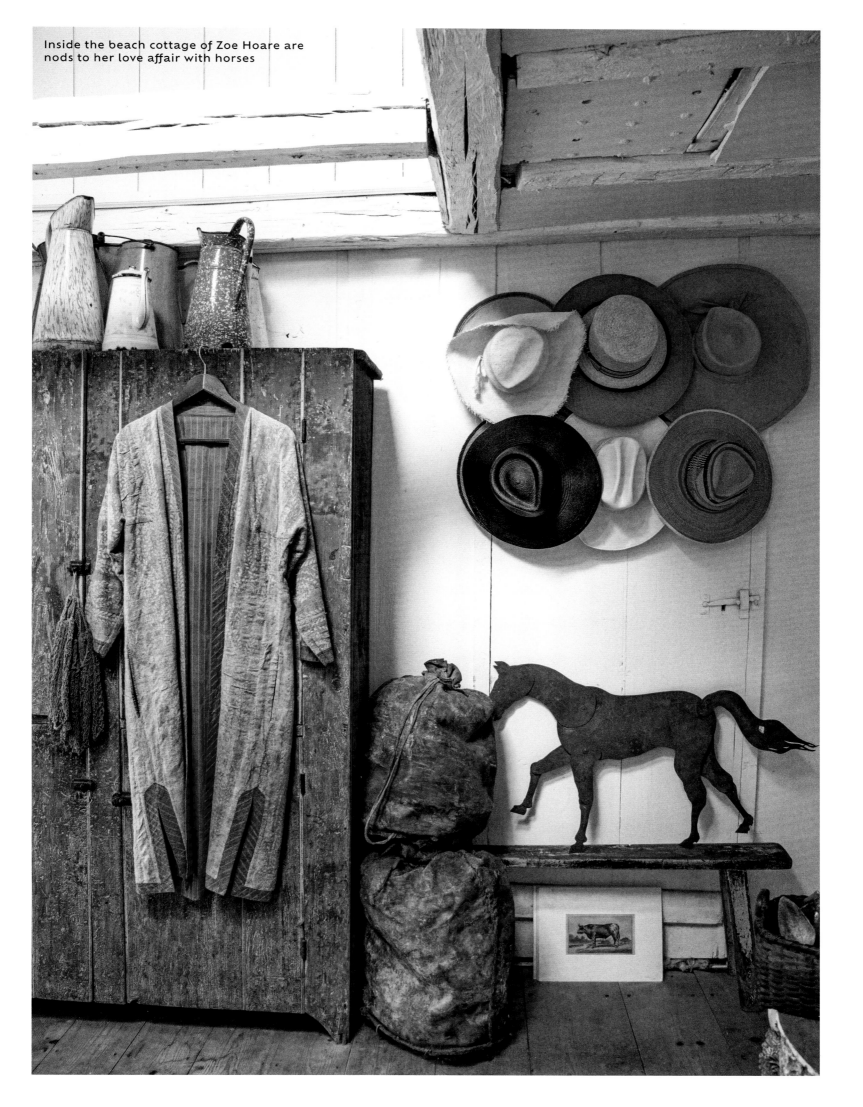

Inside the beach cottage of Zoe Hoare are nods to her love affair with horses

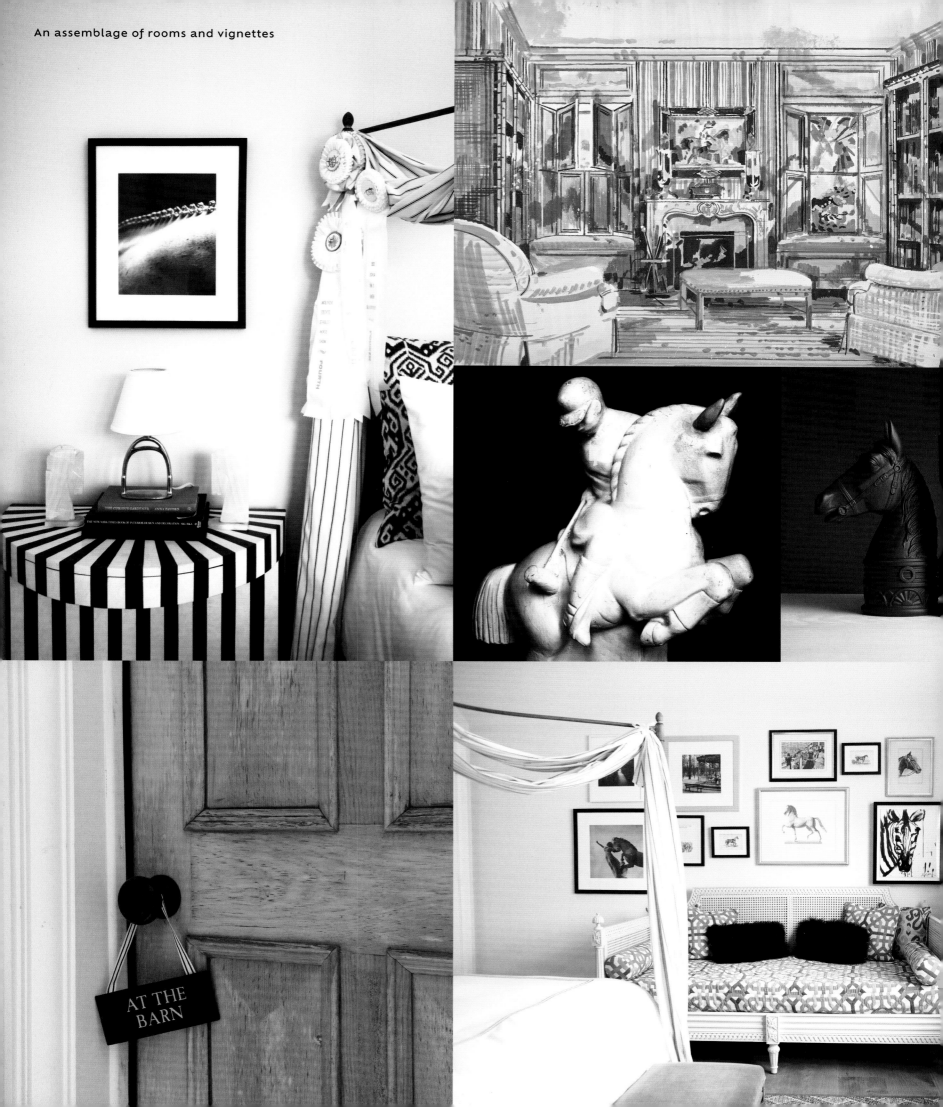

An assemblage of rooms and vignettes

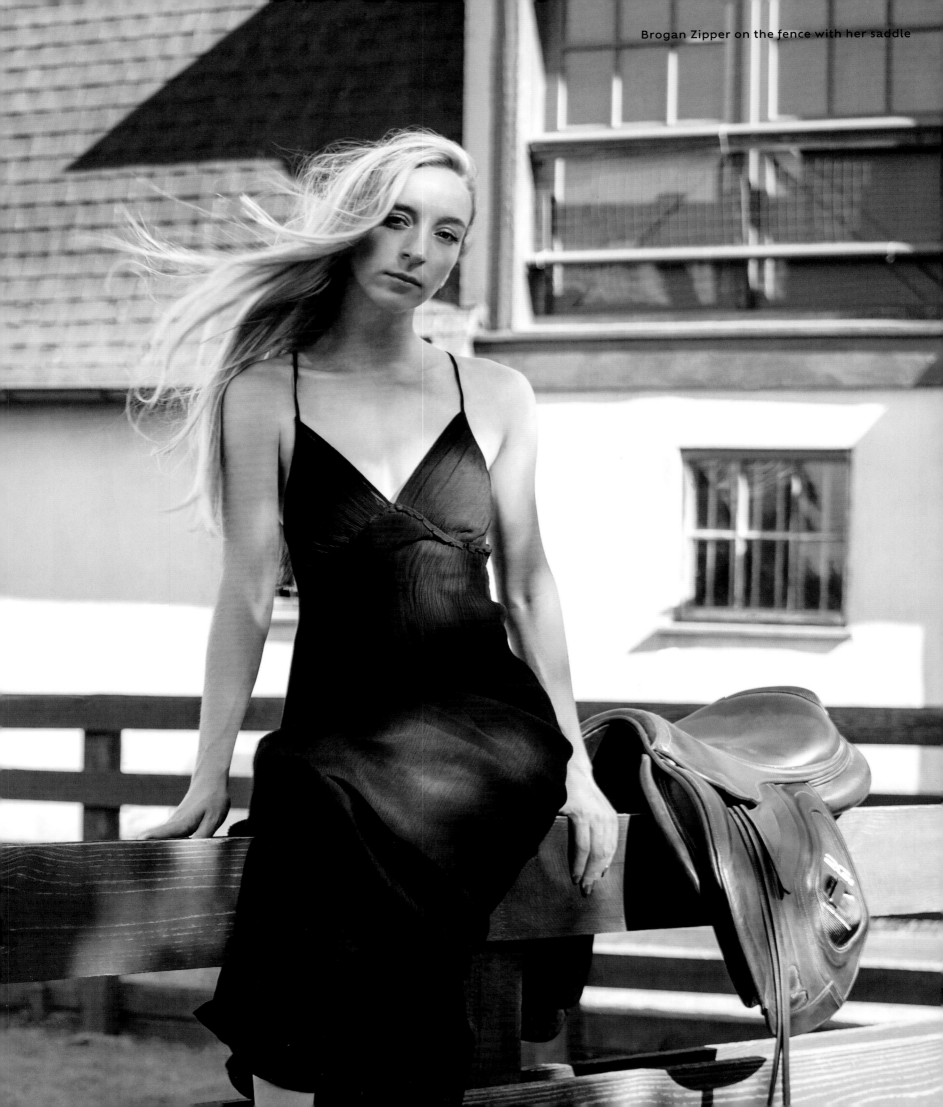

The entryway of a beach house in Water Mill, created by Marie Christine Design

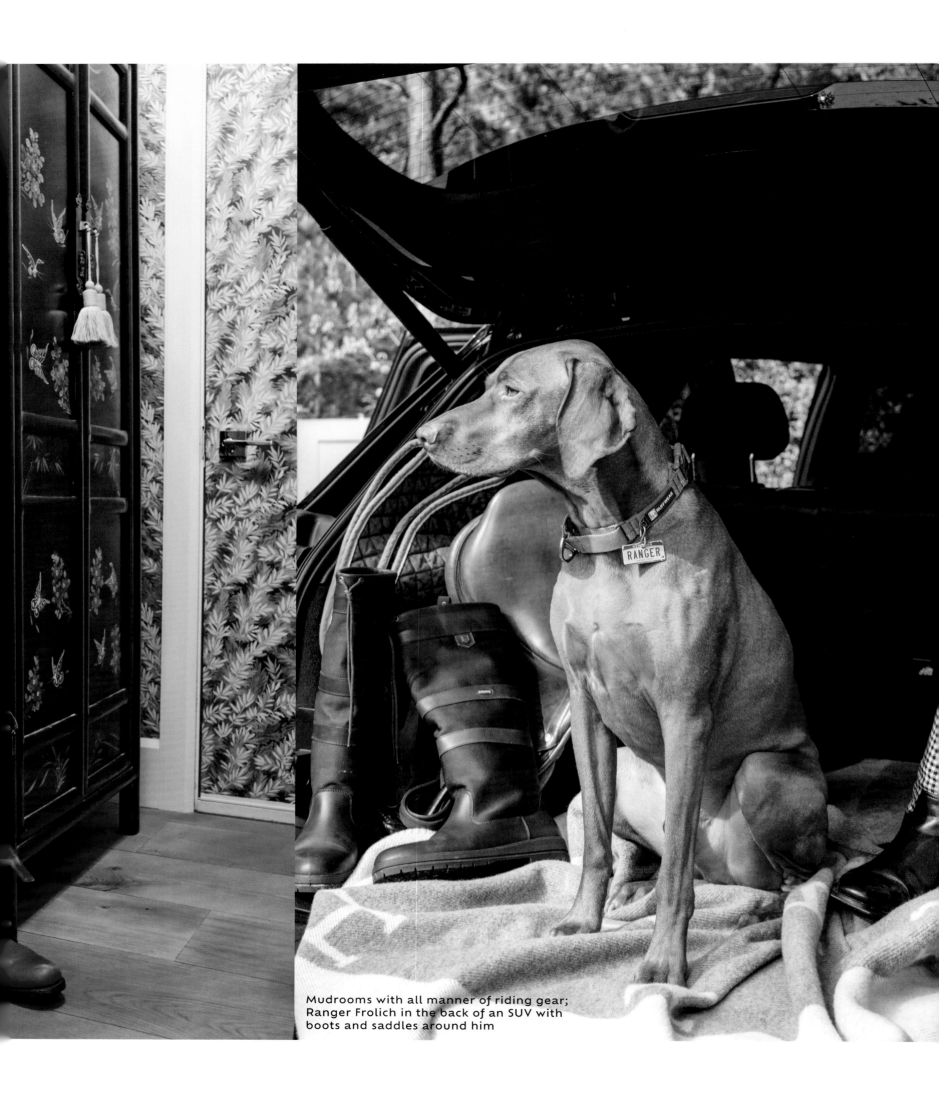

Mudrooms with all manner of riding gear; Ranger Frolich in the back of an SUV with boots and saddles around him

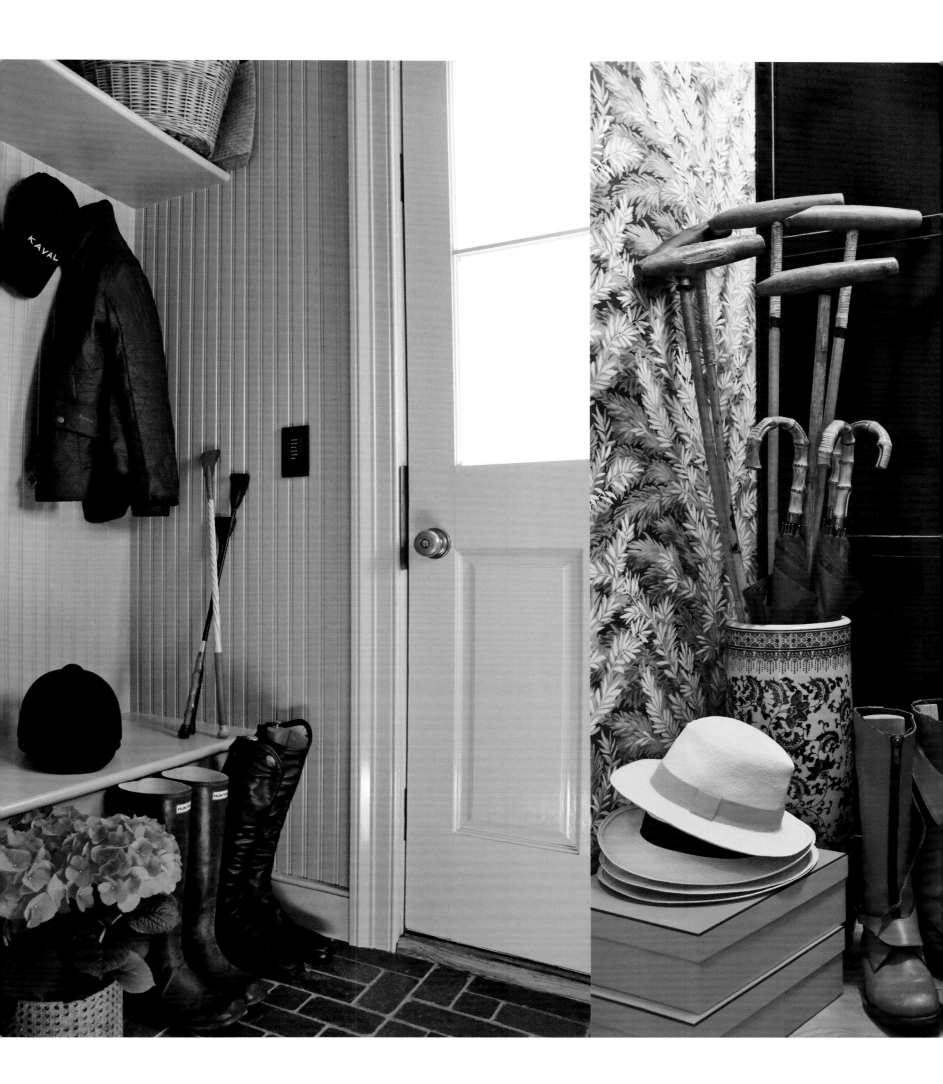

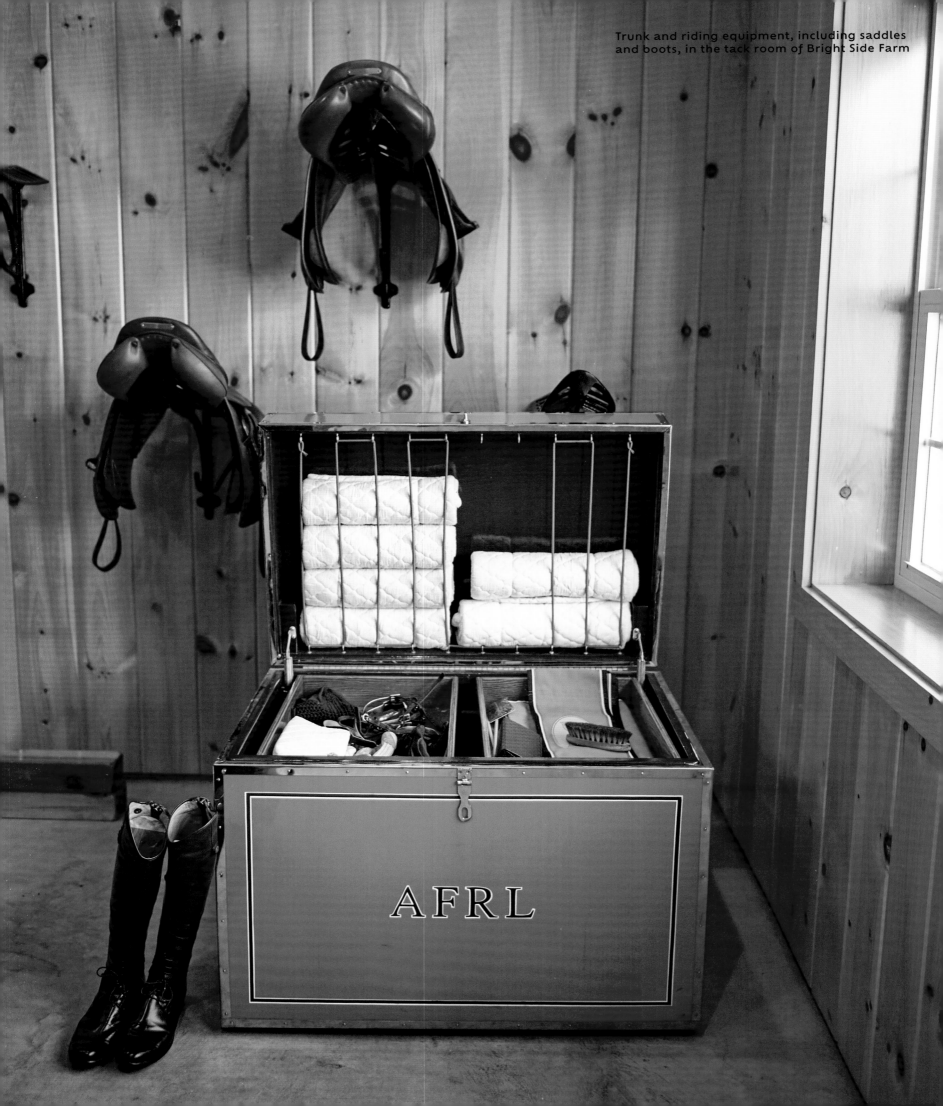

AFRL

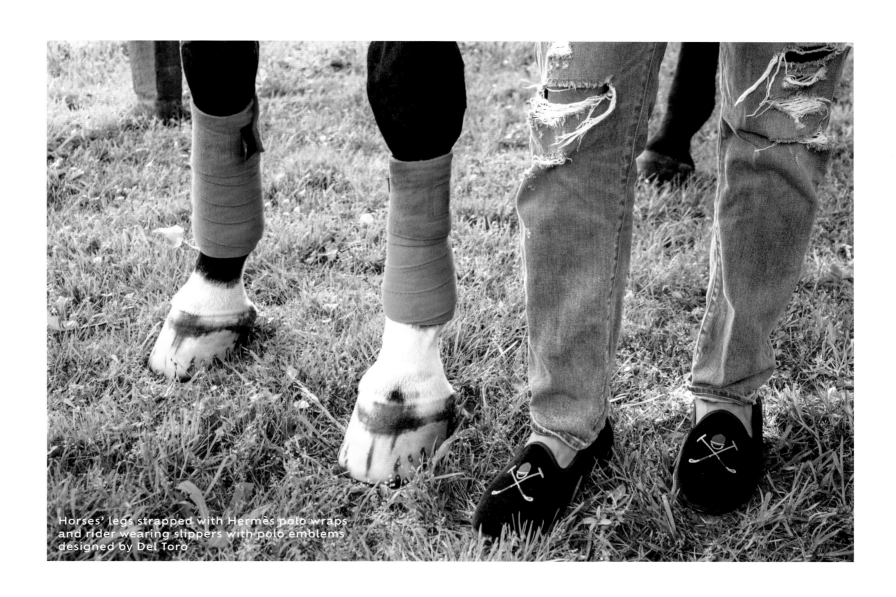

Horses' legs strapped with Hermès polo wraps
and rider wearing slippers with polo emblems
designed by Del Toro

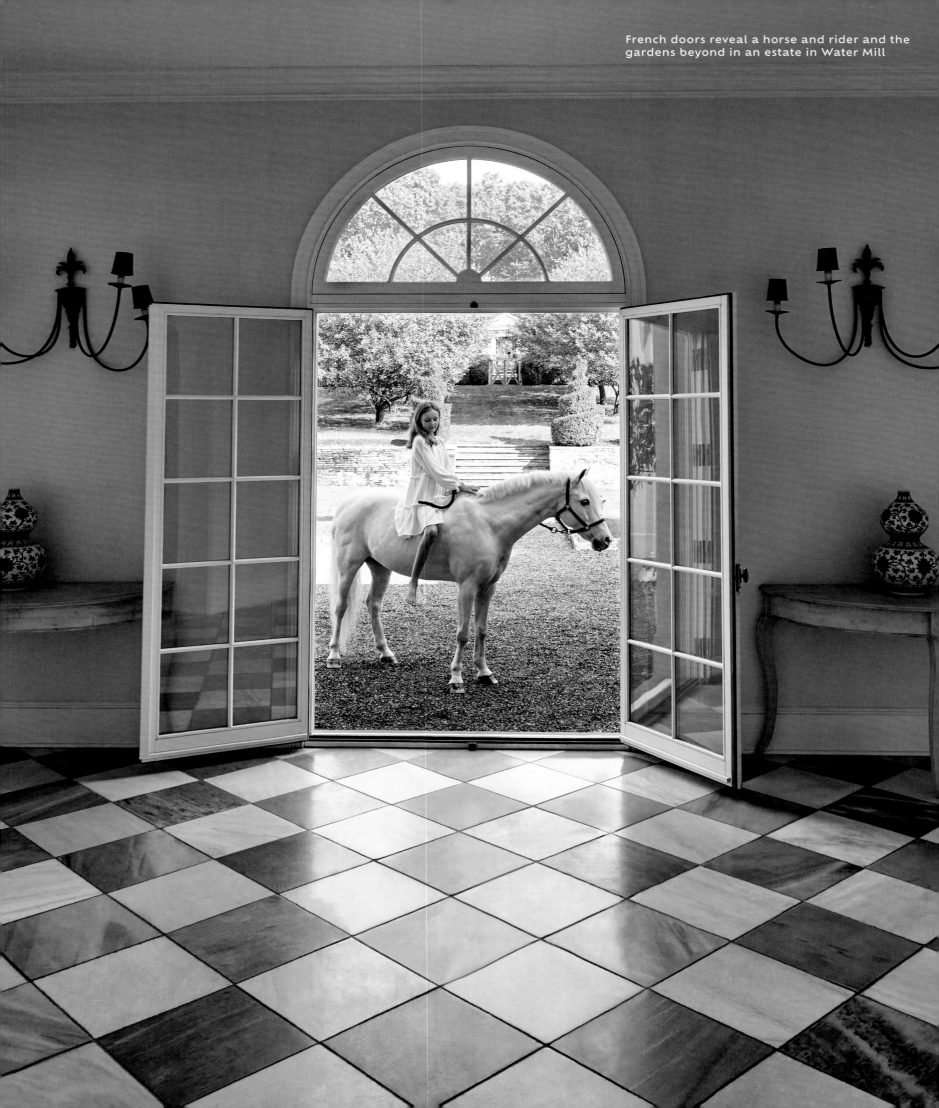

other brands, such as Asprey and Hermès. Of course, Hermès is perhaps the brand that is most intertwined with the equine world, tracing its origins in saddlery. The French house also sponsors top-caliber riders and top-notch horse shows, including the Hampton Classic.

Decorating a home in the equestrian style or with an homage to the world of horses has become a timeless motif. It could be as simple as resting a saddle on a stair bannister, or putting up framed Hermès scarves with equestrian figures, or repurposing horseshoes as coat hangers, or finding new life for old show trunks as coffee tables. Or it could be more complex, such as paneling a mudroom to look like a pinewood-covered tack room of a barn or enveloping a space in a scenic wallpaper inspired by a country hunt. Those with horses of their own may have large-scale portraits of their mounts by Shelli Breidenbach or Juan Lamarca hanging in their study. Younger riders may decorate their bedrooms with rows of ribbons earned from horse shows.

Dressage rider Zoe Hoare, the proprietor of home goods store English Country Home in Bridgehampton, lives in a 1700s-era saltbox-style cottage in Sagaponack. Her home is chock-a-block with equine elements, in a layered style that recalls European homes. There are wooden antique horse figures, various art prints of horses, vintage riding boots, and ribbons earned from past competitions.

"I think my collecting of horse-related artefacts started with a plaster model of a draft horse my mother, Appley Hoare, an antiques dealer in the United Kingdom, bought for me in Paris," Zoe says. "I've always loved the magnificence of horses, and their stature. Antique sketches of horse body parts are so intriguing, and mesmerizing. As a study, the horse is quite tough to get right. So many artists have tried and failed to get the proportions just right. All the paintings I have are antique images of someone's pride and joy, and each image holds a story," Zoe explains. "Horseshoes, bits, spurs—sometimes harsh and cruel things—are still items of beauty, made by hand by blacksmiths. Each one with a different role and look and they make for wonderful accessories and decorative vignettes. Even my front door is in the style of a stable door. Decorating with equestrian accents gives a home a country feel, a bucolic atmosphere—of times past when horse-drawn carriages were the only way to travel. Horses have steadfastly worked alongside us for so long. The paraphernalia that goes with them is grounding, and simple, and real. The majesty of the equine world brings a taste of grandeur and luxury, without the glare of the shiny and new," Zoe states.

The Hamptons Vibe

Fashion, Design, and Parties Inspired by the Equestrian Culture

When I was in the process of decorating our guest bedroom in East Hampton, I happened upon a vintage illustration that reminded me of the Ascot scene in the film adaptation of the musical *My Fair Lady*. The glamour of the costumes and the excitement of a horse race immediately informed the decoration of the room. I had the illustration framed and it became the first picture to hang on the wall. This was followed by various equine-related photography and artwork that includes past posters from the Hampton Classic, lithographs of winning racehorses from thrift stores, fashion photographs, and other various horse-related assortments.

In a nod to the black-and-white costumes from the movie, including the ribbons and bows that adorned Audrey Hepburn's gown, came the swags of black-and-white striped fabric that grace the canopy bed and the black-and-white striped stone inlay nightstands. To finish off the room are stirrup-shaped lamps from Ralph Lauren. The room has since been dubbed the 'Horse Suite.'

No one has done more for equestrian design as Ralph Lauren. Horses are part of the brand's DNA. The logo after all features a polo player on his mount, his mallet in mid-swing. The horsey inspiration runs through various categories in fashion and home. Ralph Lauren successfully adopted the look of grand English manor houses with their walls hung with monumental horse portraits, mantels decorated with bronze statues of prized horses, and mudrooms lined with riding boots, and made it his own and packaged it for general consumption. Thus, there's been a proliferation of horse-themed napkin rings, stirrup-shaped candle holders, chandeliers with stirrup leathers, plates adorned with horse bits—not only from Ralph Lauren but from various

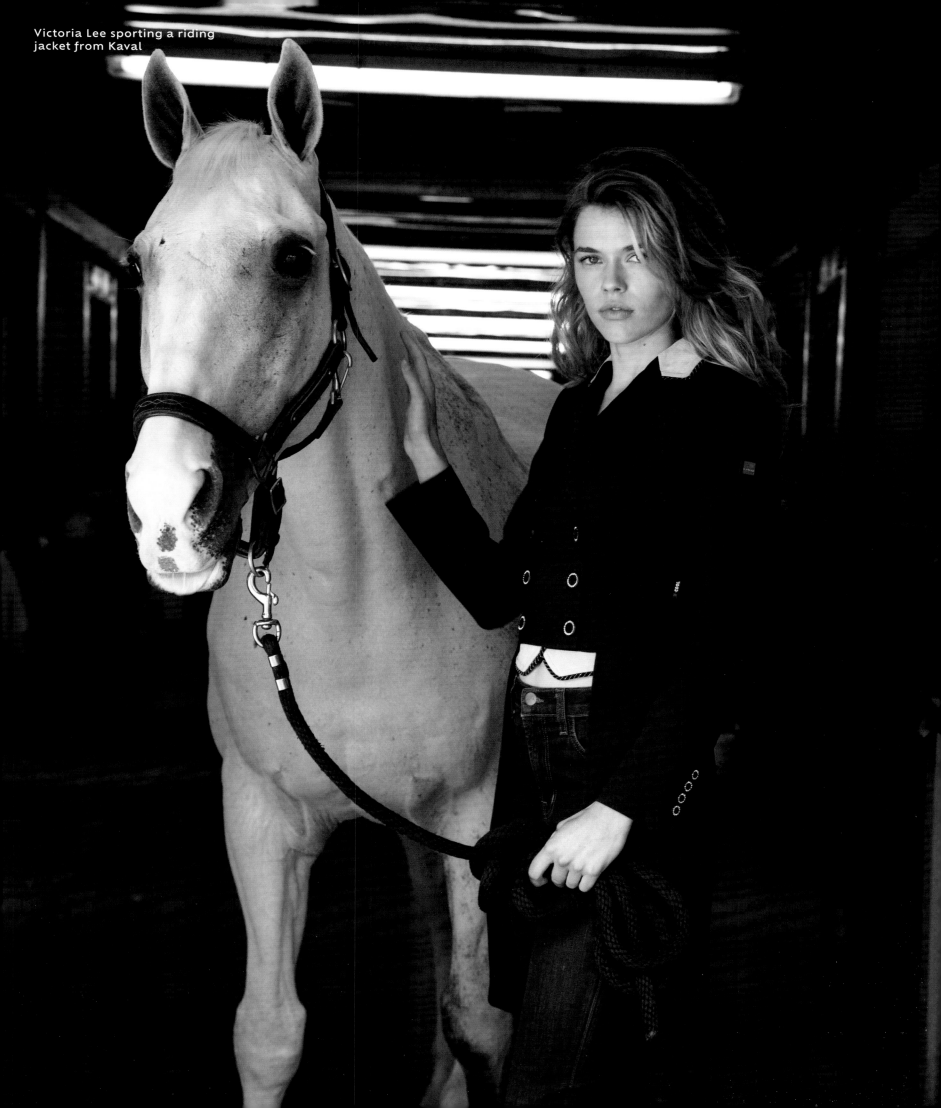

Victoria Lee sporting a riding
jacket from Kaval

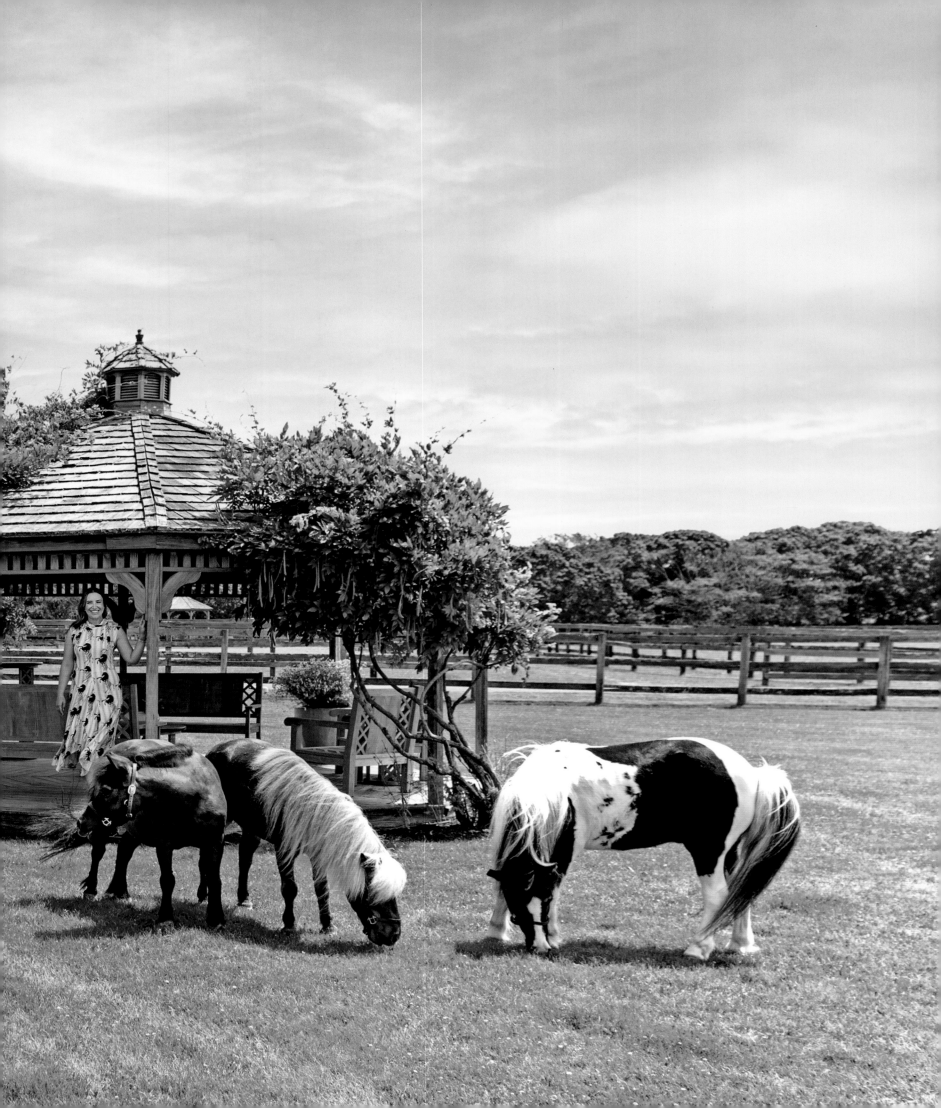

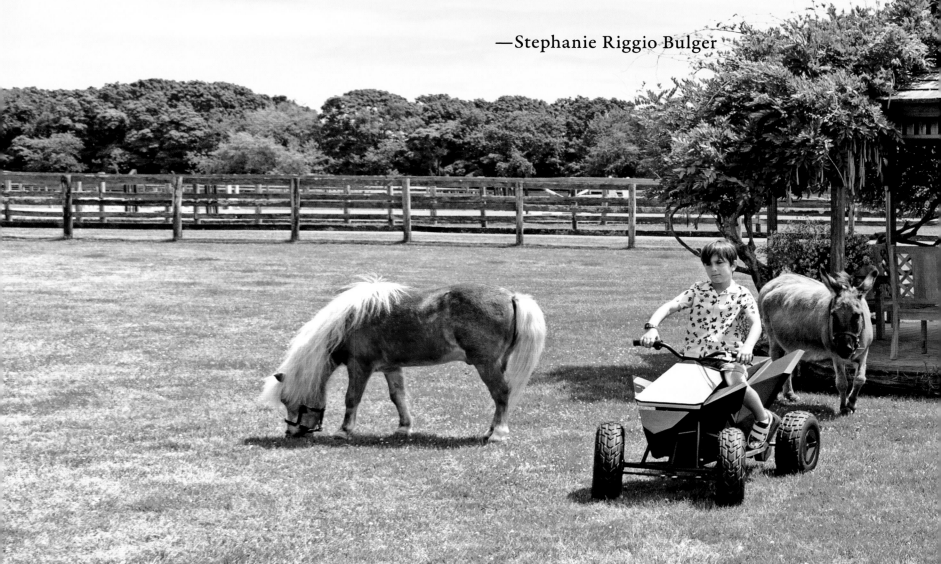

"Having a farm in the Hamptons with our show horses and rescue animals is a gift. I am so pleased that I can share this sanctuary with my family, and that my son can grow up surrounded by the magic of nature."

—Stephanie Riggio Bulger

Stephanie Riggio Bulger with her son, Leo, and their herd of miniature horses and donkeys at their private barn MeadowView Farms

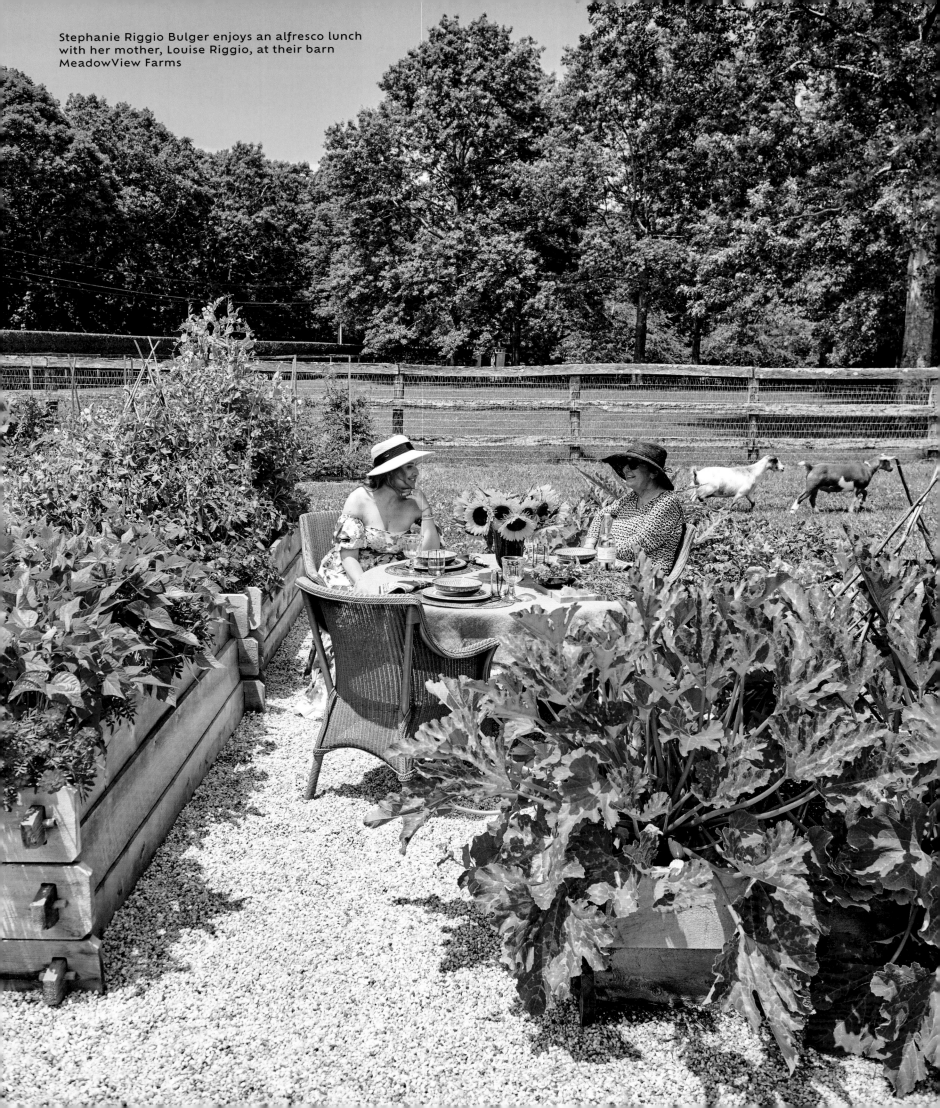

Stephanie Riggio Bulger enjoys an alfresco lunch with her mother, Louise Riggio, at their barn MeadowView Farms

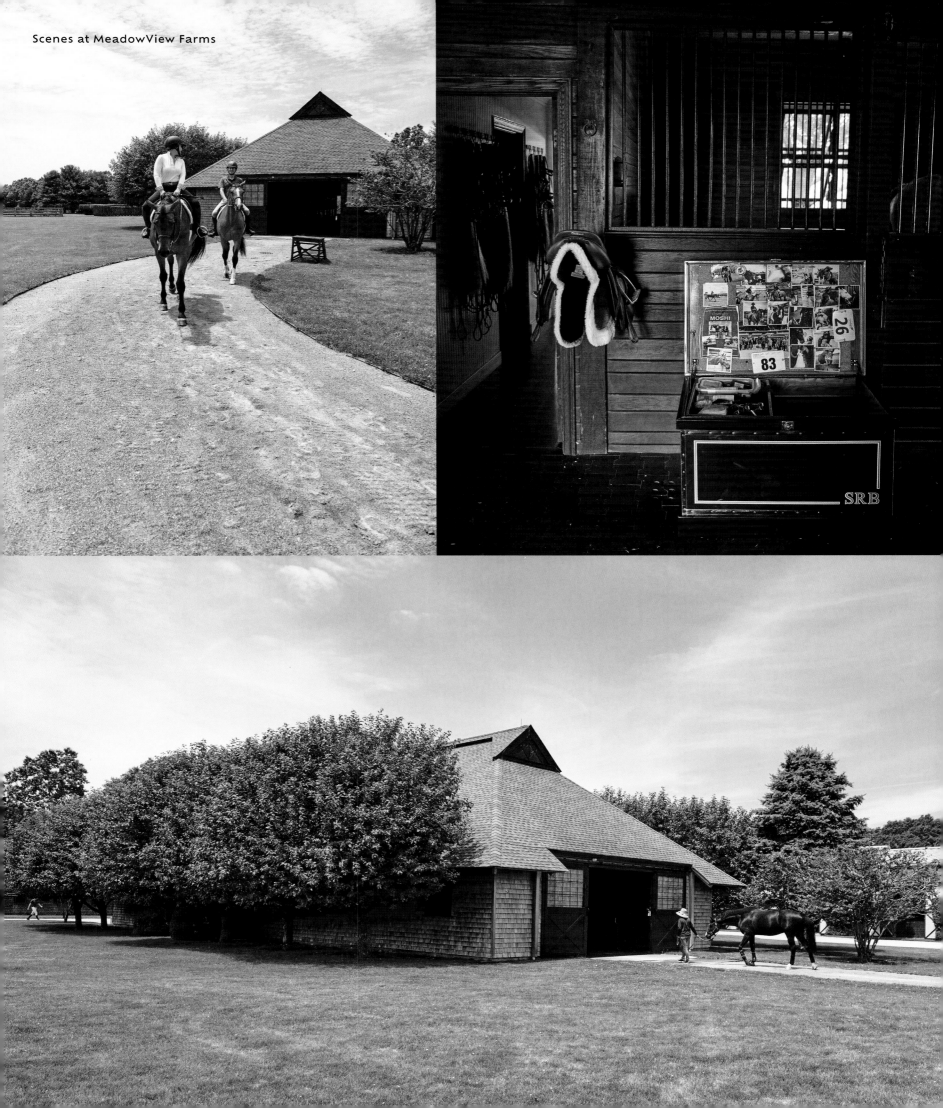

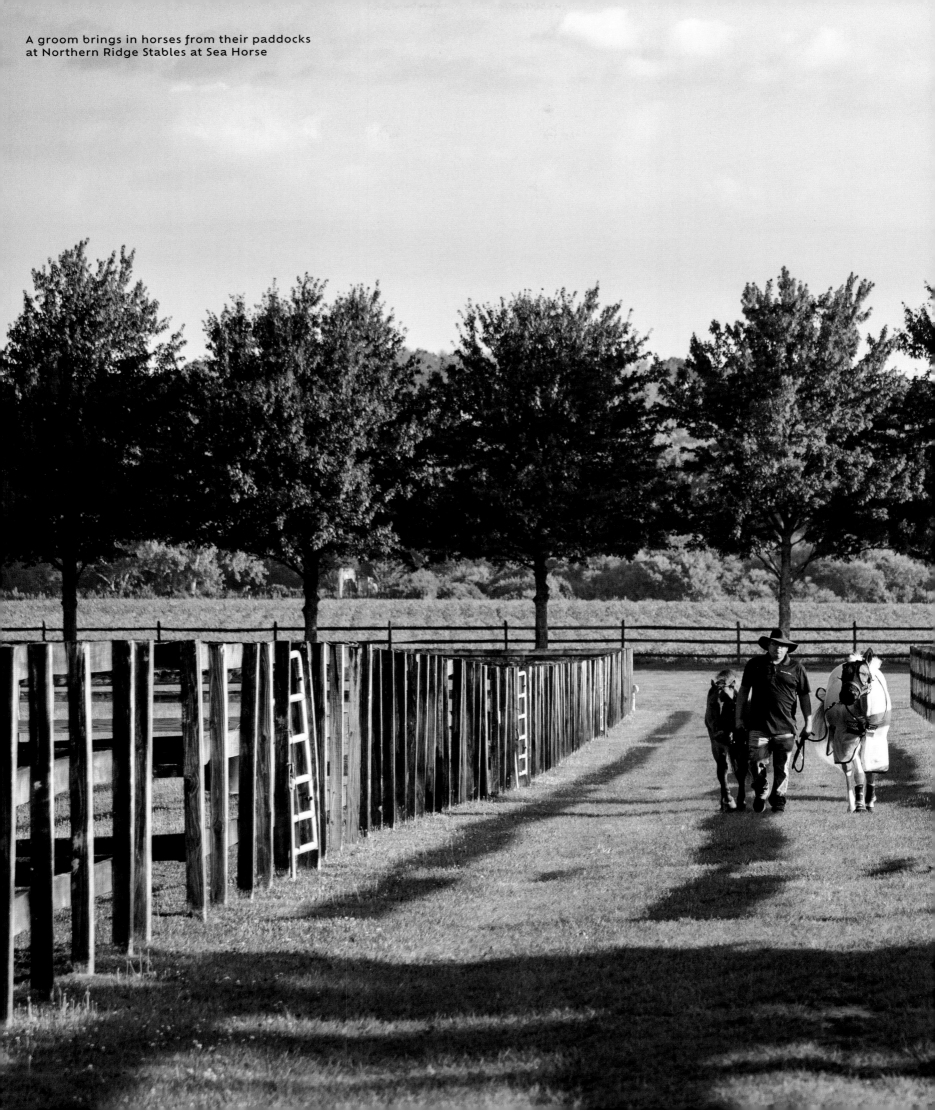

A groom brings in horses from their paddocks at Northern Ridge Stables at Sea Horse

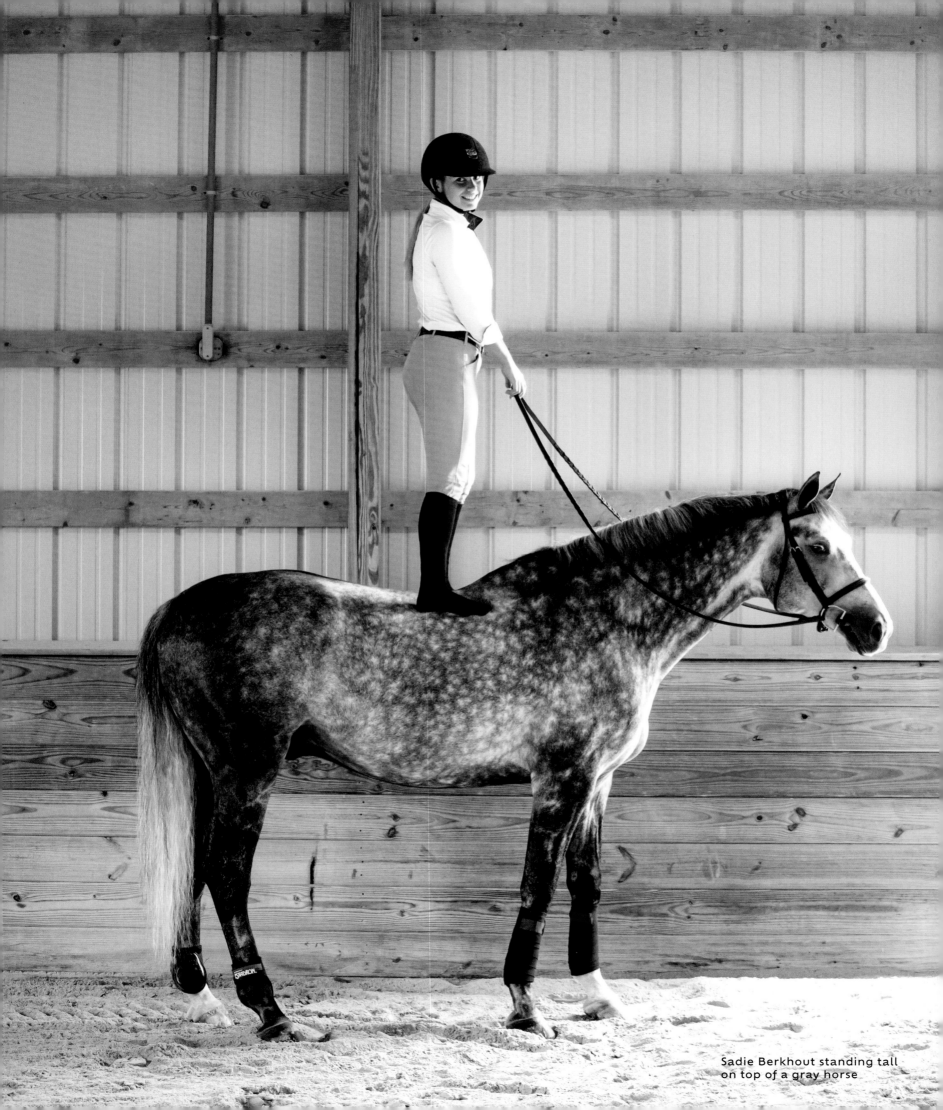

Sadie Berkhout standing tall on top of a gray horse

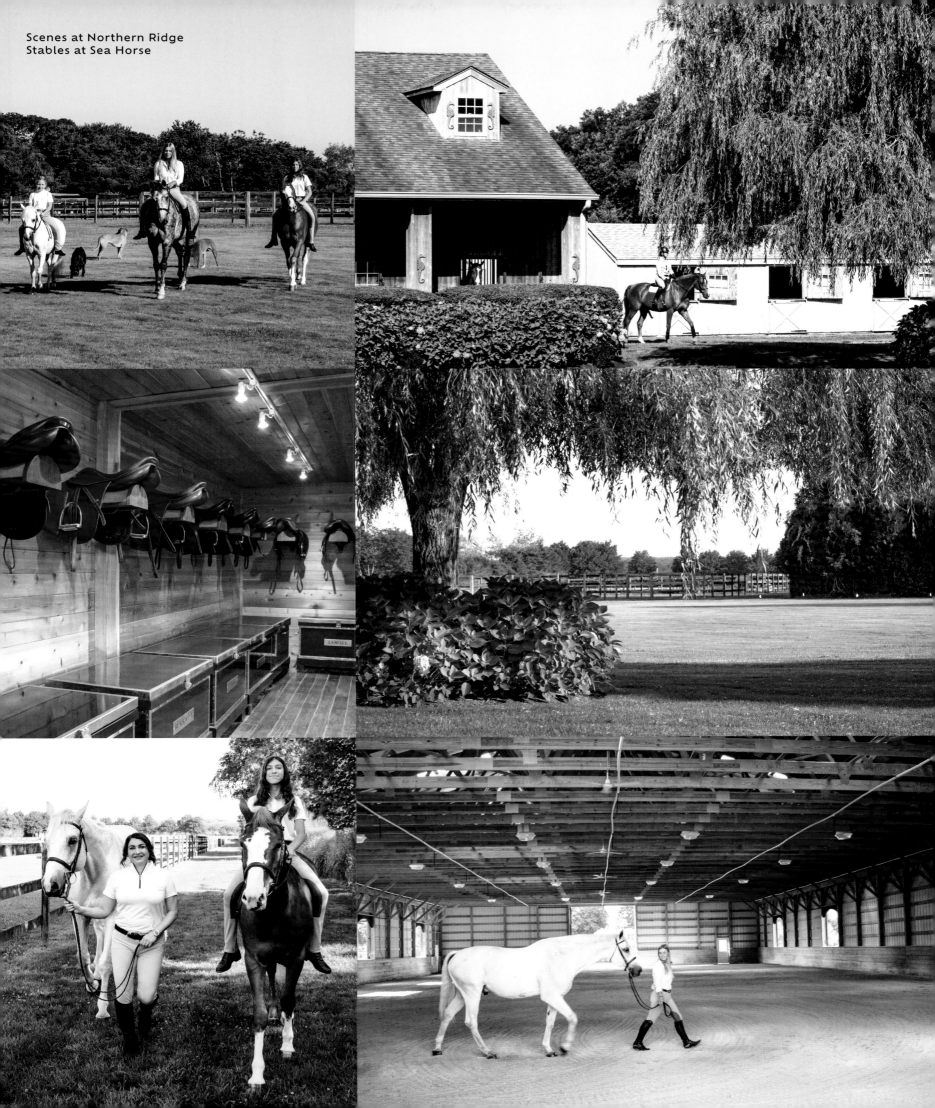

Scenes at Northern Ridge
Stables at Sea Horse

And, of course, there are the private barns that are just for the enjoyment and pleasure of their owners and choice friends. Merry Berry of Northern Ridge Stables has the ideal set-up of having her operation at the private boutique barn Sea Horse, where she trains the owners and their horses and a select group of riders. Unlike large barns where conflicts in scheduling can occur and where a large number of riders may just happen to show up in a ring all at once, Merry does not have to contend with such issues. "My business over the years has been evolving in different and new directions. I just hope to keep growing as a farm with a great clientele and with people who really care about the horses and the sport. I have only been in the Hamptons in the past ten years but I have noticed a growing sense of community and camaraderie among the trainers and farms," Merry observes.

Show jumper Stephanie Riggio Bulger keeps her horses at her magical property in Water Mill called MeadowView Farms. It is a seventy-acre compound of barns, paddocks, hills, vegetable gardens, and a menagerie of animals. Prized show horses coexist with a half-a-dozen or so miniature ponies who roam the property freely. Stephanie's son Leo, who is a budding equestrian, can sometimes be seen zipping through the trails and winding paths on his motorbike, while in the distance are donkeys and chickens.

"Having a farm here with our show horses as well as all our rescue animals is a gift. I am so pleased that I can share this sanctuary with my family, and that my son can grow up surrounded by the magic of nature. No matter what kind of day I am having, the animals always improve it. They make a bad day good and a good day great," Stephanie says.

Having a property such as MeadowView Farms is a big undertaking and requires a team who can look after the grounds and, more importantly, the animals. Stephanie has equipped herself with a capable support staff to help with the day-to-day operations of her barn. "Having a farm such as ours with so many different animals and plants can be overwhelming!" Stephanie states. "Between our vegetable garden and orchard, beehives, flock of hens, rescue mini horses, goats, and donkeys, as well as current and retired show horses, there is always something going on and something or someone that needs attention. It is my privilege and honor to oversee the care of everyone at MeadowView and provide the best life possible for the animals who call it home," Stephanie reflects in closing.

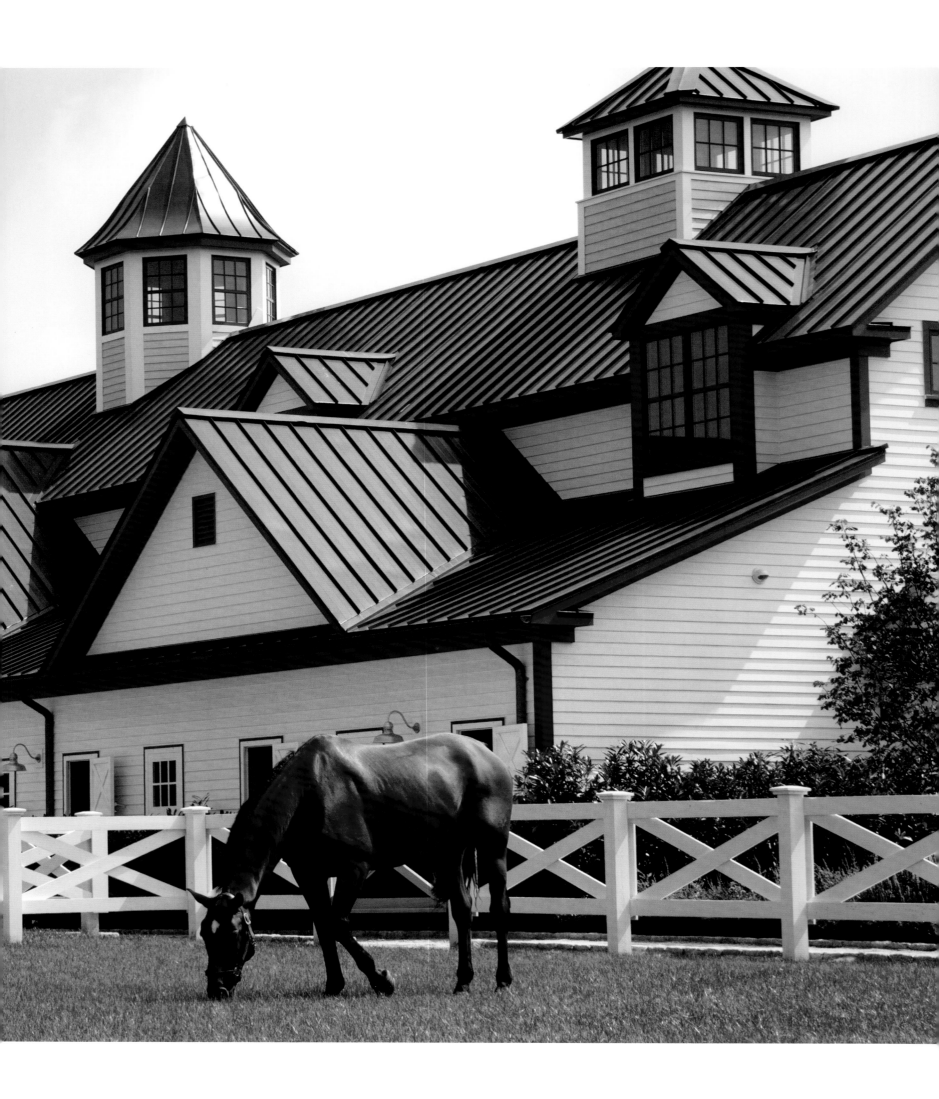

Khalily Stables in Water Mill, formerly Campbell Stables, has striking architectural features designed by DH Murray Architecture

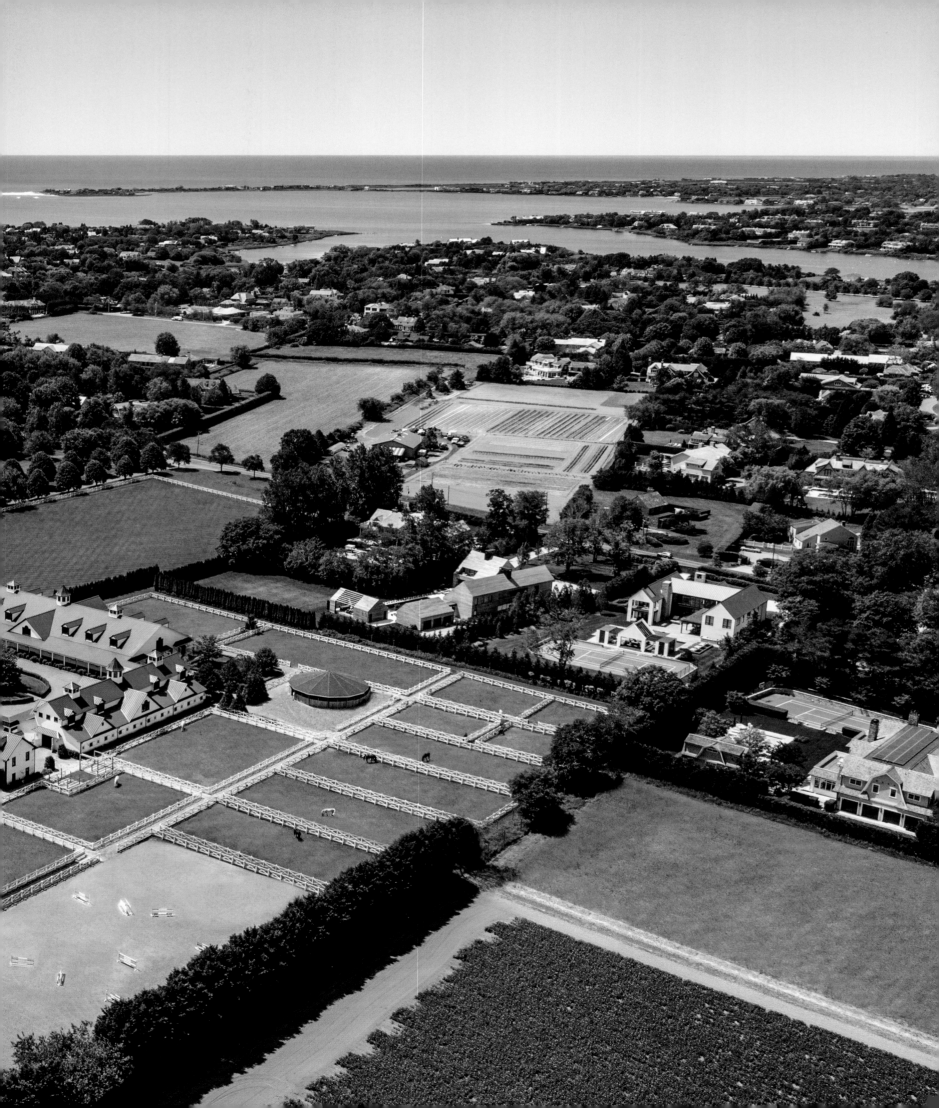

Aerial view of Khalily Stables and the surrounding mansions, farmlands, and the Atlantic Ocean beyond

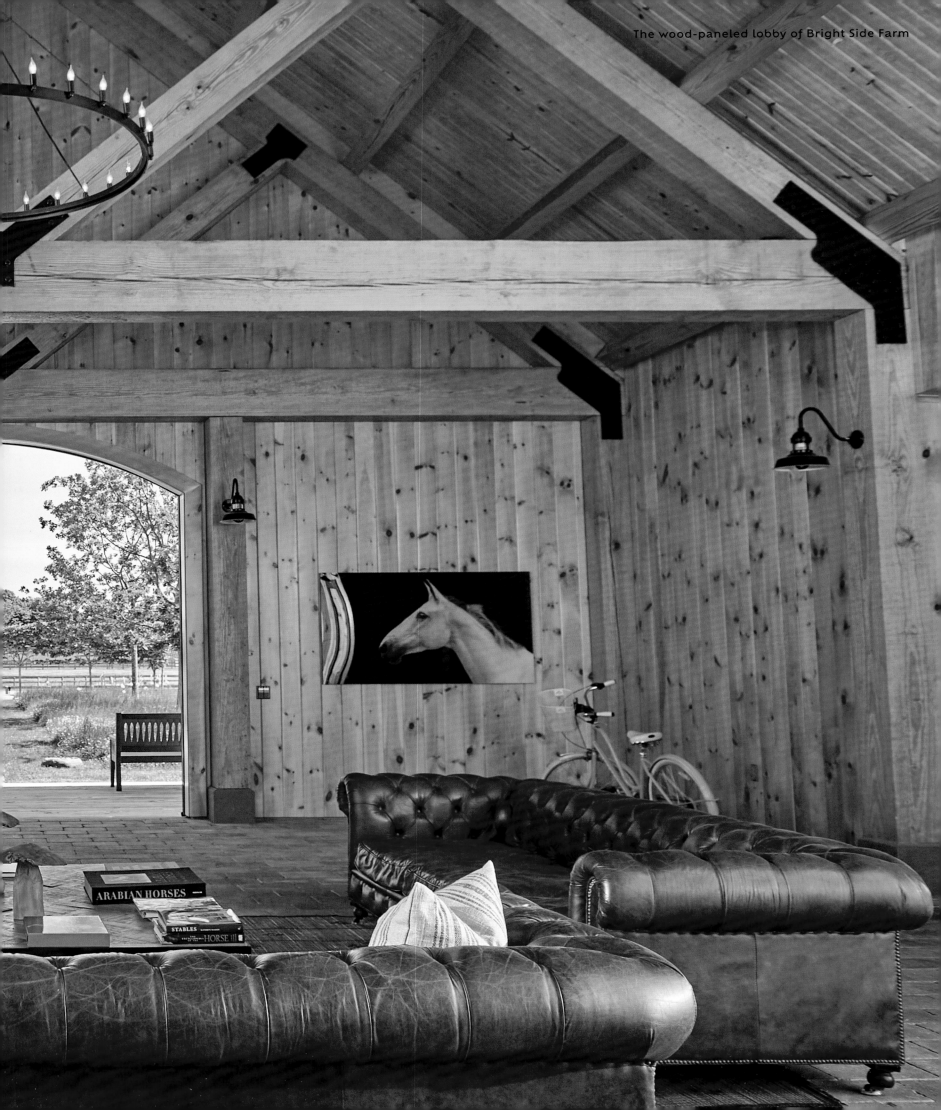

ARABIAN HORSES

STABLES

HORSE

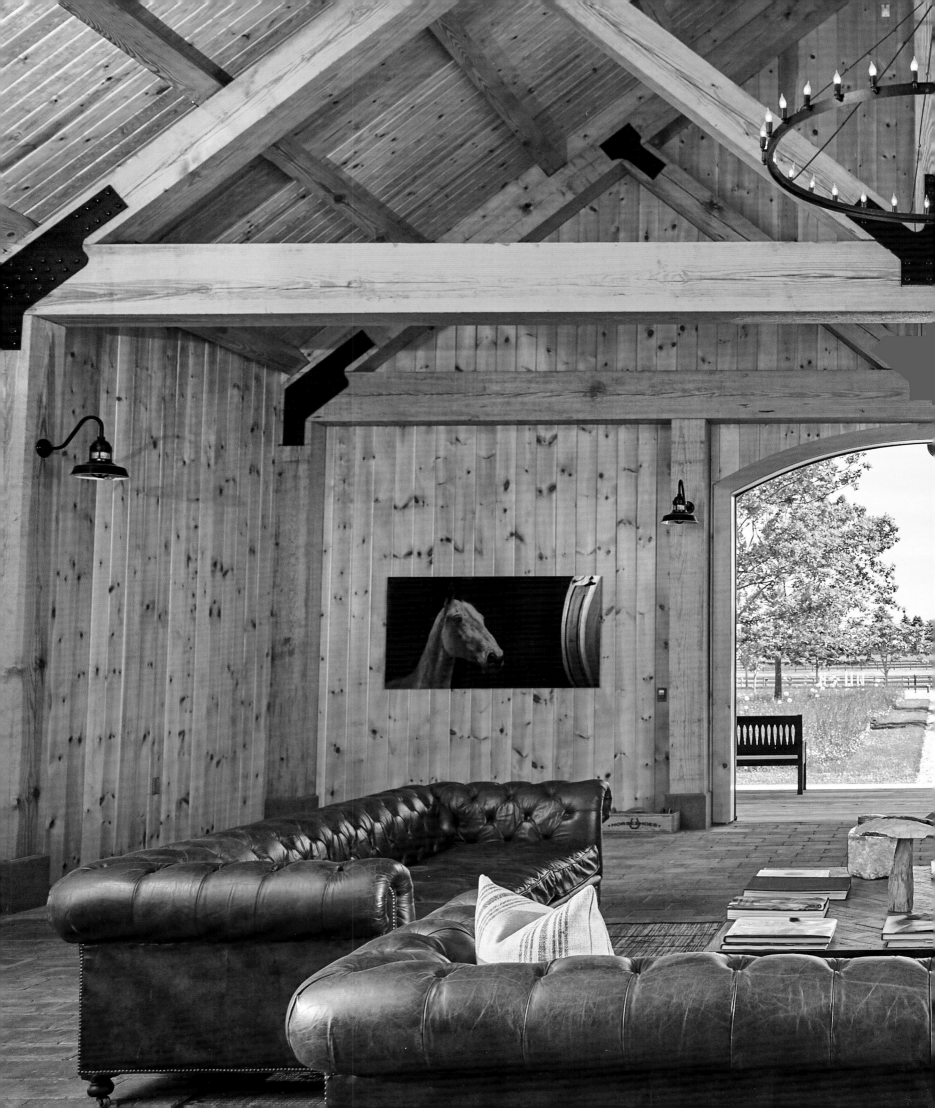

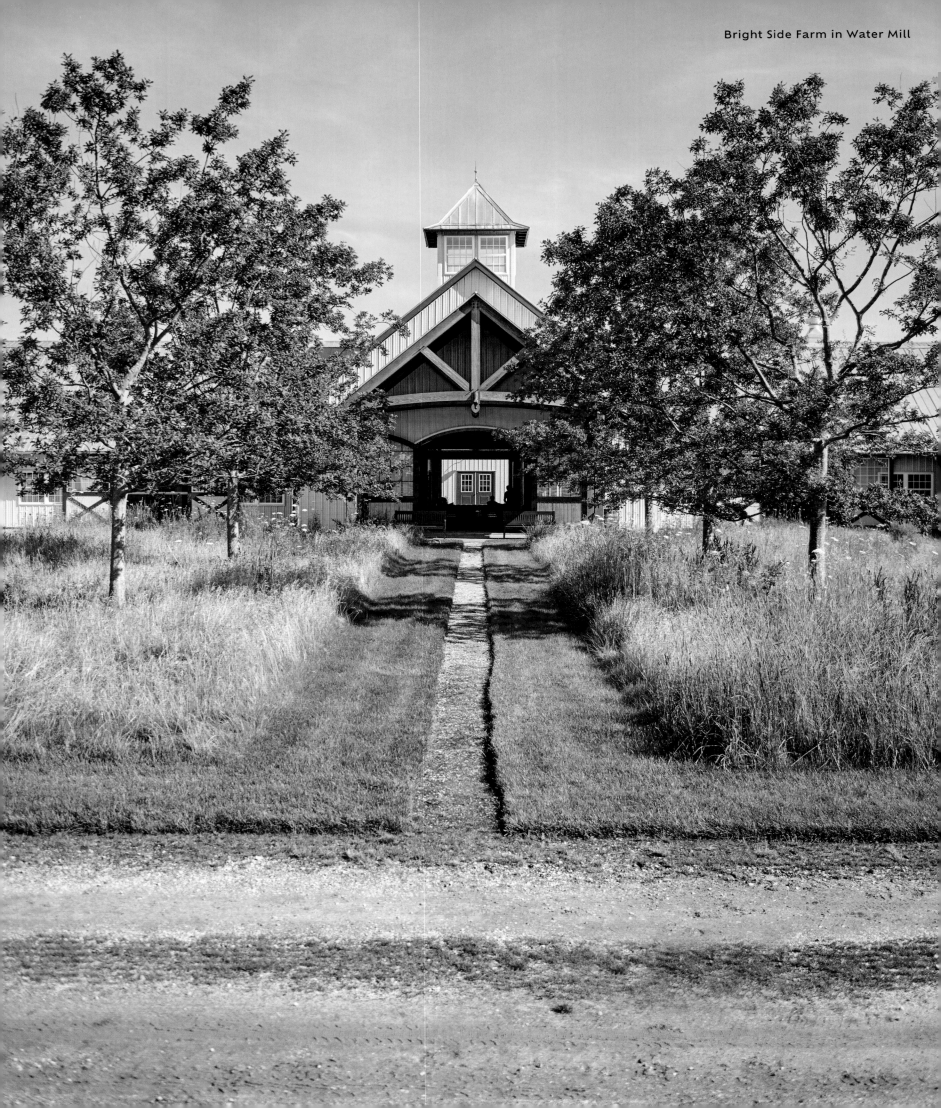

Not far from Two Trees Stables, just a short drive and past a roundabout by Madonna's farm and at the end of a quiet cul-de-sac is the private barn of Wendy and Larry Schmid, called Two Crows. It has uniform white fencing, two barns, and an indoor ring. Wendy and her husband live in a shingle-style cottage on the property. "My husband Larry and I built this place in 1993. It was my Barbie dream house," Wendy says. "My husband and I found this property and it was an old cornfield. We had this dream to make a beautiful horse farm and this is how it came to be. Back then there was nothing. It was an open field and farmland, and I used to take my boy to the Hampton Day School (a three-mile distance) on a horse. I could just ride and keep going and going and nothing bad would happen," Wendy remarks.

For many years Two Crows, formerly Applewild Farm, was where Wendy and her friends trained for the hunters and jumpers. In 2022, they started making a transition to Western-style riding; a discipline that has long lost its appeal in the Hamptons but for Wendy and her husband, it's one that is ripe for a comeback.

One of the barns at the Two Crows farm is being rented by Pamela Suskind, who founded and runs Silver Tide Stables. Pamela's primary thrust is to foster a love for riding among kids through her fun pony camp program. She developed her passion for horses at a very young age with both her parents riding and joining competitions. "I did not realize this was the perfect career for me until I was thirty. I spent all my free time at the barn with my horses and a desk job was not fulfilling to me," Pamela shares. She has a two-fold approach to teaching her students: "I emphasise patience and dedication. Patience is crucial to our sport and dedication is what separates a rider from a winner."

The wide fields and open skies of the Hamptons set the stage for a scenic backdrop to many beautiful barns, such as Bright Side Farm in Water Mill, which is owned by Annette Lauer and is where her daughter Romy Lauer trains. It is arguably one of the most beautiful barns in the Hamptons. Annette transformed a forty-acre former plant nursery into an equestrian facility with a pinewood-paneled lobby and tack rooms, two barns with thirty-six horse stalls, two outdoor rings, an indoor ring, a derby field, and cross-country obstacles—all within a meadow-like setting designed by A-list landscape designer Miranda Brooks.

Also in Water Mill is the picturesque Khalily Stables, formerly Campbell Stables. Although it is comparatively small at sixteen-and-a-half acres. But what it lacks in acreage it makes up for in style, architectural beauty and sustainable features designed and realized by DH Murray Architecture. The barns are set around a landscaped courtyard. They all feature pristine white clapboard siding with hunter green roofs and maroon window frames lending the property a movie set–like atmosphere. The paddocks and arenas are all bordered by idyllic white fences. In the spring, the driveway is a profusion of cherry blossoms. In the winter, the evergreen hedges stand sentinel on snow-covered fields. The stalls feature timber woodwork contrasted by black iron gates. There is an indoor ring with a second-level viewing room, which can be accessed via an elevator. "The project incorporated numerous sustainable design strategies. By separating the facility into five separate structures we were able to better control energy consumption by only operating portions needed at a given time. By grouping the buildings in the middle of the site a large amount of open space was able to be maintained," describes the team at DH Murray Architecture. It is at Khalily Stables where Raquel Batto operates her barn Longacre MB and where Maxi Orduna teaches his students.

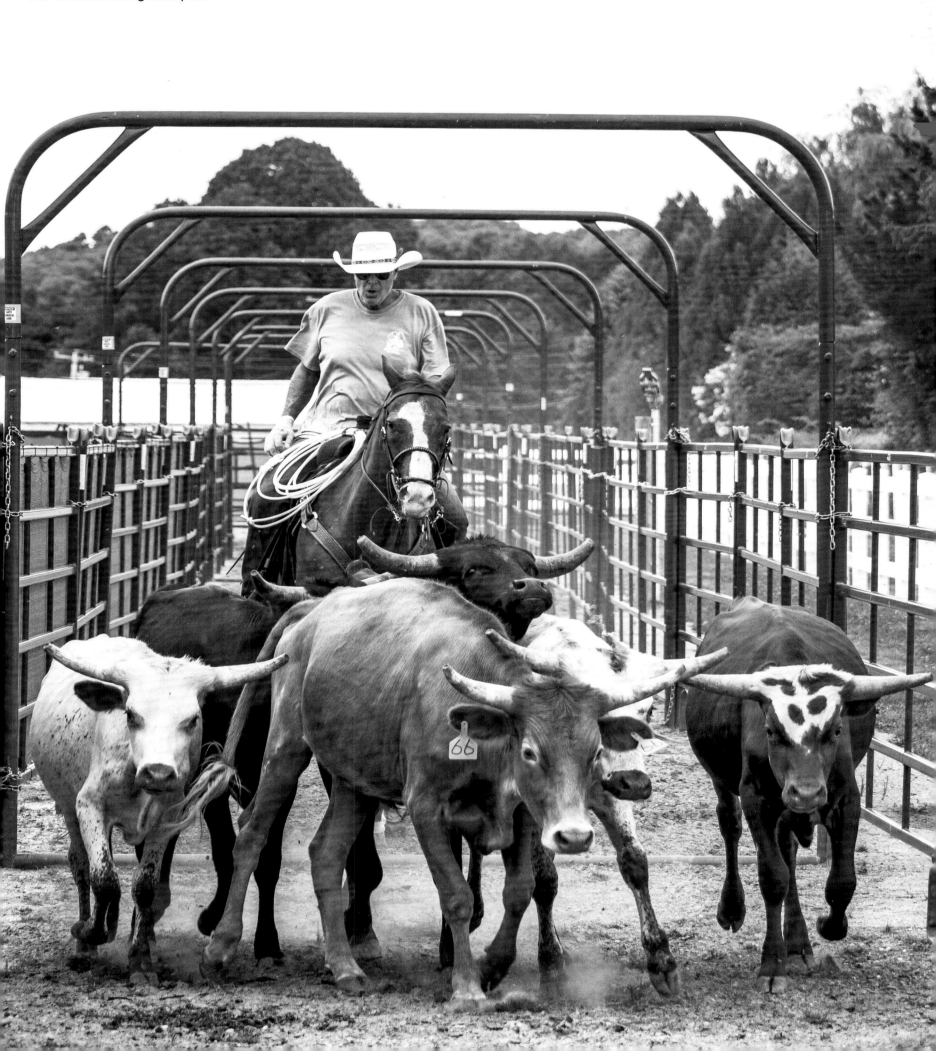

Larry Schmid at his farm
Two Crows in Bridgehampton

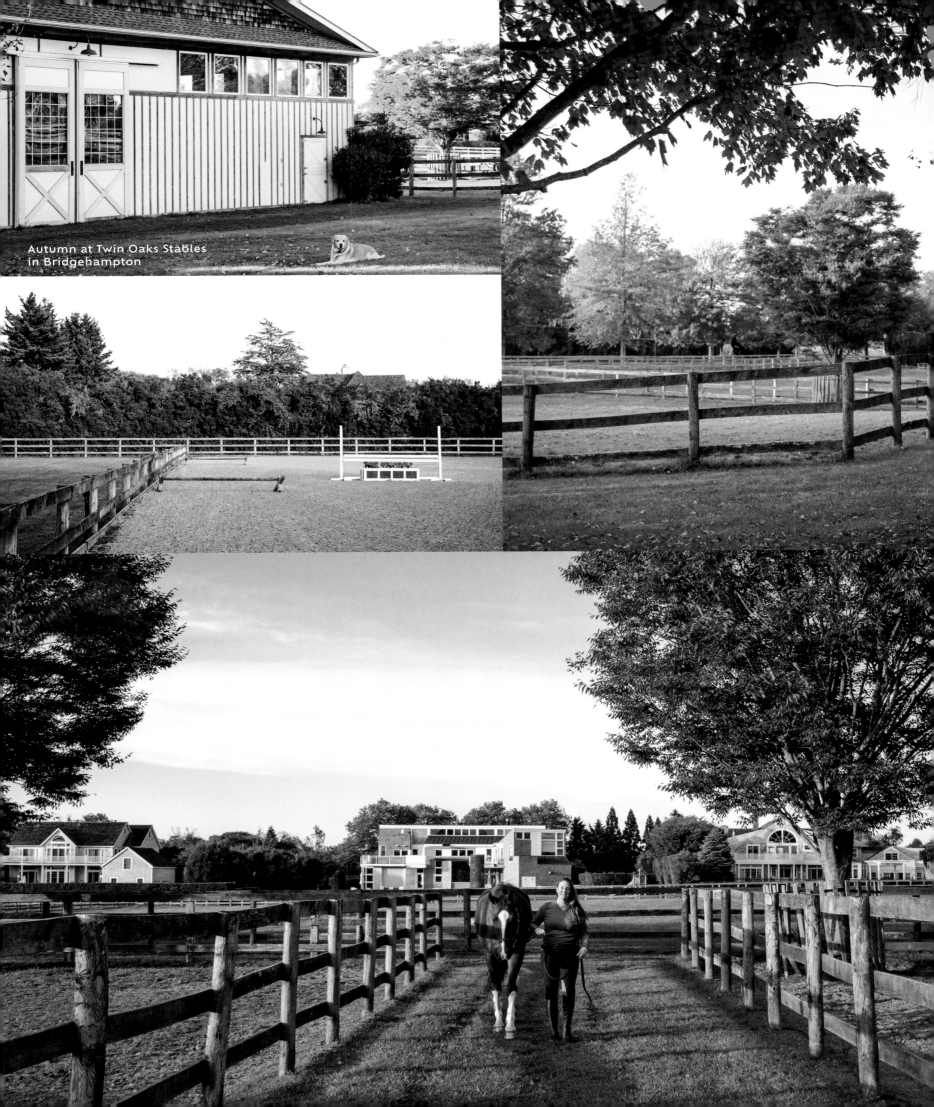

Autumn at Twin Oaks Stables
in Bridgehampton

"A horse, a horse!
My kingdom for a horse!"

—Shakespeare

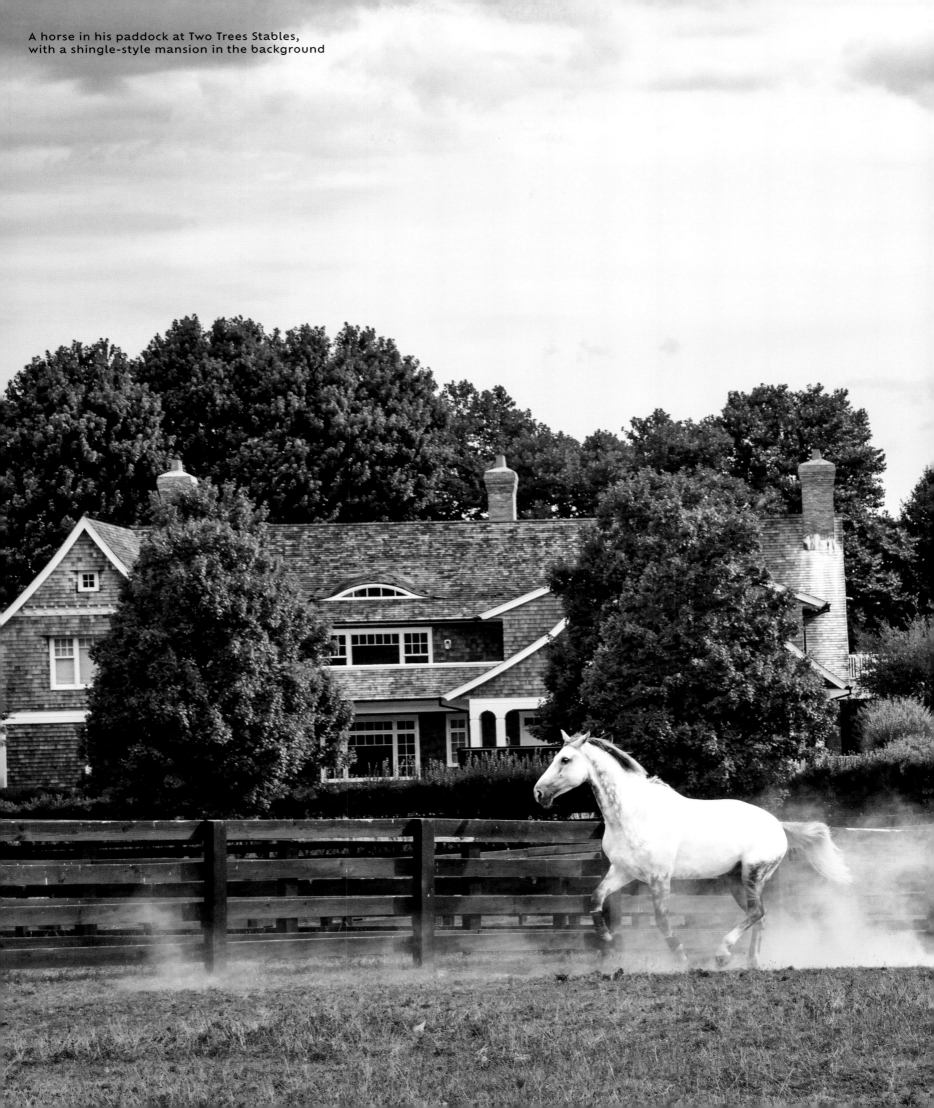

A horse in his paddock at Two Trees Stables, with a shingle-style mansion in the background

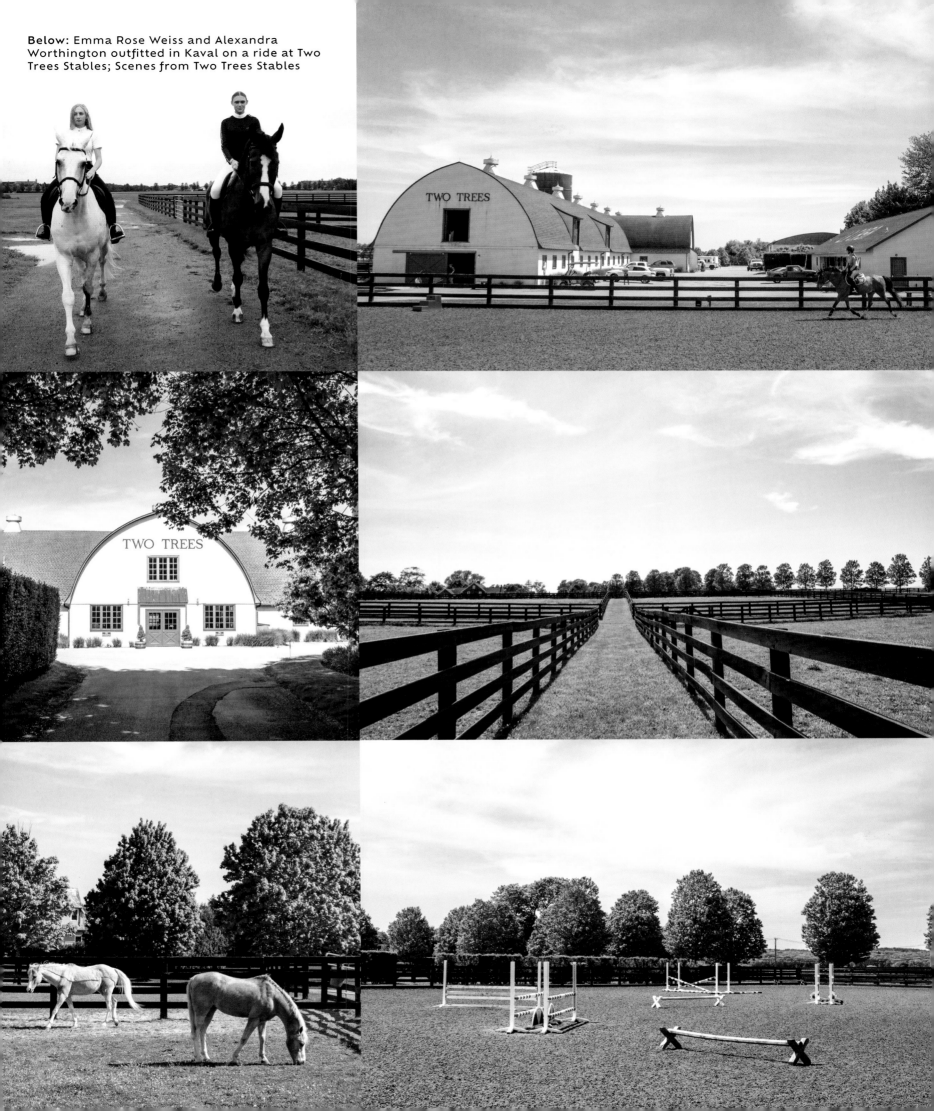

Below: Emma Rose Weiss and Alexandra Worthington outfitted in Kaval on a ride at Two Trees Stables; Scenes from Two Trees Stables

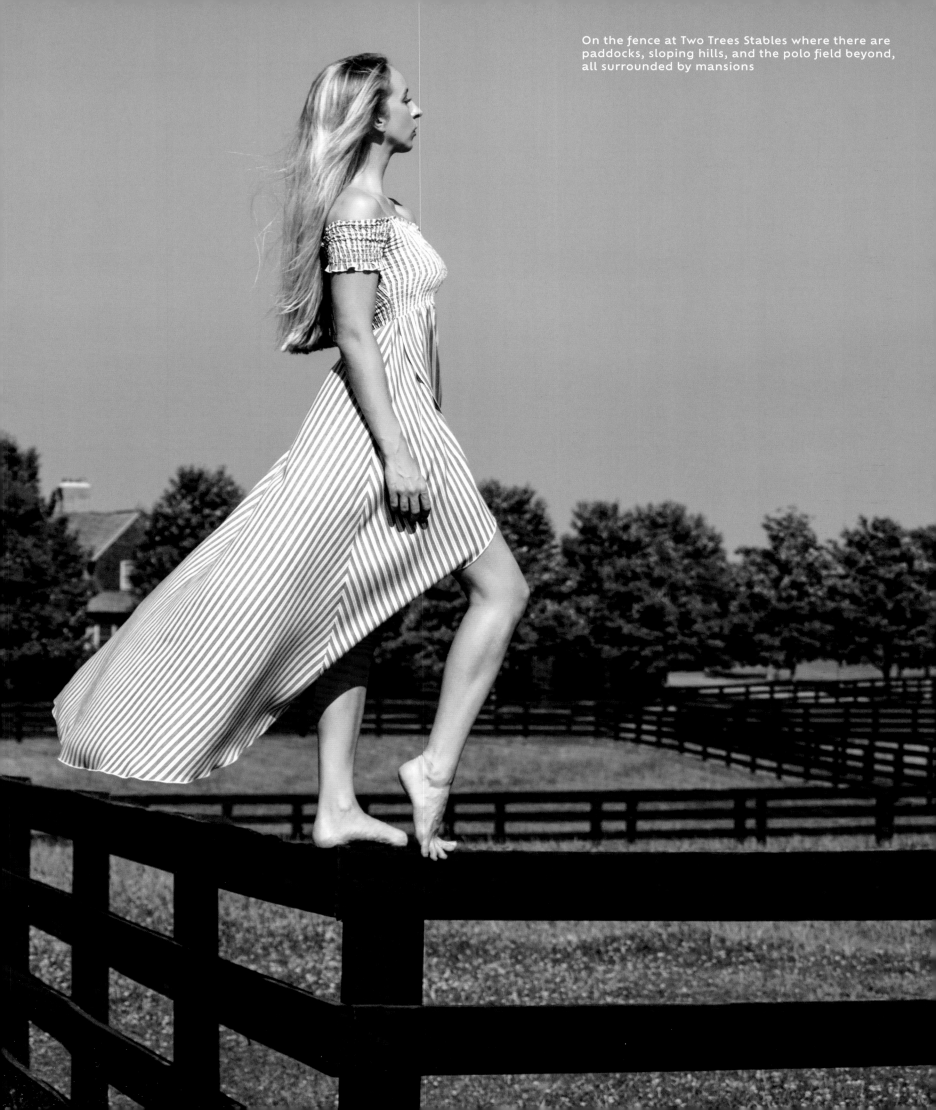

On the fence at Two Trees Stables where there are paddocks, sloping hills, and the polo field beyond, all surrounded by mansions

Unbridled passion is a prerequisite for owners and managers of stables—be they legacy barns or smaller operations within a big complex like the many barns at Two Trees Stables in Bridgehampton. Within the sixty-five acres of Two Trees Stables are Firefly Farm, Grey Horse Farm, Ocean's Edge Farm, and Jimenez Jumpers. There are multitudes of stalls in three different barns, two indoor rings, paddocks that stretch and roll down the landscape, and an adjacent polo field. Around its perimeter are multimillion-dollar homes that give their owners and residents views of polo matches and horse-jumping lessons from their living room and bedroom windows.

"The challenge is making sure that everyone melds together. That the employees and clients are happy. More importantly looking after the horses and making sure you have the right people behind you," says Heidi Earle of Firefly Farm, who recognized as early as her teenage years that the horse business was the career path for her. "I would get up at 5:00 am cross the street to go to a barn, clean some stalls, go to school, get out of school, work at the golf course to make some money then back to the barn and ride. I went to college for a couple of years and worked for Michael Matz [Olympic rider, two-time Hampton Classic Grand Prix champion and horse trainer] one summer and just decided that this is what I wanted to do. I never wavered. And I wanted to create a business where people can learn how to ride and that is what I am most proud," Heidi adds.

Joanne Comber-Jimenez of Jimenez Jumpers says that to foster a love for horses and to see kids' personalities transform when they get on a horse is at the crux of her teaching philosophy. Joanne together with her husband John Paul Jimenez has been running a pony camp for over twenty years. Their three children are also avid riders, so much so that the two younger girls, Juliette and Jilliana, would roleplay as barn managers. "They would play at running a stable. They would have names for students and horses and organize leases and work out a training schedule," Joanne says.

Joanne is also hoping to find ways to make equestrian reach an economically diverse group. It is an expensive sport and more so in the East End where costs can be prohibitive—even for its wealthy residents. Because of the Hamptons' remote location, trucking feed and hay, equine transportation, and getting veterinary care and farriers to come to the East End compound expenses. "I work with Hamptons Community Outreach and it has a fund that allows kids, who otherwise cannot have afford to ride, have access to horses and lessons. And I have been teaching a couple of them. I wish we could do more so we can somehow erase the stigma that you have to be rich to ride horses. I would love to teach more kids because I get so much fulfilment from doing so," Joanne says.

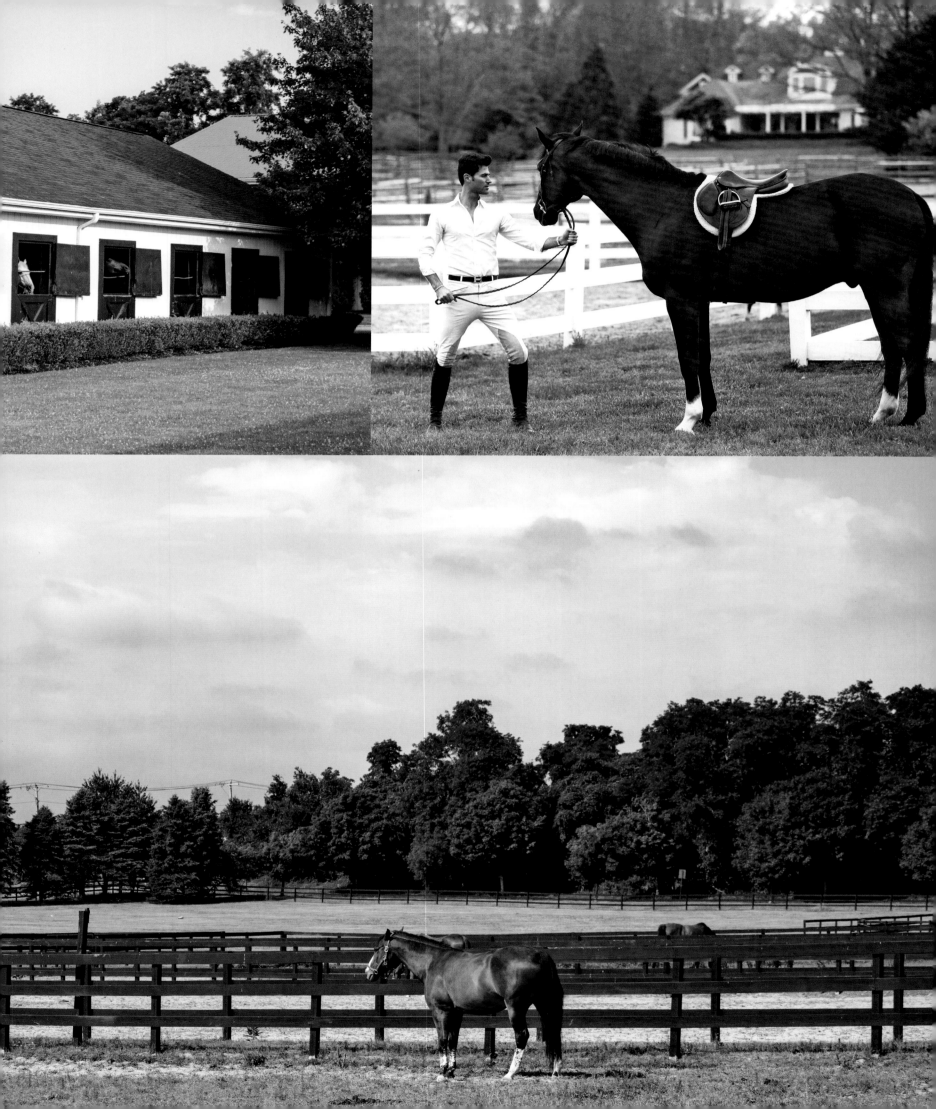

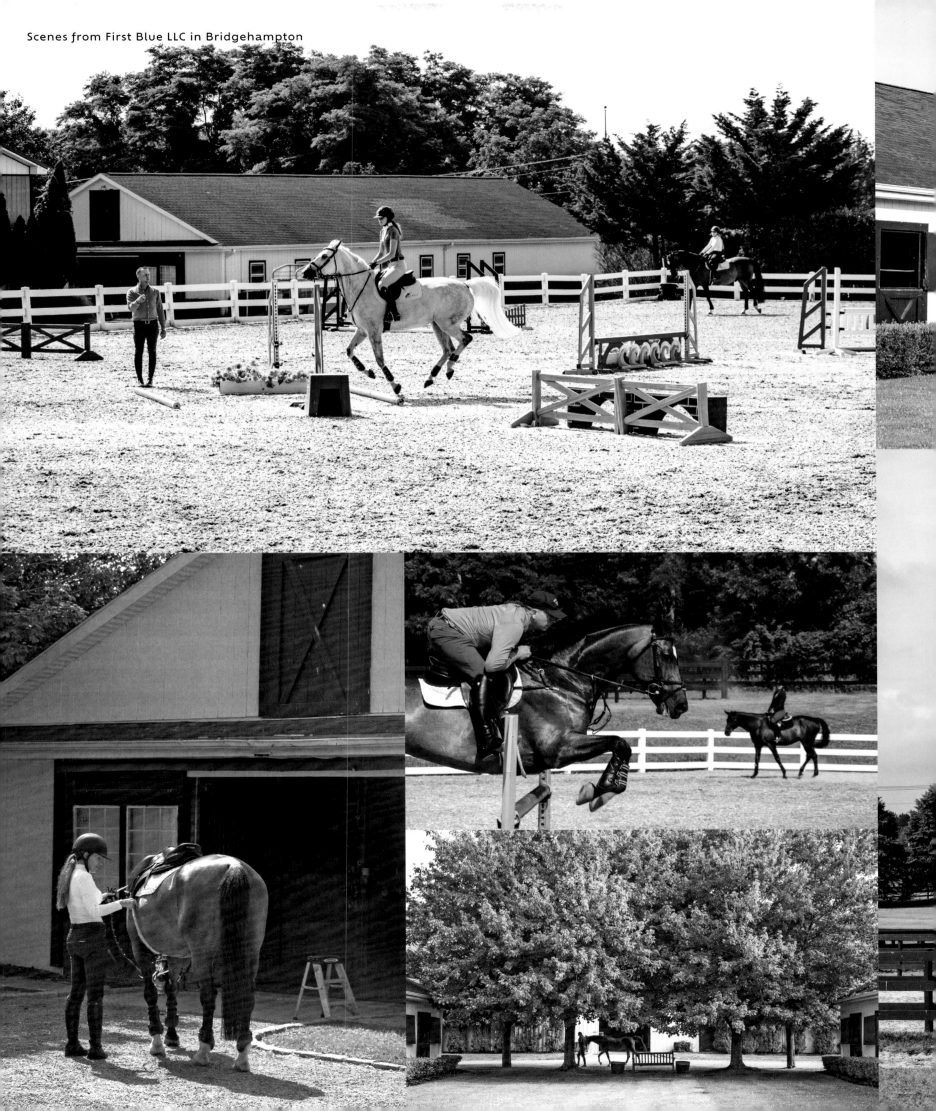

"The sheer majesty of horses. The seductive discipline of equestrian dress. The awe-inspiring spirit of the sport."

—Vera Wang

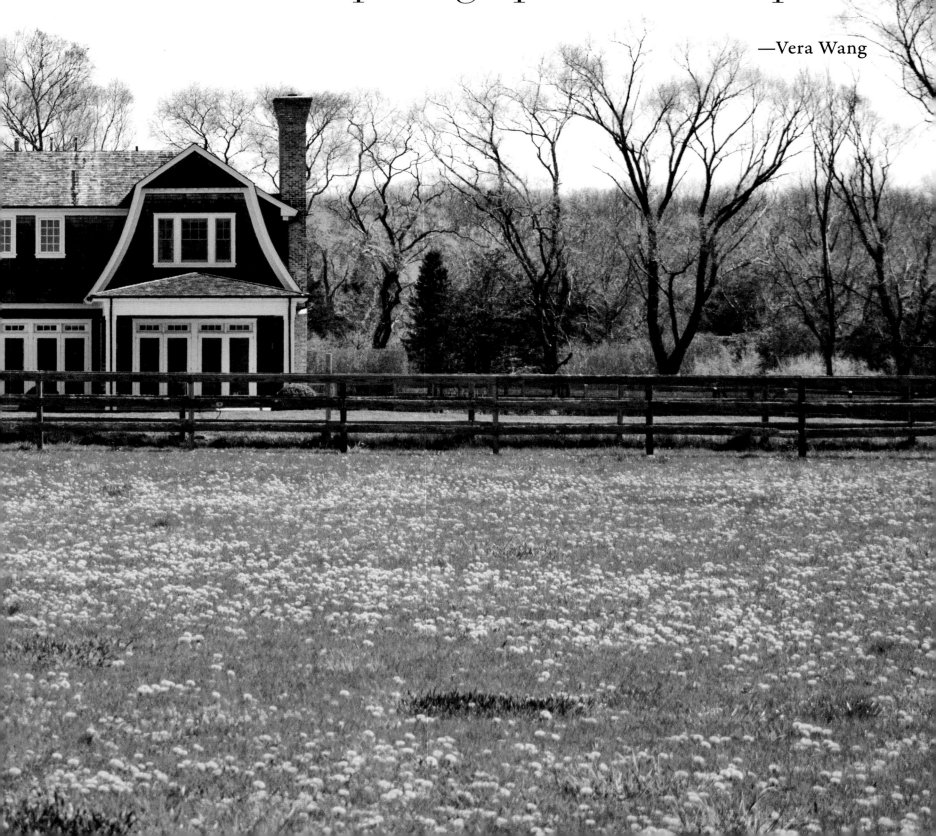

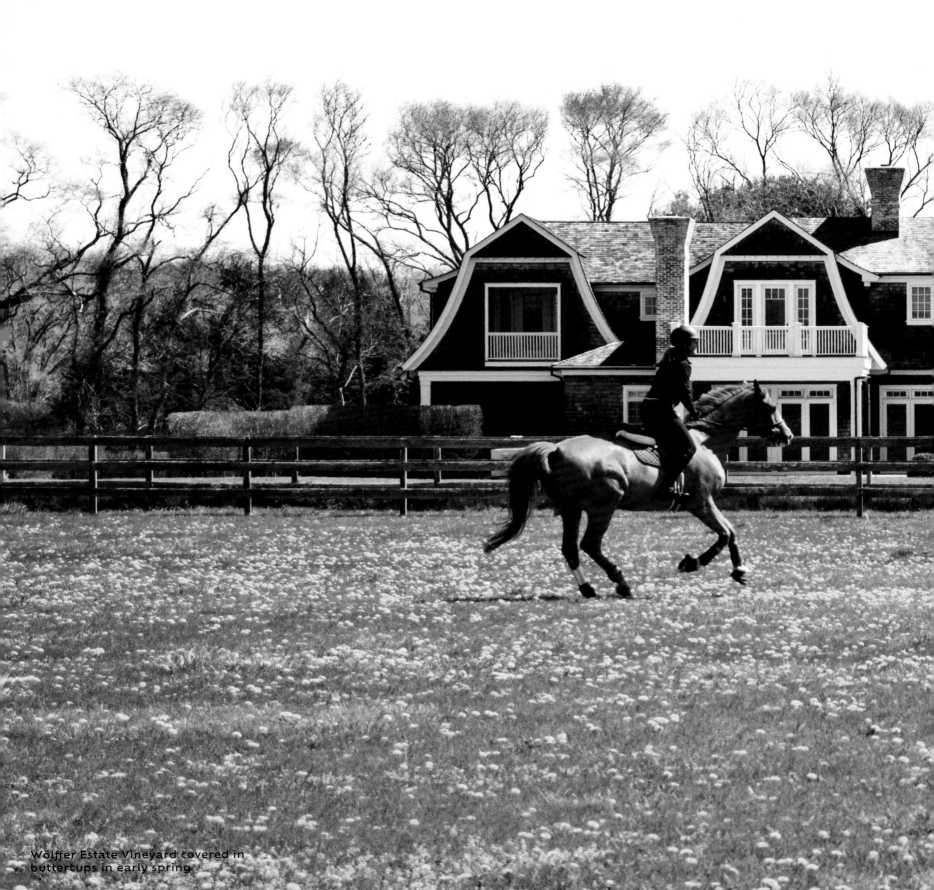

Wölffer Estate Vineyard covered in
buttercups in early spring

Around 1966 Liz Hotchkiss with her husband Lawrence moved their equestrian operation out of Stony Hill Farm and established Stony Hill Stables. Liz Hotchkiss would pass on Stony Hill Stables to her daughter Wickety 'Wick' Hotchkiss, who is a distinguished dressage rider. "I grew up with horses and I just assumed that this would be the career for me. I didn't consider any other options," says Wick, who also recalls being able to ride her horses all over Amagansett, from the ocean to the bay beaches.

Jack Graves, a local reporter and a chronicler of local equestrian sporting events, described Stony Hill Stables: "[it] has always been a cute one, a wonderful place to start the kids riding." And this remains true. Past its long narrow driveway, you happen upon a small office bordered by glorious blue hydrangeas. Throughout are pocket gardens maintained by Wick herself. Groups of children are instructed on the fundamentals of caring for their horses by the wash stalls. In the hunter ring are the teenagers learning to trot over poles or going over their first jumps. In the dressage arena you might find Wick working on half passes and piaffes on her horse Romance. "I always like to emphasize patience and the love for the horse. As well as a willingness to learn and be educated by experts from different avenues be it horse care, flatwork, jumping, and so forth," Wick says of her teaching methods.

At Wölffer Estate Stables, the grounds are expansive and park-like. There are about 100 acres consisting of barns, jumper rings, paddocks, an indoor ring, a central courtyard with a tiered fountain that some horses like to drink from, trails, a Grand Prix field, a pond, and access to the Wölffer Estate Vineyard. When the owner Joey Wölffer is not training and leaping over four-

foot-high jumps with her horses, you may find her on trail rides through the vineyard. The stables were built by Joey's father, Christian Wölffer, for his children. "He didn't get to ride as a child ... he picked it up when he was in his fifties and he really got into it. He loved it. He was bad at it, but he loved it. He would go to horse shows and would fall off or knock down the jumps or get lost in the course," Joey shares.

It is surprising to learn that for much of her youth, Joey didn't really have her own ponies and horses. One would assume that she would have had a herd of top horses given to her by her father. But for many years she only rode horses on the farm that no one else wanted to ride and she didn't have her own mounts until much later in life. "But I was instantly horse obsessed. Growing up, it was more about learning about the horses, the body parts, taking care of your pony, the tack and braiding. Doing it in a very real way—where you do it yourself. We would have group lessons where there were six of us. We had a lot of working students at the barn because my dad wanted to make the sport accessible to a lot of people. We would finish the lessons and then clean our horses, muck the stalls, and clean our tack," Joey recalls.

She oversees the running of the stables concurrently with other business ventures that all bear her family name. However, her approach to the stable enterprise is different from the winery or the restaurant or the fashion boutique: "It's a very hard business to make money. You have to do it because you love it. It's a passion and it's a family legacy. It's not a business opportunity. It's a life opportunity. Eventually we will live on the farm, and I would love for my daughters to grow up and to wake up with horses greeting [us] at the window. And that's a happy life," Joey says.

Joey Wölffer astride her chestnut horse, Lady Chester,
at her family's Wölffer Estate Vineyard in Sagaponack

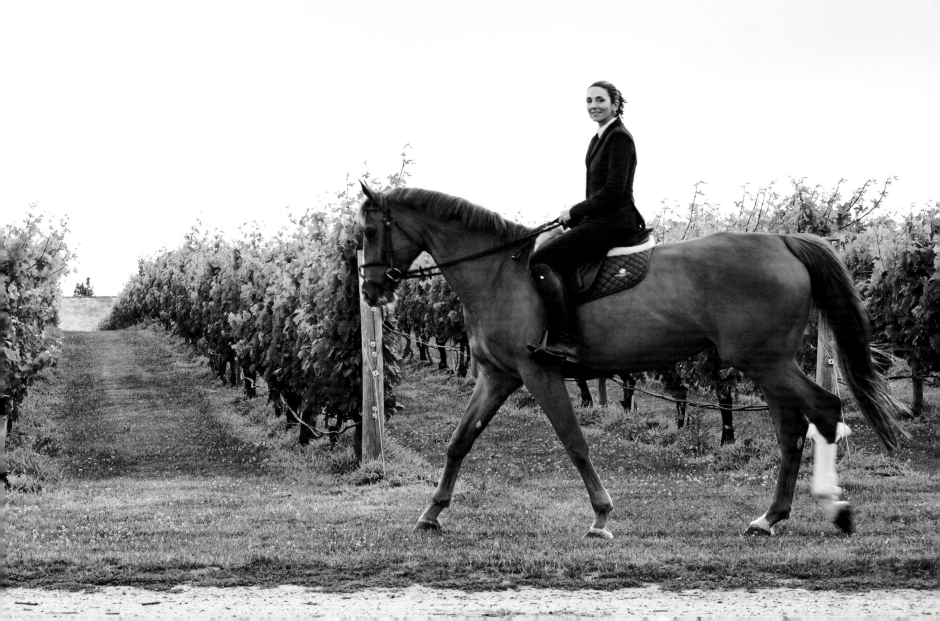

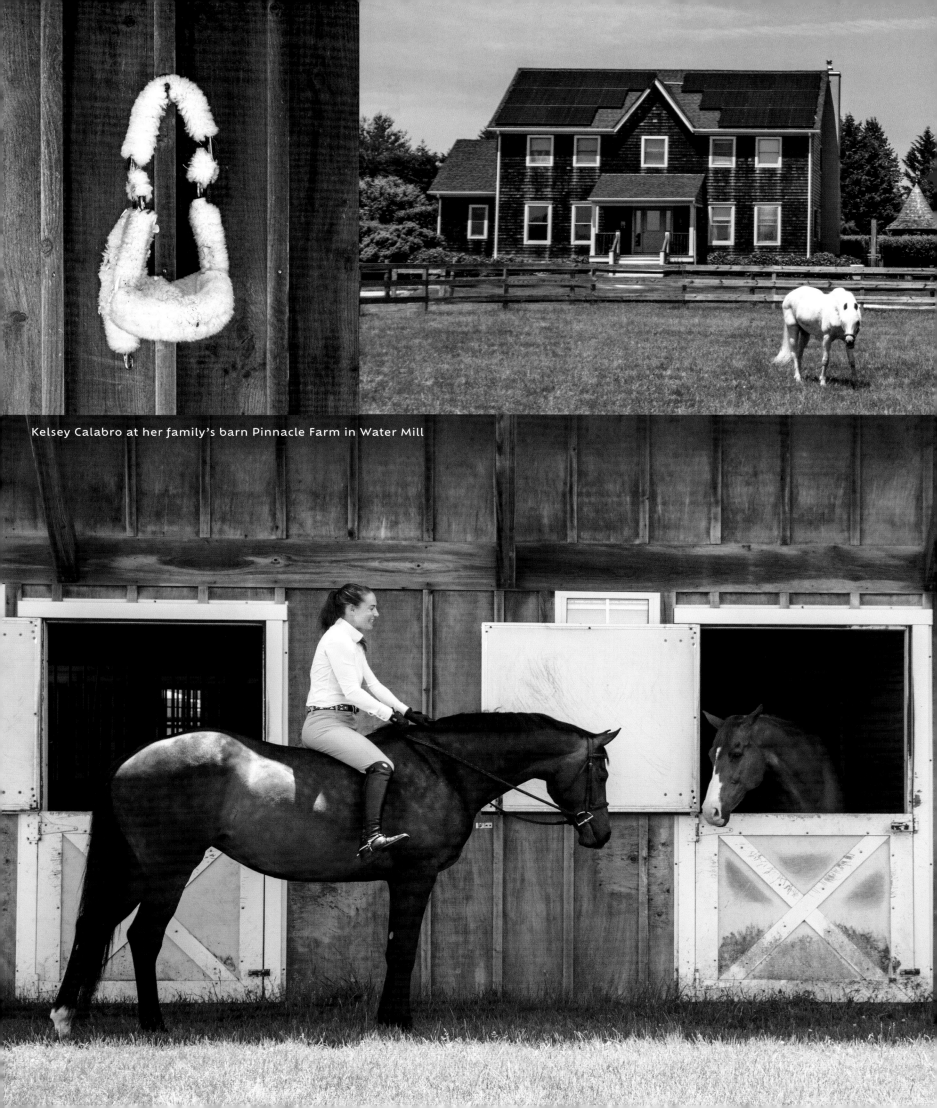

Kelsey Calabro at her family's barn Pinnacle Farm in Water Mill

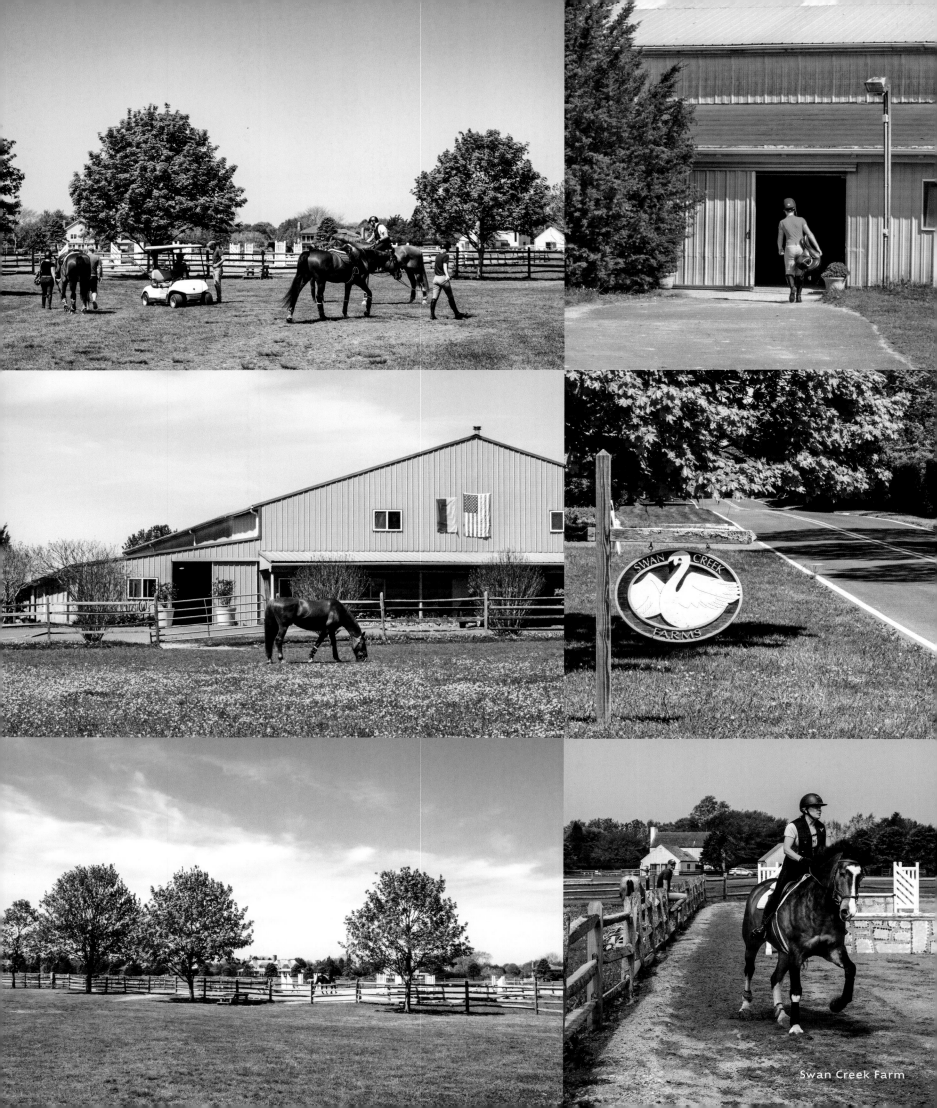

Swan Creek Farm

"Competing is something I've always enjoyed. It's exciting to get in the ring at the bigger shows knowing the horses I'm riding are ready to compete at a high level. I have a lot of respect for the people who consistently produce winning rounds and am motivated by them to make myself better as a rider and trainer."

—Gretchen Topping

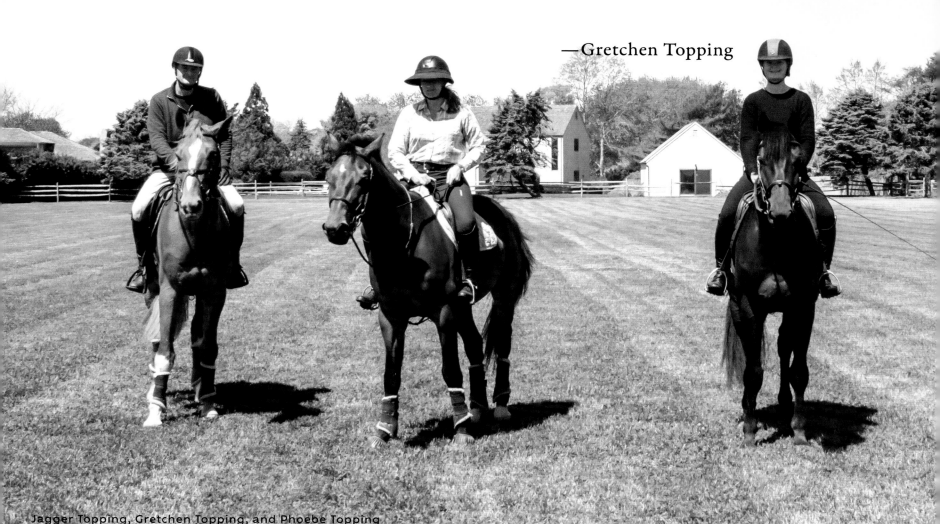

Jagger Topping, Gretchen Topping, and Phoebe Topping
at their family's barn Swan Creek Farm in Bridgehampton

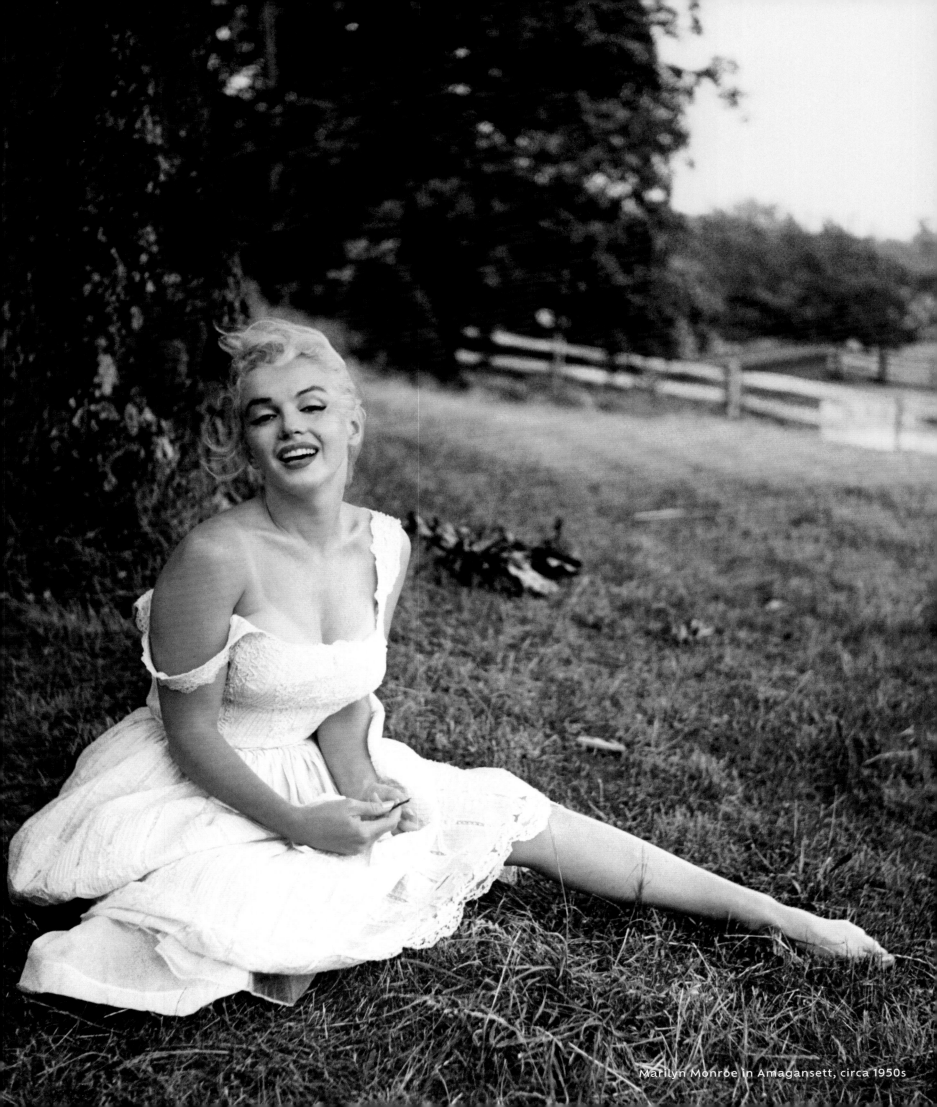

Marilyn Monroe in Amagansett, circa 1950s

businesses these days, but the Toppings had no such problem. Everyone from eighteen-year-old Tim, who ties his hair up in a ponytail when he's doing chores like haying, to Kathy, fourteen, the family's best rider and teacher, and even Jennefer—called Jenno and just turned three—helps," wrote the newspaper on September 20, 1970.

"In the beginning we really didn't know what we were doing but we just kept at it and soon we had different trainers working for us, especially after Jenno started winning in all the horse shows," says Tinka. Jenno Topping's rise to the pinnacle of horse showing and her anointment as the best junior rider in America in the 1980s brought attention to the barn that bore her family name. Jenno stopped showing when she went to college and has long since carved a name as a film producer in Hollywood.

A few miles from the Topping Riding Club is Swan Creek Farm, which was founded by Bud Topping's brother Alvin and his wife Patsy. Like the story of the Topping Riding Club, agricultural upheavals led to the pivot to horse barns. "We supplied fresh potatoes to the state of New York, but as frozen foods entered the market, the demand for potatoes dwindled and the agricultural market was reduced," recalls Alvin Topping of that time in the late 1960s when he had to reassess how best to move forward with the land they owned. "As that was dwindling, the Hamptons was going uphill with new people moving in and land became increasingly valuable and large houses started going up. We started [the business] as an after-school activity for the kids in the area. The kids eventually became competitive and that's how we became what we are. My wife Patsy and I and our kids really did everything together. The trees you see here surrounding the property were a birthday present to my wife one year. She wanted trees to surround the property, so we planted trees all around," remarks Alvin. To this day, you will find Alvin on a tractor on the farm's grounds looking after the trees or the grass paddocks or doing general maintenance work. His son Jagger with his wife Mandy and their daughter Phoebe have taken over the reins of managing, teaching, and fostering new generations of riders.

Lolly Clarke (sister of Patsy Topping) was a champion equestrian in her youth and had trained with Harry deLeyer; she also had the enviable experience of having ridden the legendary horse Snowman. She reminisced about meeting Marilyn Monroe at the former location of Stony Hill Stables. Before Stony Hill Stables moved to its current location on Town Lane in Amagansett, it operated out of the Potter family's Stony Hill Farms just on the north side of Town Lane. It was a large, bucolic hundred-acre property with rolling hills, a main house, and various cottages that the Potters would rent out to summer visitors. Lolly recalls: "It was around 1957 and I was eight years old, and Marilyn and her husband Arthur Miller had rented one of the cottages. She had a little dog that would always run away and I would return it to her. We went bicycle riding together a few times and she would sit on the fence and watch me have my riding lessons."

Frank Stella's *Wooden Star* at The Ranch in Montauk

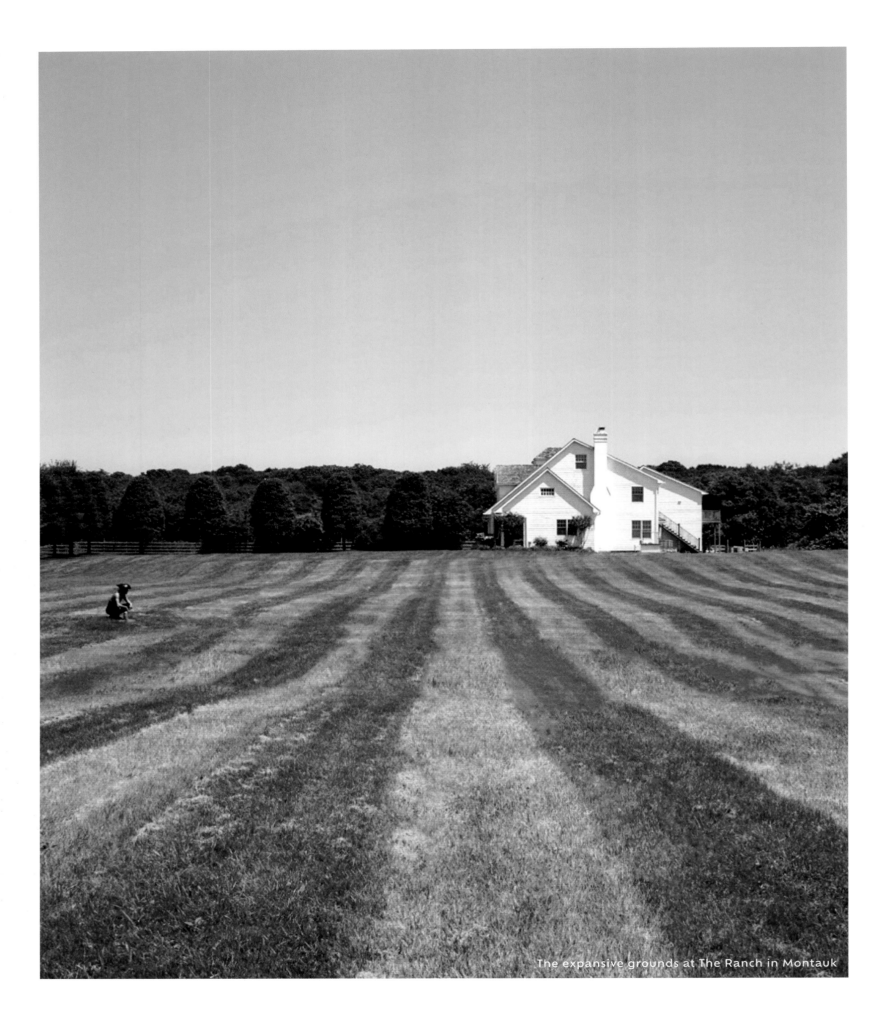

The expansive grounds at The Ranch in Montauk

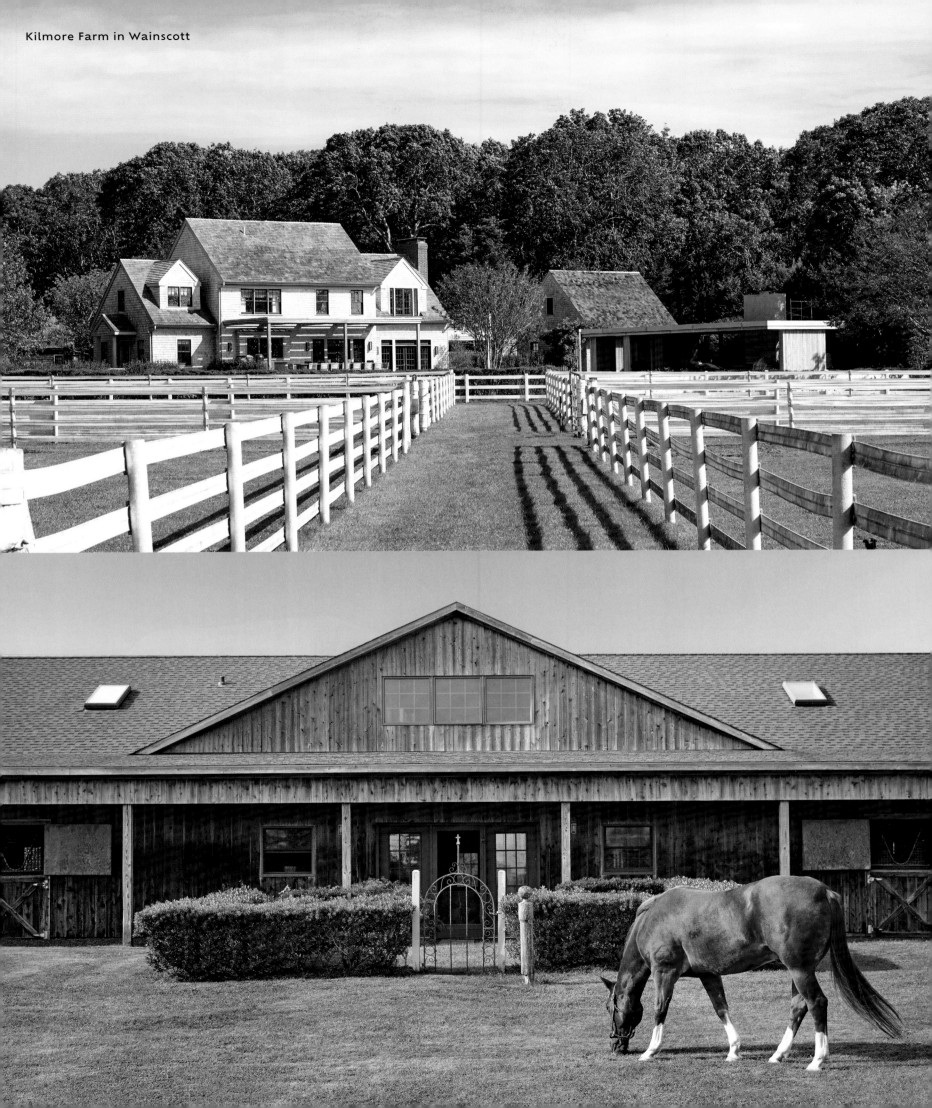

Over at the Stables

Tours of Barns, Tack Rooms, and Stables

Before full-service stables became *de rigeur* in the Hamptons, horse barns were modest family affairs. The changing agricultural and socioeconomic landscape of the Hamptons contributed to the evolution of the barns just as much as the increasing awareness for the sport. The towns of Bridgehampton and Sagaponack, which now boast luxury stabling facilities, were largely many acres of potato fields once upon a time. In fact, the pioneering families that helped cement the Hamptons as an equestrian hub were farmers.

The Topping family can trace their roots in the Hamptons all the way back to the 1600s, and the original barn that has become Tinka and Bud Topping's home was built in the early 1800s by Bud's great-great-grandfather. "This was a potato farm," reflects Tinka of a time in the 1960s, from her home on the grounds of the Topping Riding Club. The farm has the enviable location of being within trotting distance from the beach. Tinka and Bud's house was actually the original barn structure that has since been converted into a residence. "The horse and cattle stalls were over there," she says, pointing to an area just beyond the kitchen. "Above is the hay loft, which is now a bedroom."

Tinka goes on to explain: "When the potato business was going downhill, my husband Bud, who was very creative, said, 'Why don't we turn this into a horse operation?'"

It immediately became a family enterprise with Bud managing the barn and maintaining the grounds and their children Tim and Kathy teaching local students. Three years after they opened, the *New York Times* published a story on their family venture: "Many parents have to drag their children by their long hair into family

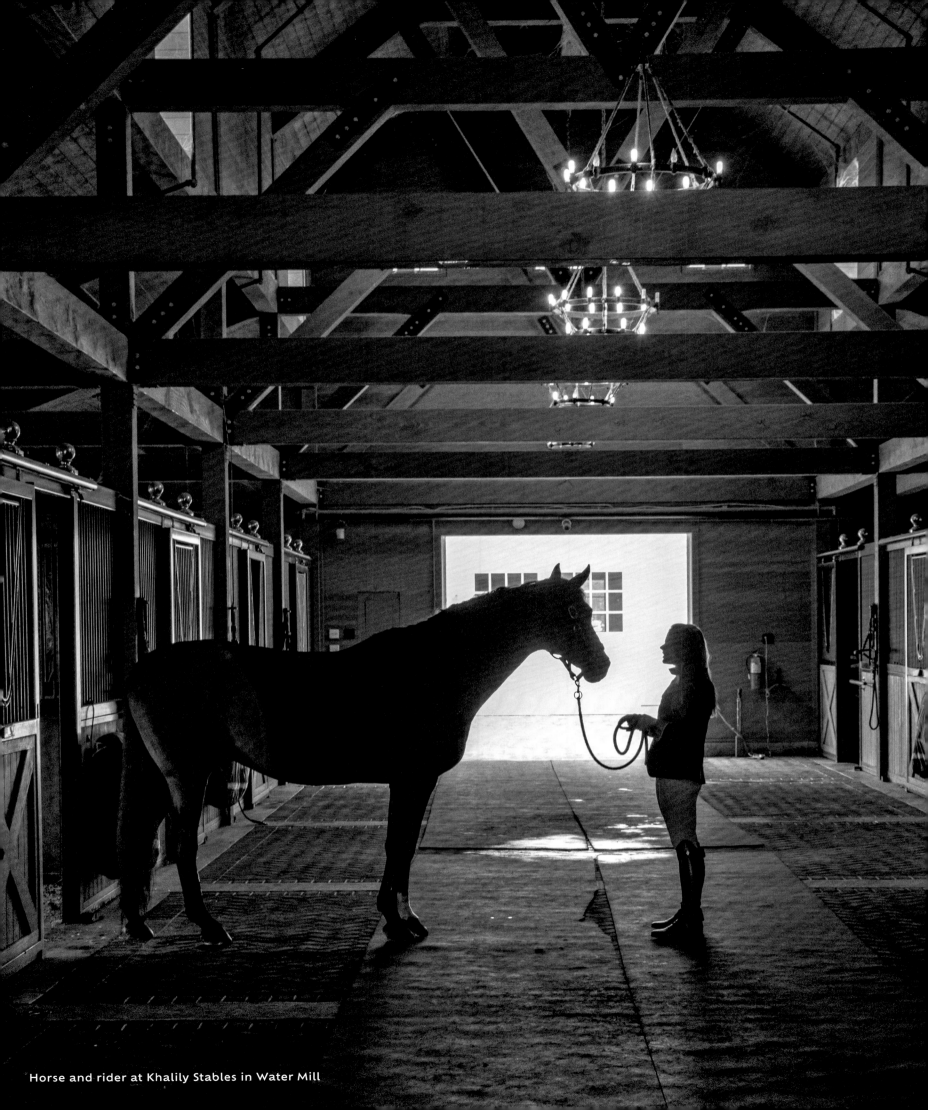

Horse and rider at Khalily Stables in Water Mill

Lisa Ellis with her three horses, C'est La Vie, Je Suis,
and Verne Xequoia

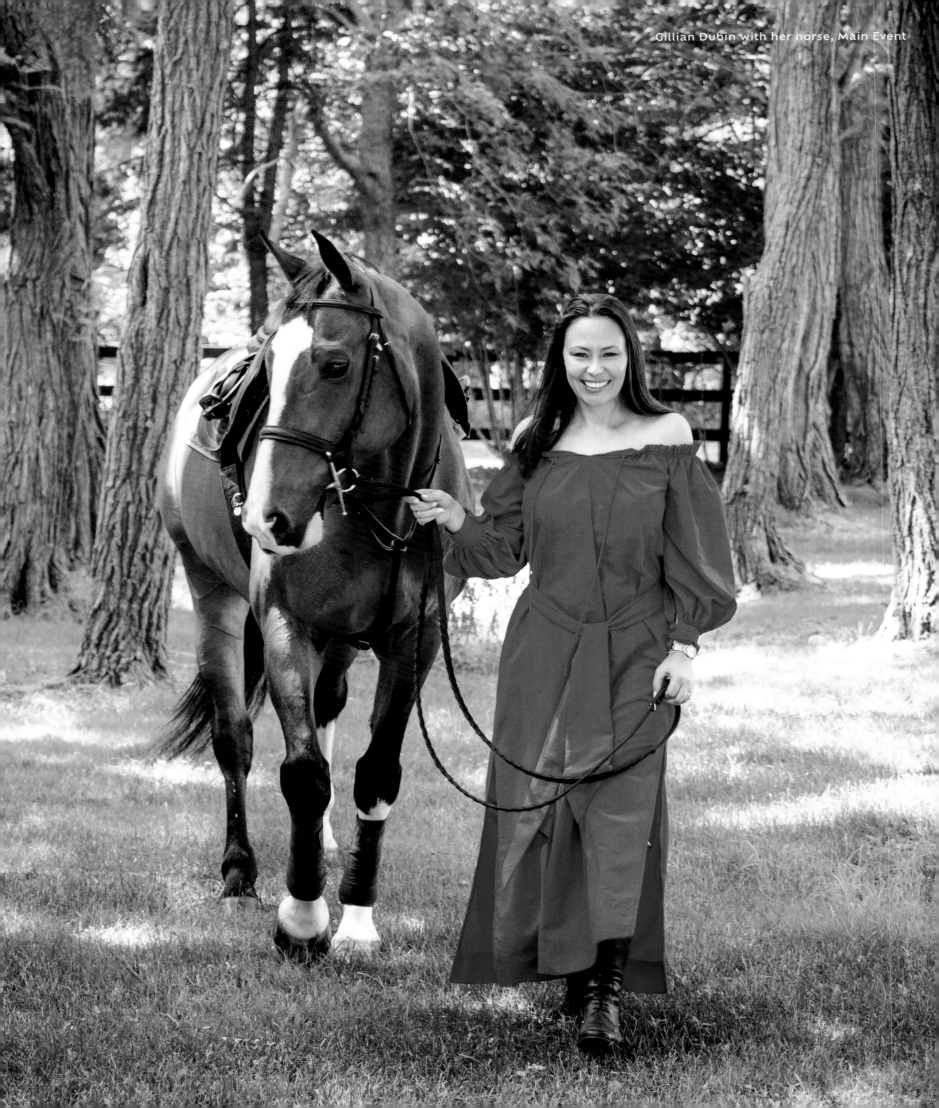

Gillian Dubin with her horse, Main Event

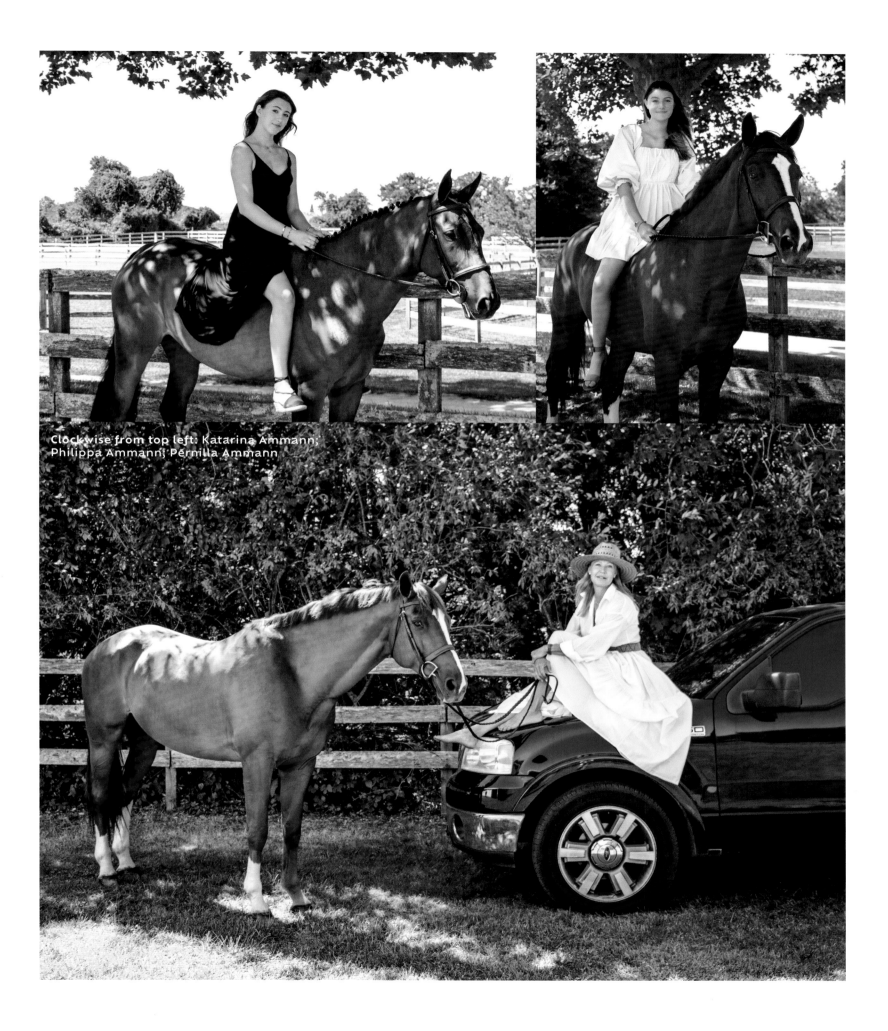

Clockwise from top left: Katarina Ammann;
Philippa Ammann; Pernilla Ammann

"What I loved about riding so much was that I forgot everything else when I was riding. And I had no fear. And I couldn't wait to jump. Couldn't wait to just do it, do it, do it."

—Brooke Shields

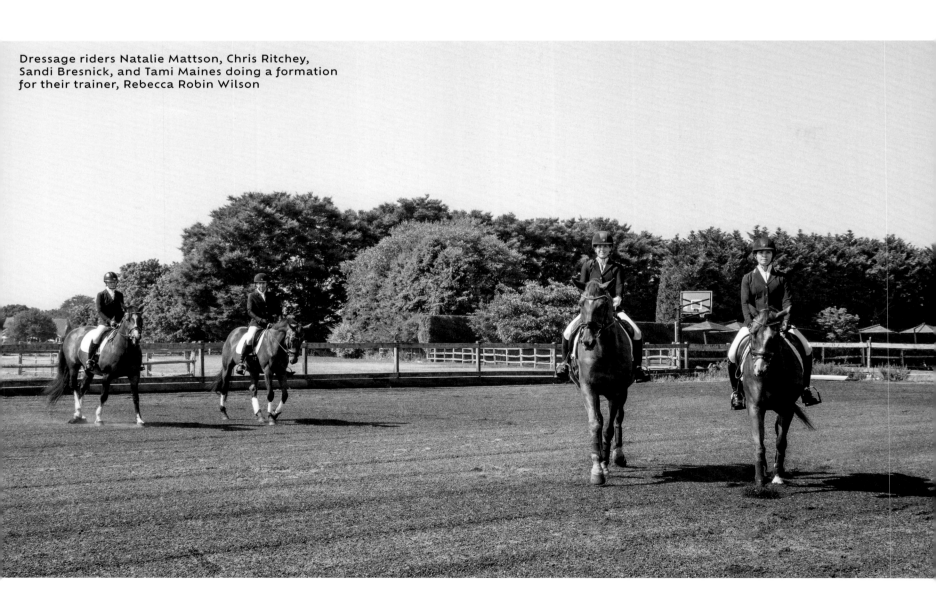

Dressage riders Natalie Mattson, Chris Ritchey, Sandi Bresnick, and Tami Maines doing a formation for their trainer, Rebecca Robin Wilson

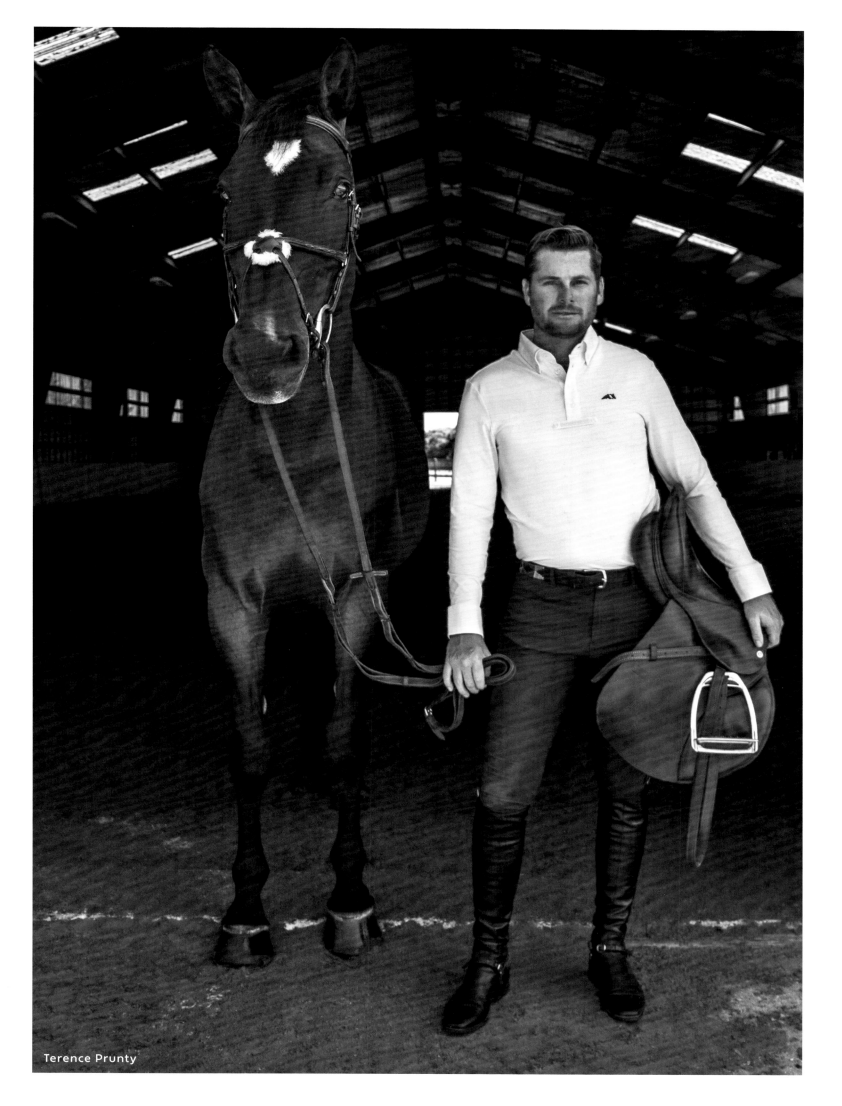

Terence Prunty

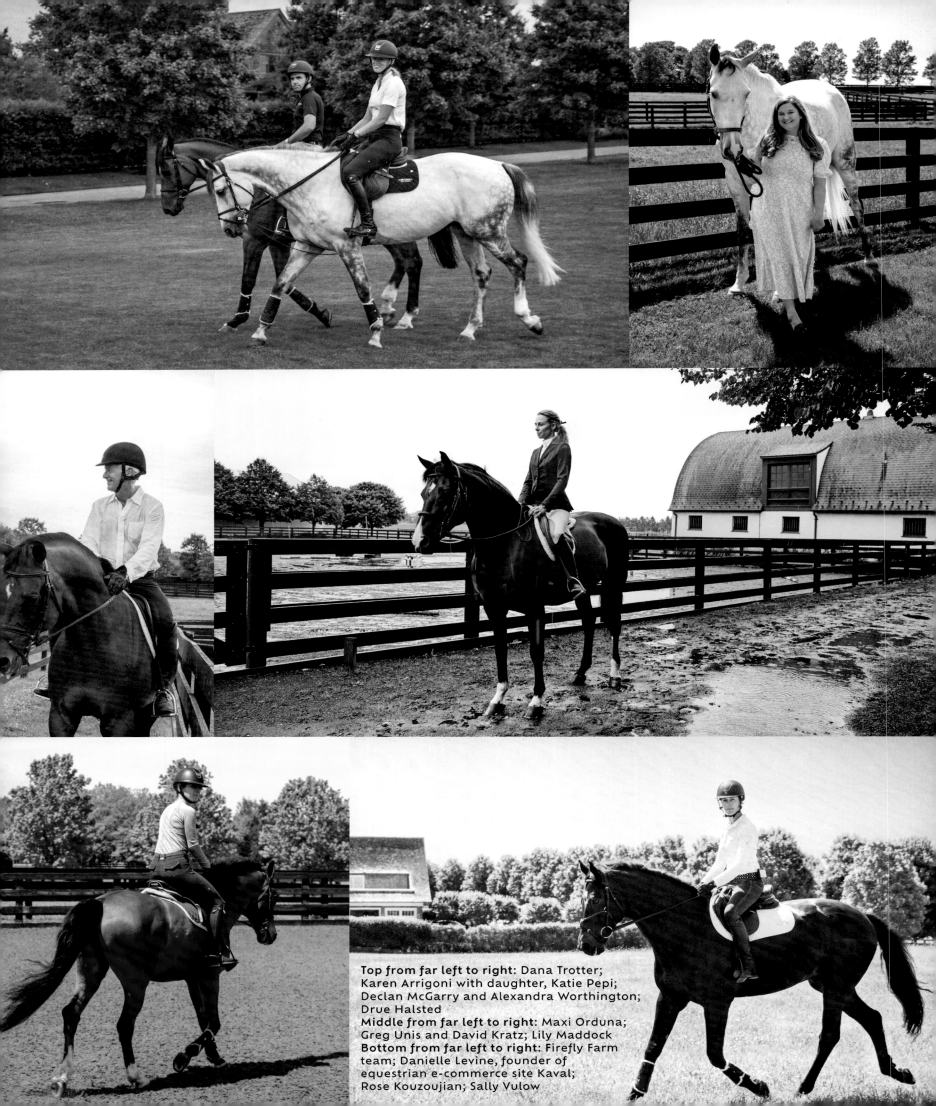

Top from far left to right: Dana Trotter;
Karen Arrigoni with daughter, Katie Pepi;
Declan McGarry and Alexandra Worthington;
Drue Halsted
Middle from far left to right: Maxi Orduna;
Greg Unis and David Kratz; Lily Maddock
Bottom from far left to right: Firefly Farm
team; Danielle Levine, founder of
equestrian e-commerce site Kaval;
Rose Kouzoujian; Sally Vulow

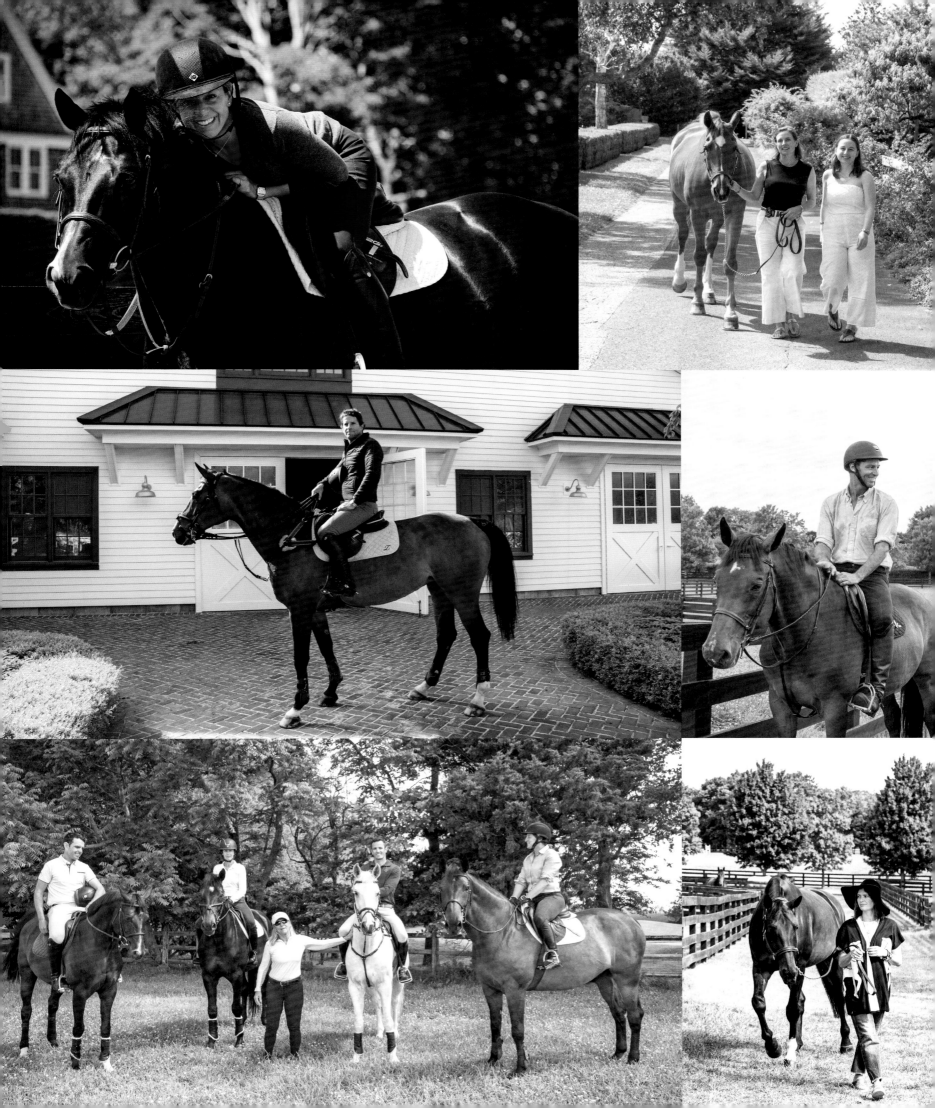

Top from left to far right: Gabrielle Payne, Austin Payne, Thea Chavasse, and Broudy Keogh at Deep Hollow Ranch; Sisters Dawn Brennan Hagen and Deborah Brennan Thayer with horse Asterix; Gretchen Topping
Bottom from left to far right: Jenn Bowery of Ocean's Edge Farm with her horses and hounds; Woody Boley; Benjamin Tula and wife Nicole Parise-Tula

Stefano Maderna

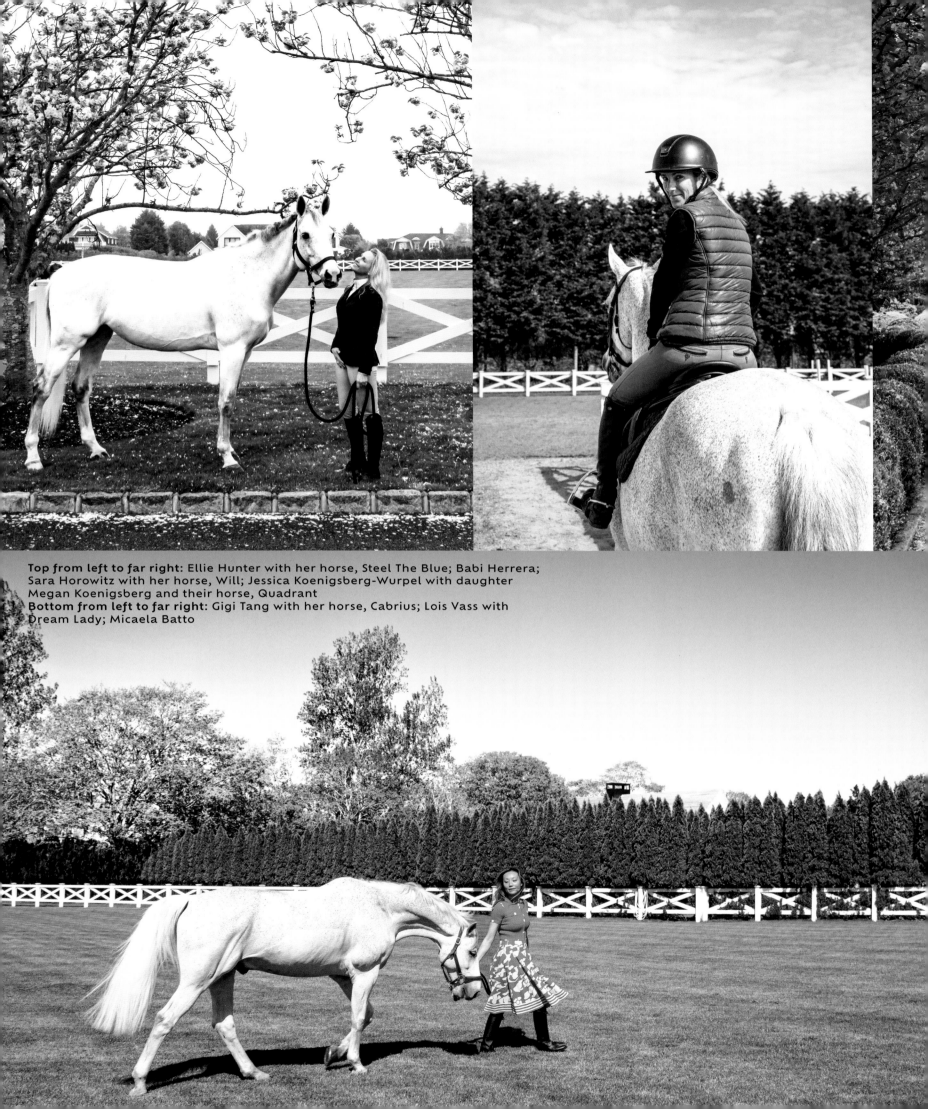

Top from left to far right: Ellie Hunter with her horse, Steel The Blue; Babi Herrera; Sara Horowitz with her horse, Will; Jessica Koenigsberg-Wurpel with daughter Megan Koenigsberg and their horse, Quadrant
Bottom from left to far right: Gigi Tang with her horse, Cabrius; Lois Vass with Dream Lady; Micaela Batto

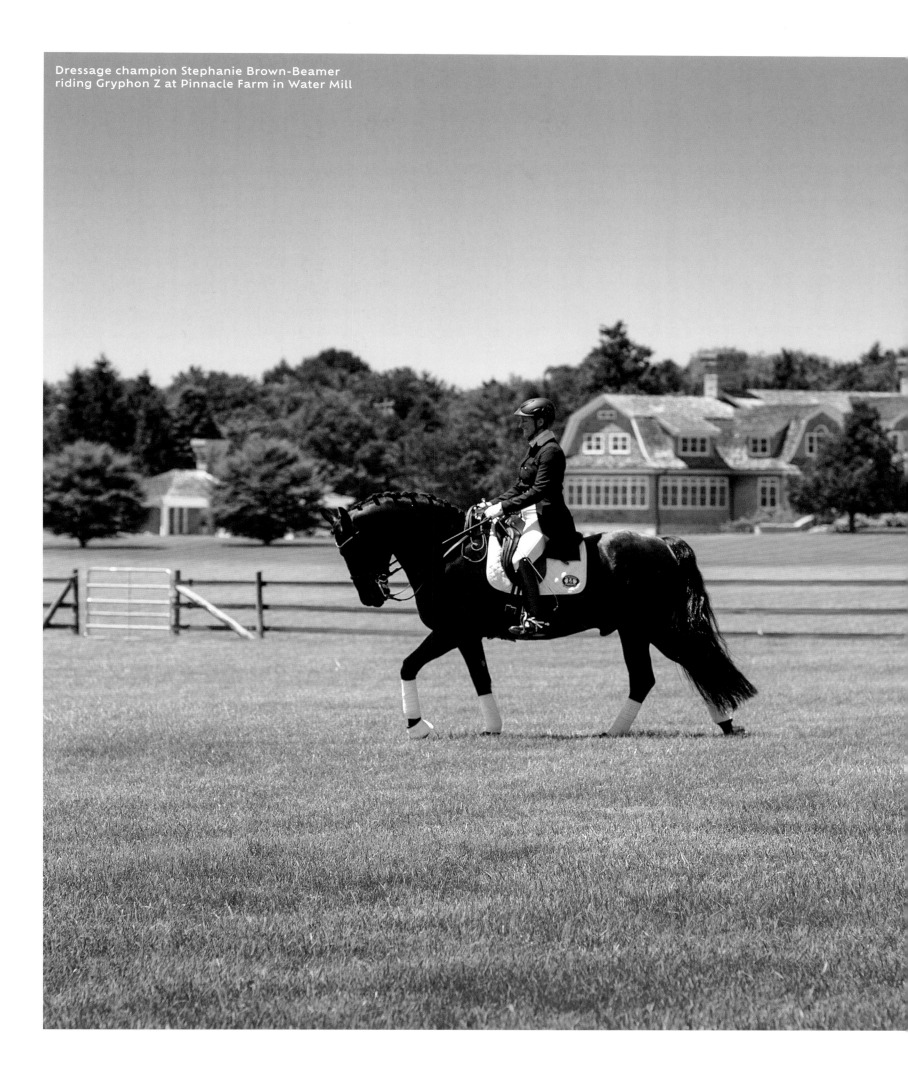

Dressage champion Stephanie Brown-Beamer
riding Gryphon Z at Pinnacle Farm in Water Mill

Jagger Topping recalls of how he innocently came to ride horses at his parent's barn Swan Creek Farm at around the age of five: "I always wanted to be with my mom (Patsy) and dad (Alvin) and they were always out here in the ring and so I rode a horse." He would eventually become a seasoned horseman and transitioned to a professional. "My parents, they wanted to win," continues Topping. "They trained their horses and their kids, and they wanted to go to horse shows. I tell my students now that they should not be afraid to pursue it and get dirty. To get in there, give it your best and keep at it. But also, the horses themselves have taught us a lot."

For sisters Jenn and Laura Bowery who run their horse businesses Ocean's Edge and Sea Are Inc. (respectively) and train a lot of young riders, their love for the sport began at the age of five and six. Jenn Bowery says, "Our dad started us. It just stuck with us. We became barn rats on the weekends. My trainer became my second mom. They put us under their wings and took us to horse shows and had us ride young horses for them. My sister became a professional first. I tried to get out of the horse business. Tried to go to college and it didn't really work. I went

back to horses. It's my passion. I don't see myself doing anything else." On training young riders, Jenn states: "I try to install goals in my students every year. I ask them what they would like to accomplish and we work toward that. Yet, I also like to make it fun. I don't want it to be so competitive all the time. I want them to be able to come here and play with their ponies. Go out on a trail ride or try things on their own sometimes."

Multi-generational riders like the Topping and deLeyer families abound in the Hamptons. There is also the Olympian Mario des Lauriers and his daughter Lucy who have on multiple occasions competed—and continue to compete—against each other. Many parents hope to pass on their life-long passion for horses to their children, and some parents initiate themselves into the sport after being inspired by their children's horsey pursuits.

Therein lies the beauty of equestrian. You can be a rider at any age and you can approach it however you wish: be it a lofty goal to achieve competition status or as simple as jumping on a horse and going on a calming, leisurely trail ride. Horses have a way of casting a spell on you. And once you get on that saddle, there is no turning back.

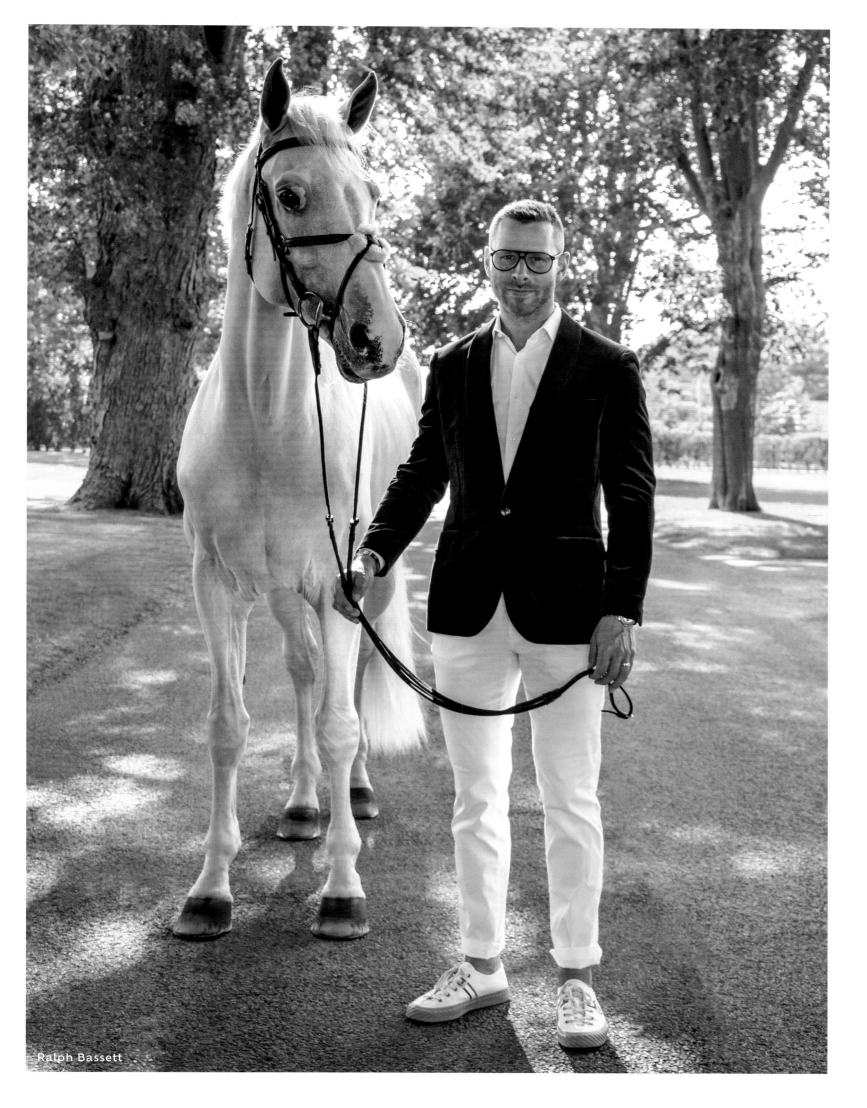

Ralph Bassett

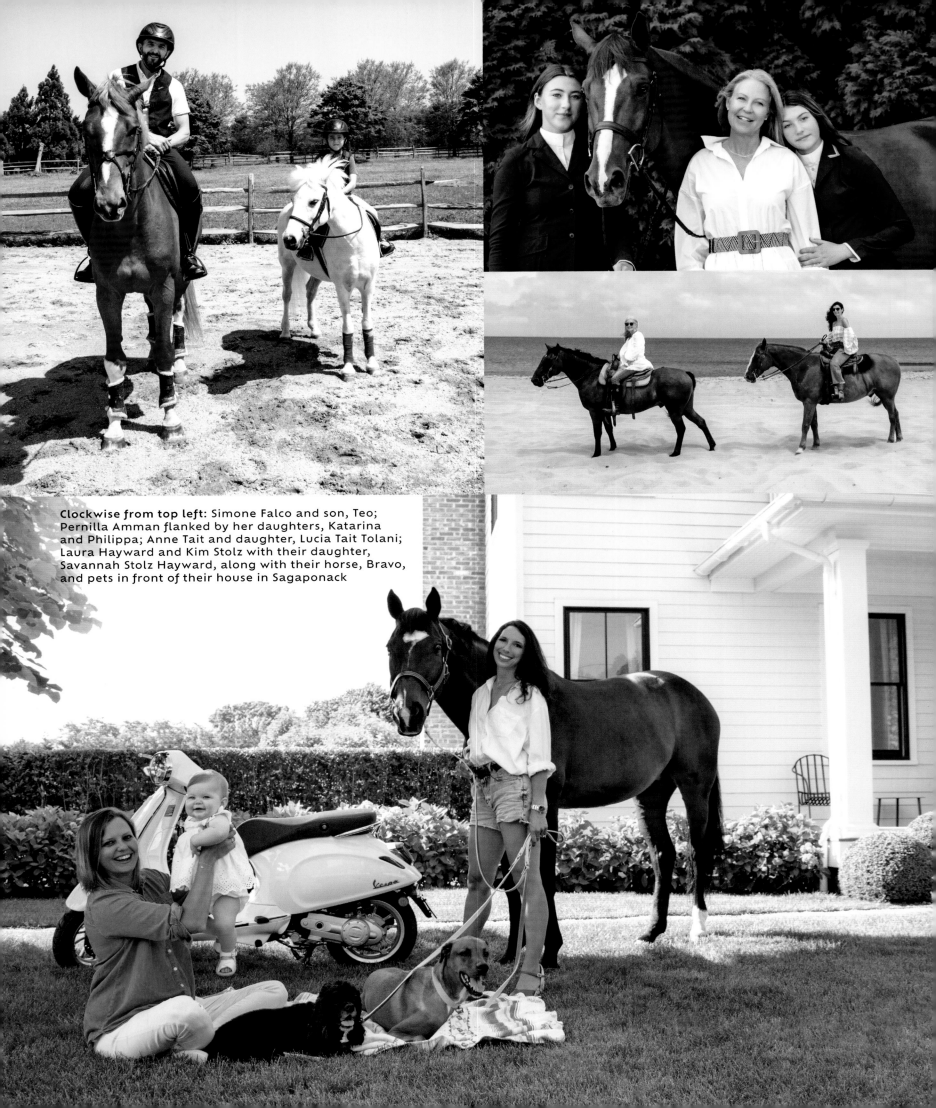

Clockwise from top left: Simone Falco and son, Teo; Pernilla Amman flanked by her daughters, Katarina and Philippa; Anne Tait and daughter, Lucia Tait Tolani; Laura Hayward and Kim Stolz with their daughter, Savannah Stolz Hayward, along with their horse, Bravo, and pets in front of their house in Sagaponack

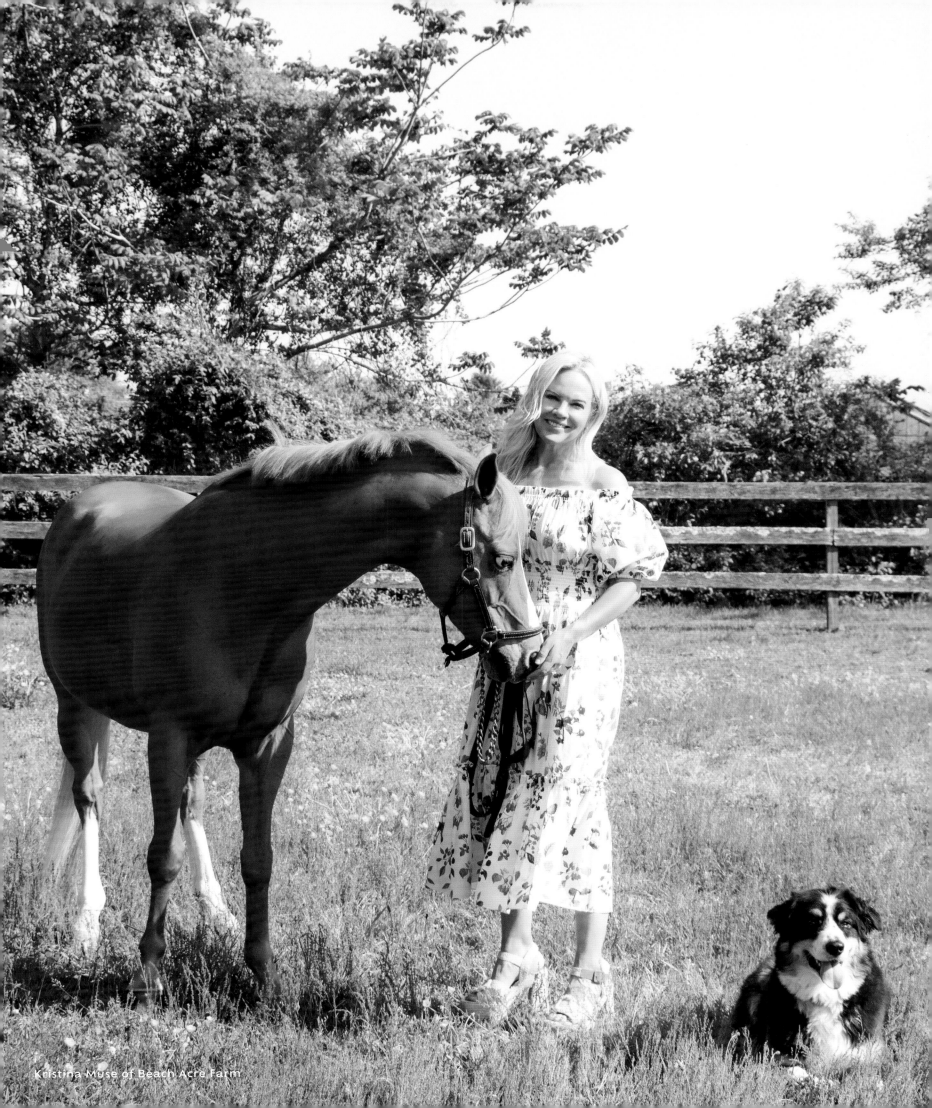

Kristina Muse of Beach Acre Farm

CTREE is not alone in fostering the virtue of charitable giving within the equestrian community. There is also Georgina Bloomberg's The Rider's Closet. "When I started my program The Rider's Closet, it was because I wanted to make the sport more accessible and easier for others," says Georgina. "It was such an easy thing to collect riding clothes and equipment and to get it to others, but I know that for so many people not having the proper items to wear or struggling to afford the pricey clothing and equipment meant that they couldn't or didn't want to pursue the sport," she explains.

The Hamptons equestrian community has rallied with Georgina on this cause and has set up avenues where riders can donate new or slightly used clothing and equipment to The Rider's Closet. "I couldn't have started this program without the riding community helping me do so by donating items, and hopefully it is helping others become a part of or stay in the sport, or at least make it easier for them," Georgina adds.

Georgina also ranks as a leading figure of the sport, an equestrian celebrity. And it is not uncommon to spot celebrities like her at a barn in the Hamptons. Christy Turlington could be watching her daughter Grace Burns have a jumping lesson; Donna Karan might be cheering on her granddaughter Stefania Felice at a barn show; Kelly Bensimon could be getting ready to get on a saddle; or Mary Kate Olsen riding one of her prized mounts. Other celebrity parents like Sarah Jessica Parker, Mariska Hargitay, Kelly Ripa, Jerry Seinfeld, Billy Joel, and Bruce Springsteen have frequented stables and horse shows in the Hamptons in support of their children.

Offsprings of the landed gentry, progenies of captains of industries, like Eve Jobs and Jennifer Gates, heirs to cosmetic and fashion fortunes like the Chantecailles and Karans, are all on equal footing with children of more modest means and working students at a barn. Muck, grooming and falling off a horse and landing on dirt are the great equalizers of the sport.

While horse riding is a physical sport and some form of physical ability is required, almost all trainers and professional show jumpers believe that this is but one small aspect of horsemanship. To be able to connect and care for the horse are paramount, and this is what separates a good rider from a great rider. "Putting your horse first. Focusing on learning the way of horses. How they live, how they think, what they like and don't like, how to keep them comfortable and happy. It's a lifestyle that you must enjoy," remarks two-time Hampton Classic Grand Prix winner Daniel Bluman.

For some riding is second-nature, as is in the case of Harriet deLeyer who as a young girl in the 1950s would watch her father Harry deLeyer ride and a jump a course. Because of this front-seat view of a master rider in action, Harriet deLeyer says, "Naturally, I found the rhythm of how things went and the sense of not interfering with the horse. Your horse is your partner and there has to be trust between the two of you." She started competing at age nine and when she was thirteen years old, she placed third in the ladies' sidesaddle class at Madison Square Garden. Harriet states, "I also take great pride in being able to teach students to compete at a high level, like at the Hampton Classic, and for them to become partners with their horses. If there is one thing I learned from my father it is that there has to be a partnership and respect between a rider and a horse. You have to be able to communicate, just like in any other relationship."

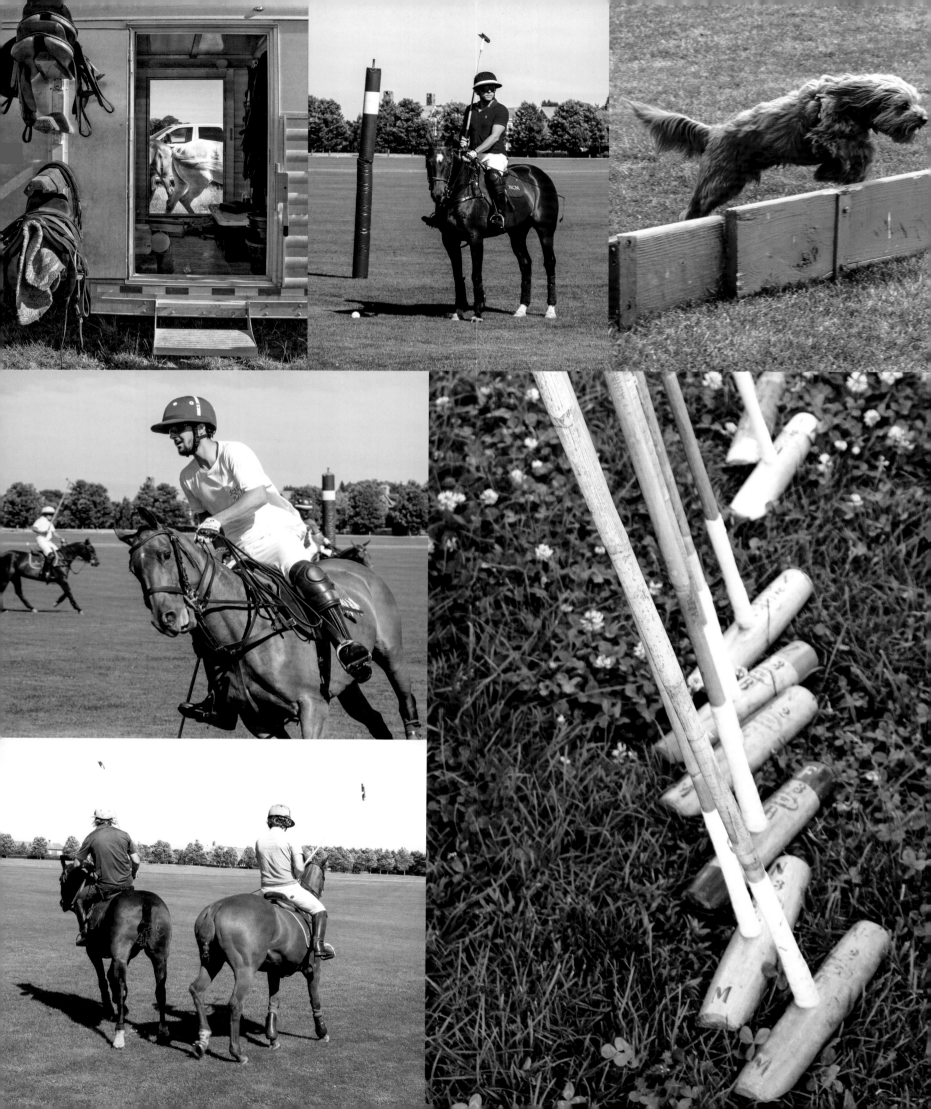

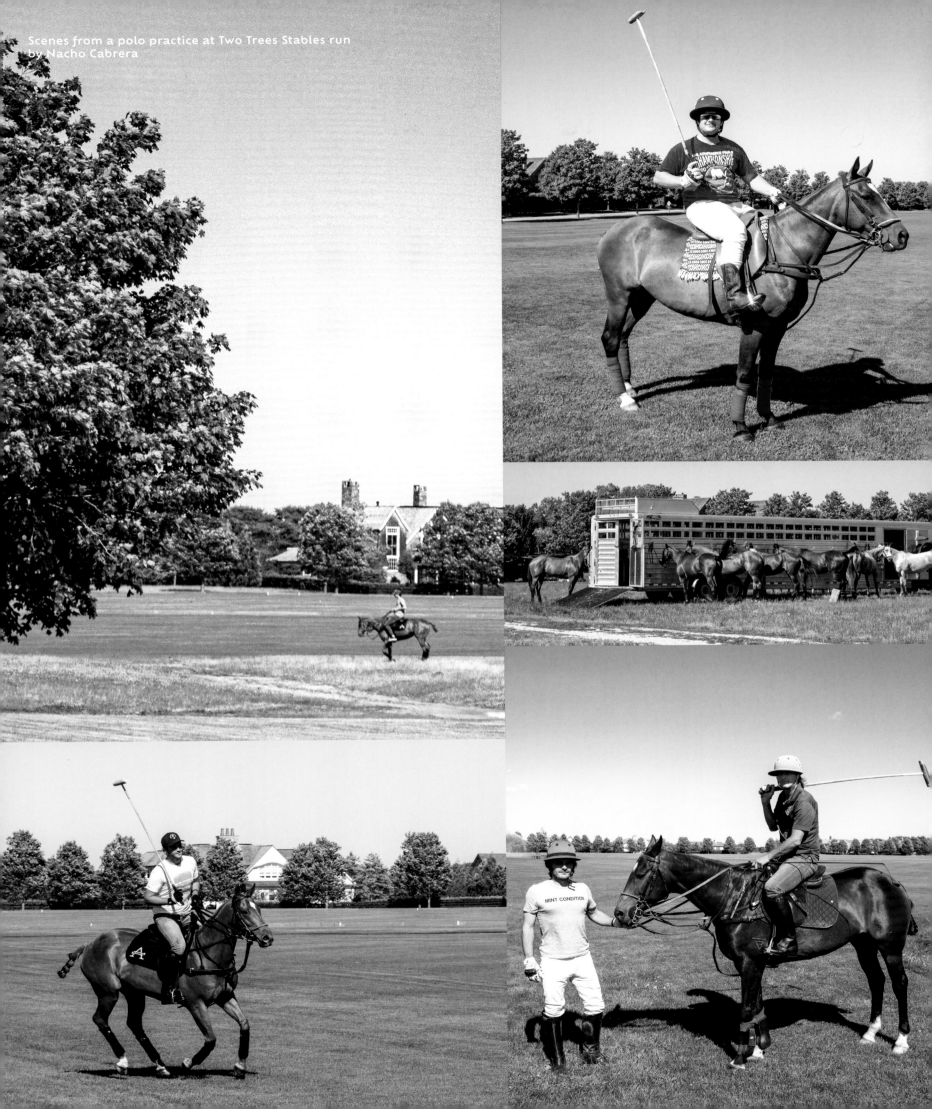

Scenes from a polo practice at Two Trees Stables run by Nacho Cabrera

"Playing polo in the Hamptons is so special because you are so close to the beach and nature, which is so beautiful. I've won a few high-goal matches, which is a great achievement. But personally, I like to play in all the charity matches and be able to help others."

—Martin Pepa

The polo players make for a small contingent of the riding community in the Hamptons. Although, polo is no less thrilling than the jumpers, what with the speed of the gallop required for polo and its close resemblance to a contact sport. Argentine players, who are arguably the best in the sport, lend their expertise to amateur polo players and those looking to get on a horse and pick up a mallet. Nacho Cabrera, who runs a polo training operation in the Hamptons and Florida, likens polo to an extreme sport. Athleticism, quick decision making, awareness of the horse's position and those of the other players and their horses, and a thirst for excitement and adrenalin are required of practitioners of this so-called 'sport of kings.'

Nacho Figueras, perhaps the best-known polo player in the world owing to his supreme athleticism, and for starring in Ralph Lauren advertisements, comes to the Hamptons to play in charity matches with resident polo player Martin Pepa and his team. Figueras led his team BlackWatch Polo to victory at the 2004 Bridgehampton Mercedes-Benz Polo Challenge.

Nacho Figueras has also partnered with the Center for Therapeutic Riding of the East End (CTREE)—a nonprofit organization that uses equine-assisted methods to help children and adults with cognitive, physical, and emotional disabilities—to give polo lessons to their riders. Delfina Blaquier, Nacho Figueras's wife, who was with her husband and their children at the CTREE charity polo lesson wrote, in her family's blog *We Are Figueras* on January 1, 2017: "I was so overwhelmed with joy to see how the riders' eyes [lit] up when they approached the horses. It made tears come to my eyes."

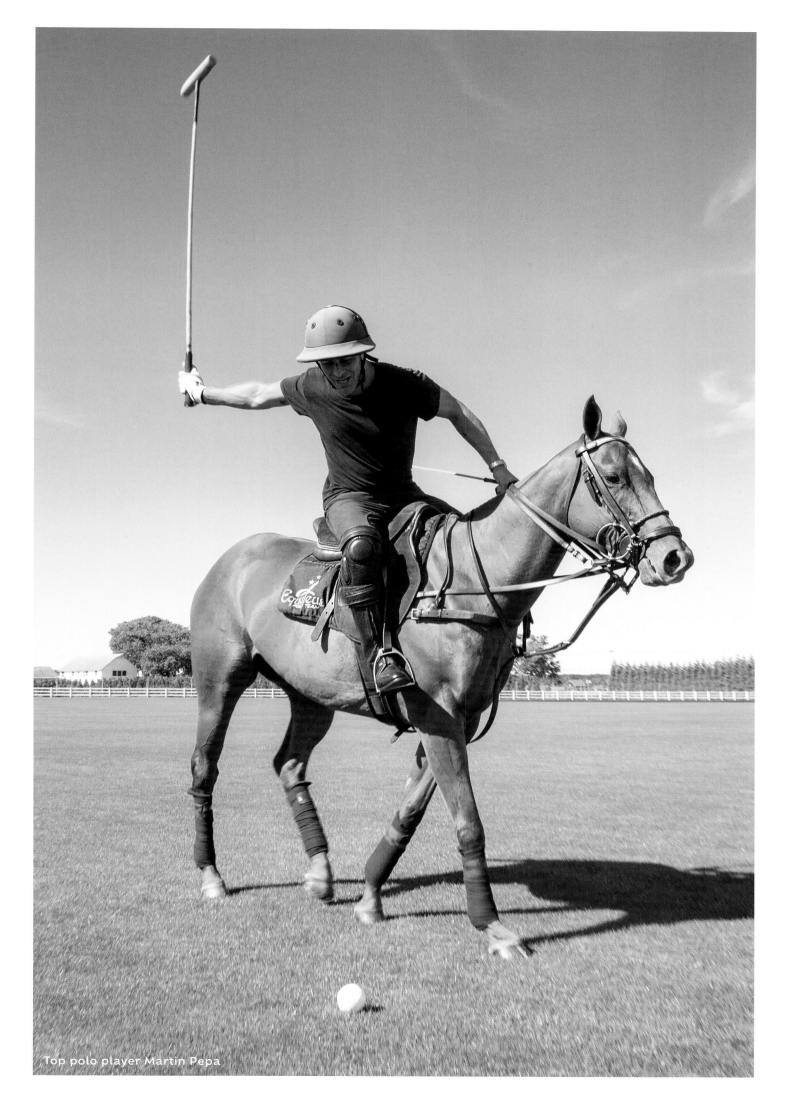

Top polo player Martin Pepa

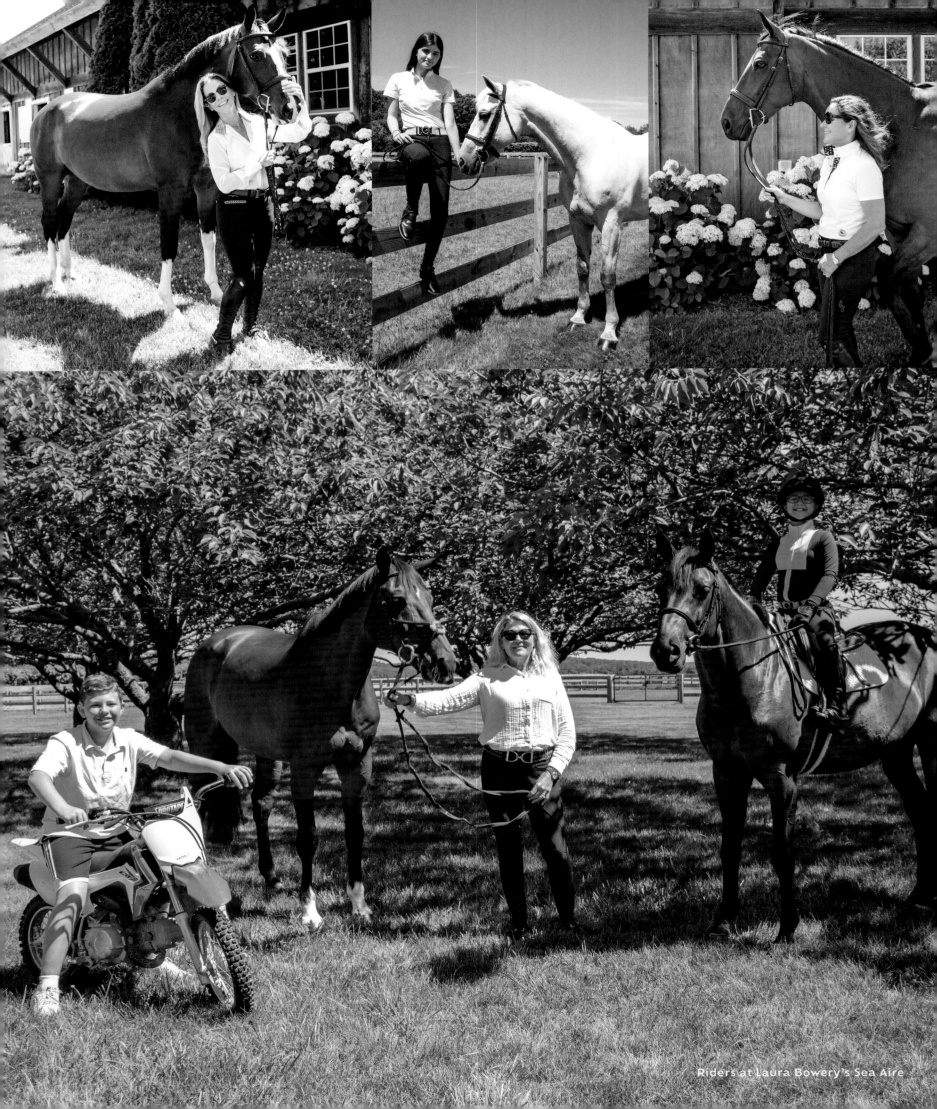

Riders at Laura Bowery's Sea Aire

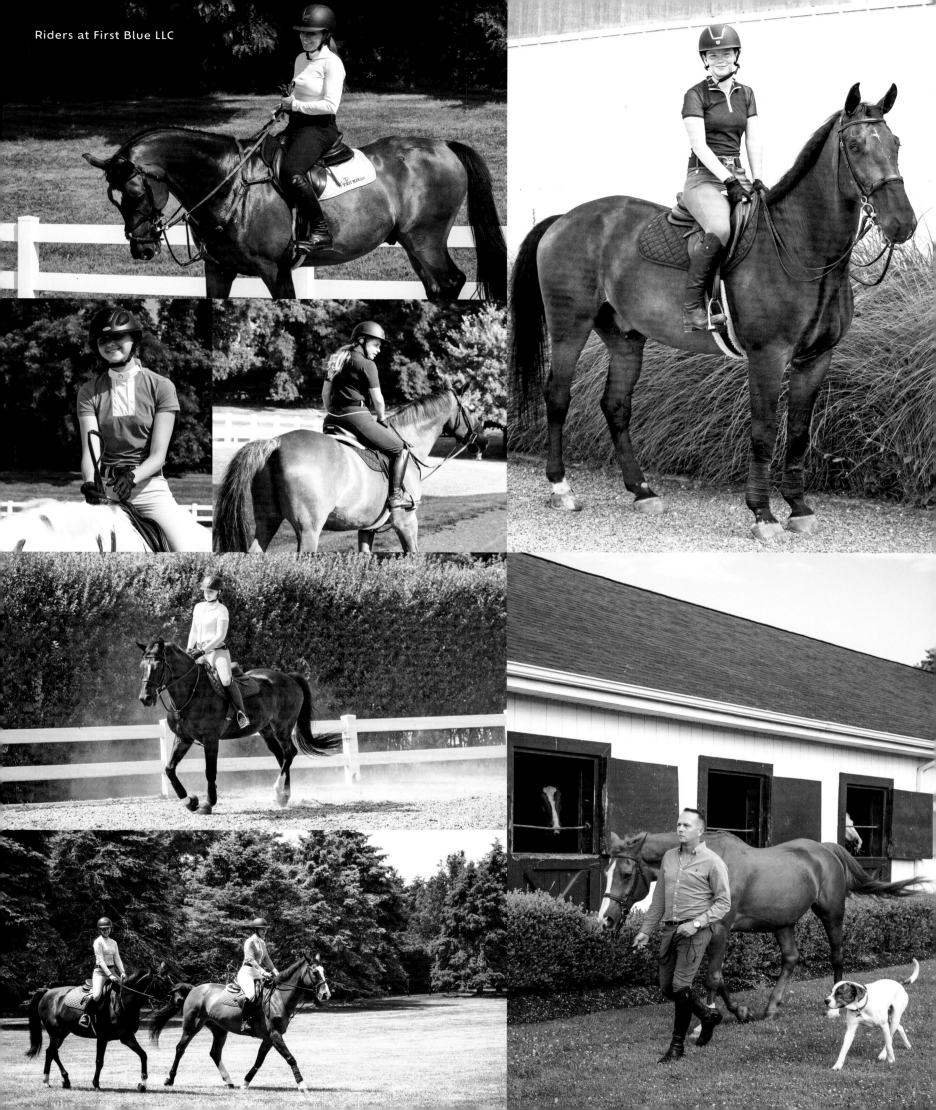

Riders at First Blue LLC

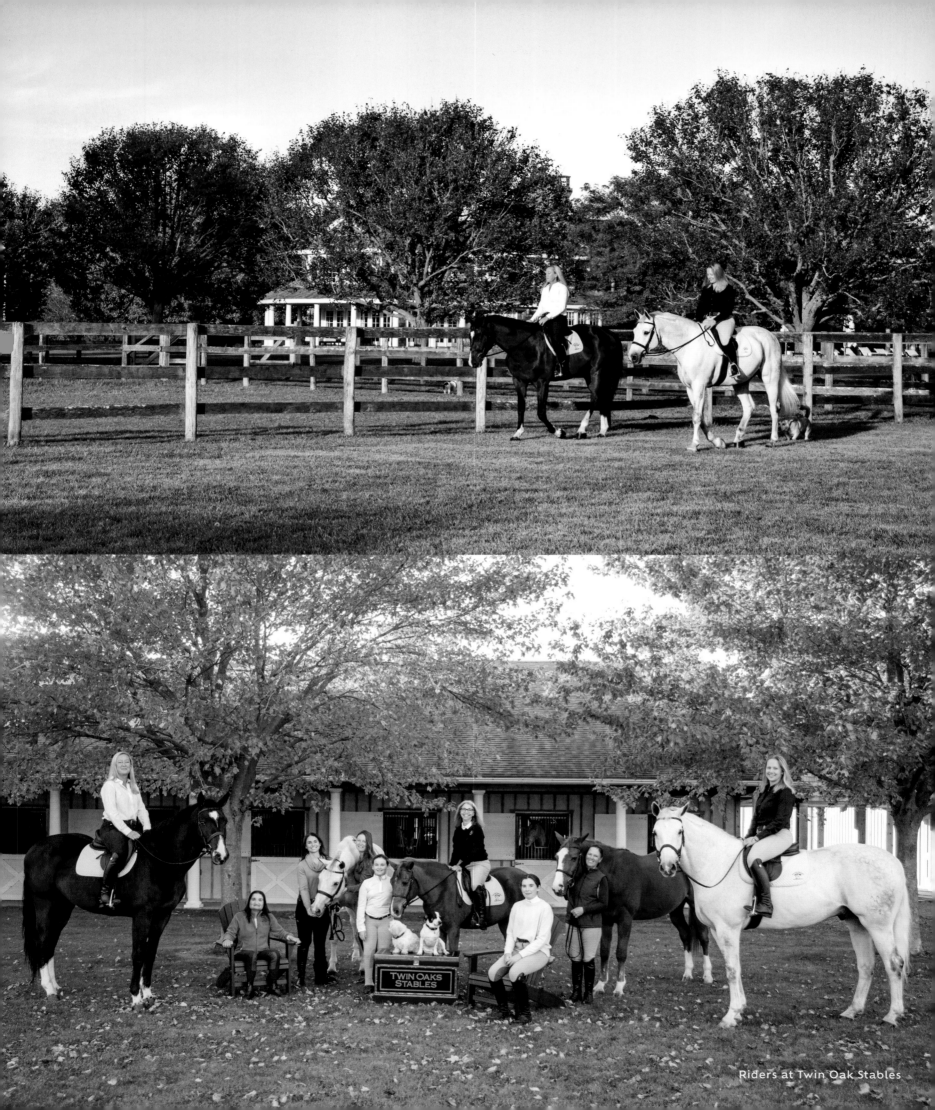

Riders at Twin Oak Stables

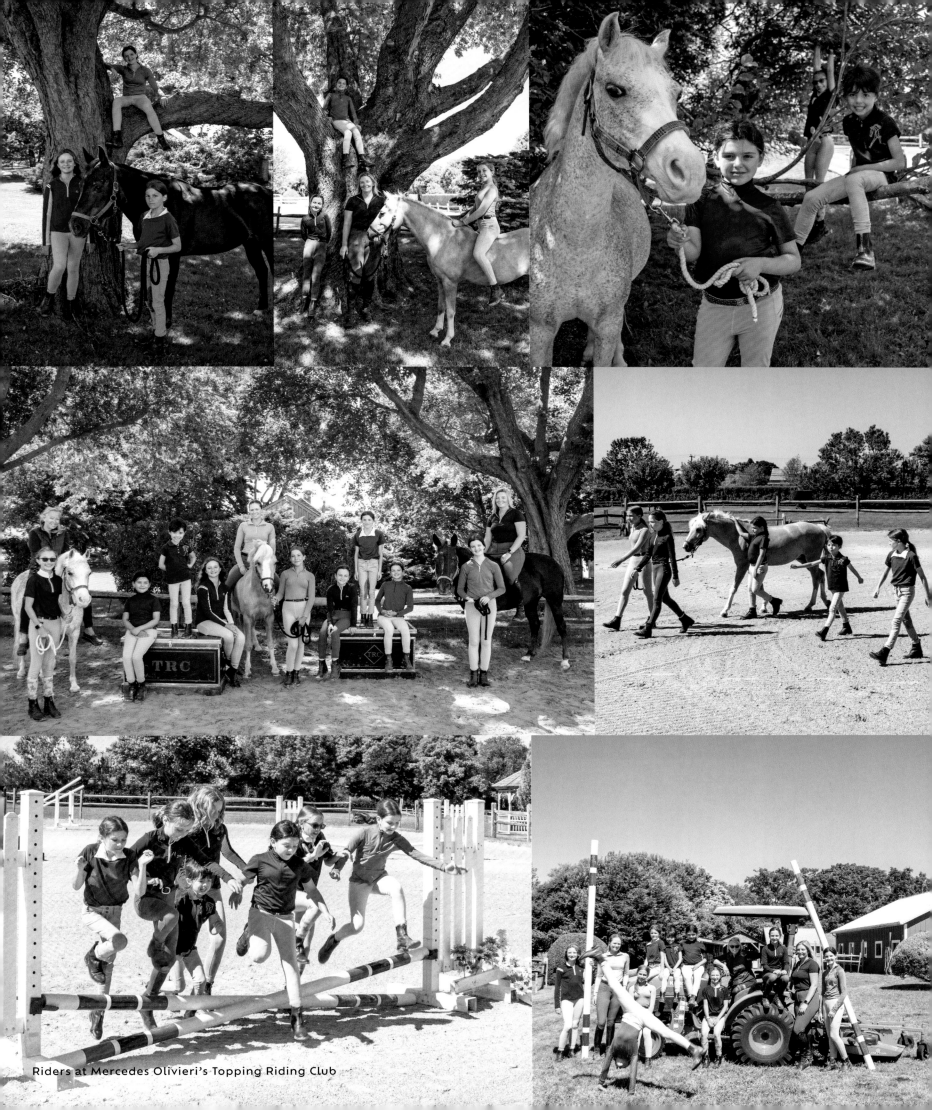

Riders at Mercedes Olivieri's Topping Riding Club

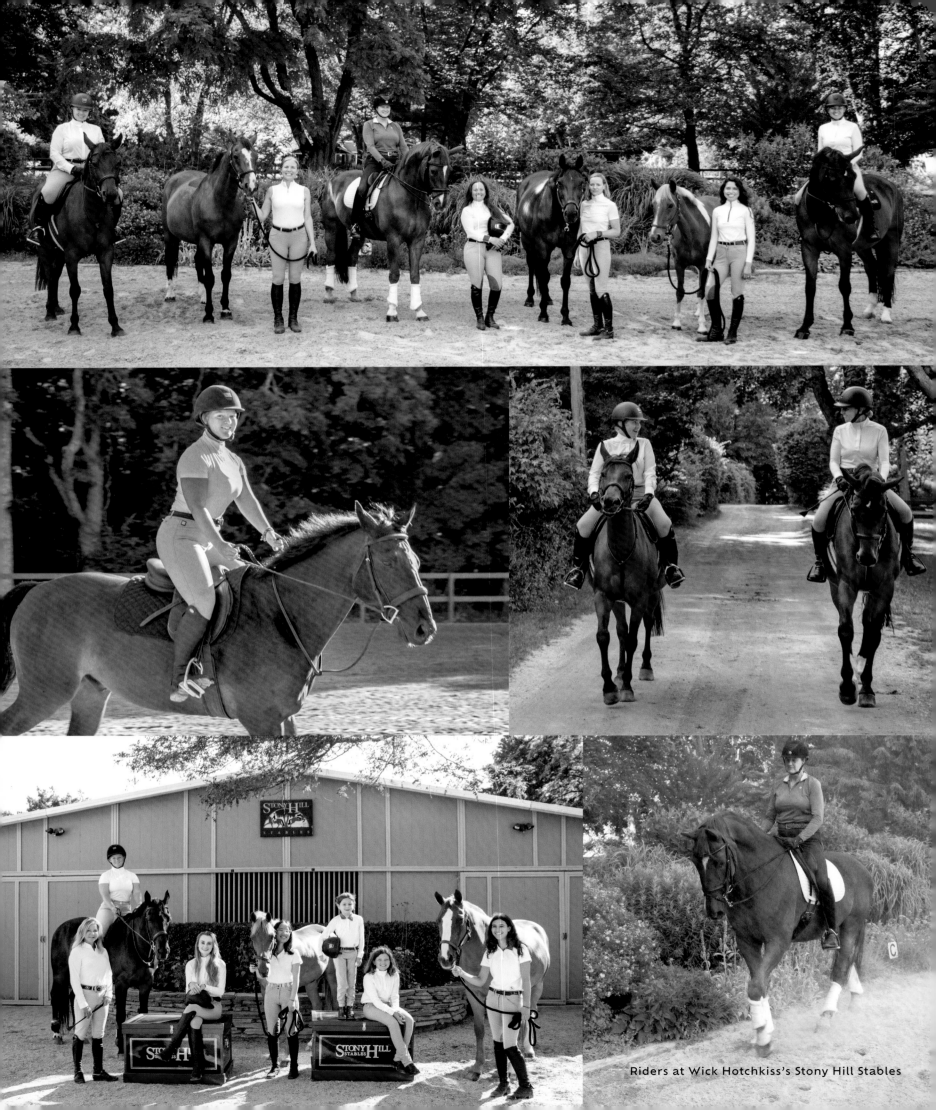

Riders at Wick Hotchkiss's Stony Hill Stables

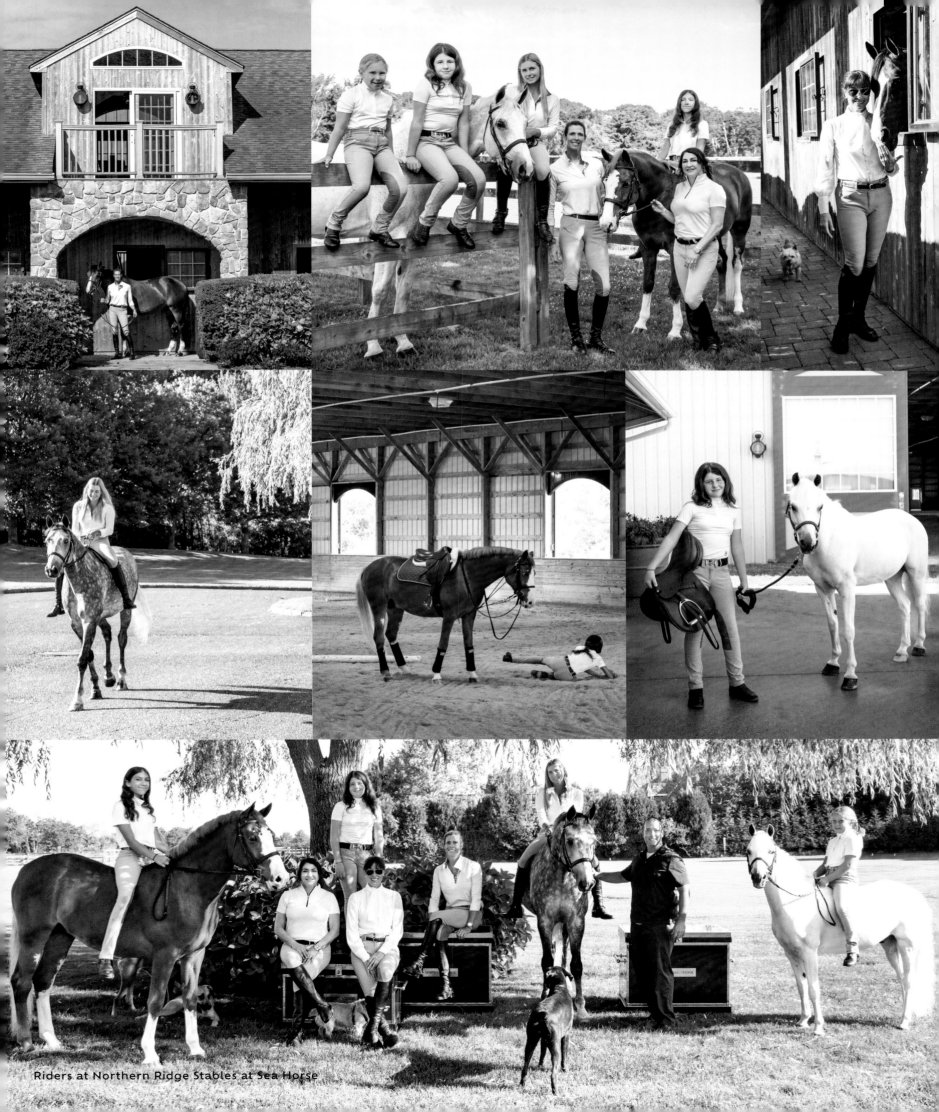

Riders at Northern Ridge Stables at Sea Horse

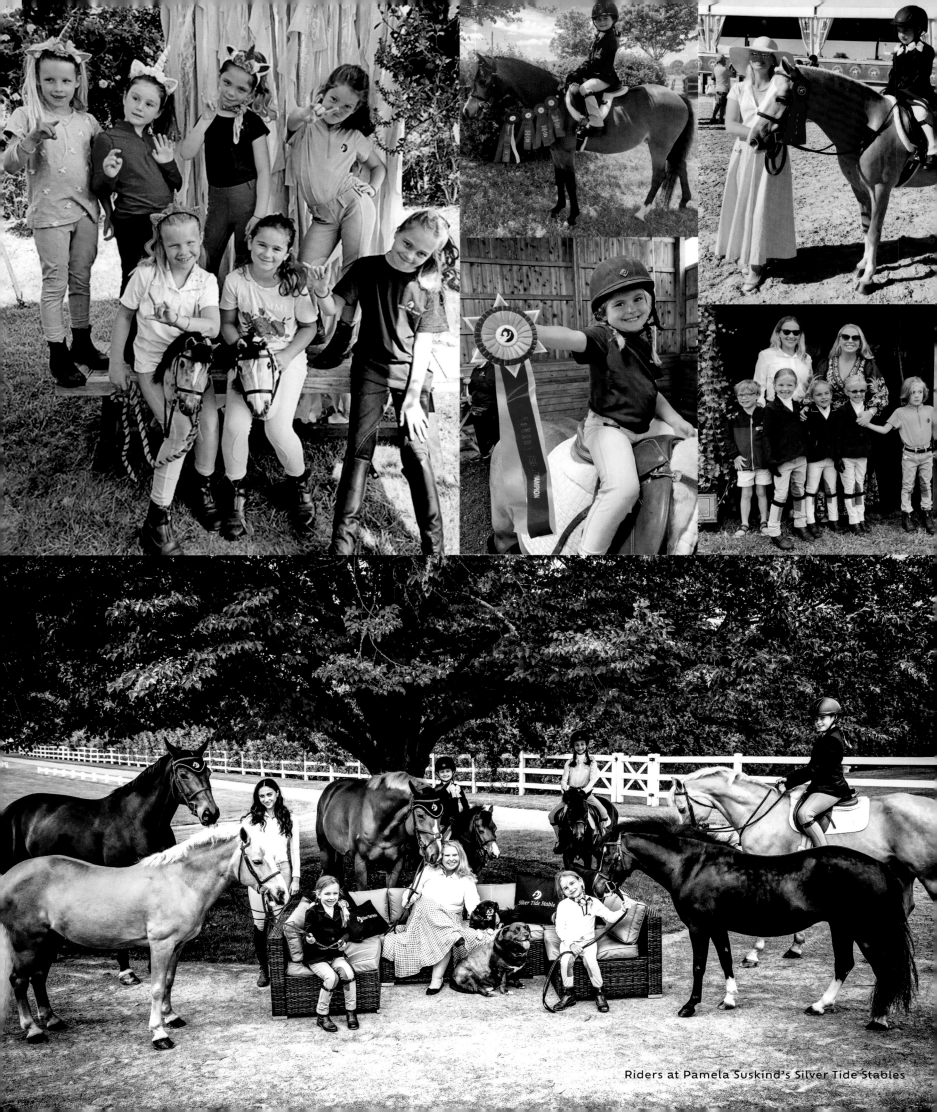

Riders at Pamela Suskind's Silver Tide Stables

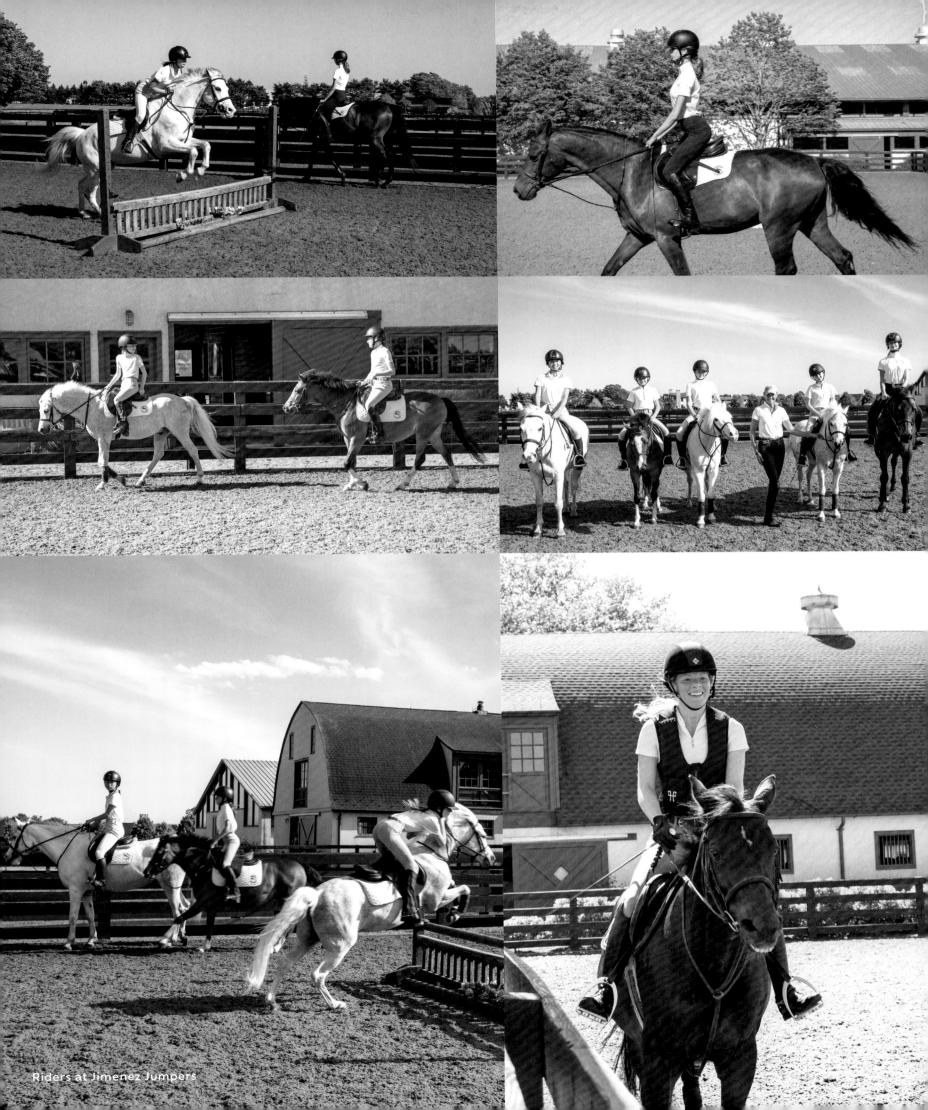

Riders at Jimenez Jumpers

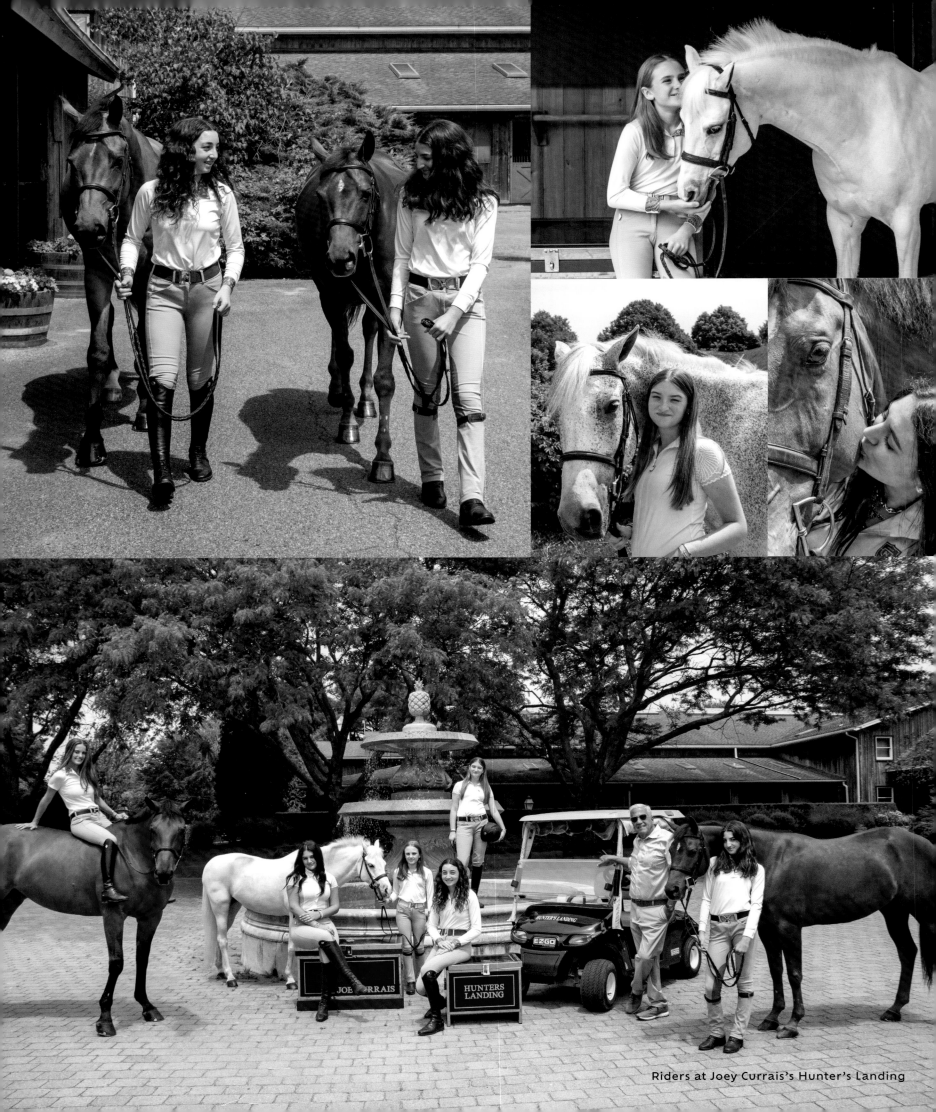

Riders at Joey Currais's Hunter's Landing

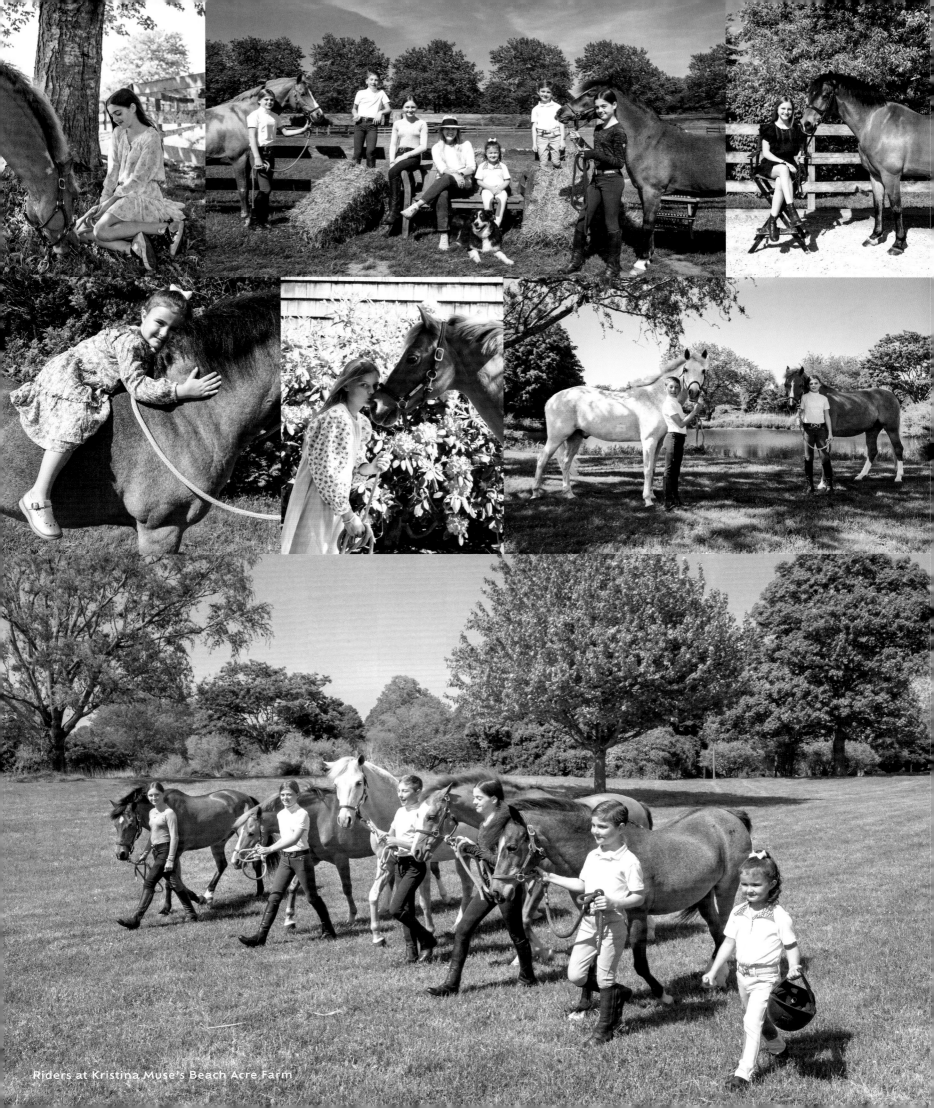

Riders at Kristina Muse's Beach Acre Farm

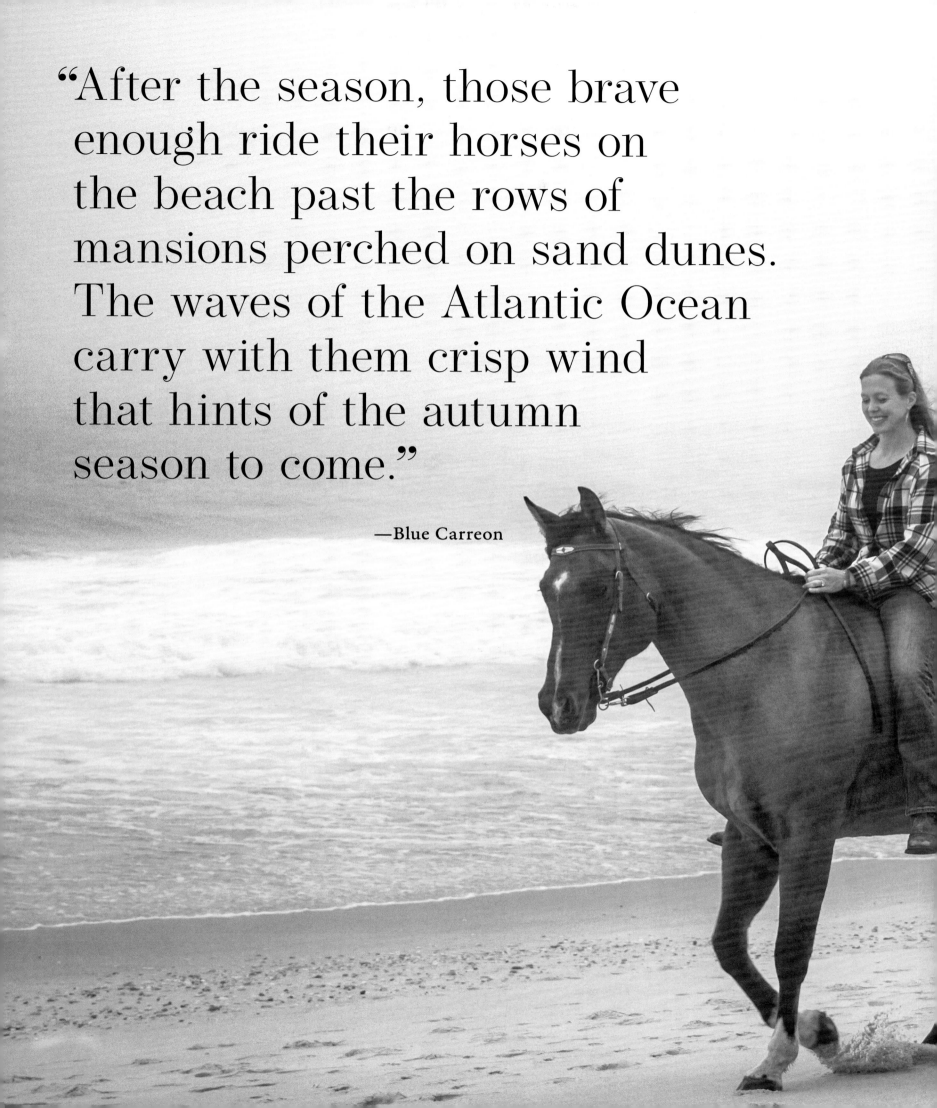

"After the season, those brave enough ride their horses on the beach past the rows of mansions perched on sand dunes. The waves of the Atlantic Ocean carry with them crisp wind that hints of the autumn season to come."

—Blue Carreon

Clockwise from top left: Lisa Weiss; Alexandra Worthington; Brogan Zipper; Laura Hayward

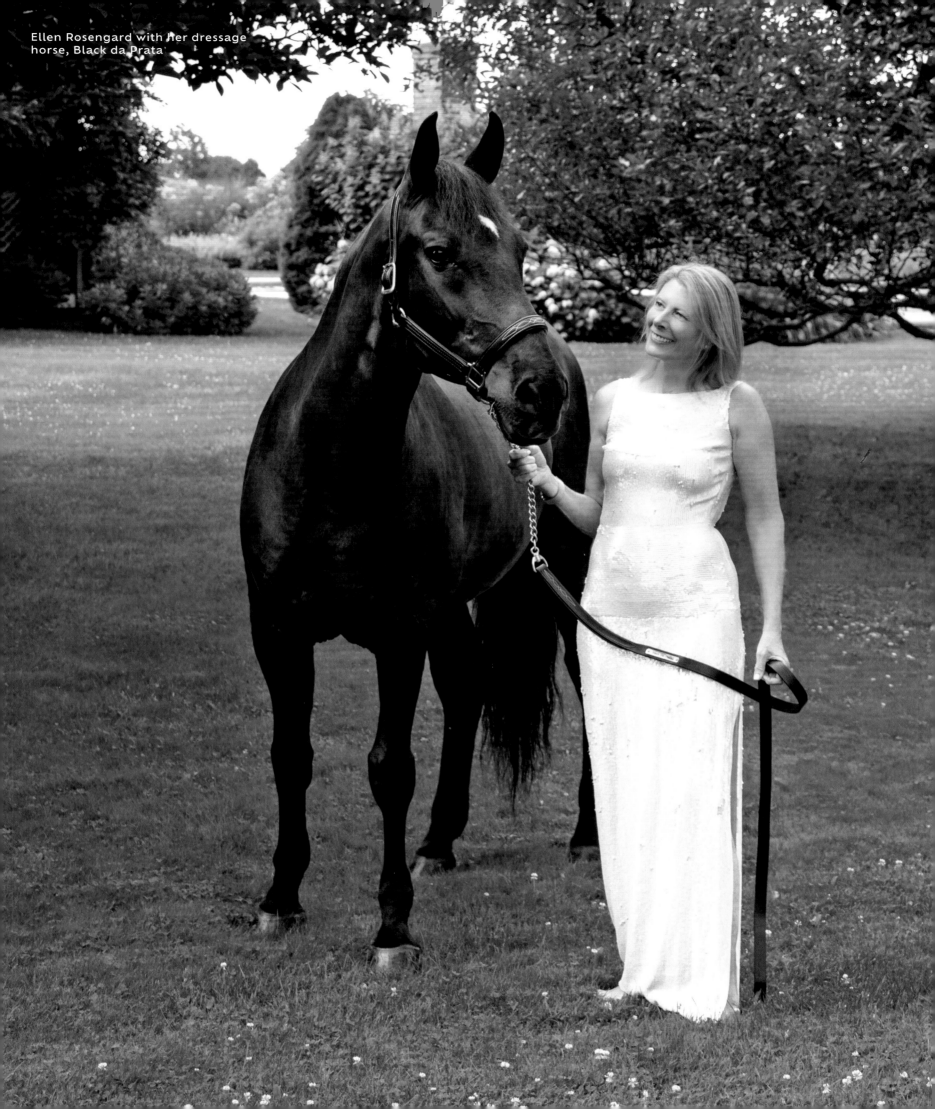

Ellen Rosengard with her dressage
horse, Black da Prata

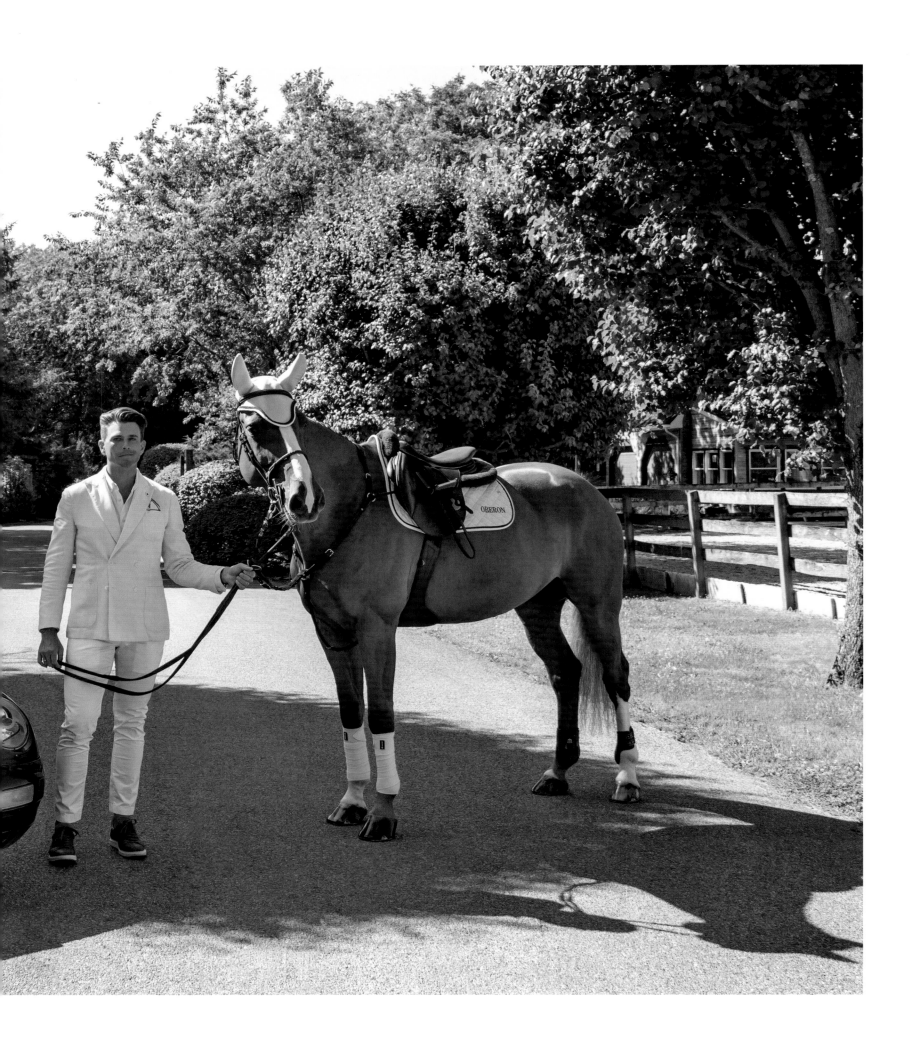

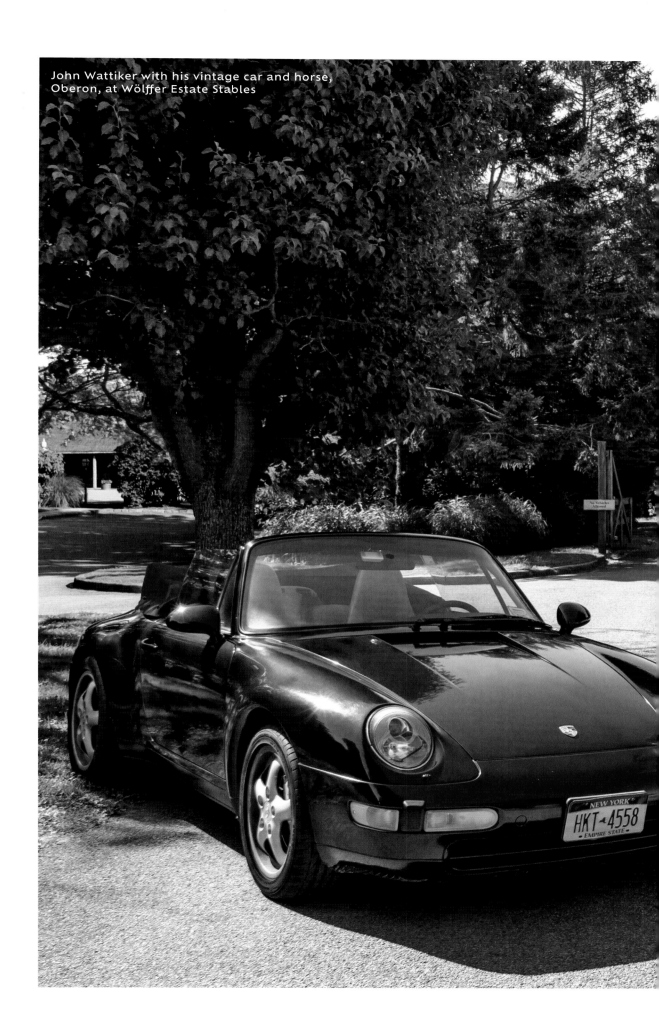

John Wattiker with his vintage car and horse, Oberon, at Wölffer Estate Stables

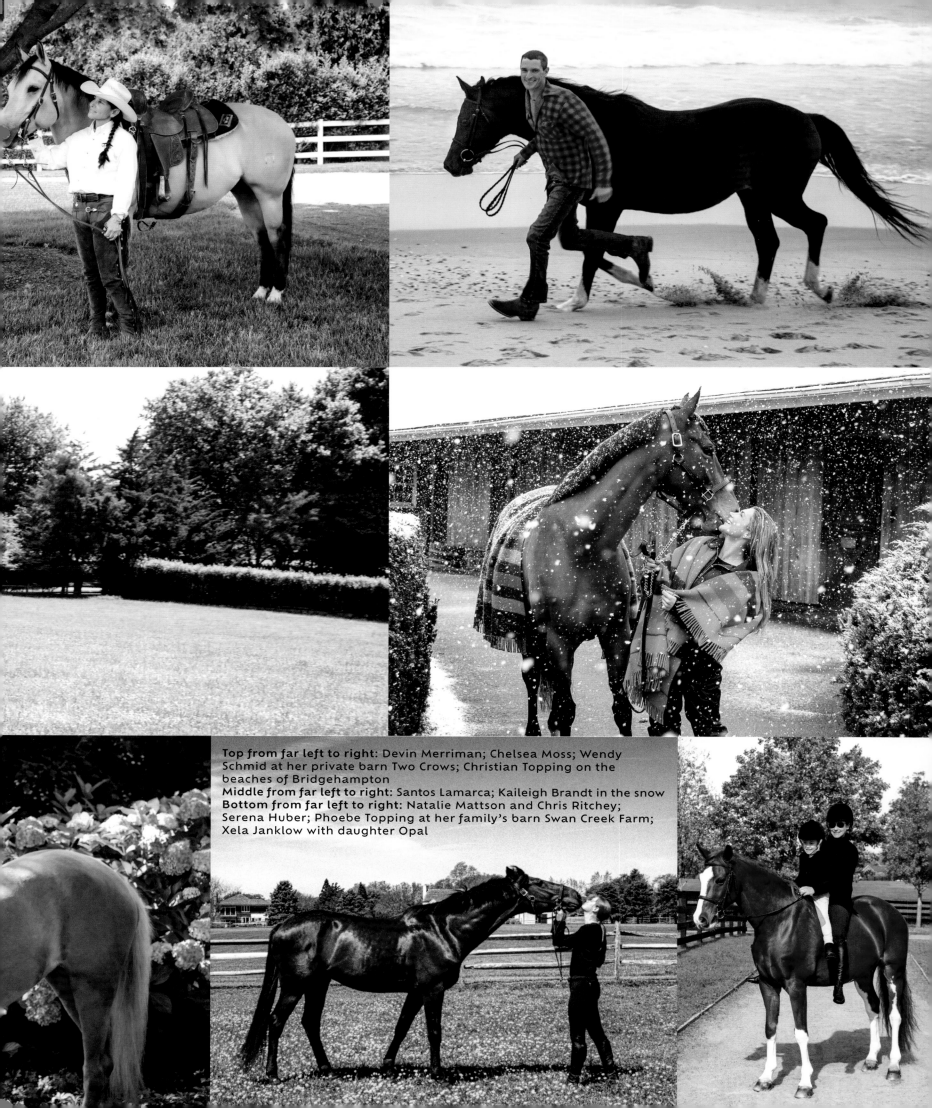

Top from far left to right: Devin Merriman; Chelsea Moss; Wendy Schmid at her private barn Two Crows; Christian Topping on the beaches of Bridgehampton
Middle from far left to right: Santos Lamarca; Kaileigh Brandt in the snow
Bottom from far left to right: Natalie Mattson and Chris Ritchey; Serena Huber; Phoebe Topping at her family's barn Swan Creek Farm; Xela Janklow with daughter Opal

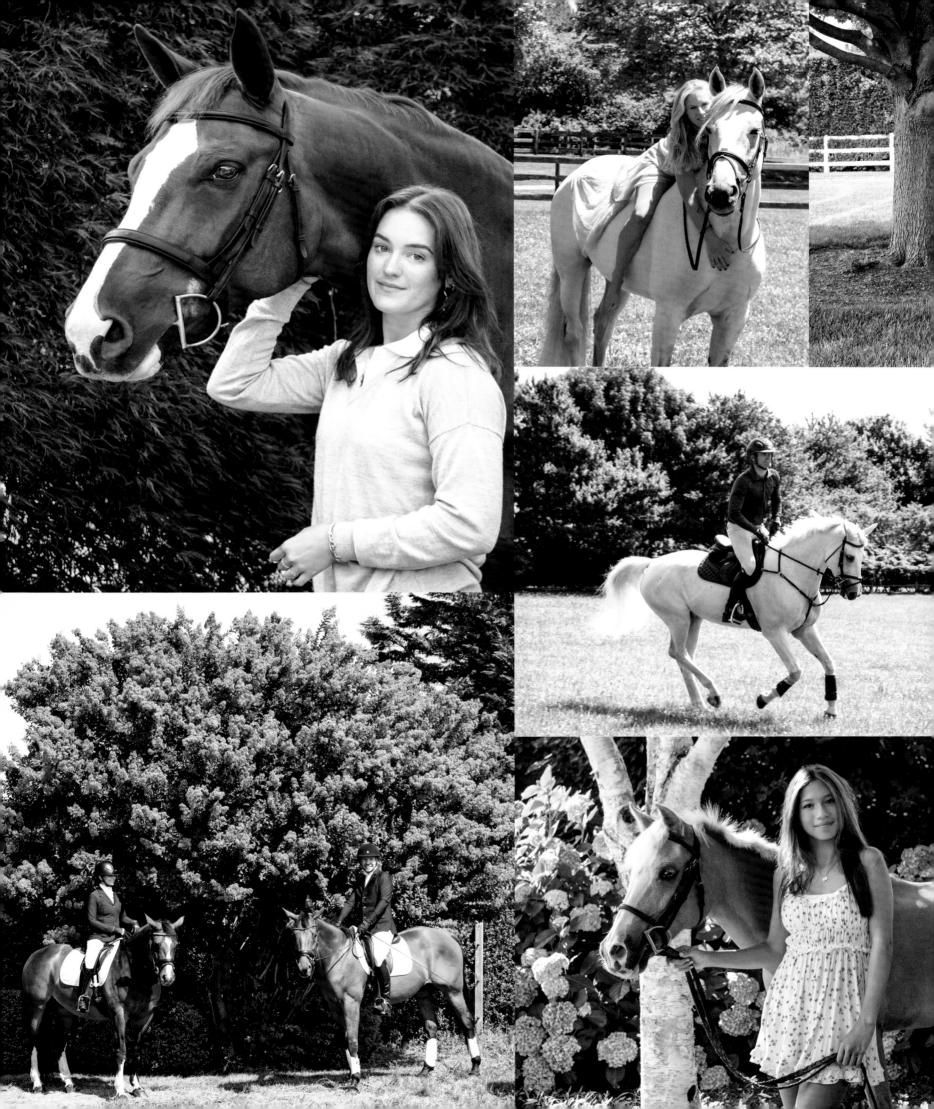

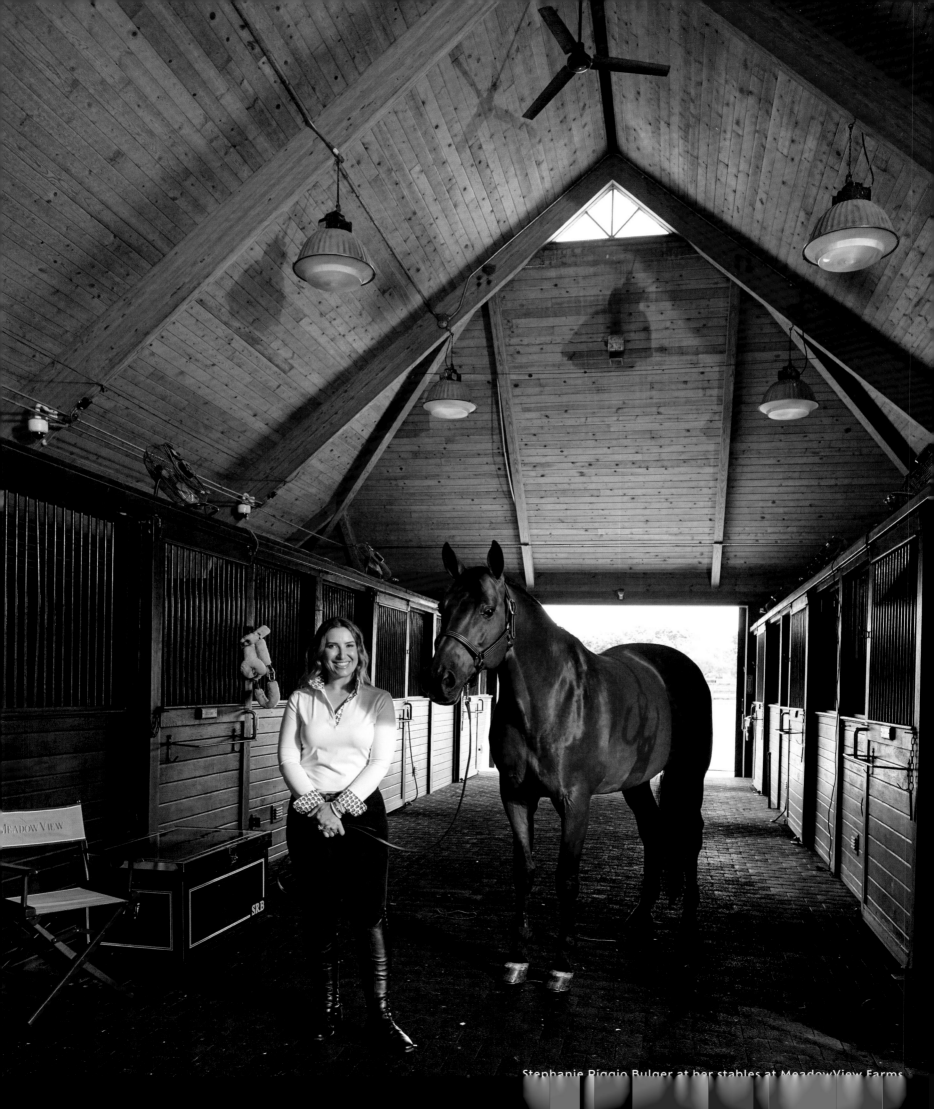

Stephanie Riggio Bulger at her stables at MeadowView Farms

and eager to get on their ponies and enter horse shows. In high summer, just as the famous Long Island corn is ready for picking and the vineyards that dot Southampton, Bridgehampton, and Sagaponack are glorious and abundant with globes of grapes, those who follow the show circuit start making their way to the Hamptons to acclimatize their horses to the heat and the surroundings in preparation for the Hampton Classic.

There are various kinds of riders in the Hamptons, but the hunters and jumpers, however, make up most of the equestrian population. Those who brave jumps and water hurdles and try to defy gravity while on leaping 1,200-pound animals. They are anywhere from novice riders making their way through ground poles to experienced amateurs going over jumps three-and-a-half feet high to Grand Prix show jumpers who love the big fences and the even bigger arenas. There are small children who are just learning to count their strides; teenagers who manage to find a balance between their schoolwork and the rigours of training and competing alongside other extracurricular activities like tennis or swimming; and adults who enjoy the exhilaration of competition. There are recreational senior riders who were competitive in their youth. And, of course, the professionals who foster among riders a love for the sport and the discipline it requires to thrive. Of equal significance, too, are the leisure riders at their home barns, content to canter along and pop over the occasional jump or two.

Juan Patricio Villanova

Getting on the Saddle

Riders and the Horse-Sporting Life

The horse riders of the Hamptons fall into two distinct categories: the year-round residents who get on their horses in all four seasons, and the sun chasers who follow the show circuit, migrating to the sunnier climes of Florida or the West Coast with their horses come fall.

Hamptonites who stay in their hamlets throughout the year—and more and more people are becoming full-time residents—get to revel in riding their horses as the seasons and the landscape change. The long summer days give way to the cool hints of fall. Beach restrictions are lifted and if they are brave, riders can trailer their horses to the beach for a canter along the dunes, past sprawling beach mansions that have been closed for the colder months. In the winter, snow blankets the paddocks and the show arenas. Occasionally, when the weather is not too frigid or the ground too frozen, riders may be able to

take their horses outside for trail ride. But most of the time it is in the indoor rings where the action happens. In the spring, pathways are blooming with flowering trees, with yellow and white daffodils underfoot. Horse paddocks turn into fields of gold as the grass makes way for dandelions and buttercups. Horses shed their winter blankets and the slow march to summer begins.

Those who left during the winter season begin their trot back to the Hamptons when the ground starts to thaw, and the bright golden blossoms of forsythia bushes become a ubiquitous sight. The arrivals come in waves. Manhattan dwellers start making the weekend trips back to their Hamptons cottages around Easter and would get into the routine of riding their horses weekly. Returning residents and their horses arrive just before Memorial Day, the beginning of the season, followed by students starting their summer breaks

Justine Ryan

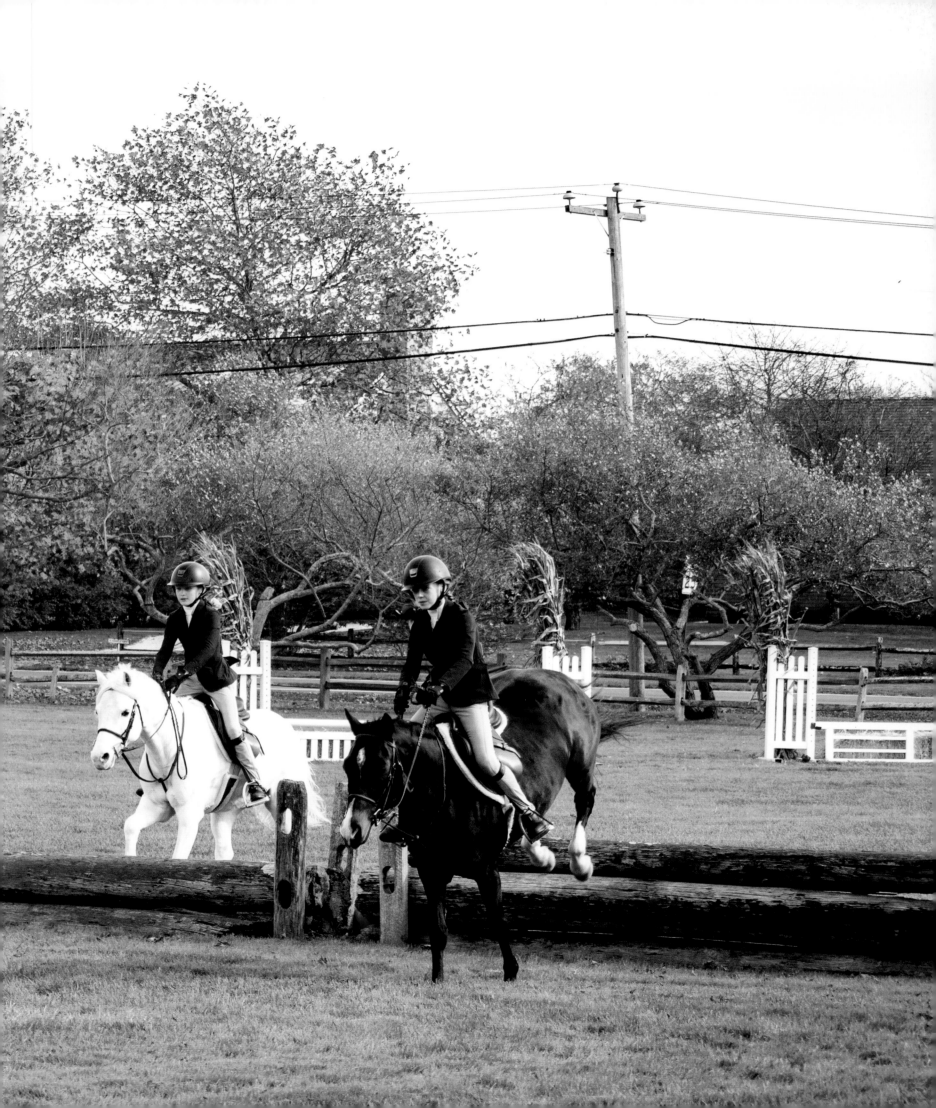

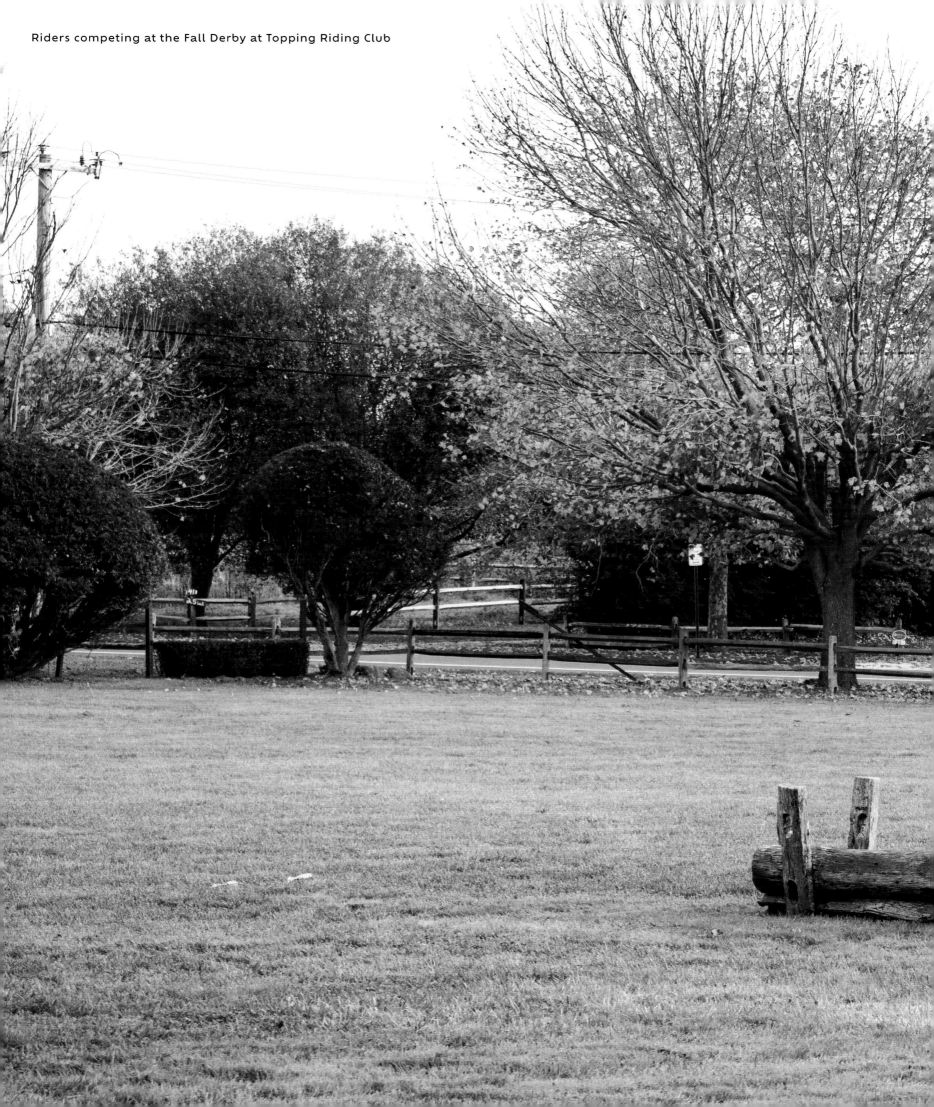

Riders competing at the Fall Derby at Topping Riding Club

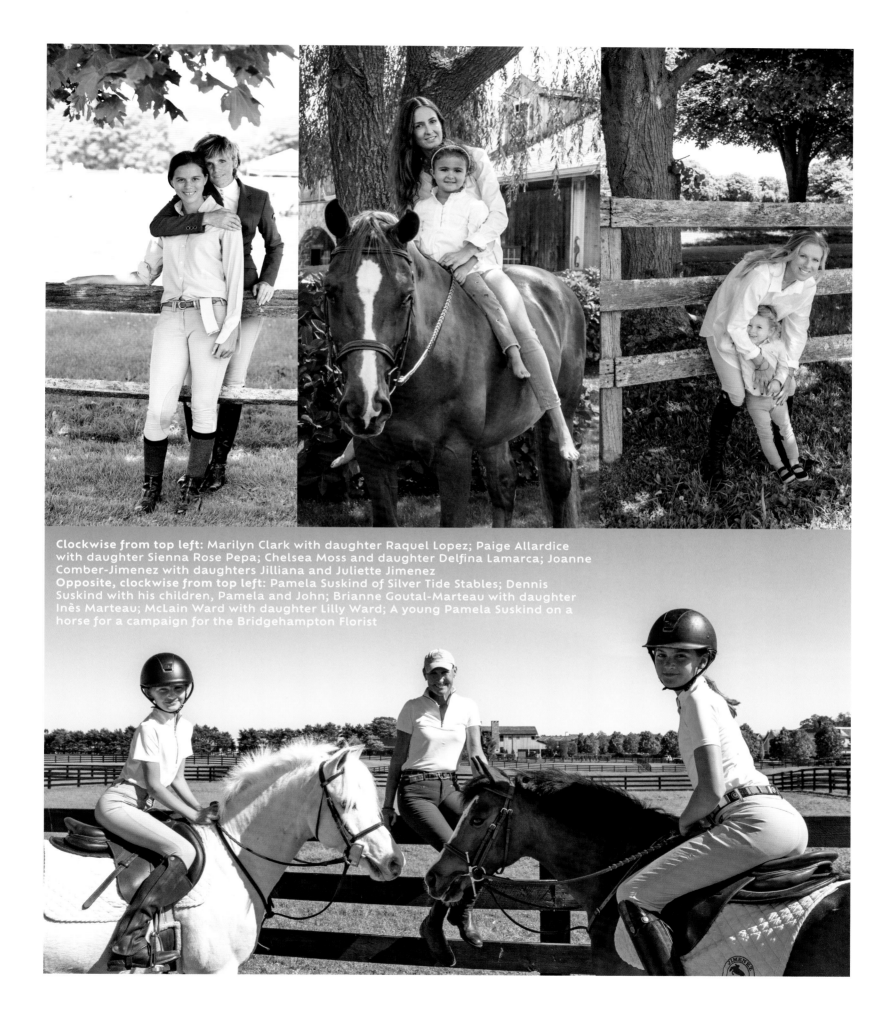

Clockwise from top left: Marilyn Clark with daughter Raquel Lopez; Paige Allardice with daughter Sienna Rose Pepa; Chelsea Moss and daughter Delfina Lamarca; Joanne Comber-Jimenez with daughters Jilliana and Juliette Jimenez
Opposite, clockwise from top left: Pamela Suskind of Silver Tide Stables; Dennis Suskind with his children, Pamela and John; Brianne Goutal-Marteau with daughter Inès Marteau; McLain Ward with daughter Lilly Ward; A young Pamela Suskind on a horse for a campaign for the Bridgehampton Florist

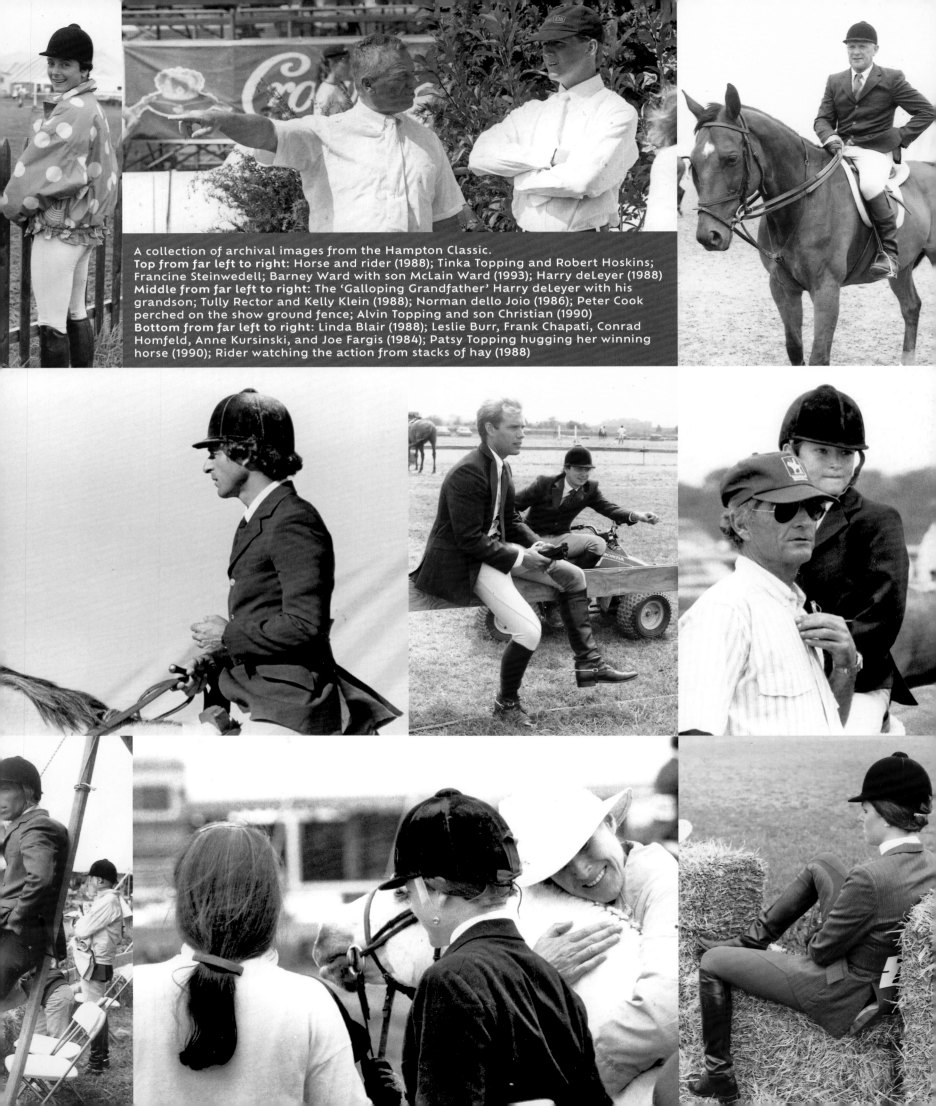

A collection of archival images from the Hampton Classic.
Top from far left to right: Horse and rider (1988); Tinka Topping and Robert Hoskins; Francine Steinwedell; Barney Ward with son McLain Ward (1993); Harry deLeyer (1988)
Middle from far left to right: The 'Galloping Grandfather' Harry deLeyer with his grandson; Tully Rector and Kelly Klein (1988); Norman dello Joio (1986); Peter Cook perched on the show ground fence; Alvin Topping and son Christian (1990)
Bottom from far left to right: Linda Blair (1988); Leslie Burr, Frank Chapati, Conrad Homfeld, Anne Kursinski, and Joe Fargis (1984); Patsy Topping hugging her winning horse (1990); Rider watching the action from stacks of hay (1988)

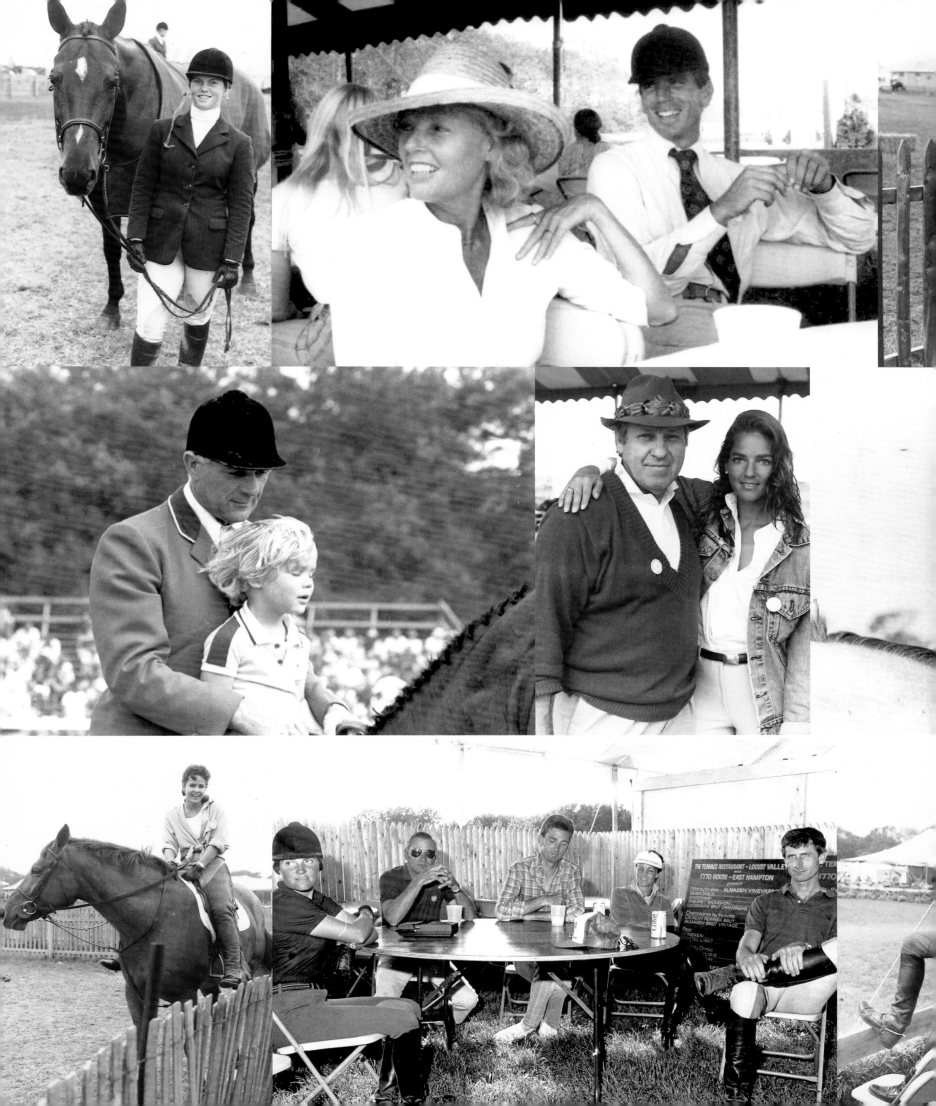

"I remember I was scared of everything, but I wasn't scared of horses. I was really timid and shy. The horses gave me this incredible confidence that I didn't have anywhere else in my life. When I'm on a horse is when I'm happiest."

—Joey Wölffer

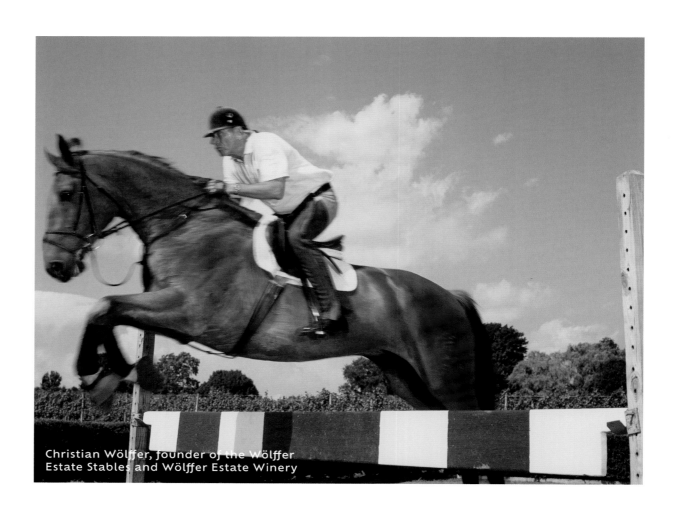

Christian Wölffer, founder of the Wölffer Estate Stables and Wölffer Estate Winery

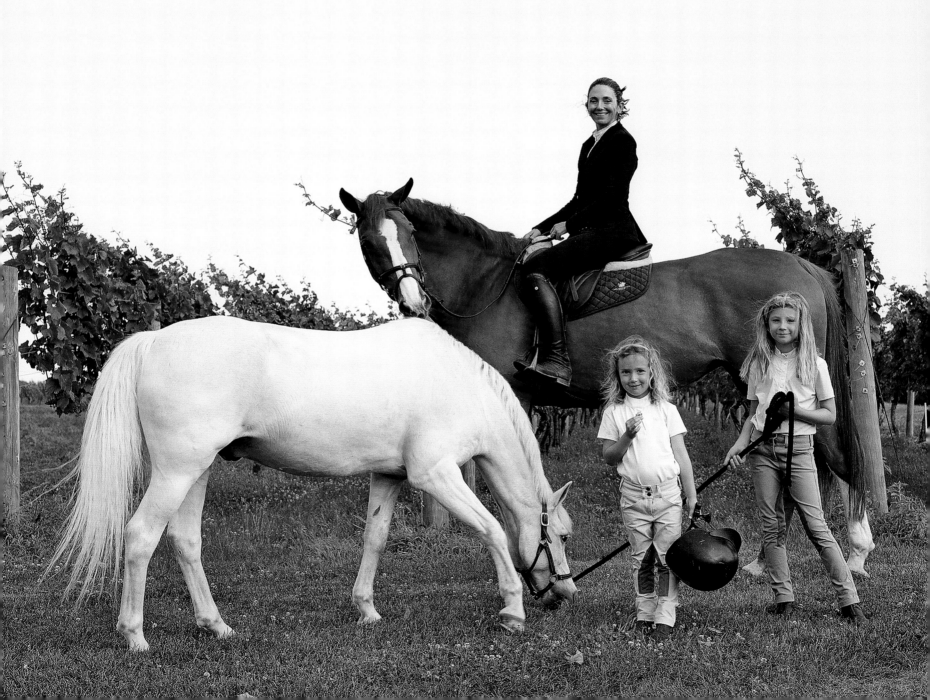

Joey Wölffer with her daughters, Evie and Nell, at the adjacent vineyard at Wölffer Estate Stables

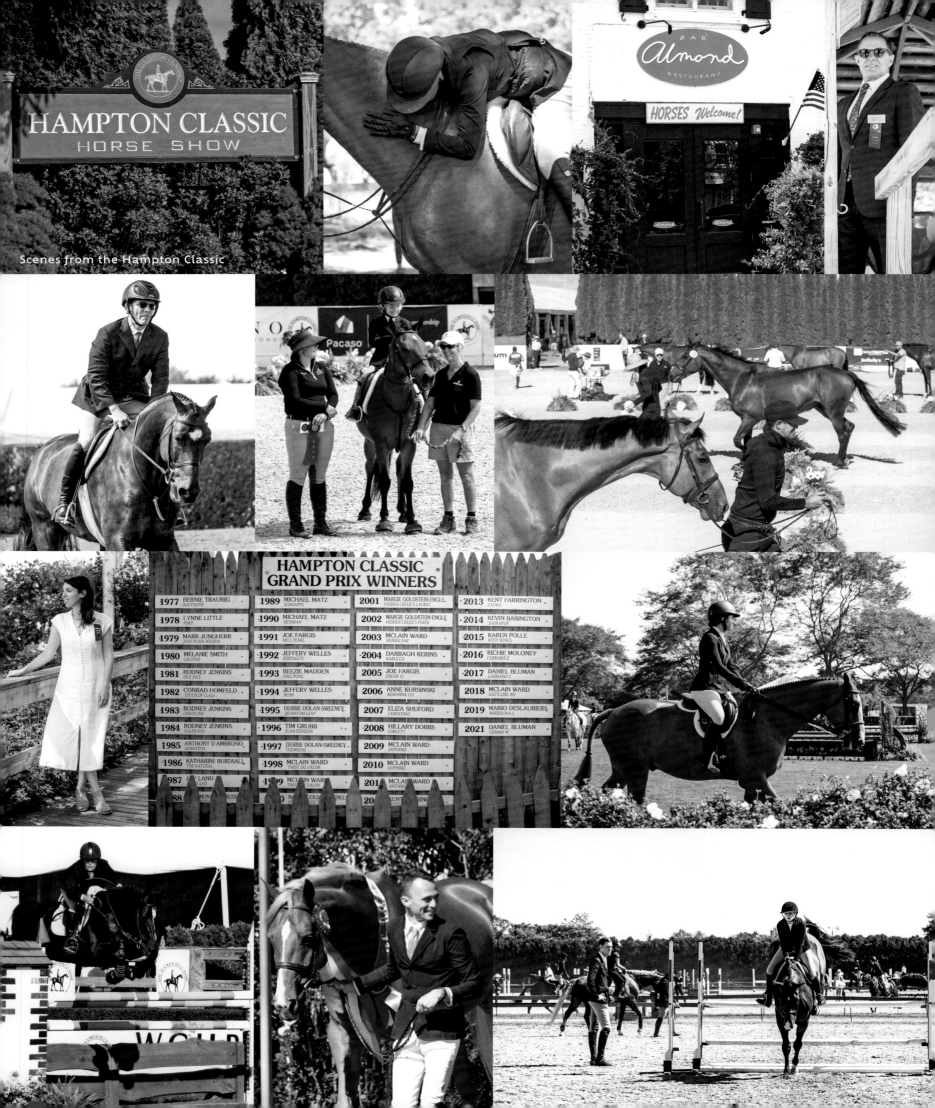

Scenes from the Hampton Classic

HAMPTON CLASSIC GRAND PRIX WINNERS

Year	Winner	Horse	Year	Winner	Horse	Year	Winner	Horse	Year	Winner	Horse
1977	BERNIE TRAURIG	SOUTHSIDE	1989	MICHAEL MATZ	SCHNAPPS	2001	MARGIE GOLDSTEIN-ENGLE	HIDDEN CREEK'S LAUREL	2013	KENT FARRINGTON	ZAFIRA
1978	LYNNE LITTLE	PORT	1990	MICHAEL MATZ	HEISMAN	2002	MARGIE GOLDSTEIN-ENGLE	HIDDEN CREEK'S PERIN	2014	KEVIN BABINGTON	SHORAPUR
1979	MARK JUNGHERR	JUST PLAIN WILBUR	1991	JOE FARGIS	MILL PEARL	2003	MCLAIN WARD	HURRICANE	2015	KAREN POLLE	WITH WINGS
1980	MELANIE SMITH	CALYPSO	1992	JEFFERY WELLES	SERENGETI	2004	DARRAGH KERINS	NABUCO	2016	RICHIE MOLONEY	CARRABIS Z
1981	RODNEY JENKINS	IDLE DICE	1993	BEEZIE MADDEN	PING PONG	2005	JOE FARGIS	EDGAR 12	2017	DANIEL BLUMAN	LADRIANO Z
1982	CONRAD HOMFELD	TOUCH OF CLASS	1994	JEFFERY WELLES	IRISH	2006	ANNE KURSINSKI	ROXANNA 112	2018	MCLAIN WARD	GIGI'S GIRL BH
1983	RODNEY JENKINS	COASTLINE	1995	DEBBIE DOLAN-SWEENEY	QUANTUM LEAP	2007	ELIZA SHUFORD	LARENTINO	2019	MARIO DESLAURIERS	BARDOLINA 2
1984	RODNEY JENKINS	SUGAR RAY	1996	TIM GRUBB	ELAN DENIZEN	2008	HILLARY DOBBS	CORLETT	2021	DANIEL BLUMAN	GEMMA W
1985	ANTHONY D'AMBROSIO	NIMMEDOR	1997	DEBBIE DOLAN-SWEENEY	ITZIWEENI	2009	MCLAIN WARD	SAPPHIRE			
1986	KATHARINE BURDSALL	THE NATURAL	1998	MCLAIN WARD	TWIST DU VALON	2010	MCLAIN WARD	SAPPHIRE			
1987	JEFF LAND	LY LAD	1999	MCLAIN WARD	ANTARES	2011	MCLAIN WARD	ANTARES			
1988			2000	MARGIE GOLDSTEIN-ENGLE		2012	KENT FARRINGTON				

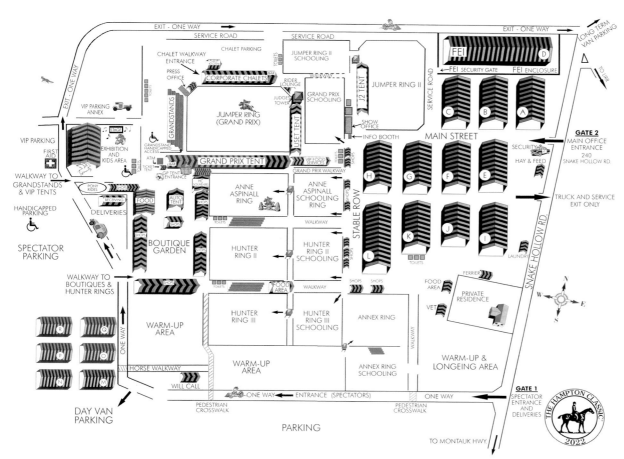

Above: The expanded grounds of the Hampton Classic at its present location in Bridgehampton
Below: An aerial view of the Hampton Classic showgrounds

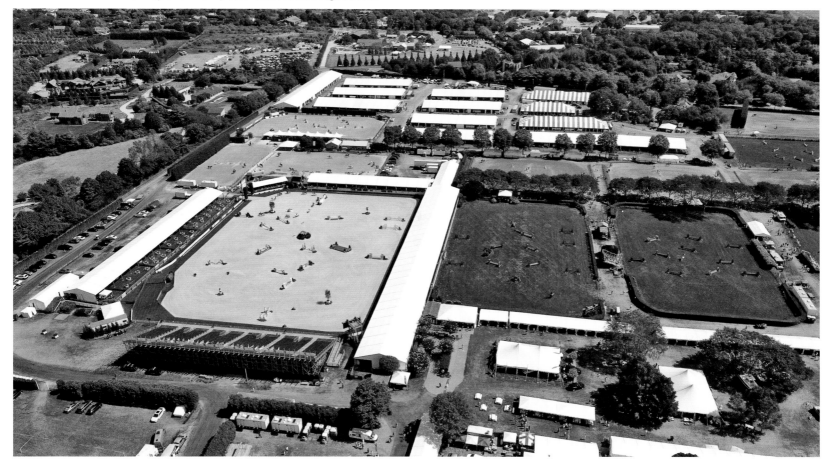

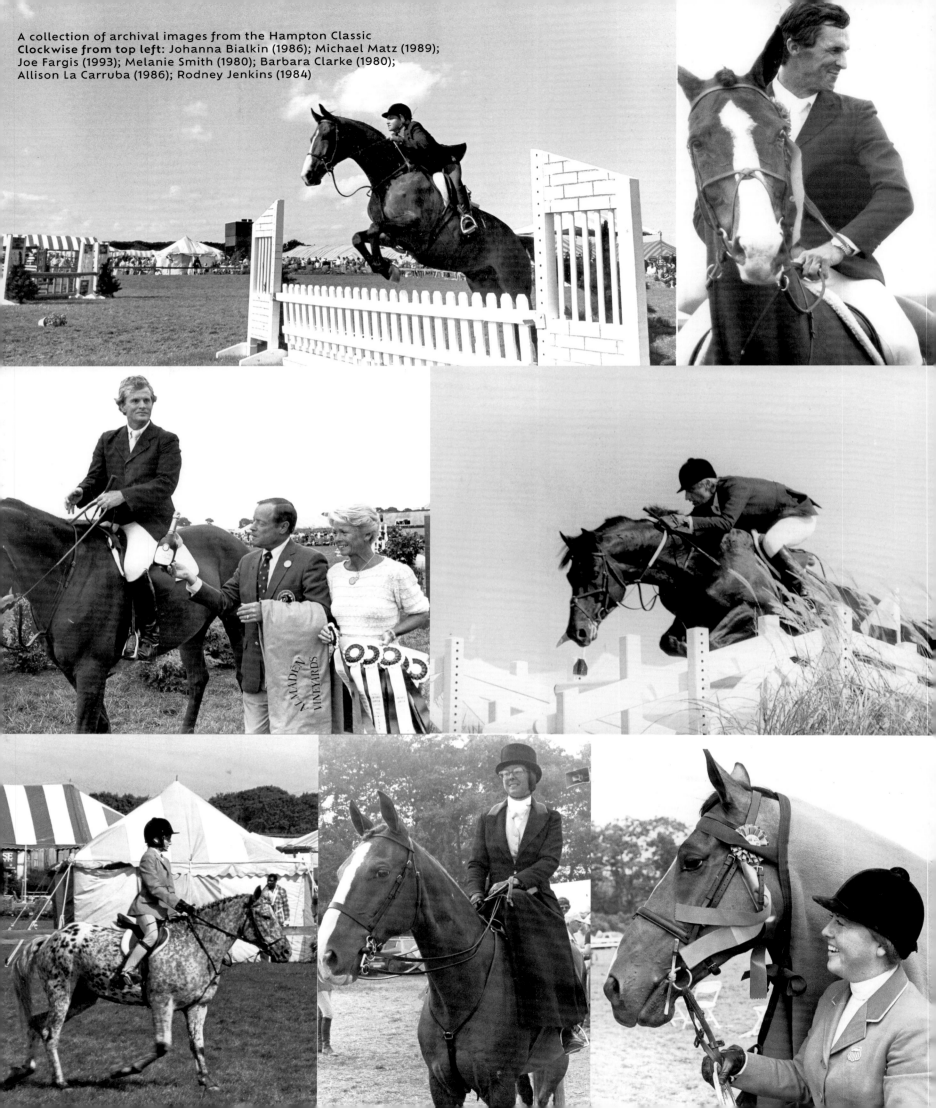

A collection of archival images from the Hampton Classic
Clockwise from top left: Johanna Bialkin (1986); Michael Matz (1989);
Joe Fargis (1993); Melanie Smith (1980); Barbara Clarke (1980);
Allison La Carruba (1986); Rodney Jenkins (1984)

"Michael Matz's Grand Prix win in 1989 was thrilling if for no other reason than he had just a week before survived a plane crash in an Iowa corn field."

—Jack Graves, Sports editor for the *East Hampton Star*

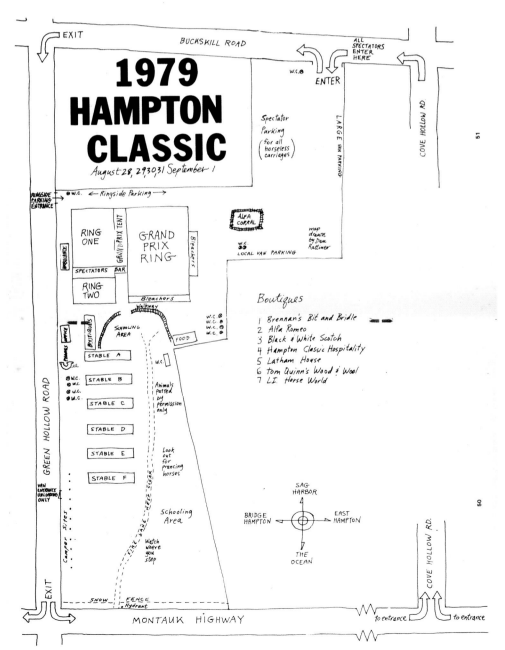

Grounds map of the Hampton Classic during its early years at Dune Alpin in East Hampton

At the suggestion of philanthropist, heiress to the Schlumberger oil fortune and horse enthusiast Marie-Christophe de Menil, the show was expanded from a one-day local show to a nationwide five-day A-rated event, attracting riders from all over the United States much like the shows in the 1930s. Thus, began the modern-day incarnation of the Hampton Classic. "My daughter was riding, and I thought it would be great to have a show here where so many of us were already based and I didn't have to travel to see her compete. Besides, it promised to be fun, and I believe in fun," de Menil told the *New York Times* on July 23, 1989.

But it wasn't until 1976 that the Southampton Horse Show would be given its new name. "We chose the Hampton Classic name to help bring the two communities together," said Tinka Topping to the *East Hampton Star* on September 7, 1978. The first venue was at Dune Alpin Road in East Hampton where rings and striped tents were set up for horses and riders. There was also a small boutique garden (a precursor to a much larger current boutique garden boasting the likes of Gucci, Calvin Klein, and Hermès as marquee vendors). Deborah Brennan Thayer's family at that time still owned Brennan's Bit & Bridle and she recalls being one of the six stores in the boutique garden. "We brought a two-seat wagon and set it up as a store. My mom was in charge, and my sister and I would help out while waiting for our classes at the show."

On the night before the 1977 show, the area was hit by a hurricane and the horses had to be evacuated and sheltered in local barns.

Since then, unforeseen weather would become intertwined with the Hampton Classic, including most recently in 2021 when the tents had to be dismantled a couple of days prior to the opening because of a hurricane. In 2020, the Hampton Classic was not held because of the pandemic. The first time it was cancelled since its inception.

The Hampton Classic moved to its current sixty-acre location in Bridgehampton in 1982. "It's like an instant city has sprung up on a potato field," remarked Tinka Topping to the *New York Times* in an article published August 28, 1983. Tinka is also described as being responsible for turning what was a local horse show into a major competition. Agneta Currey, a horse enthusiast and the head of the Flower Committee of the Hampton Classic made the showgrounds beautiful.

The Hampton Classic would add to the allure and gloss of the Hamptons, further cementing the reputation of affluence and glamor for this part of Long Island. It would also transform the horse show as a venue to watch society members at play, as well as an arena that would feature elite athletes of Olympic caliber, and horses of extraordinary value and capabilities.

From 1982 to the present day, the Hampton Classic has become a stage for triumphal stories, hair-raising derring-dos, *force majeure* dramas, death-defying escapes, and, of course, soaring glories that warrant a victory lap as spectators stand and cheer the victorious horse and rider. "This is the World Series," says Dennis Suskind, the current president of the Hampton Classic. "You come here to compete at the highest levels," he adds.

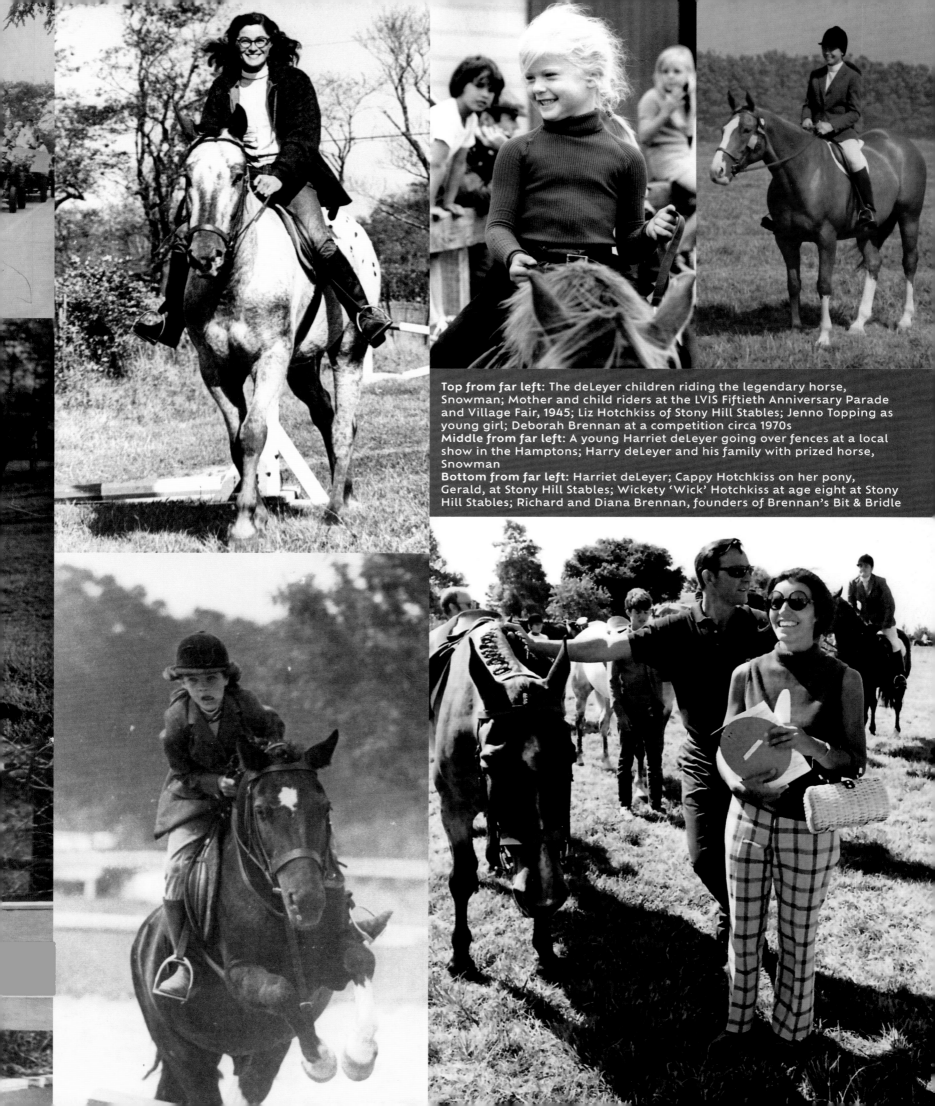

Top from far left: The deLeyer children riding the legendary horse, Snowman; Mother and child riders at the LVIS Fiftieth Anniversary Parade and Village Fair, 1945; Liz Hotchkiss of Stony Hill Stables; Jenno Topping as young girl; Deborah Brennan at a competition circa 1970s
Middle from far left: A young Harriet deLeyer going over fences at a local show in the Hamptons; Harry deLeyer and his family with prized horse, Snowman
Bottom from far left: Harriet deLeyer; Cappy Hotchkiss on her pony, Gerald, at Stony Hill Stables; Wickety 'Wick' Hotchkiss at age eight at Stony Hill Stables; Richard and Diana Brennan, founders of Brennan's Bit & Bridle

Gray horse, Escobar, amid the spring greens and florals at Wölffer Estate Stables

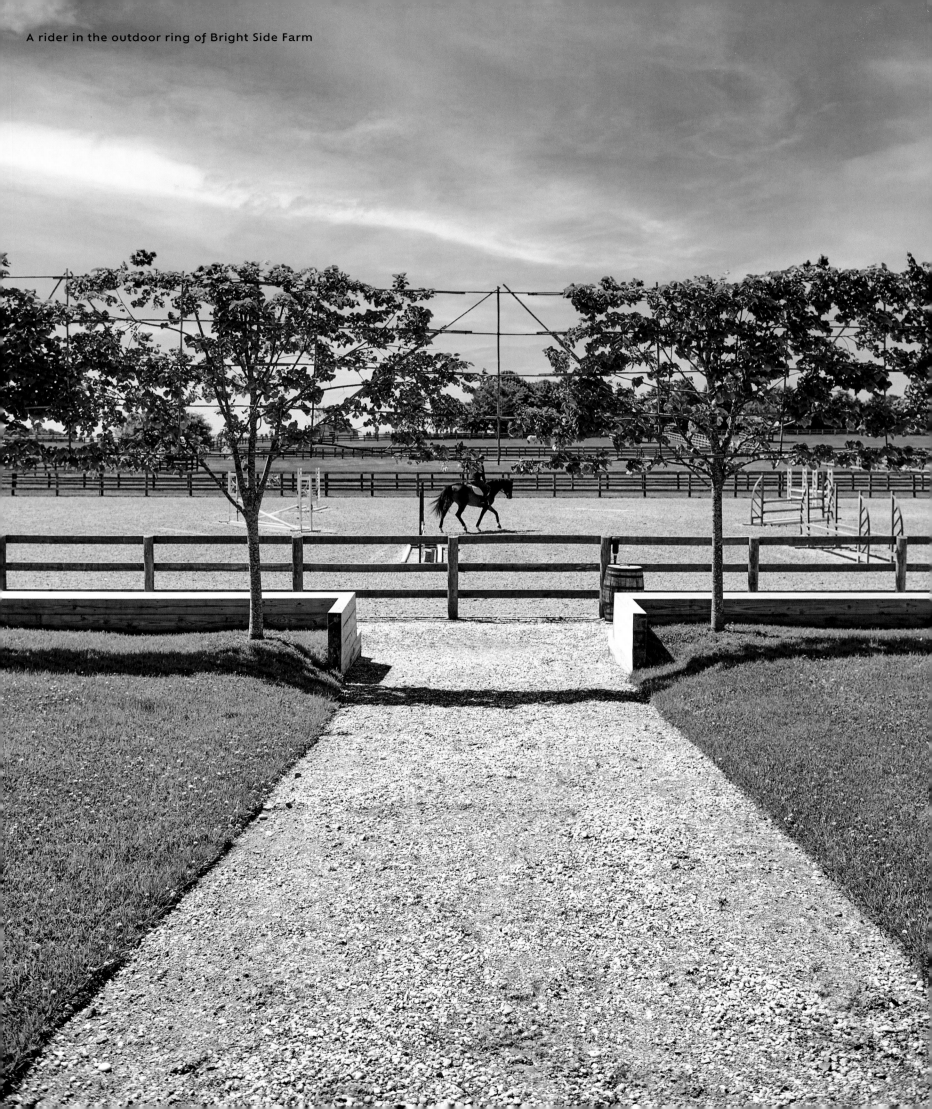

A rider in the outdoor ring of Bright Side Farm

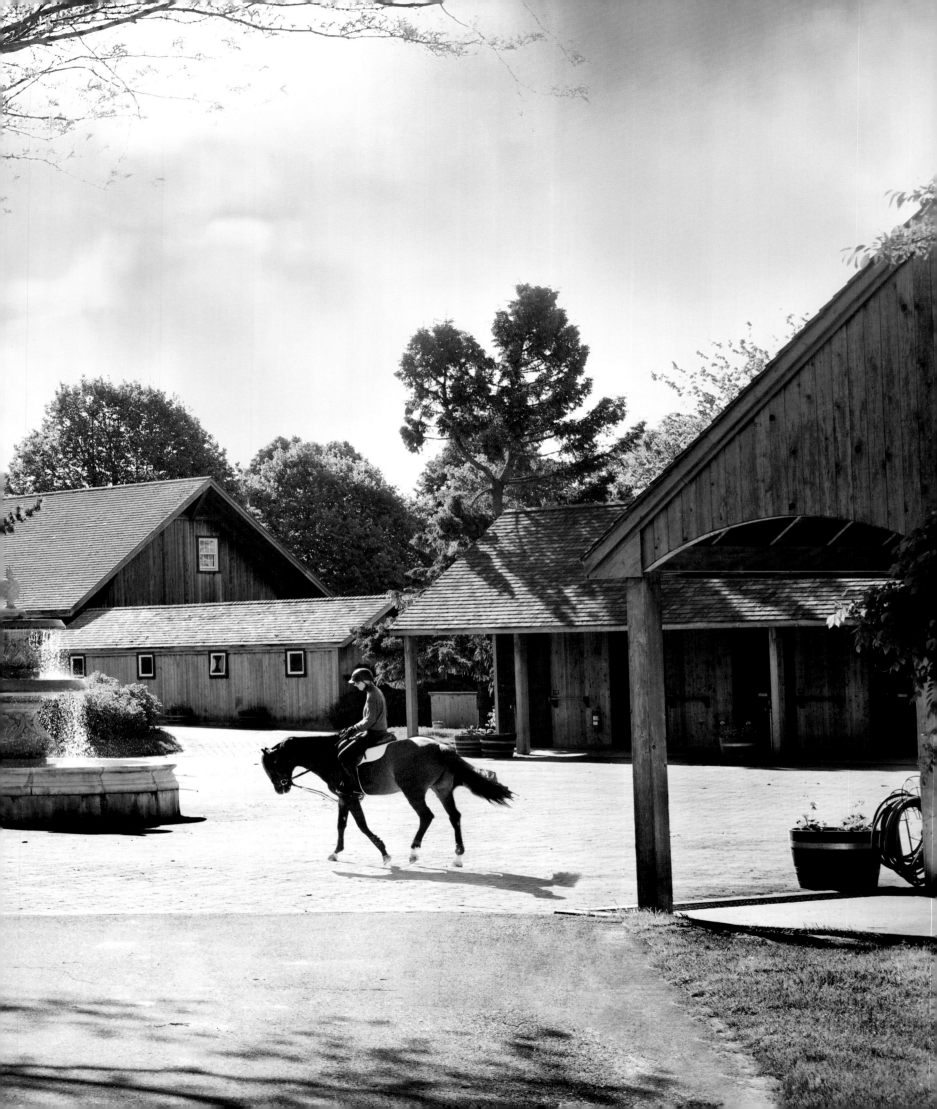

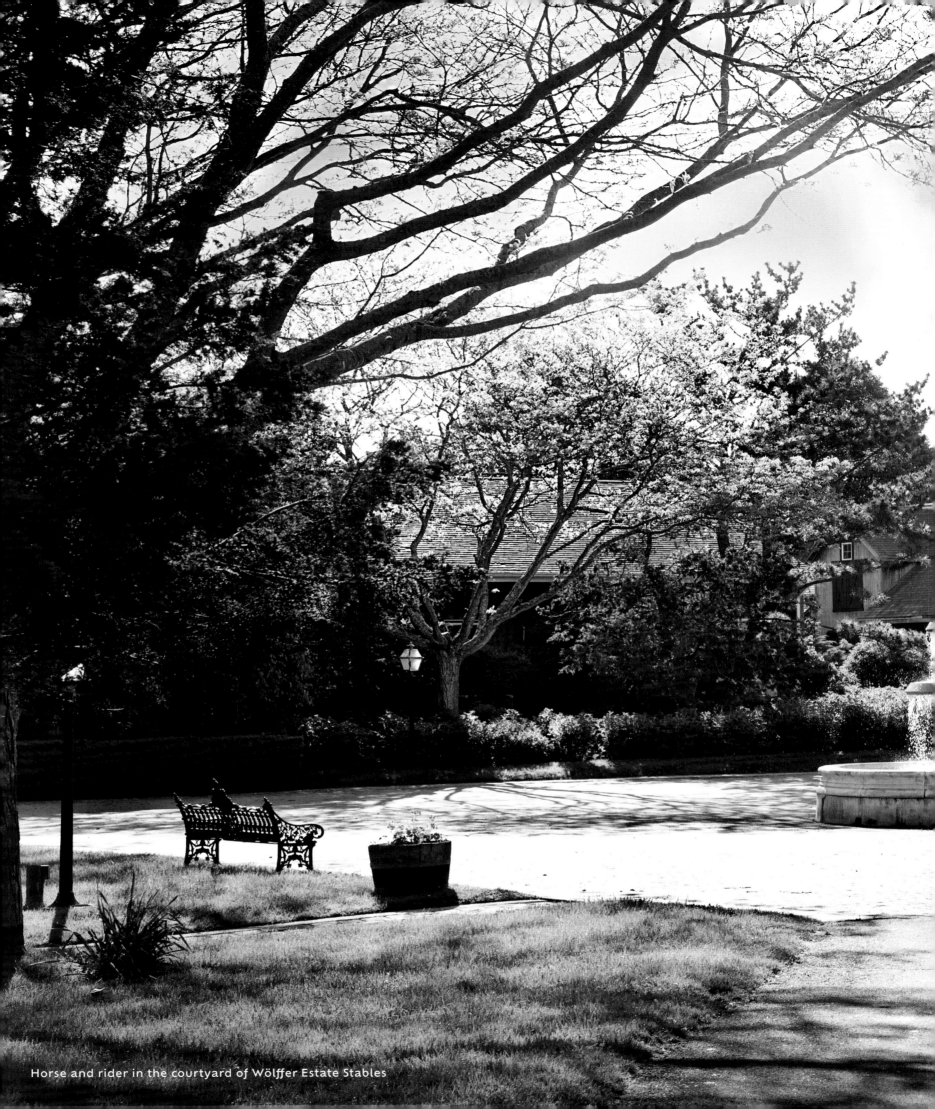

Horse and rider in the courtyard of Wölffer Estate Stables

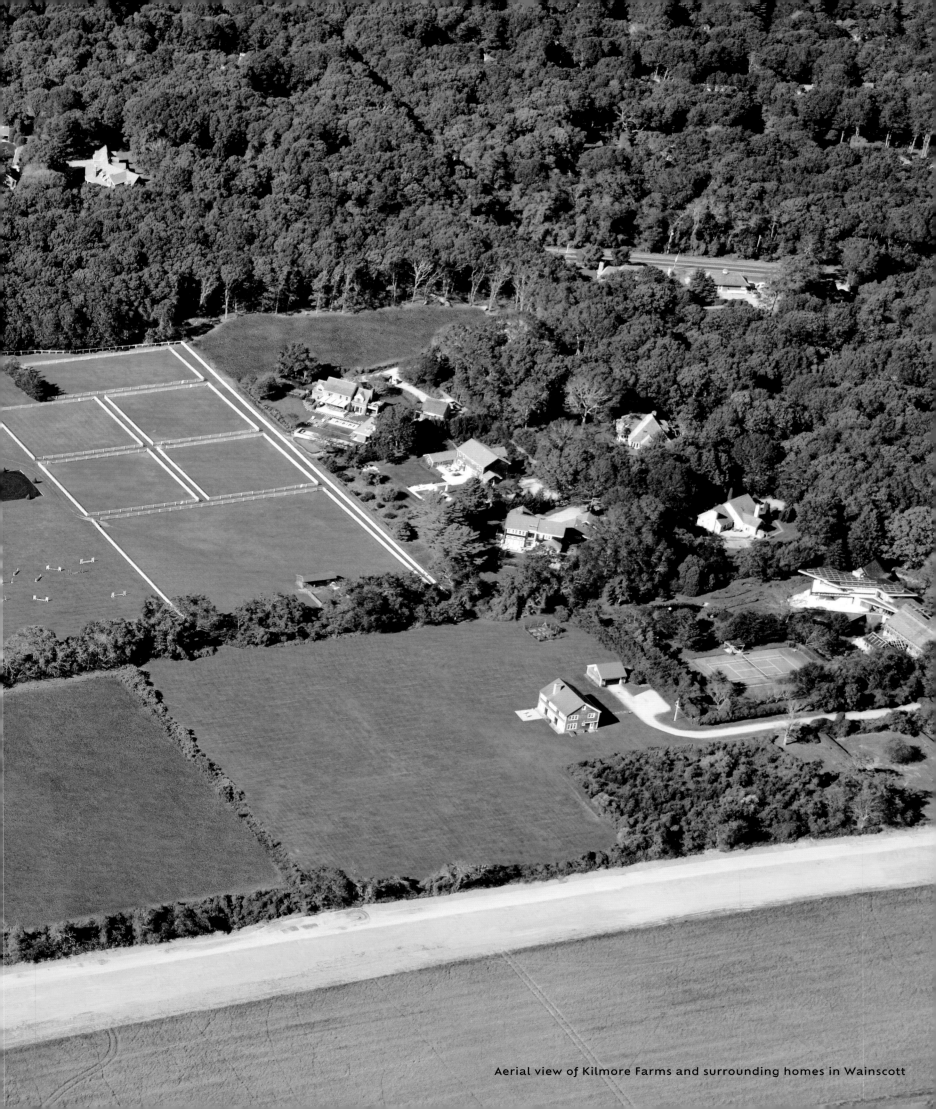

Aerial view of Kilmore Farms and surrounding homes in Wainscott

Introduction

A Love Affair with Horses in the Hamptons

During high summer, up and down this part of Long Island that is the Hamptons, it is not an unusual sight to see horses grazing or rolling around in paddocks surrounded by white fences along a back road. Or riders and their horses waiting for cars to slow down so they can continue their trail rides, past fields with adjacent farm stands selling fresh produce, and around grand estates shielded by soaring and immaculately clipped hedgerows.

The towns of the Hamptons are dotted with barns and stables, coexisting with the shingle-style mansions with sweeping lawns, and modernist beach houses with uninterrupted views of the dunes and ocean beyond. There are barns that are open to boarders and those looking for riding lessons. Some are private and exclusively for their owners' use, like Madonna's and the fashion photographer Steven Klein's, usually behind imposing gates or hidden from view by snaking driveways lined with hornbeams or crape myrtle trees.

Drive around and you may just happen upon a horse show not far from a stretch of beach in Sagaponack at the Topping Riding Club, one of the oldest riding clubs on Long Island. Join the throng of onlookers in their vintage convertible cars, classic station wagons, and open-air jeeps parked on the side of the road witnessing riders of all ages navigate jumping courses; riders—either jumpers or hunters—going over fences, hay bales, and barrels. Note the little boys with their show jackets and breeches and girls with their hair braided and tied with an array of colorful bows, all awaiting their turn to show their skills at trot and canter. See the horses lined up along the perimeter of the show ring with their manes and tails plaited to absolute perfection; their bodies

powerful, majestic, and regal. Their coats are shiny from the constant cleaning and brushing by devoted grooms who are experts at the rituals of horse care—essential members of a successful equestrian team.

On the weekends you may find yourself in your car crawling the length of Montauk Highway sandwiched between the Hampton Jitney and a trailer transporting prized horses, some of them coming home from out-of-town competitions where they and their riders were pinned blue ribbons. Others will be arriving from various parts of the United States or Europe to compete in the Grand Prix of the Hampton Classic where the courses are a test of a rider's dexterity and a mount's agility. The jumps are at once impressive and terrifying; where poise and experience triumph over tension and nerves. Olympic riders and elite athletes are not an uncommon sight at the Hampton Classic.

Should you happen to have a mansion in Bridgehampton, you may just find that your neighbors are hosting a polo match in their garden, unconcerned for the ravage horses' hooves will cause on their expensively maintained lawn. Polo players from the Hamptons, Manhattan, nearby Connecticut, or as far as Argentina

galloping in hair-raising speeds against a backdrop of hydrangeas and privet. Guests in all manner of summer dresses, seersucker suits, and linen ensembles clutching their glasses of rosé as horses and riders have near-collision encounters while mallets cross and tangle to score goals over six chukkers.

At the Wölffer Estate Vineyard, while you are enjoying its rosé wine with the charming name of 'Summer in a Bottle,' be on the lookout for riders enjoying a stroll past the many rows of vines. You may also hear an echo of a yell for "Heels down" or "Woah" because someone might be having a lesson in the jumper ring not far from the wine stand by the highway.

There is also no shortage of pony camps in the Hamptons. From Quogue to Montauk and the towns in between, there are barns offering day camps for would-be equestrians. These pony camps, like Pamela Suskind's Silver Tide Stables, emphasise learning on and off a horse. Apart from understanding a horse's different gaits and finding balance on the saddle, these camps teach children about horsemanship and about making a connection with the horse through lessons on pony care, such as grooming, brushing, and putting on tack.

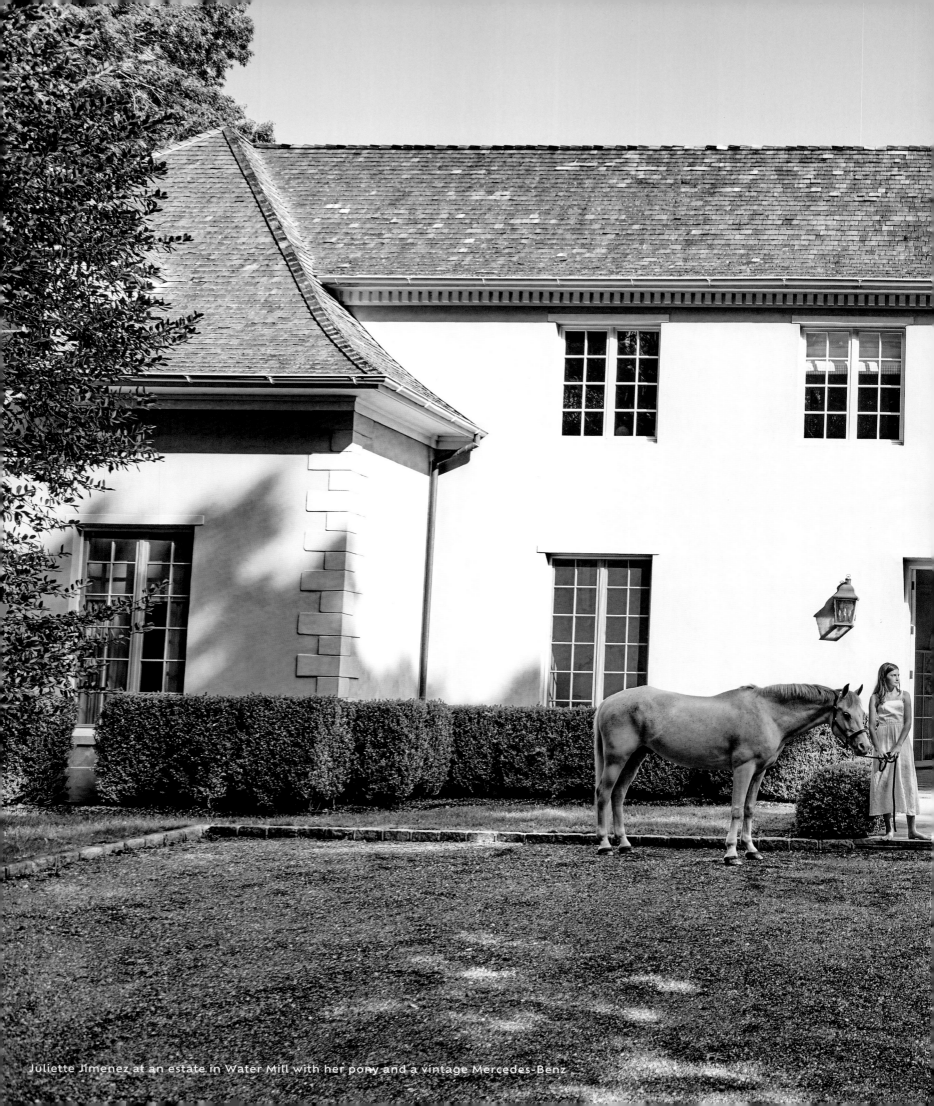

Juliette Jimenez at an estate in Water Mill with her pony and a vintage Mercedes-Benz

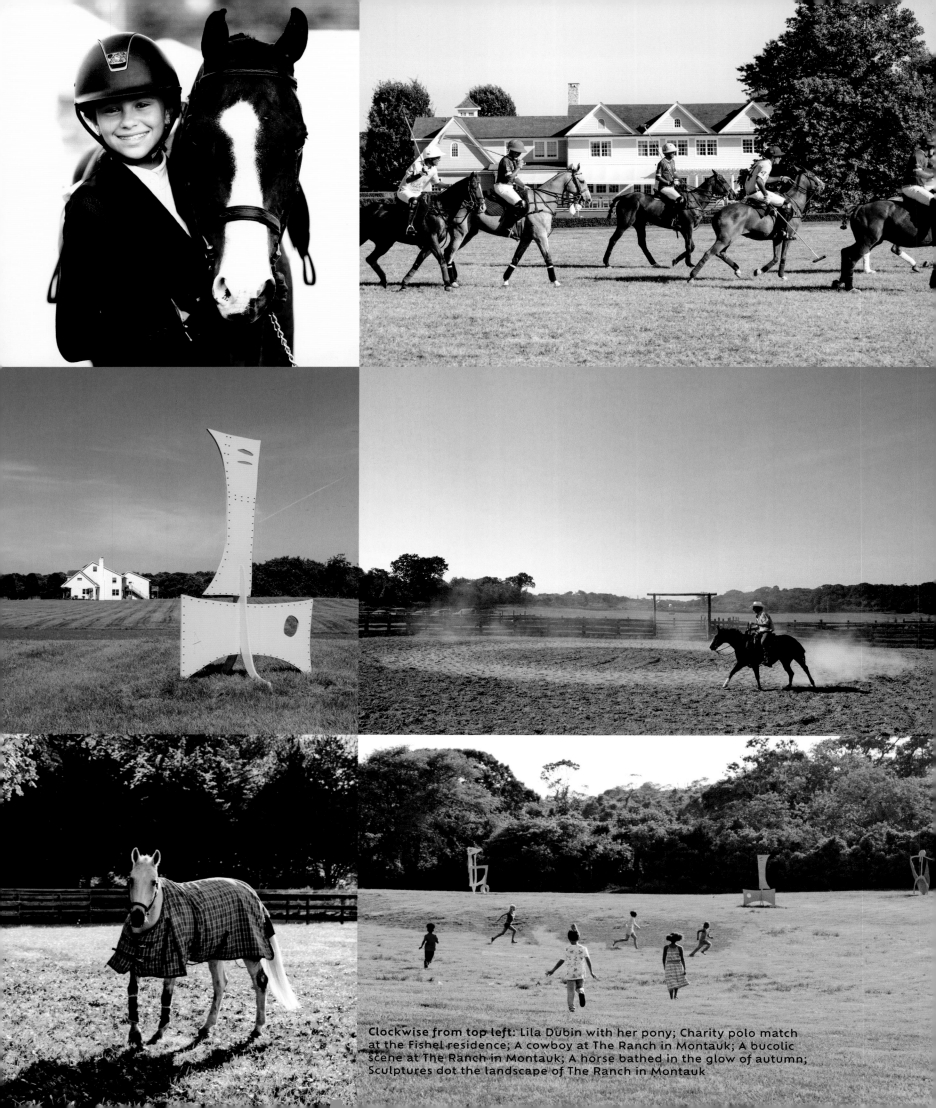

Clockwise from top left: Lila Dubin with her pony; Charity polo match at the Fishel residence; A cowboy at The Ranch in Montauk; A bucolic scene at The Ranch in Montauk; A horse bathed in the glow of autumn; Sculptures dot the landscape of The Ranch in Montauk

Make your way to Amagansett to see Wick Hotchkiss at Stony Hill Stables practice half passes and piaffes and other various dressage moves. She is one of the very few dressage riders and trainers in the Hamptons. Her barn has also taught—and continues to teach—generations of riders, a few of whom have reached highly competitive levels.

On your way to Montauk (which is endearingly called 'The End of the World') to sample a lobster roll from Lunch, and to see the lighthouse and the surfers braving the waves of the Atlantic Ocean, be on the lookout for horses at Deep Hollow Ranch. It is the oldest cattle ranch in America, established in 1658. It is the last remaining site where Western-style riding and cattle cutting are still practiced in the Hamptons. The ranch also offers trail rides that lead to the beach. Across the road from Deep Hollow Ranch is the bucolic The Ranch, which is part working stable, part art venue. The owner, Alex Levai, has converted a barn into an art gallery and its expansive lawn features large-scale sculptures, providing an idyllic *mise-en-scène* of horses among artworks.

On your way back to East Hampton or Southampton, there is a possibility of spotting a rider in full schooling outfits—breeches, boots, and all—darting into shops or coffee spots before or after a lesson. Perhaps a quick stop at The Tack Trunk in Bridgehampton for stirrups or saddle pads. Or at Ralph Lauren on Main Street for the equine-inspired fashion that is an integral part of the house's identity.

Around Labor Day weekend, after the victory lap of the winner of the Grand Prix at the Hampton Classic and the tents go down, the summer season unofficially ends in the Hamptons. Some of the summer residents pack up and head back to the city for the start of another school year and the changing of the seasons. The summer flowers begin to wilt. The tractors in the fields harvest the last of the famous Long Island corn. The beach crowd thins. Apple picking becomes the must-do activity.

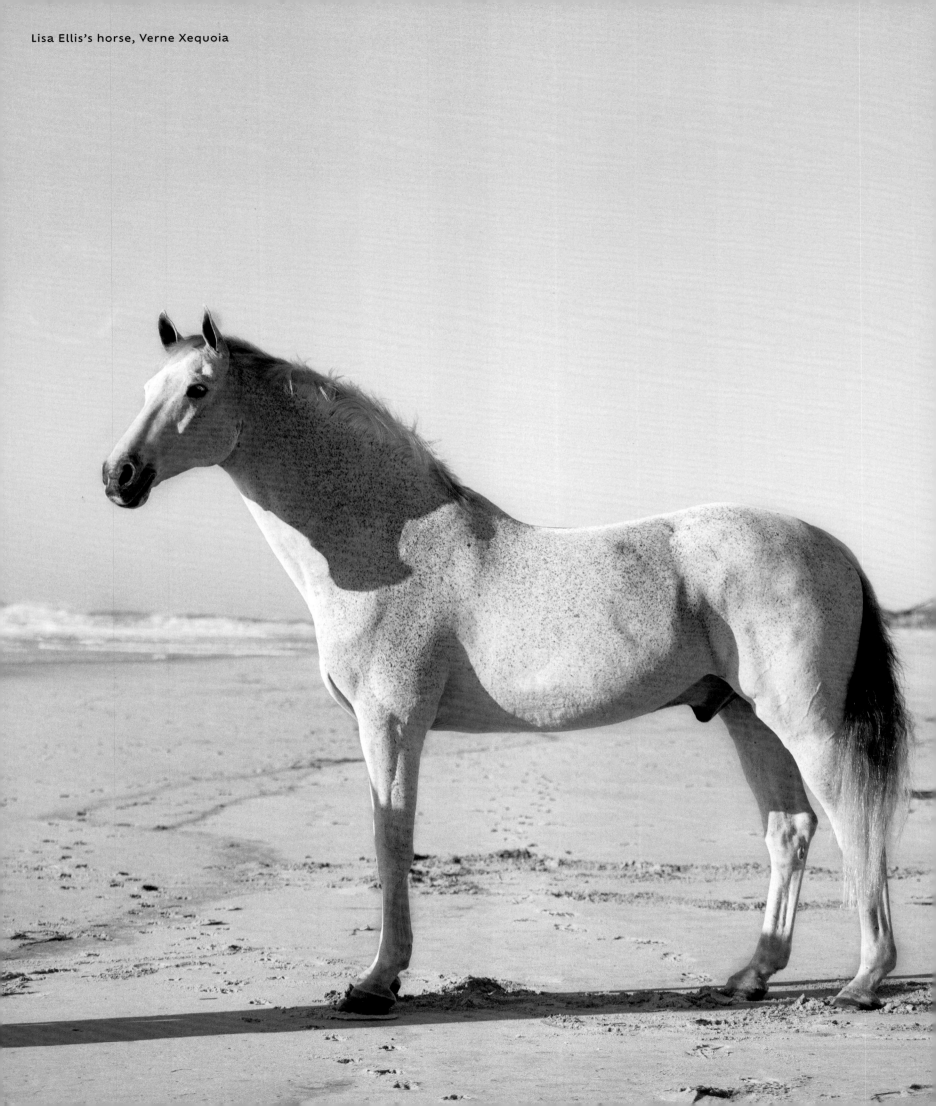

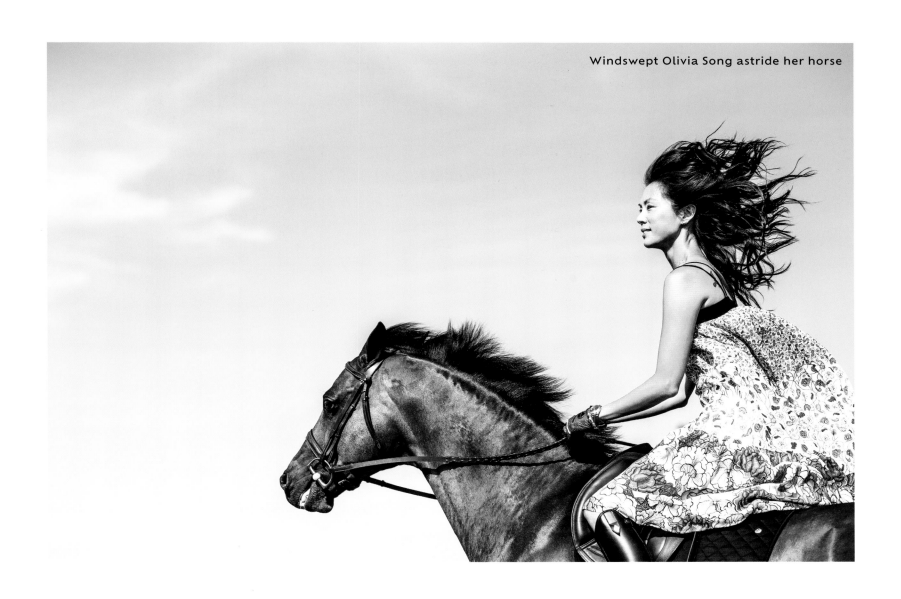

Windswept Olivia Song astride her horse

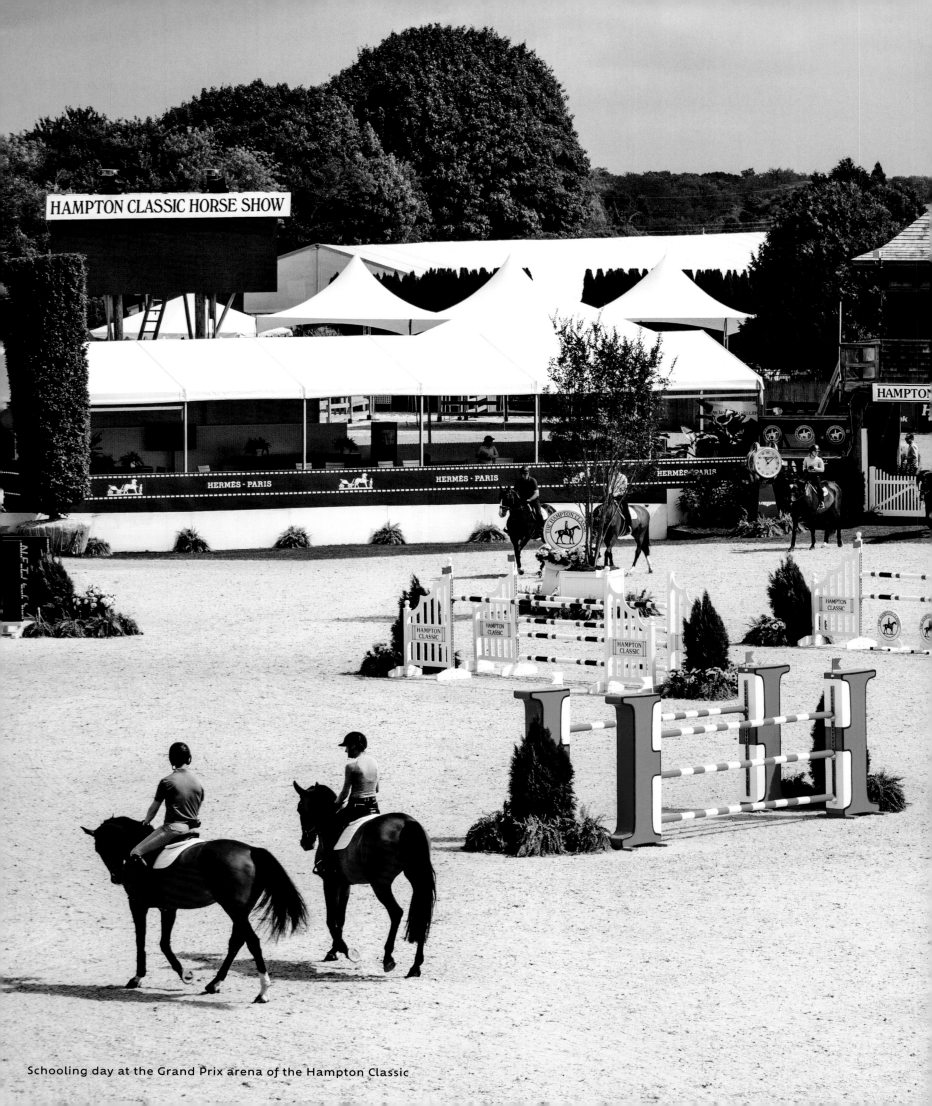

HAMPTON CLASSIC HORSE SHOW

Schooling day at the Grand Prix arena of the Hampton Classic

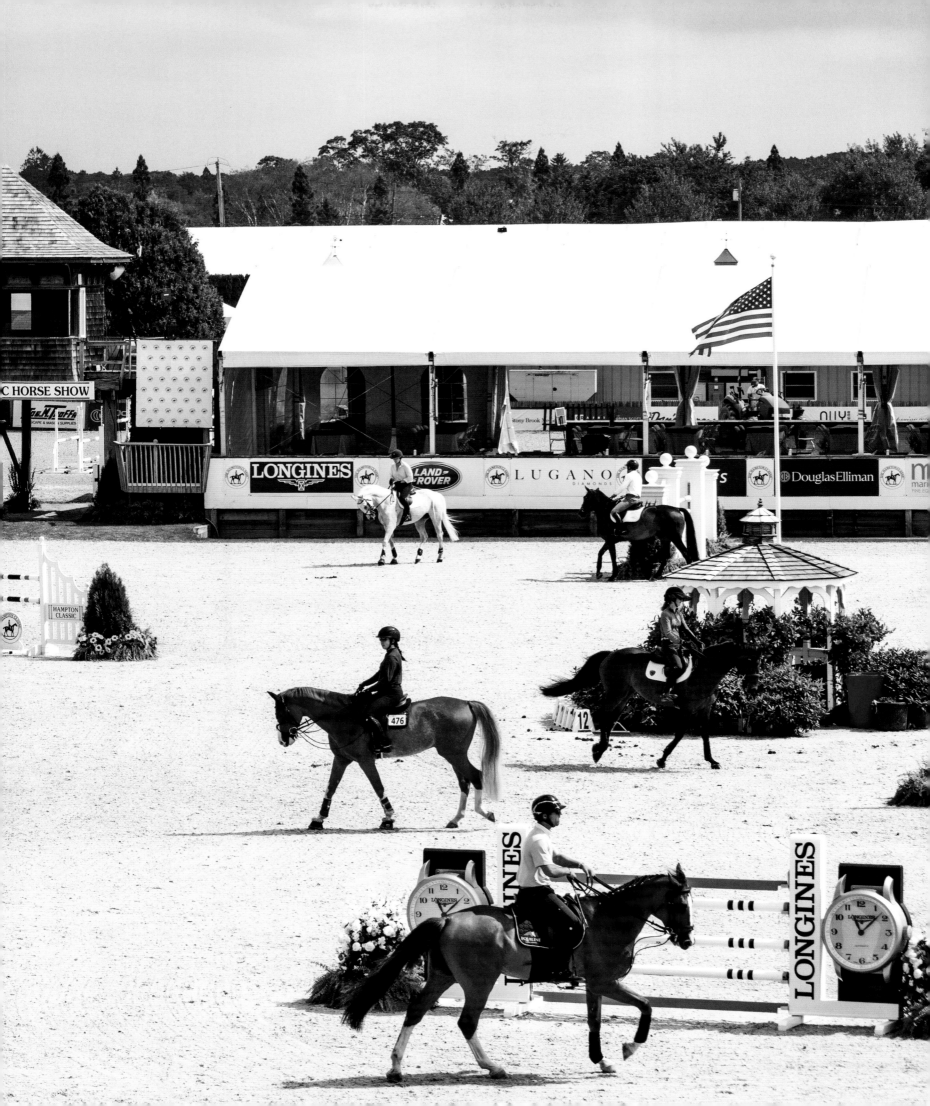

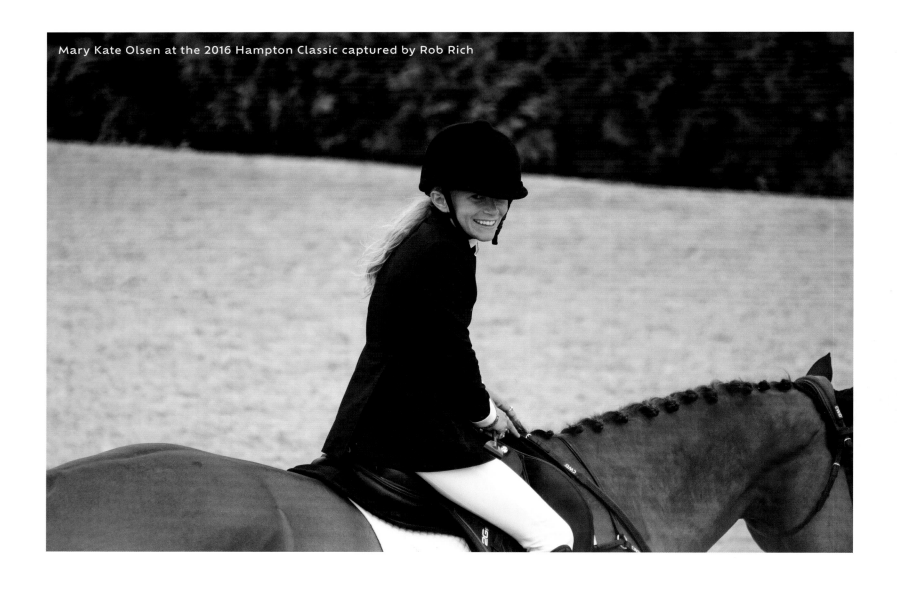
Mary Kate Olsen at the 2016 Hampton Classic captured by Rob Rich

"The pristine nature. Unlike other popular resorts, the Hamptons maintains its elegance, its ties with the past, and its original natural beauty."

—Martha Stewart

Deep Hollow Ranch in Montauk offers horseback trail rides to the beach

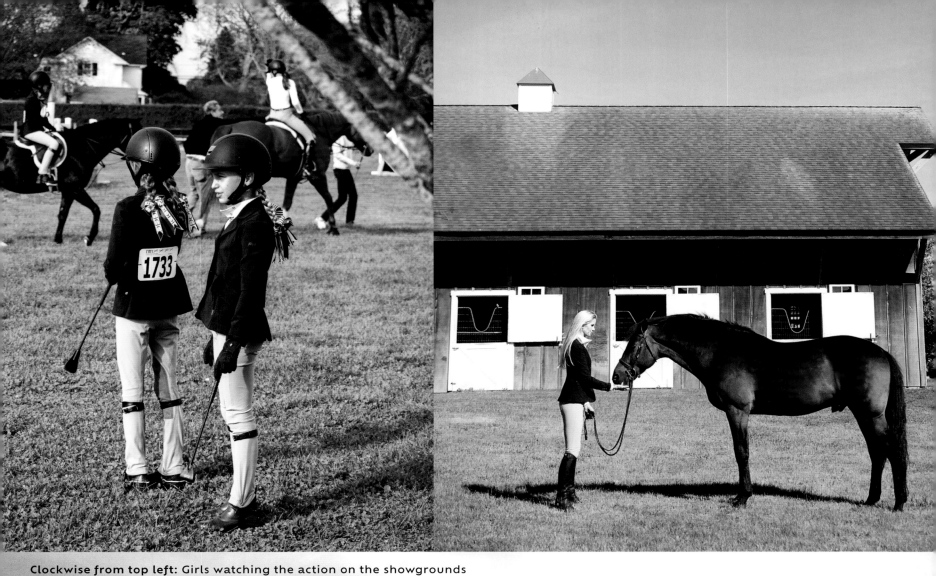

Clockwise from top left: Girls watching the action on the showgrounds at the Fall Derby at Topping Riding Club; Rolanda Blue Dolan modeling for The Tack Trunk; A show jumper competing in the rain
Opposite: A horse in leaping motion

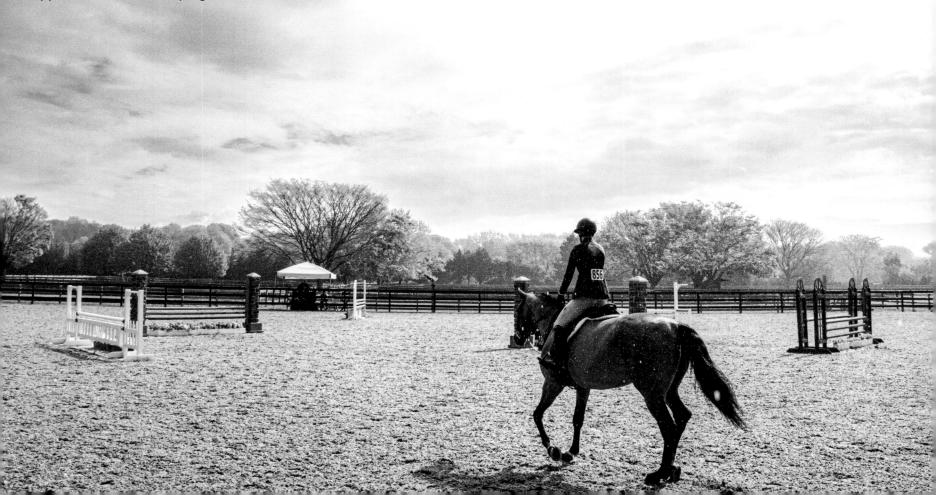

Brogan Zipper in the fields of Two Trees Stables
with a horse from Firefly Farm

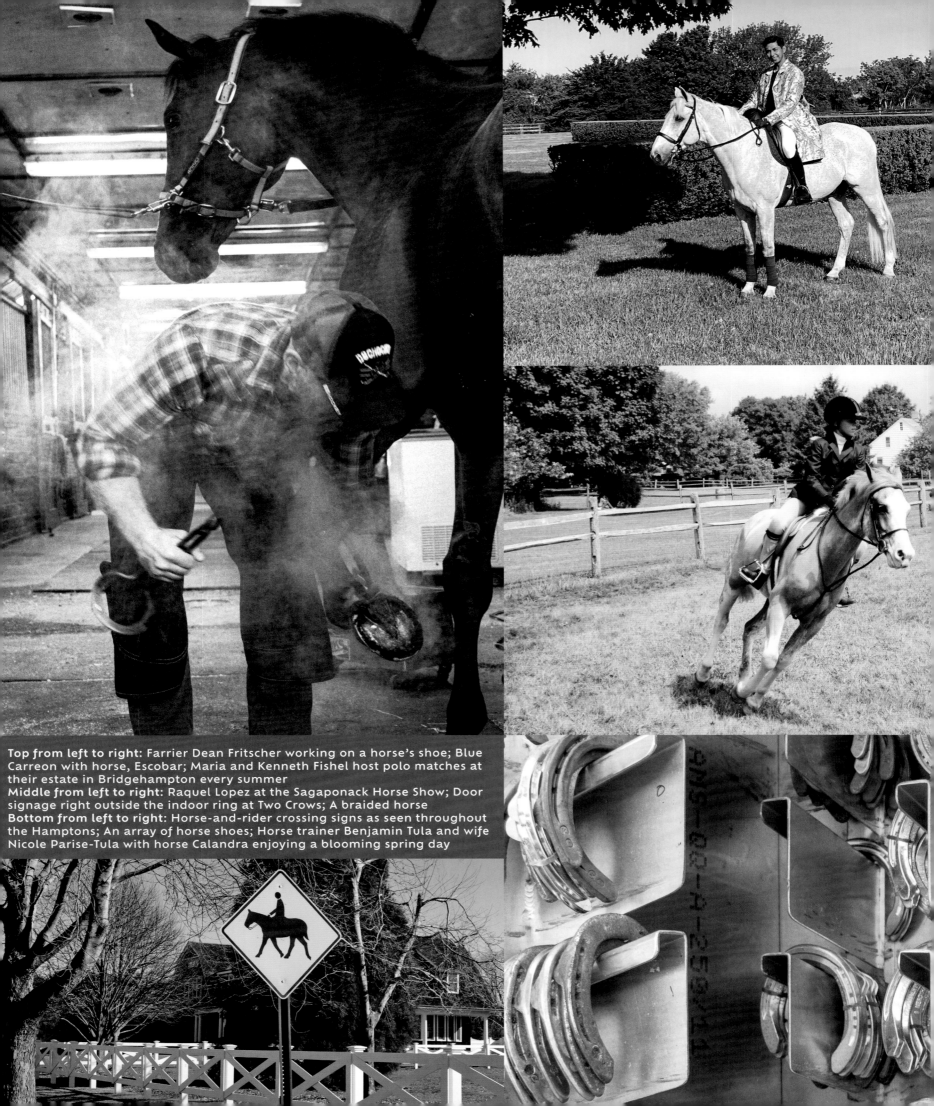

Top from left to right: Farrier Dean Fritscher working on a horse's shoe; Blue Carreon with horse, Escobar; Maria and Kenneth Fishel host polo matches at their estate in Bridgehampton every summer
Middle from left to right: Raquel Lopez at the Sagaponack Horse Show; Door signage right outside the indoor ring at Two Crows; A braided horse
Bottom from left to right: Horse-and-rider crossing signs as seen throughout the Hamptons; An array of horse shoes; Horse trainer Benjamin Tula and wife Nicole Parise-Tula with horse Calandra enjoying a blooming spring day

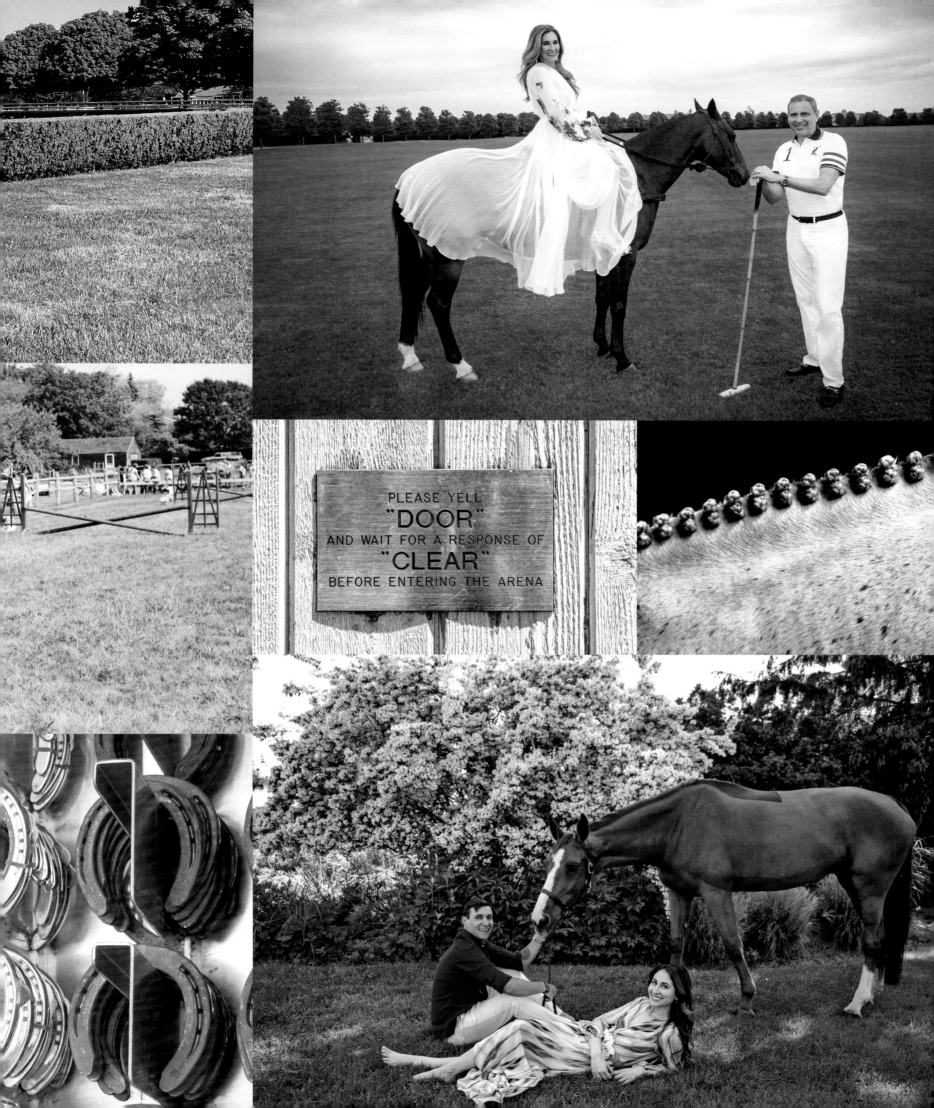

PLEASE YELL
"DOOR"
AND WAIT FOR A RESPONSE OF
"CLEAR"
BEFORE ENTERING THE ARENA

An early autumn morning at Wölffer Estate Stables

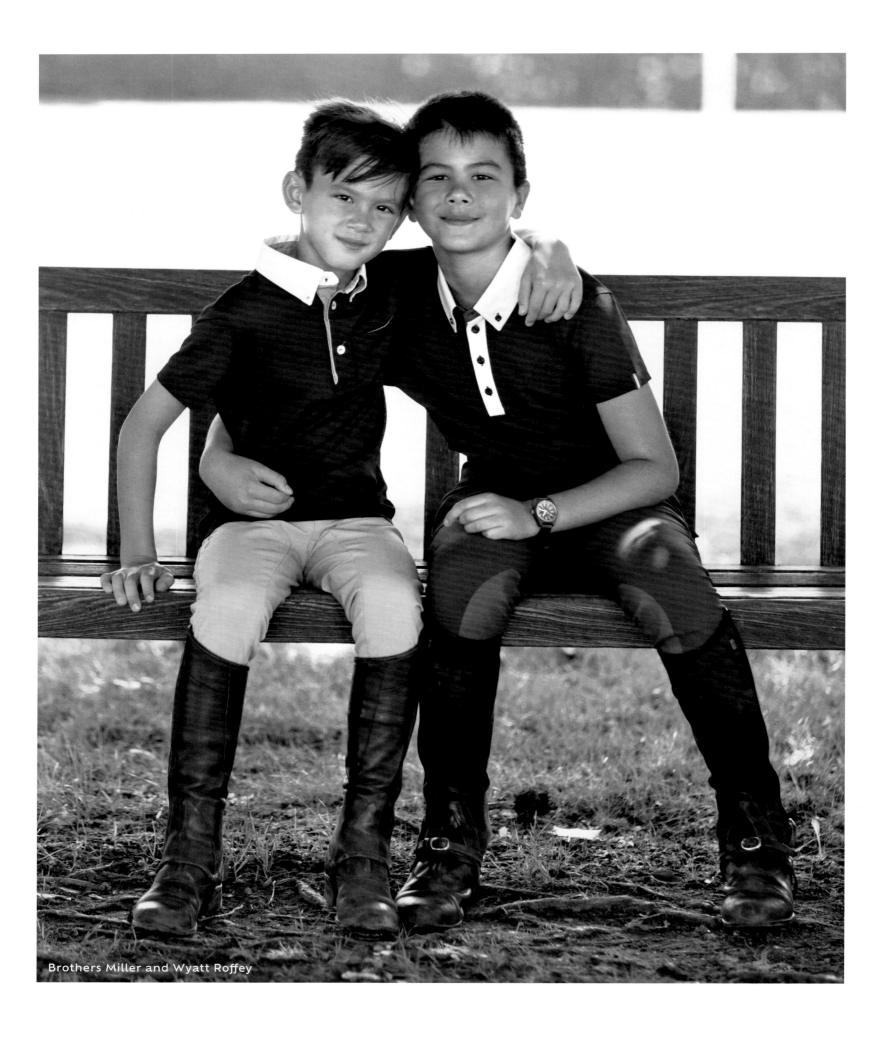

Brothers Miller and Wyatt Roffey

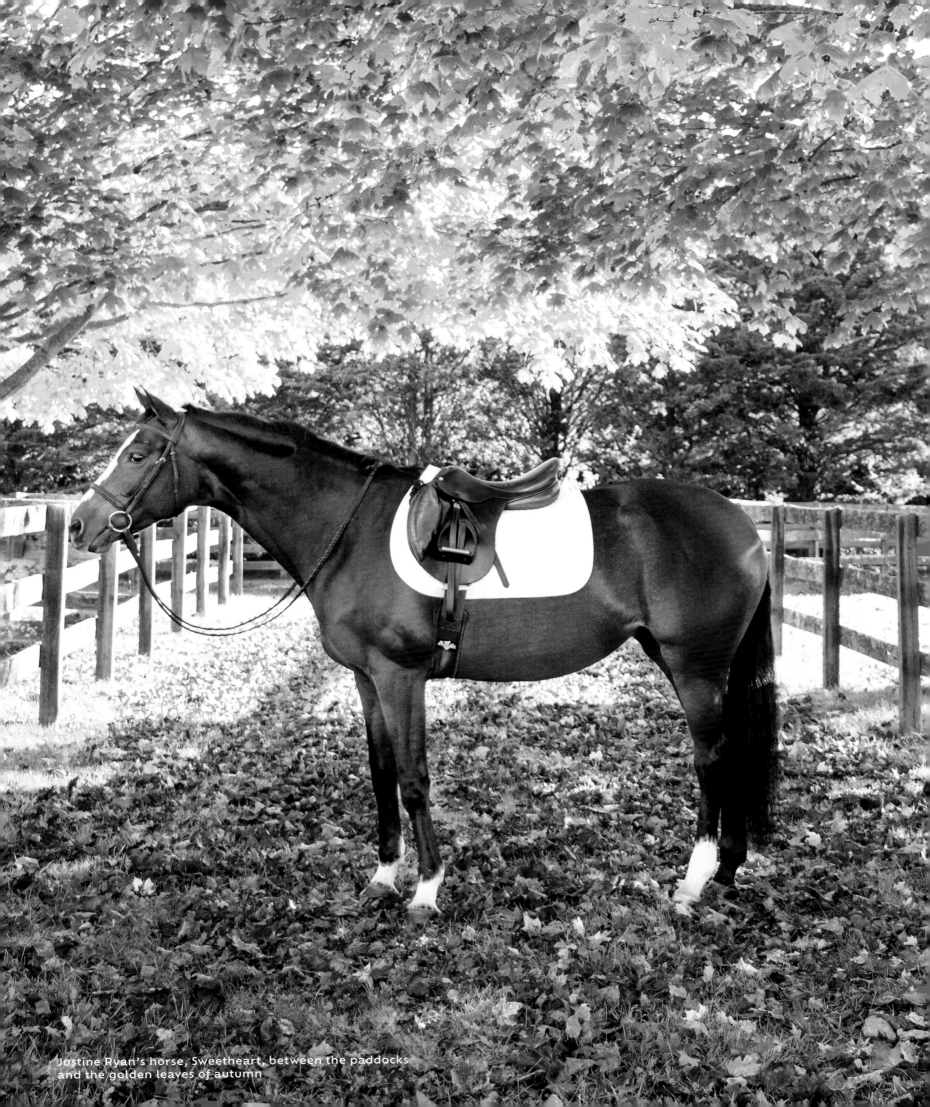

Justine Ryan's horse, Sweetheart, between the paddocks and the golden leaves of autumn

In the autumn when garden centers like Marders switch out their pots of lavender and roses for pumpkins and mums, most of the riders will start putting their horses in trailers to ship them to Wellington, Florida, in anticipation of the Winter Equestrian Festival. At the Topping Riding Club, Mercedes Olivieri prepares for the fall derby competition. It's the last hurrah, and perhaps the most fun of the local horse shows because it is reminiscent of the hunts that were once the ultimate hobby of the Hamptons' leisure class. Riders go through a series of obstacles that include rails and fences; and brush, water and ditch jumps making for excellent spectating.

Those who stay behind, those who call this place home, however, become witnesses to nature's beautiful handiwork in the Hamptons. A rhythm of life that cannot be hastened. The leaves on the trees turning into vivid shades of ochre, orange, and russet at peak fall weather. The dappled natural light bathing trail riders in a magnificent glow—a glorious radiant effect that no filter can recreate.

In the winter after a snowfall, the grazing paddocks and rings are blanketed in the white sugar-like confection. The hedge jumps are dusted with powder. A winter wonderland if there ever was one, with the wide, open spaces enveloped in snow. The whiteness broken in parts by evergreen trees and bright blue skies. Riding is moved indoors and horses and riders both don layers to ward off temperatures that can go below freezing.

In April, when the daffodils start blooming and the apple trees are bursting with constellations of pink buds, the horses and riders emerge from the indoor rings. And those who left for warmer climes make their way back to the Hamptons for another season of horses, horse shows, and long summer days.

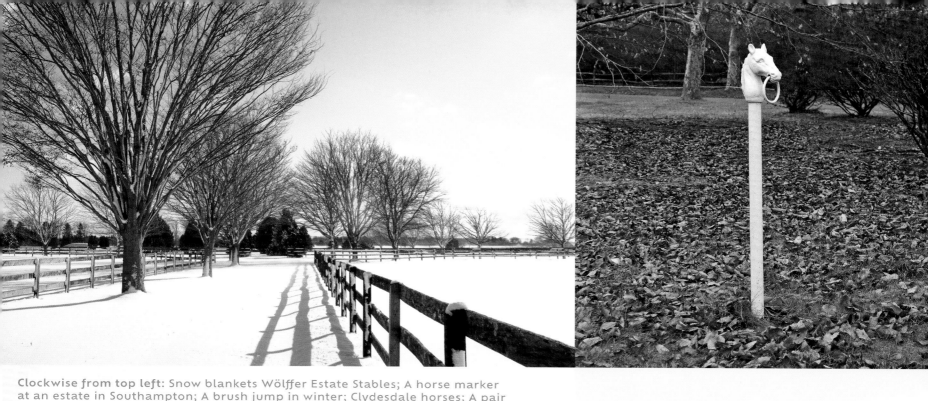

Clockwise from top left: Snow blankets Wölffer Estate Stables; A horse marker at an estate in Southampton; A brush jump in winter; Clydesdale horses; A pair of horses running free in a field after a snowstorm in Montauk; Rolled hay and mansions by the ocean in Sagaponack

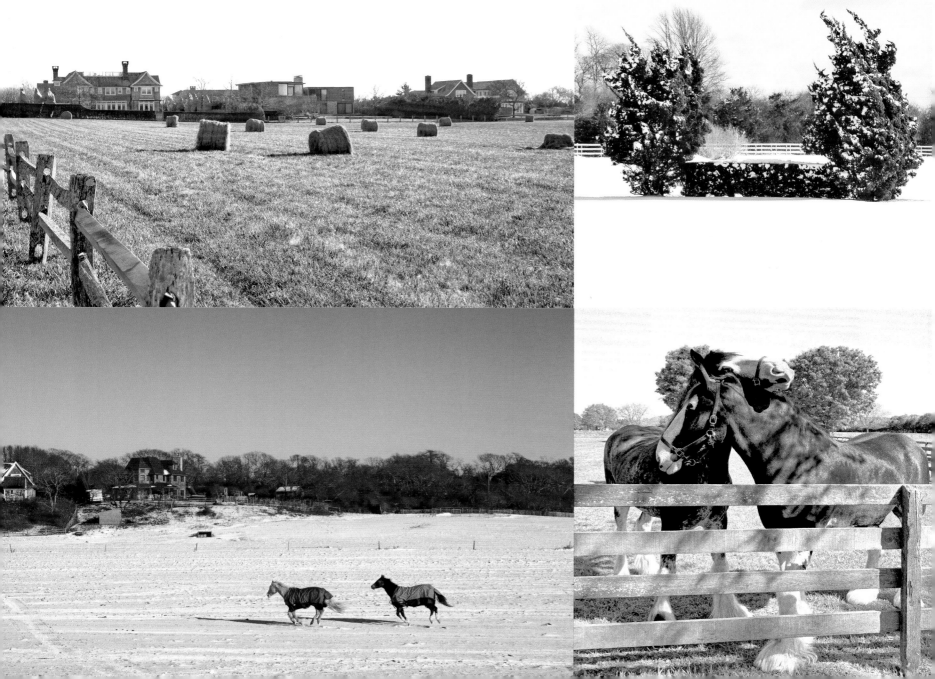

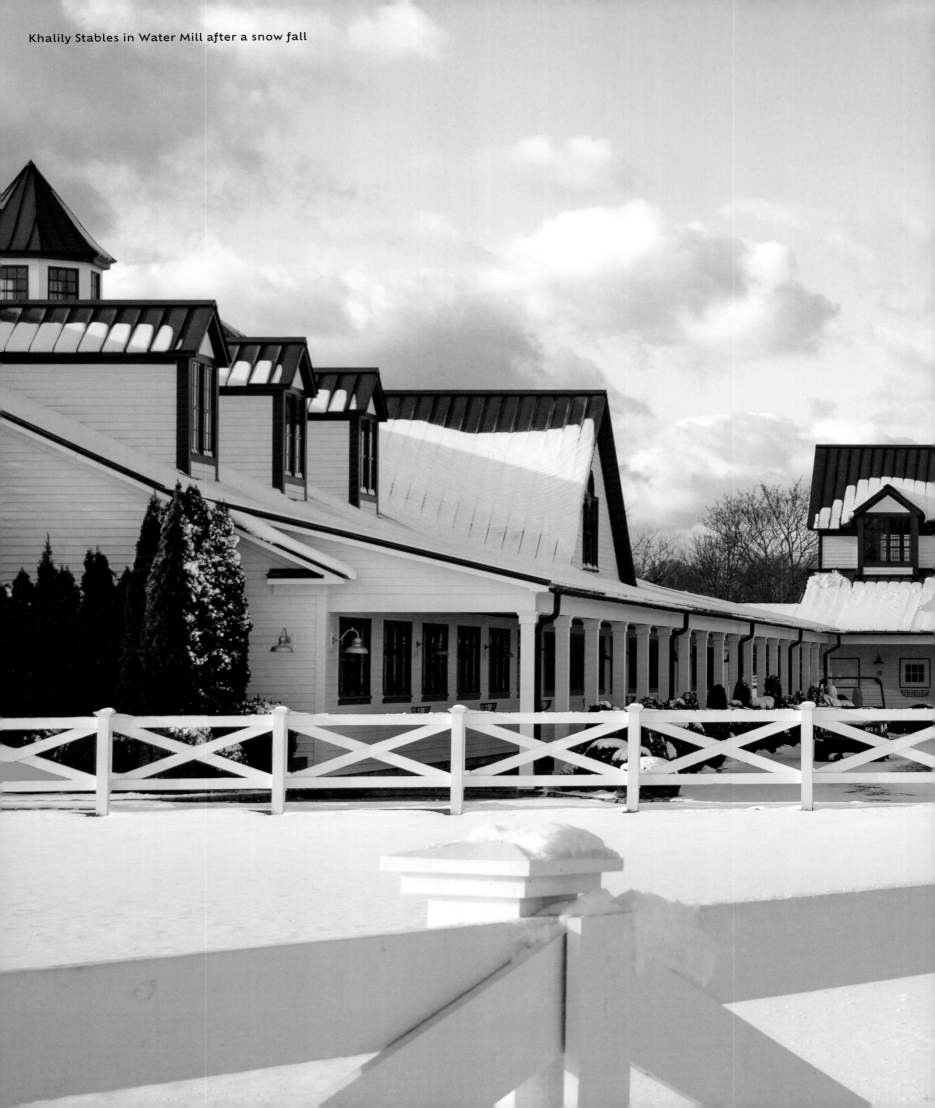

Khalily Stables in Water Mill after a snow fall

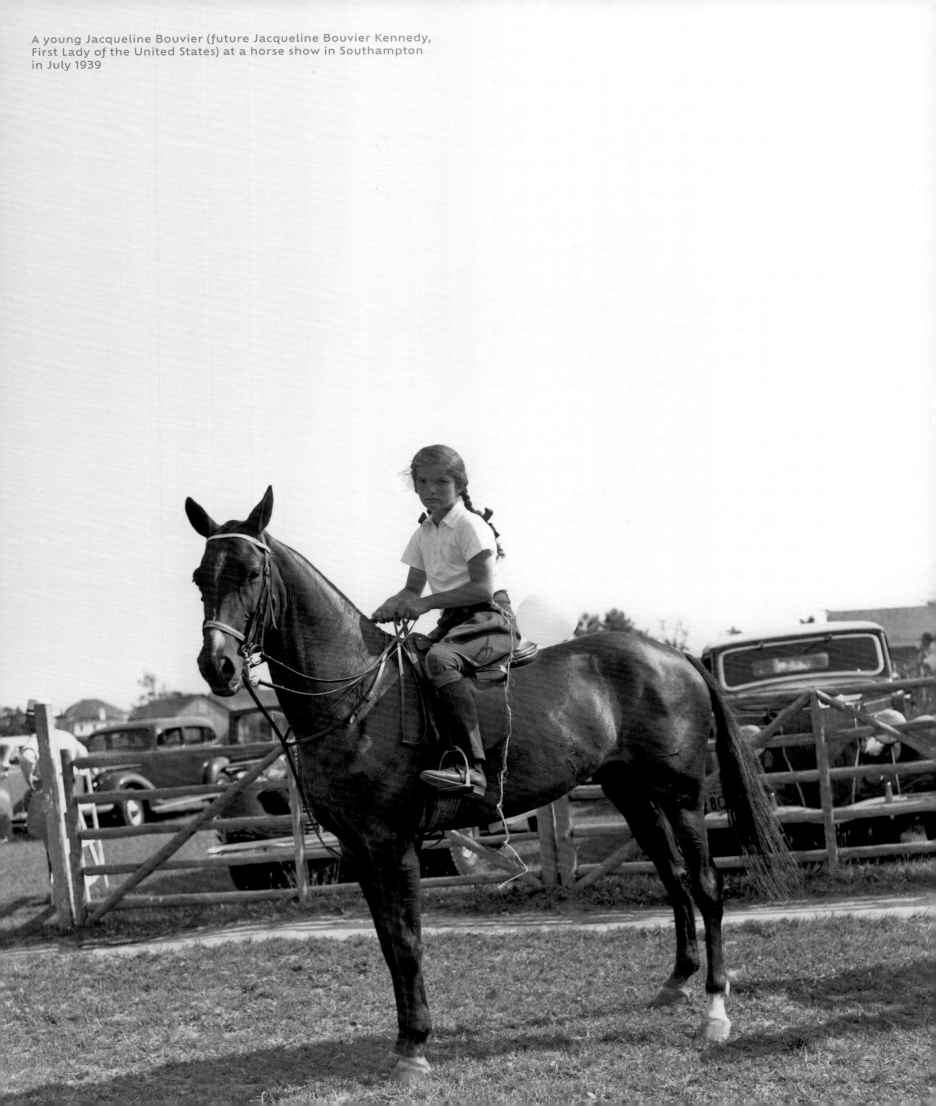

A young Jacqueline Bouvier (future Jacqueline Bouvier Kennedy,
First Lady of the United States) at a horse show in Southampton
in July 1939

Galloping Through Time

A Historic Overview

Just before the realities of World War II would put a hold on the leisurely pursuits of the privileged class of New York, a twelve-year-old girl was winning ribbons in horse shows on Long Island. That girl would go on to become one of the most famous and idolized women in history. She was Jacqueline Bouvier (and later Jackie Kennedy Onassis).

On August 24, 1941, the *New York Times* reported glowingly of her equestrian achievements in partnership with her mount. "Miss Bouvier's Danseuse was a star performer in today's show. Danseuse won blues for her young rider in the horsemanship class for children under fourteen, the hunter hack event, the riding competition for children under sixteen, and the ladies hunter contest for the Hamlin Memorial Challenge." The Hamlin Memorial Challenge was one of the most

prestigious trophies given by the East Hampton Riding Club, requiring winners to place first at the competition three times before they get to bring home the coveted trophy.

As young as five years old, Jacqueline Bouvier was already earning ribbons at horse shows in East Hampton and Southampton. She was a natural on a horse with the poise of a winner. Her ponies Buddy, Dance Step (a piebald pony), and Danseuse (a chestnut mare) would help her achieve successes at the local shows, thereby attracting social and media attention even at a very young age. The local newspaper the *East Hampton Star* reported on August 18, 1934: "One of the most attractive riders at Saturday's show who would have received a blue ribbon, if the spectators had anything to say about the judging, was the five-year old daughter of Mrs. John Vernon Bouvier III."

To write about the history of equestrian sports in the Hamptons, one must weave the story of Jackie Kennedy and her mother Janet Lee Bouvier. Janet was a champion horsewoman, winning peerlessly in local and national horse shows, including earning the top prize in the hunter championship at the National Horse Show at Madison Square Garden three times. She was the rider to beat in many of the classes at the competitions held at the East Hampton Riding Club.

The club, long defunct and whose grounds have been subdivided into commercial and residential lots, was established in 1924. It was located on Pantigo Road, on twenty-five acres that straddled East Hampton and Amagansett, and a mere couple of miles from Two Mile Hollow Beach and a just a few blocks from Jacqueline Bouvier's summer home, Lasata, on Further Lane. The clubhouse dated back to 1740, a homestead that once belonged to Abraham Baker, a descendant of one of East Hampton's founding fathers, Thomas Baker. Its first president was Frank B. Wiborg, whose house called 'the Dunes' on what is now referred to as Wiborg's Beach was one of the grandest cottages in East Hampton a century ago. (It was purposely burned down by the town's fire department in the 1940s when Wiborg's daughter and heir Sara Murphy—she and her husband Gerard Murphy were character inspirations in F. Scott Fitzgerald's *Tender Is the Night*—could not find a buyer for the house.)

There were twenty-nine original members of the riding club, and over the years the membership would swell and its roster would go on to read like the descendants of Mrs. Astor's 400 List, some of whom bore the names of streets, beaches, and various landmarks in the Hamptons. Members of families like the Gardiners, Beales, Fishes, Wards, Duryeas, Appletons, Morgans, and Murrays. The horse shows were held to benefit various charities, including the Soldiers and Sailors Club of New York City.

The Society section of the *East Hampton Star* (the banner of which featured the various hobbies of the summer colonists, including polo, fox hunts, and show jumping) reported breathlessly on the thrills of the horse shows, which were followed by dances and fashion shows at the highly exclusive Maidstone Club. "The grounds of the East Hampton Riding Club will be the Mecca *[sic]* of hundreds of summer colonists in the Hamptons as well as seventy horse owners from all parts of Long Island all day tomorrow when the fifth annual horse show of the riding club is held," reported the *East Hampton Star* on August 16, 1929. In fact, even horse owners from Kentucky and Virginia made the pilgrimage to the horse show. And the cadets from West Point Army were also invited to participate, they were one of the best groups of riders in the country and perhaps also because the history of equestrian sports is partly rooted in the military.

But the real rivalry was between the members of the East Hampton Riding Club and the slightly younger Southampton Riding and Hunt Club, in classes that included hunters race against time, pairs of hunters, hunt teams, sidesaddle, parent and child, and various children's categories.

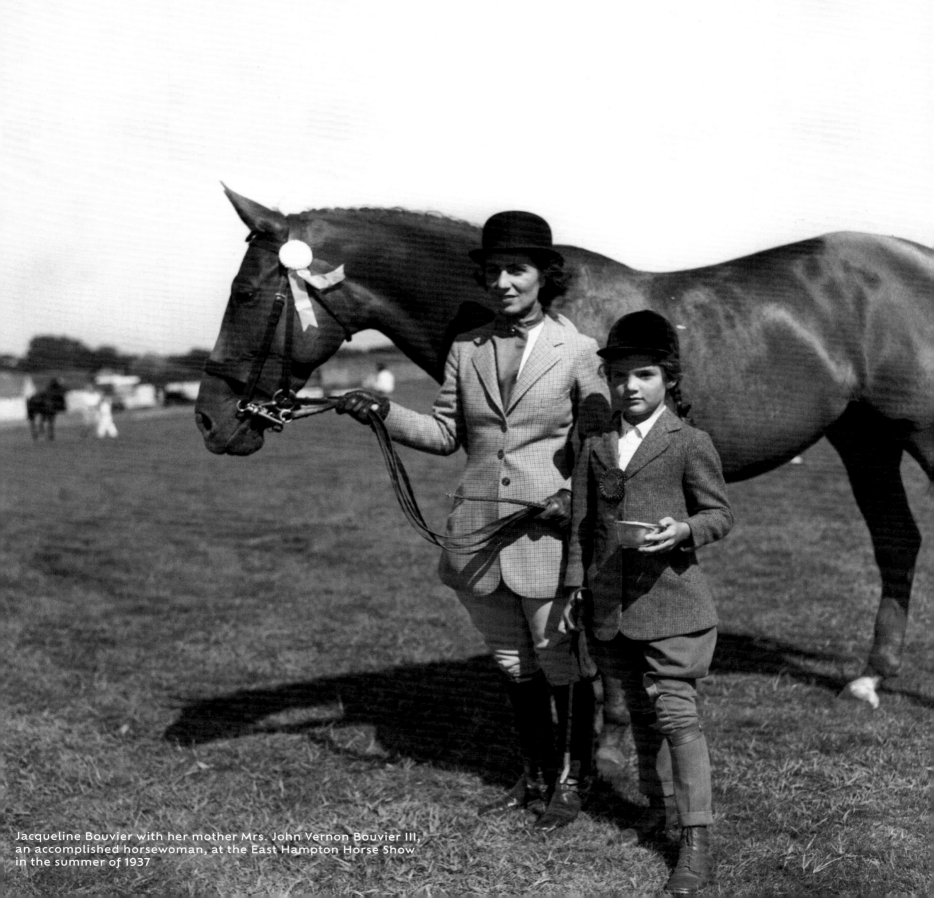

Jacqueline Bouvier with her mother Mrs. John Vernon Bouvier III, an accomplished horsewoman, at the East Hampton Horse Show in the summer of 1937

"We want to bring back the type of horse shows in the Hamptons that Jacqueline Bouvier won Blue Ribbons at, and the Duke of Windsor came from England to ride in."

—Edwardina O'Brien, Chairman of the LVIS Horse Show 1973, *Newsday*

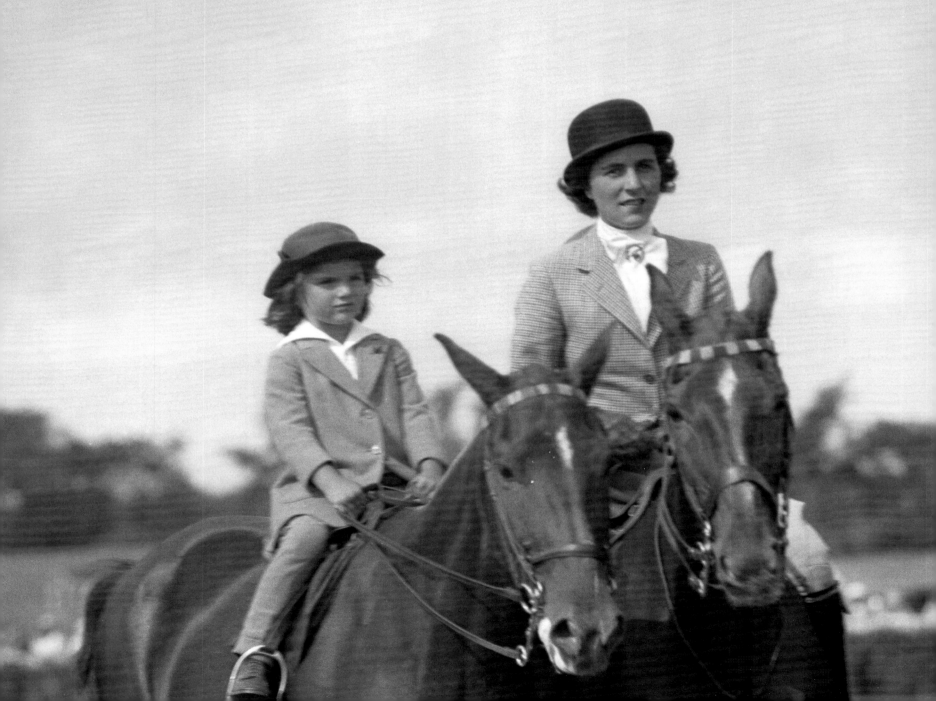

Opposite: Jacqueline Bouvier with her mother Mrs. John Vernon Bouvier III on their mounts at the mother and child class at the East Hampton Horse Show in 1934
Above: Scenes from a horse show in East Hampton, circa 1930s

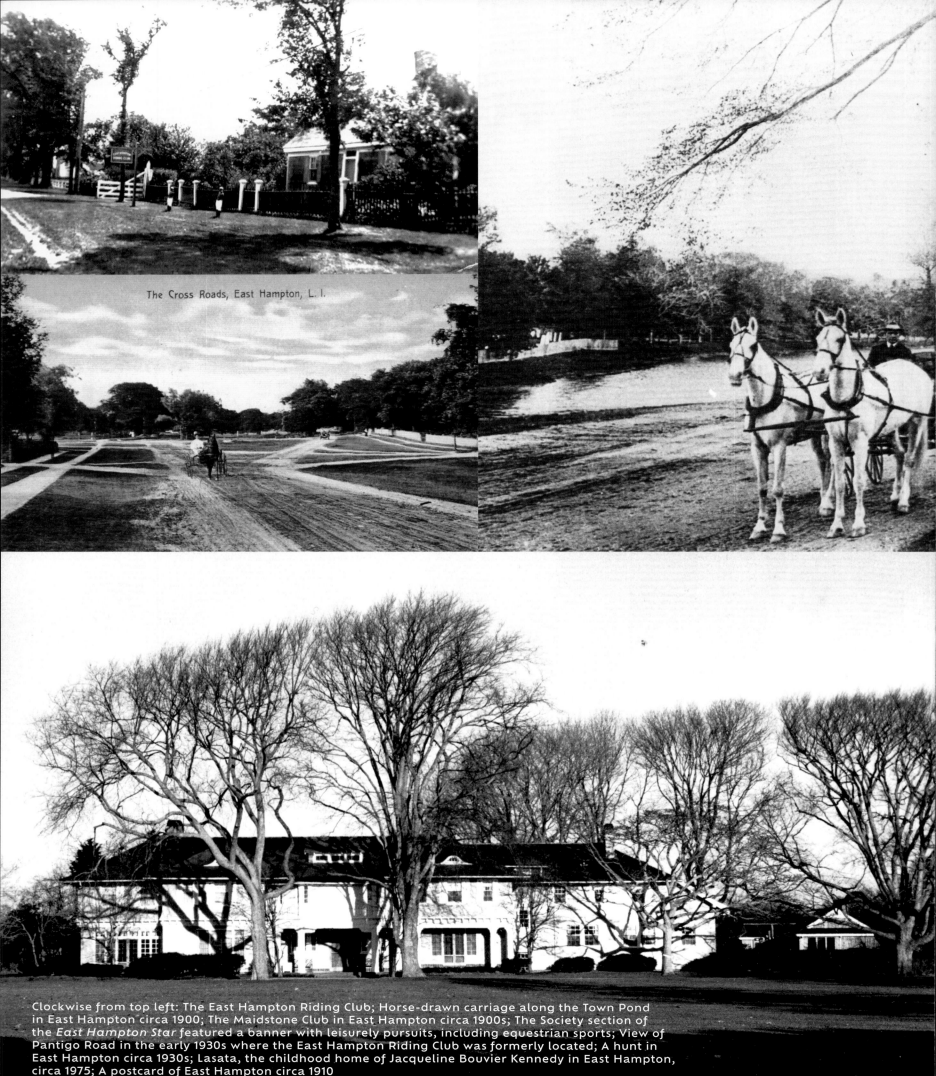

The Cross Roads, East Hampton, L.I.

Clockwise from top left: The East Hampton Riding Club; Horse-drawn carriage along the Town Pond in East Hampton circa 1900; The Maidstone Club in East Hampton circa 1900s; The Society section of the *East Hampton Star* featured a banner with leisurely pursuits, including equestrian sports; View of Pantigo Road in the early 1930s where the East Hampton Riding Club was formerly located; A hunt in East Hampton circa 1930s; Lasata, the childhood home of Jacqueline Bouvier Kennedy in East Hampton, circa 1975; A postcard of East Hampton circa 1910

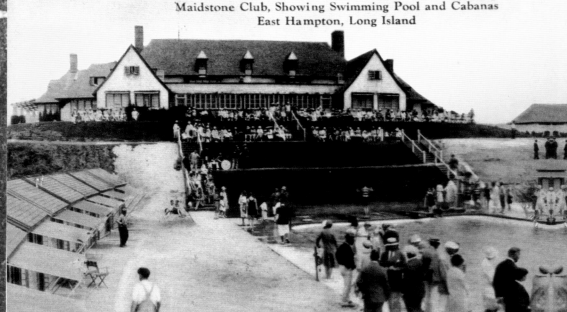

Maidstone Club, Showing Swimming Pool and Cabanas
East Hampton, Long Island

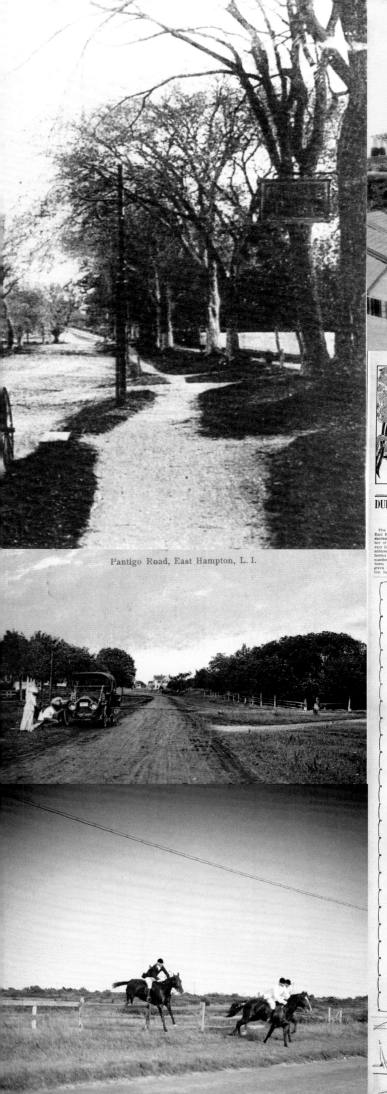

Pantigo Road, East Hampton, L. I.

Society — THE EAST HAMPTON STAR — Section

THE EAST HAMPTON STAR, FRIDAY, AUGUST 22, 1930

DURYEAS TAKE 16 RIBBONS AT 6TH ANNUAL HORSE SHOW SAT.

The sixth annual horse show of the East Hampton Riding Club was a very successful event, with a record number of entries giving East Hampton a very fine show, for many of the horses entered were among the crack show horses of Long Island, and while a number of the awards went to out-of-town exhibitors the spectators were given a full day's sport. East Hampton has never seen so many out-of-

town exhibitors and spectators for the local show and all the parking spaces were and the day before the show.

The Joan Drew Memorial Cup for the best horse or pony in the show went to the English bred polo pony, Kilbride, owned and shown by A F. Pachieri of London and New York, who had been collecting red ribbons at most of the Long Island shows prior to the East Hampton show. At Montauk

Duryea Takes 16 Ribbons

It was a field day for Mr and Mrs Duryea with their Wilmarland Farm horses, for in addition to taking the Newell J Ward Challenge Cup and a reserve ribbon for best in show they carried off seven firsts, three seconds, two thirds and two fourths in twenty-one classes. This was a very remarkable showing for there were five of the 21 classes for which the Duryeas were not eligible; two riding classes for children, a jumping class for children, the Good Hands Cup Class and the Parent and Child class...

Adelaide Moffett Takes Riding Class Award

Miss Adelaide Moffett won the riding class for children under 16, with Gay Nareo, while the riding class for children under 12, went to Miss Mildred Durand of Rye...

Willie Brennan Qualifies Six in Open Jumping

Willie Brennan, a professional rider of Glen Head, L. I., delighted the spectators with his fine riding over the jumps...

Miss Carolyn Roberts Wins

Miss Carolyn Roberts Nancy proved to be a very handy hunter in winning the class for the lady rider...

The Touch and Out Sweepstakes, the only cash event of the day, with 38 entries, went to Miss Rosemary Ward...

Clean Sweep for Duryea's New Mary Sun Dance

Mrs. William M Duryea's new cheatnut started the long string of Duryea blue ribbons in the show...

Silver Daze, Best in Show, Wins Polo Class

Another first was taken by the Duryea horses in the road hacks with Barberry, Kilbride, later given best in show, was fourth...

Show a Popular Success

The show was run off as rapidly as possible in view of the large number of entries for in many of the classes there were fifteen and twenty horses...

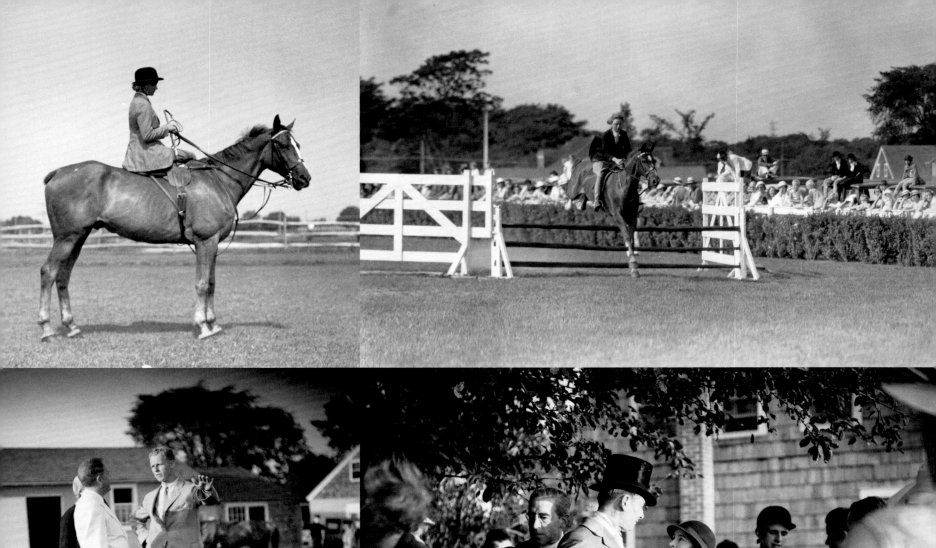

Scenes from a horse show and hunt
in East Hampton in the 1930s

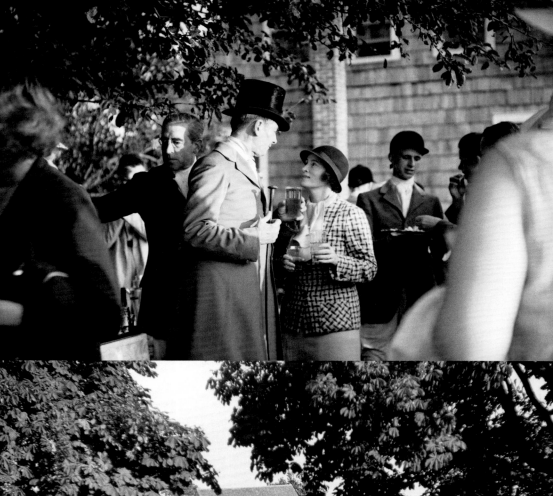

The establishment of the Southampton Riding and Hunt Club on Majors Path in Southampton Village in 1929 brought about much hoopla and excitement to the town: "The hunts are bringing out an enthusiastic group of horsemen and horsewomen, who are enjoying the delights of riding through the picturesque countryside that Southampton offers along many roads and bypaths. The rides, too, are getting the club members into their stride for the annual horse show coming next month," reported the *New York Times* on July 14,1929. Among those who would trot around at the Southampton Riding and Hunt Club were the then Duke and Duchess of Windsor who were frequent guests of Thomas Markoe Robertson at his estate on Ox Pasture Lane; Chrysler heiresses Bernice Chrysler Garbisch and Thelma Chrysler Foy; cereal heiress, socialite, and businesswoman Marjorie Weather Post, who would later build Mar-a-Lago in Palm Beach and gift it to the United States government; and the Mortimer sisters, Mary Eleanor and Wilfreda.

In the book *Southampton Blue Book*, which features archival photographs of a who's who of Southampton's glitterati by Bert Morgan, the writer Mary Cummings traces back the passion for equestrian sports in the Hamptons to the nineteenth century via Dr. T. Gaillard Thomas. The doctor is considered one of the founders of Southampton and the first to build a house on the beach in the 1860s. He was an avid horseman and frequently hosted races and hunts on his property. "Enthusiasm for equestrian competitions and games reached high pitch on June 29, 1929, when the Southampton Riding and Hunt Club celebrated its formal opening. Laid out in land fronting North Sea Road were bridle paths, riding and polo grounds, and a clubhouse where afternoon teas and evening dances attracted members of the social set from Southampton and beyond," wrote Cummings.

In 1932, Janet Bouvier won the Harry L. Hamlin Challenge Cup for ladies hunters on Danseuse and the blue ribbon in the lightweight hunters on her mount Arnoldean. At the same show, the *East Hampton Star* reported on August 16, 1932: "The Murray Clan of Southampton and Water Mill had their own way in the riding competition for boys and girls twelve years of age and under sixteen with Miss Rosamund Murray first, Miss Patricia Murray second, Miss Jeanne Murray third, and Miss Marie Murray fourth."

The Depression and the spread of the war in the 1940s brought about the closure of the riding clubs in the Hamptons. The East Hampton Riding Club was sold and the clubhouse was converted back to a private residence. The Southampton Riding and Hunt Club suffered the same fate, and its facilities and horses were sold. In 2021, the old clubhouse of the East Hampton Riding Club turned family home went on the market and associations to Jackie Kennedy's early riding years were highlighted in the real estate listing literature.

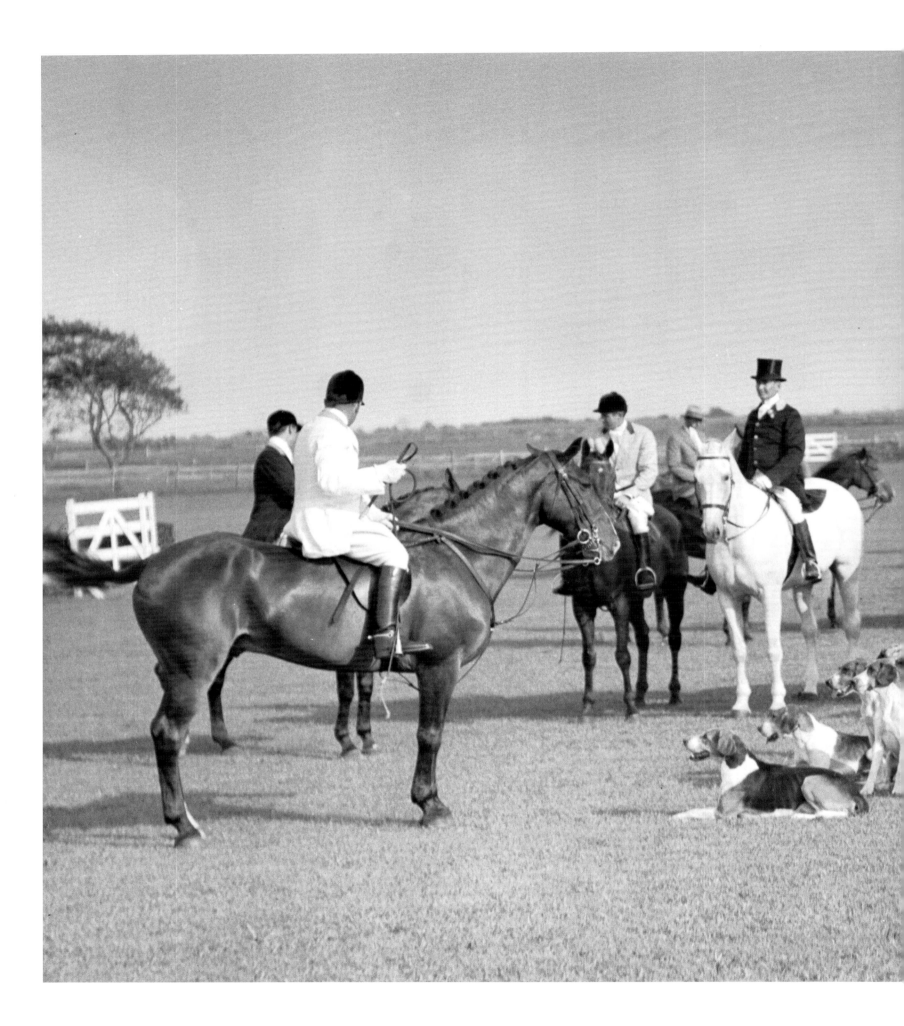

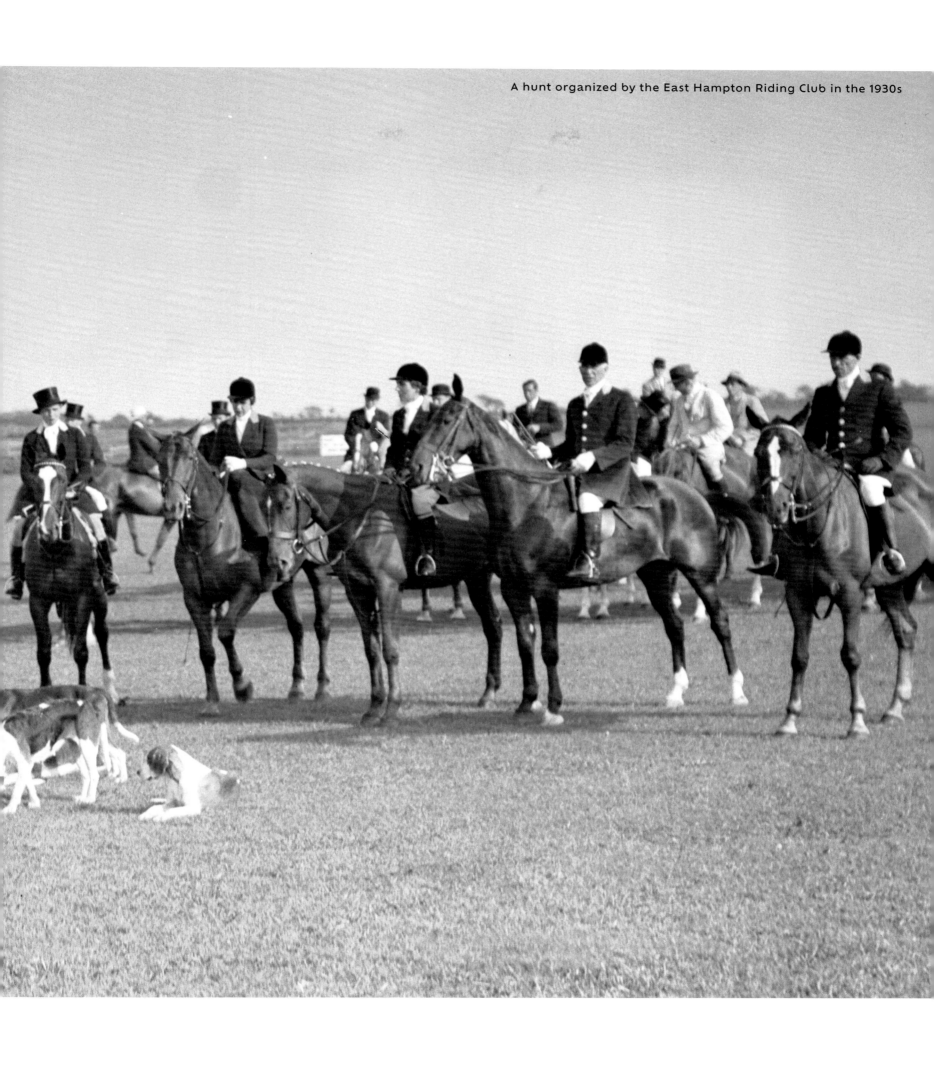

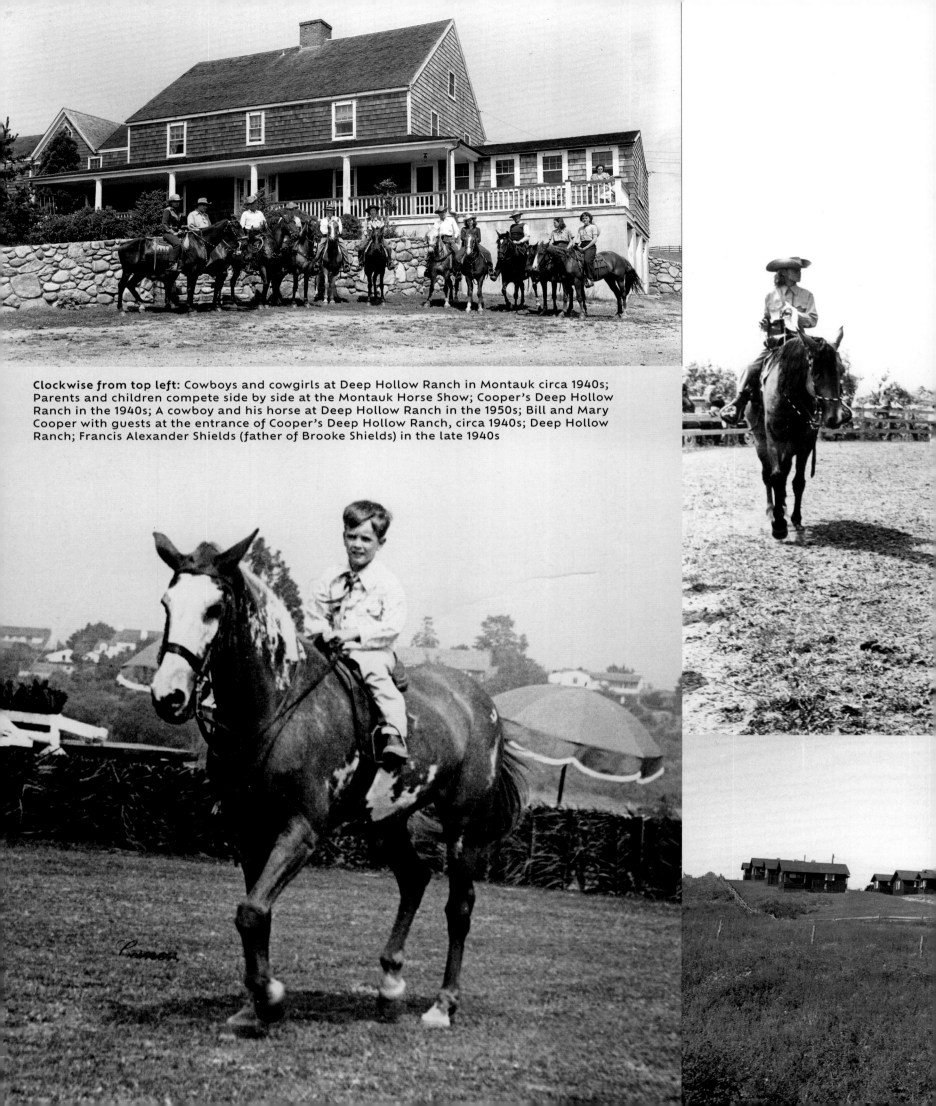

Clockwise from top left: Cowboys and cowgirls at Deep Hollow Ranch in Montauk circa 1940s; Parents and children compete side by side at the Montauk Horse Show; Cooper's Deep Hollow Ranch in the 1940s; A cowboy and his horse at Deep Hollow Ranch in the 1950s; Bill and Mary Cooper with guests at the entrance of Cooper's Deep Hollow Ranch, circa 1940s; Deep Hollow Ranch; Francis Alexander Shields (father of Brooke Shields) in the late 1940s

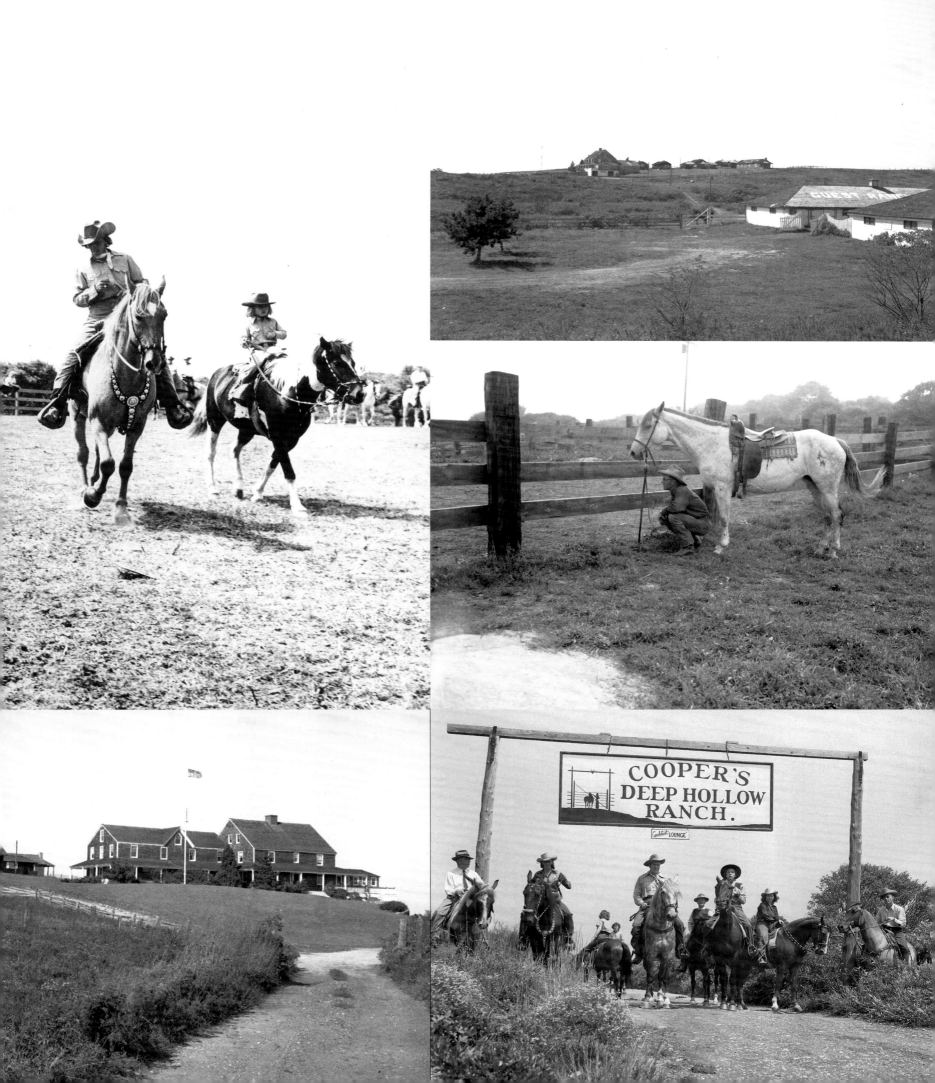

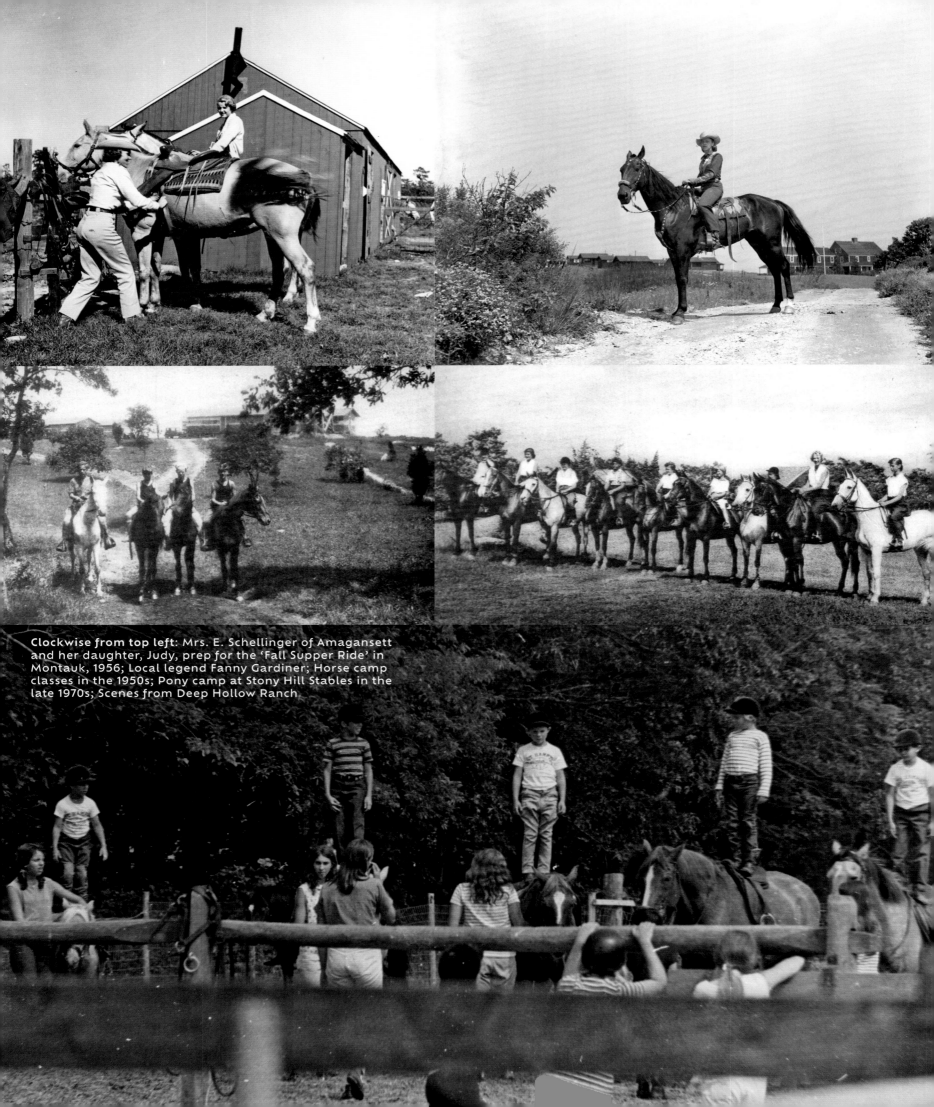

Clockwise from top left: Mrs. E. Schellinger of Amagansett and her daughter, Judy, prep for the 'Fall Supper Ride' in Montauk, 1956; Local legend Fanny Gardiner; Horse camp classes in the 1950s; Pony camp at Stony Hill Stables in the late 1970s; Scenes from Deep Hollow Ranch

For a few years in the late 1940s to the next decade, equestrian sports in the Hamptons became small affairs, mostly confined to Montauk with altogether completely different disciplines. Whereas English-style riding was favored at the erstwhile clubs, in Montauk Western-style riding led the reins, especially at Deep Hollow Ranch, the oldest cattle ranch in the United States. Among the classes at the Montauk Horse Show were quadrilles (riders working in groups and performing choreographed movements), cloverleaf races (riders racing against time to form cloverleaf patterns around barrels), and cattle cutting (horse and riders must cut a cattle away from a herd under a time limit). There was also a gymkhana for the kids, which included several games on horseback, plus egg-in-spoon races, barrel racing, and keyhole races.

One of the leading figures of Western-style riding in the Hamptons was Frances 'Fanny' Gardiner Collins. During her lifetime she was considered a legend in East Hampton. She spent her life riding, caring for and teaching about horses. She was descended from the first English family in East Hampton dating back to the 1600s when her ancestor Lion Gardiner, the first white settler in East Hampton, was bestowed what is now known as Gardiner's Island by King Charles I in 1692 following Gardiner's conquest of the Dutch settlers in Connecticut.

Frances was born on March 13, 1919, and as early as age four she was besotted with horses. She initially practiced English riding and competed at the shows in East Hampton and Southampton, and as far as Pennsylvania. But eventually she found she favored the Western-style more, trading in her jodhpurs and top hats for chaps and cowboy hats. "English horses are kept up a good deal. You can't go doodly-squat to the Candy Kitchen and tie them up to a hitching post. You live on a quarter horse," Gardiner was once quoted as saying (which was later reiterated in her obituary in the *East Hampton Star* on January 21, 2011). In her younger days in the 1930s and 1940s, Gardiner would often be spotted riding a horse around Main Street. "She was a dyed-in-the-wool horse girl. She lived with horses," added Gardiner's once business partner and former owner of Deep Hollow Ranch, Rusty Leaver, in her obituary. "When I was a kid I saw her as Annie Oakley."

The New York Times took notice of this shift in disciplines and declared in the headline on November 18, 1956: "It's Boots and Blue Jeans Now in Long Island, Where Society Sat in English Saddles."

"What stables and carriage houses are left from a generation ago, when registered society ran the Hamptons for itself alone, have been put back into use as horse stalls ... Today of course the riding style is predominantly Western style because it is easier and cheaper ... All the children want to look like Roy Rogers or Dale Evans. So, the popular riding dress is blue jeans or front pants, tooled cowboy boots, a scorchingly vivid shirt and a ten-gallon hat," read the accompanying article.

In 1959 an effort to revive the horse show in Southampton would be spearheaded by Mrs. Morris Scott Wadley as a fundraising event to benefit the Parrish Art Museum. This would become the early beginnings of the Southampton Horse Show. For a few years the show was held at the Stanley Howard Estate in North Sea, and like the horse shows of the 1930s it was followed by a formal dance.

The Southampton Horse Show would help kickstart the return to English-style riding in the late 1960s as schooling stables began to open and horse shows gained a resurgence. In fact, several stables banded together to create shows where riders can accumulate points that they can use to enter bigger horse shows. Among these were the Hotchkiss' Stony Hill Stables in Amagansett, Sue Marder's Centaur Riding Club at the Marder's house in the Springs in East Hampton, Swan Creek Farm and the Topping Riding Club at Tinka, and Bud Topping's farm in Sagaponack, which they have transformed from a potato field to a horse barn and stables. "We want to bring back, or at least encourage, the sport of English riding and hunting to an area that until 1947 was the home of three riding and hunt clubs," Lawrence Hotchkiss told the *East Hampton Star* on August 1, 1968.

"It was called the Hampton High Score and it was a good way to accumulate points," recalls early competitor and Hamptons native, Lolly Clarke. "I joined a lot of the horse shows as a junior amateur rider. I remember winning many classes and I was also determined to be the Grand Champion of Long Island. In those days unlike now where riders show up and their horses are ready to go in the ring, you had to be your own groom. You braided your own horse, prepped your own horse, and sometimes even drove the trailer yourself. There was so much joy you could get out of doing your own horse. When I should have been dating, I was getting ready for horse shows."

In the 1970s, the Ladies Village Improvement Society (LVIS) of East Hampton would stage its own horse shows. The first one was held on August 19, 1973, at Alvin and Patsy Topping's Swan Creek Farm in Bridgehampton. The Toppings were both on the LVIS horse show committee. "We put it all together ourselves," recalls Alvin Topping. "It was a different show back then because there were fewer houses and the fields were wide open. The courses were huge and long. It was a big event and we spent most of the summer preparing for that show."

The LVIS Horse Show aimed to recreate hunts replete with a breakfast spread on fine linen and bone china. "The show committee has made a supreme effort to make this our first annual show, a lovely and respected event, reminiscent of the grand shows of the 1920s and '30s sponsored by the East Hampton Riding Club," wrote LVIS Horse Show chairwoman, Edwardina D. O'Brien in the show's invitation. Since the society's mission is for the beautification of East Hampton, extra attention was given to the fences and jumps, which were described as having elegant flowers and greenery. O'Brien donated the top prizes at the horse shows, including trips for two to London and India. Proceeds from the shows went to the maintenance of the parks, greens, and trees of East Hampton Village.

Immediately after the second year of the LVIS Horse Show, O'Brien sent out a handwritten report about the horse show to members of the LVIS, which was gleaming with pride at the committee's efforts to make the event a success. "I am proud to announce that our 1974 LVIS Horse Show, Sunday, August 18th at the Swan Creek Farm was an outstanding success ... We were blessed with a beautiful, clear, cool day, and I can, now, safely say we have firmly established a quality sporting event in the Hamptons, an event of beauty and style for LVIS and East Hampton to be proud of, forever." The LVIS Horse Show was a Class B event and points earned by riders went on to their tally, which hopefully would help them qualify for the national horse show at Madison Square Garden.

Top: Alvin and Patsy Topping on their horses at their stables,
Swan Creek Farm, in Bridgehampton
Bottom: Patsy Topping competing sidesaddle at the Hampton Classic

One of the highlights of the LVIS Horse Show was the sidesaddle class. "It's quite spectacular really. The ladies wear full formal riding attire—top hats or derbies, black hunting jackets, white stock ties, and yellow vests. The horses, too, will be turned out in regulation appointments, including braided manes and tails, and they'll have the sandwich cases attached to their saddles. Do you think we should fill the cases with the customary sandwiches and flasks of sherry?" remarked Patsy Topping to the *Social Spectator* in 1976. Patsy herself was an exceptional sidesaddle rider.

A couple of competitors from the very first LVIS Horse Show in 1973 are still riding in the Hamptons today. Harriett deLeyer, whose family is steeped in the equestrian history of Long Island, was twenty at that time and she has long since become a professional and a riding instructor. Sisters Deborah and Dawn Brennan also joined the show, both of whom are still actively competing. Deborah Brennan Thayer recalls those early years in the Hamptons when she could ride her horse from her house in Bridgehampton to the schooling stable in Sagaponack, and after her lesson, she would stop by the store next to the post office to get a drink or a candy then make her way home. "It was so much fun back then. You could ride your horse anywhere because there weren't many houses and cars. All you needed was permission from the farm owners to ride through their fields. We would take our horses along Ocean Road and go to the beach. We all felt very safe. You can't do that anymore."

Brennan Thayer also remembers the years when they had horses in their backyard and threw parties for her children where they had pony rides. Having a horse on one's property is the ultimate luxury for any horse-mad individual, and back then it was possible. However, as the Hamptons started attracting more people and more development, the towns imposed rules on acreage. Zoning laws in the Hamptons would prohibit casually housing a horse on your property. There is to be a minimum of five acres of property, and an acre for each horse on farms smaller than fifteen acres. Beyond fifteen acres, two horses are allowed for every acre. The towns define horse farms as those only "for the boarding, breeding, raising, training, or stabling of four or more horses." Exceptions are made for agricultural use.

The Southampton Horse Show experienced a few years of dormancy in the late 1960s and it was revived in 1971 by Mrs. Edwin M. Schwenk, Jr. The show was held at the Topping Riding Club in Sagaponack in aid of the Hampton Day School founded by Tinka Topping. This event in 1971 would go on to be considered the birth of what is now called the Hampton Classic. It would stay at the Topping Riding Club until 1975.

Tinka Topping together with Anne Aspinall, who at the time was a riding instructor at the Topping Riding Club, helped forge the way to making the Hampton Classic one of the best, if not *the* best horse show in North America. "Anyone who has ever enjoyed even a single day of the Classic over these last thirty years owes Anne a tremendous debt of gratitude," shared Dennis Suskind, president of the Hampton Classic board of directors, at the news of Aspinall's death in 2012.

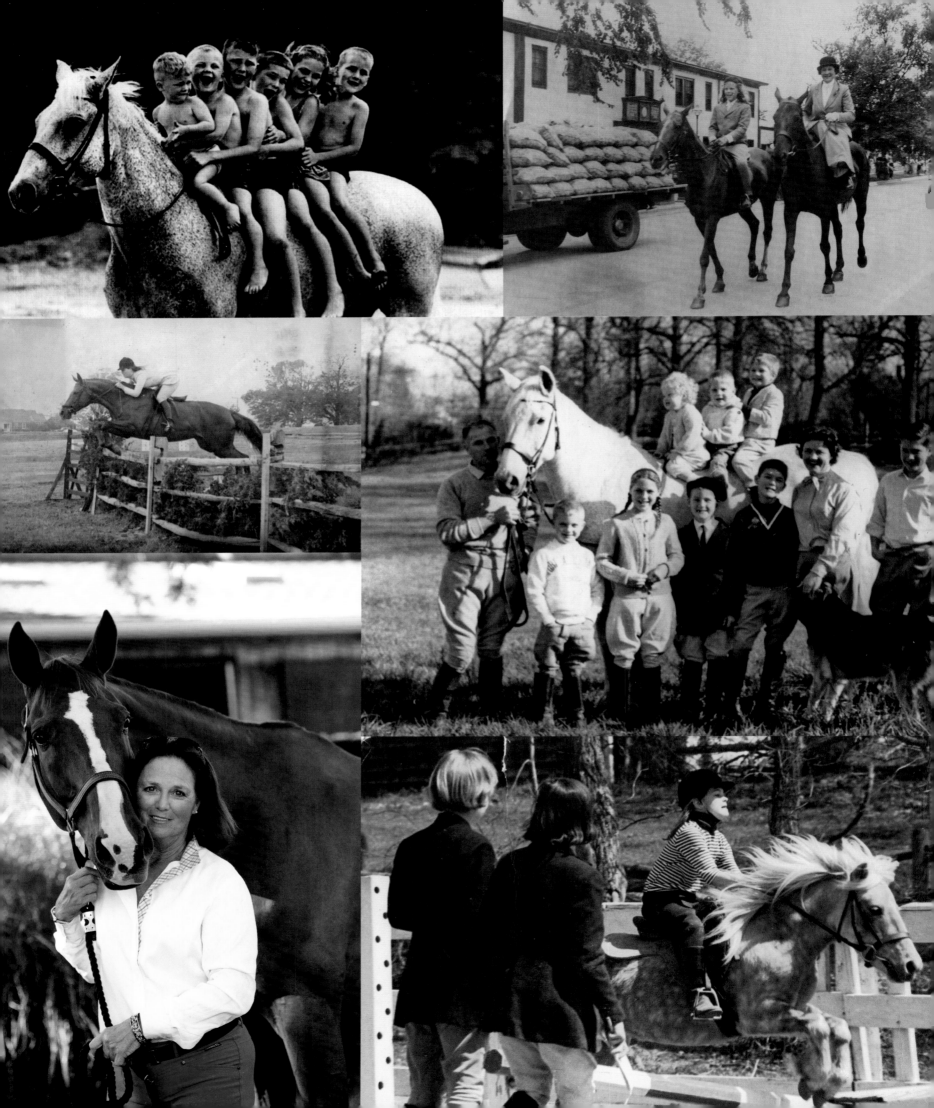

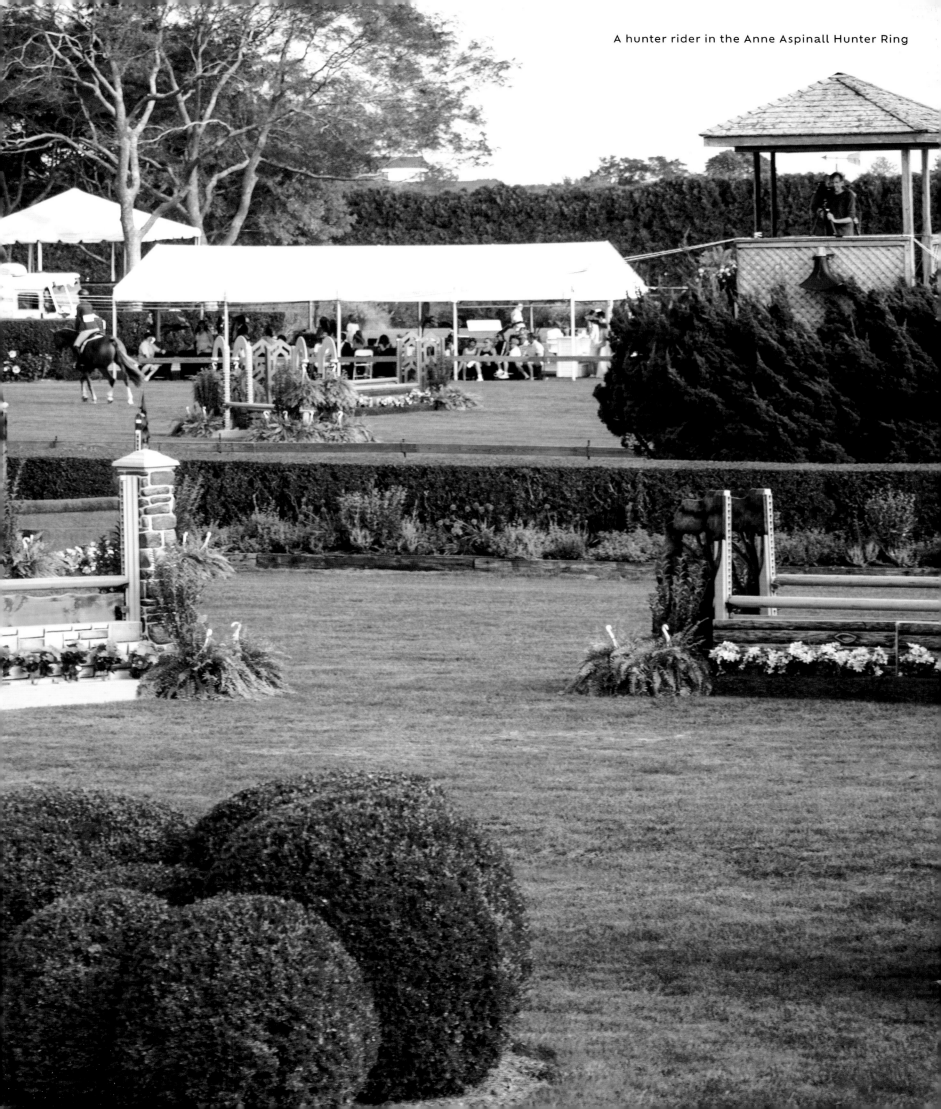

Arguably the most attended show at the Hampton Classic aside from the Grand Prix is the lead line class. This involves a parade of children aged seven years and under, decked in crisp show clothes on their shiny ponies, being guided by their trainers. It is a show that is as much about the riders as it is about the parents. Throughout the years big-name celebrities have watched their young offspring compete in the lead line class, among them have been Sarah Jessica Parker, Billy Joel, Kelly Ripa, Mariska Hargitay, Alec Baldwin, and even professional show jumpers McLain Ward and Georgina Bloomberg.

Lead line judge and Olympic champion show jumper (and the man often credited for making the sport popular in America), Joe Fargis adds, "It's a lot of fun. And I've never seen kids dressed so beautifully. I've also seen kids wet their pants. I've seen kids cry. I've seen kids get off their horses and walk out of the ring. Most of the kids, and this is the darnedest thing, they will not look at me. The minute the judge comes to them, they go into a fetal position. Their heads go down and that's it. And the leader is begging them, begging them to talk to me."

"It's quite the cheering section. Everyone looks their best and we have a lot of fun staging it. We cap it at a hundred entries and we have a waiting list. People take it seriously," says Shanette Barth Cohen, executive director of the Hampton Classic, of the lead line class.

The Hampton Classic has also expanded its competition classes to include riders with disabilities. "Personally, the element of the show I'm most proud of is the Long Island Horse Show Series for Riders with Disabilities Finals (LIHSSRD), which was one of the first things I helped add to our schedule when I took on the role of executive director," Shanette adds. "It's heartwarming to watch the athletes who compete in the LIHSSRD program each year, and their development as equestrians and as people."

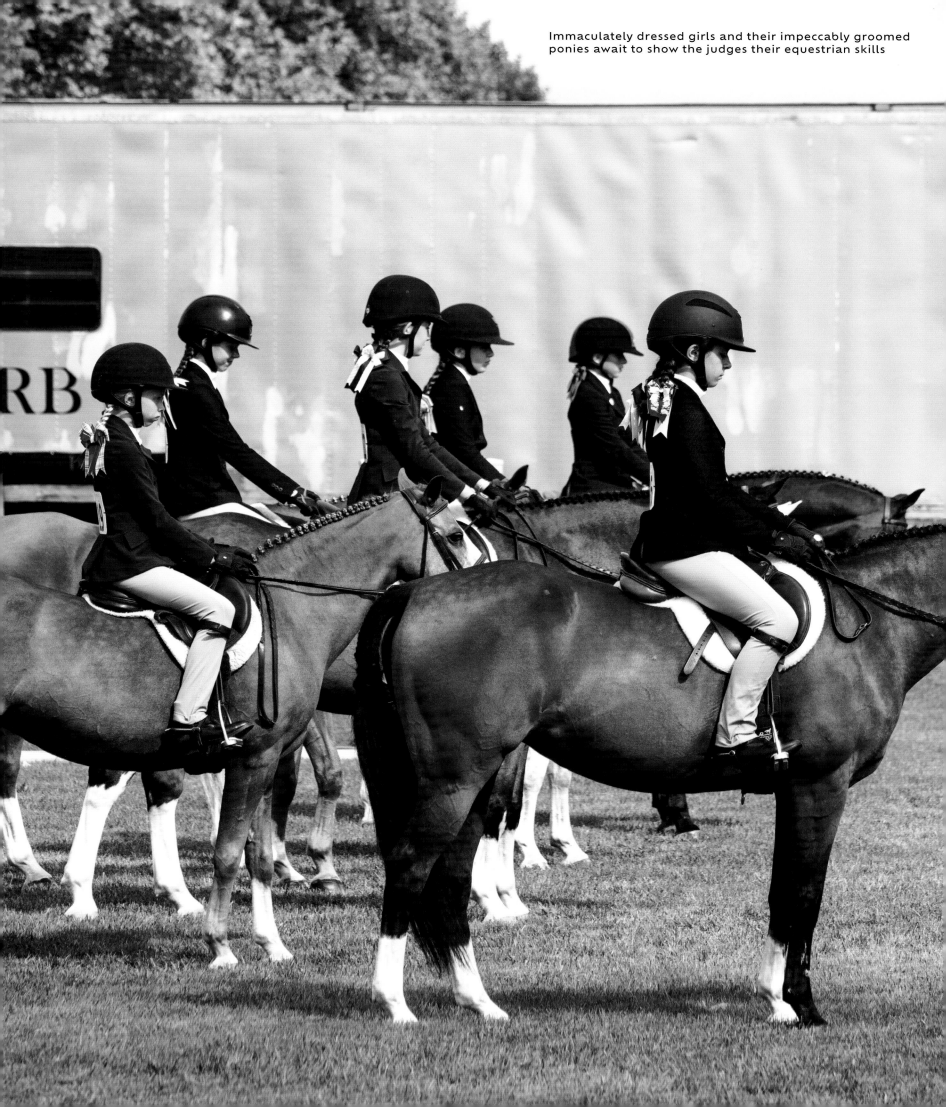

Immaculately dressed girls and their impeccably groomed ponies await to show the judges their equestrian skills

Scenes from the children's division.
Top from left to far right: Riders in eager anticipation of their ribbon standing; Horse and his champion rosette; Anais Dufresne Powell and her pony, Spice It Up; Amelia Wetenhall
Middle from left to far right: Sarah Jessica Parker gets her daughter prepped and ready for the show; Joey Wölffer's daughter, Evie Rohn, wins a yellow ribbon in the lead line competition; Georgina Bloomberg's son Jasper and his pony; Zoey Trotter; Braids and ribbons on a young rider
Bottom from left to far right: Girls watching the action ringside; Sienna Rose Pepa wins the top prize in the lead line competition and receives hugs and kisses from her aunt and father; The highly competitive and entertaining lead line competition

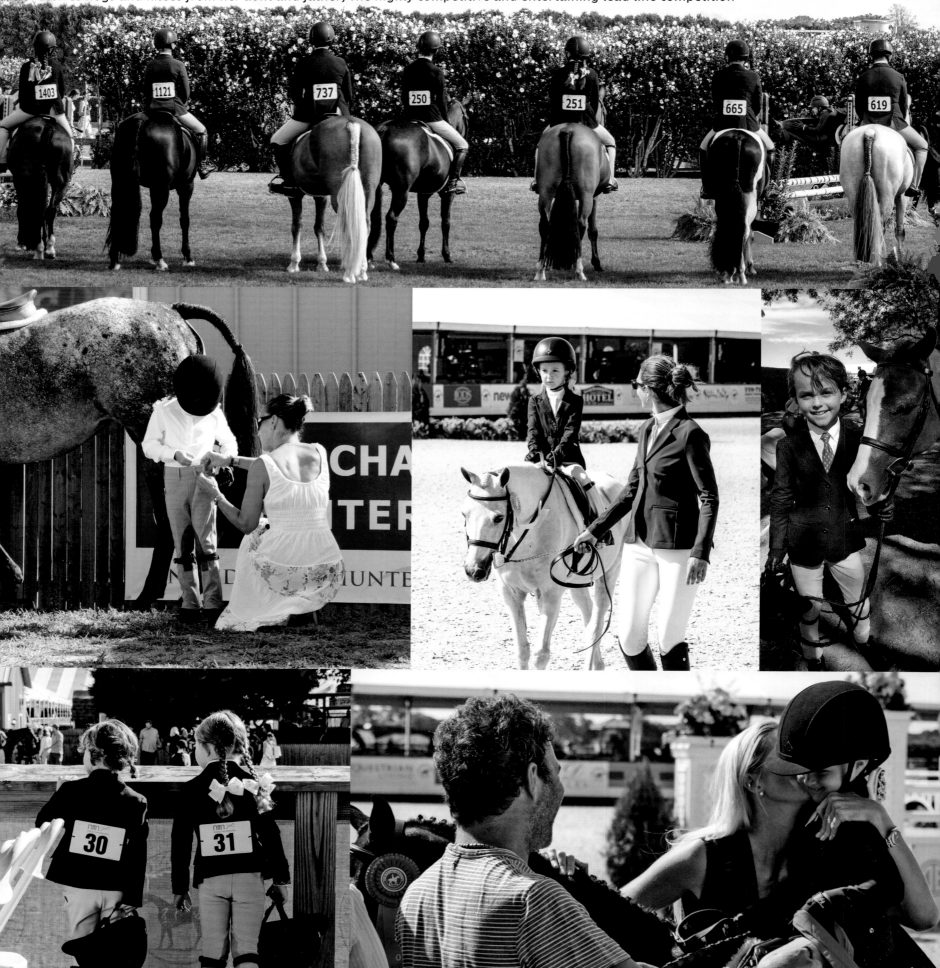

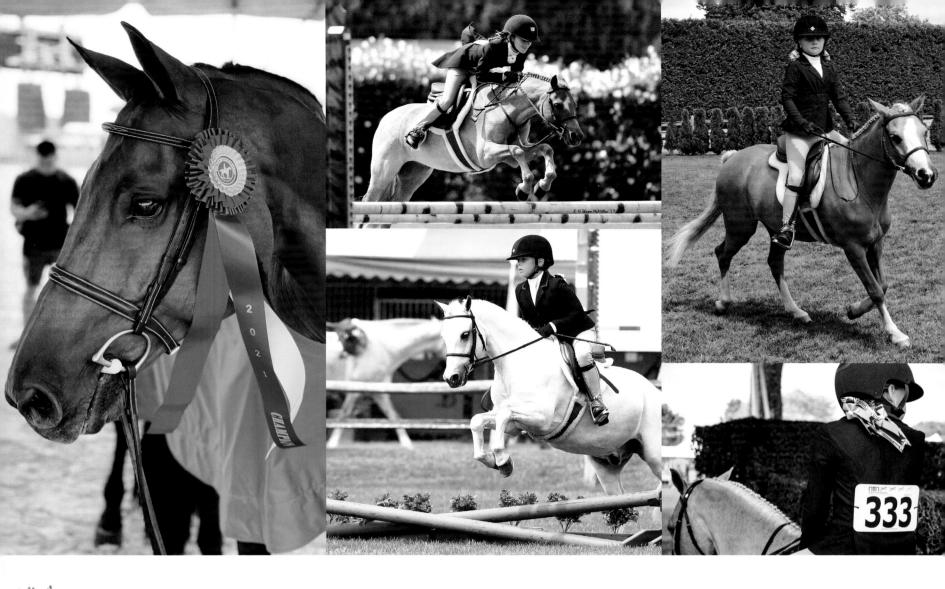
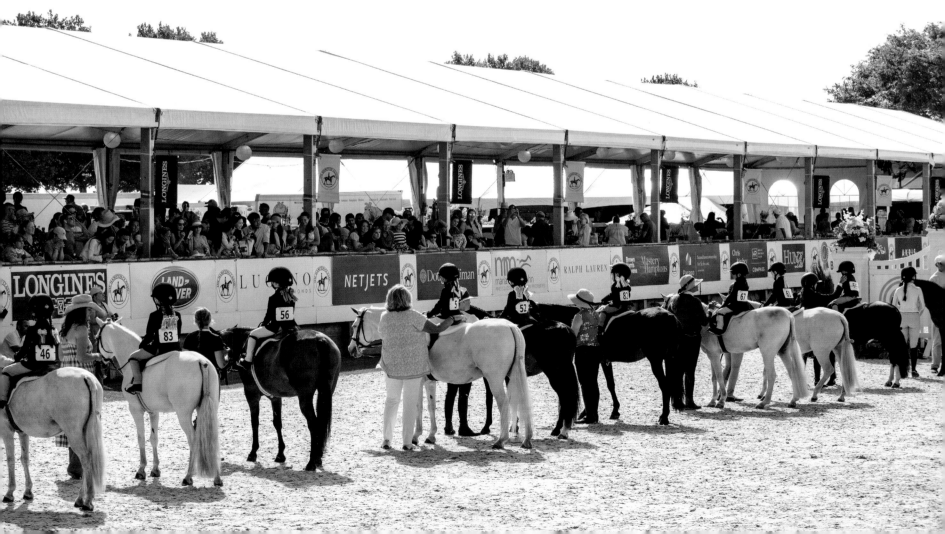

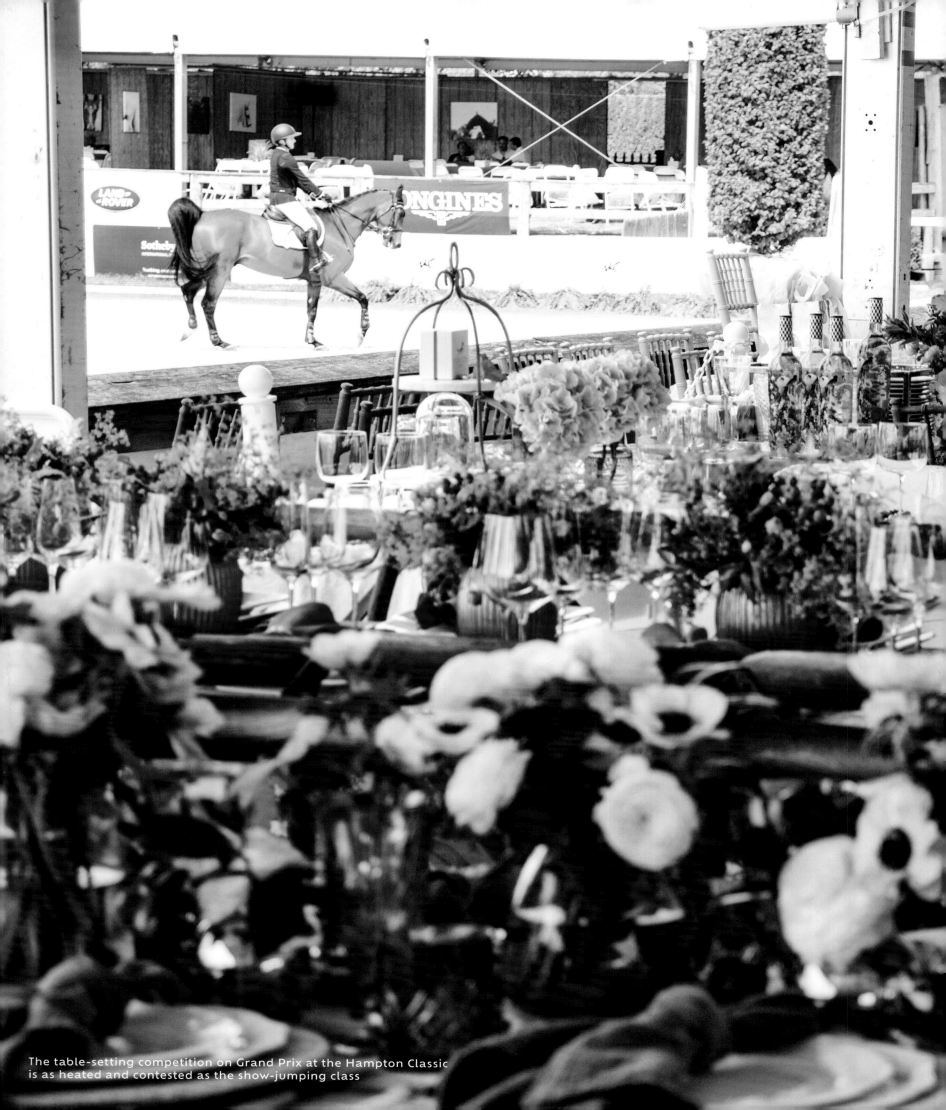

The table-setting competition on Grand Prix at the Hampton Classic
is as heated and contested as the show-jumping class

TABLE MANNERS

On the seventh day of the Hampton Classic, a different kind of competition happens in the showgrounds. There are still horses, of course. However, they are of the inanimate kind. They come in the forms of sculptures on long tables or as napkin holders or patterns on fine china. They are part of what is arguably one of the fiercest contests at this horse show: the table-setting competition on Grand Prix day.

Under the big white tent on the perimeter of the Grand Prix arena and amid the buzz and chatter from spectators in a wide range of summer dresses and fancy hats, sorbet-hued suits, and shorts dotted with nautical motifs are rows and rows of VIP lunch tables decorated in the most extravagant fashion. Floral centerpieces cascade down the tables or take on the shapes of equestrian motifs. Standard issue white tablecloths are replaced by custom-made pieces to evoke a theme. Wicker dining chairs with special cushions are brought in. Napkins are embroidered with invited guests' names. Some purchase three tables to create a horseshoe formation.

The tables are usually booked and hosted by the show's sponsors, by families who have equestrians competing during the week, or by individuals who like to partake in this last hurrah of the summer.

Since the shelter magazine *Hamptons Cottages & Gardens (HC&G)* started the tabletop competition in 2012, the settings have become more elaborate, so much so that centerpieces and floral arrangements have been capped at a height of eighteen inches. An inch higher than that means automatic disqualification. And the competition is almost as high stakes as the show-jumping events.

"What started as a sort of humble, local for-kicks kind of event has evolved into a hugely popular competition with a capital C! People have really knocked it out of the tent with elaborate floral displays and inventive table settings. The show jumping is almost an afterthought," exclaims Kendell Cronstrom, editorial director for *HC&G,* as he whipped out a yardstick to begin his judging round. "Tables that really drive home the equestrian theme or feature gorgeous, inventive flower arrangements have always caught my eye."

I was asked to be one of the judges at the 2022 Hampton Classic Tabletop Competition and I was blown away by the creativity of the table owners and their designers and florists. Table after table featured stunning and luxurious flower arrangements. The more successful tables were those that created a theme and carried it through every element of their tables, be it in the flowers or plates or napkins, down to the chairs and trunks used to store food and beverage. Big-name luxury brands like Hermès, Ralph Lauren, Asprey, and Longines compete alongside local stables, homegrown and visiting sponsors like The Colony Hotel in Palm Beach,

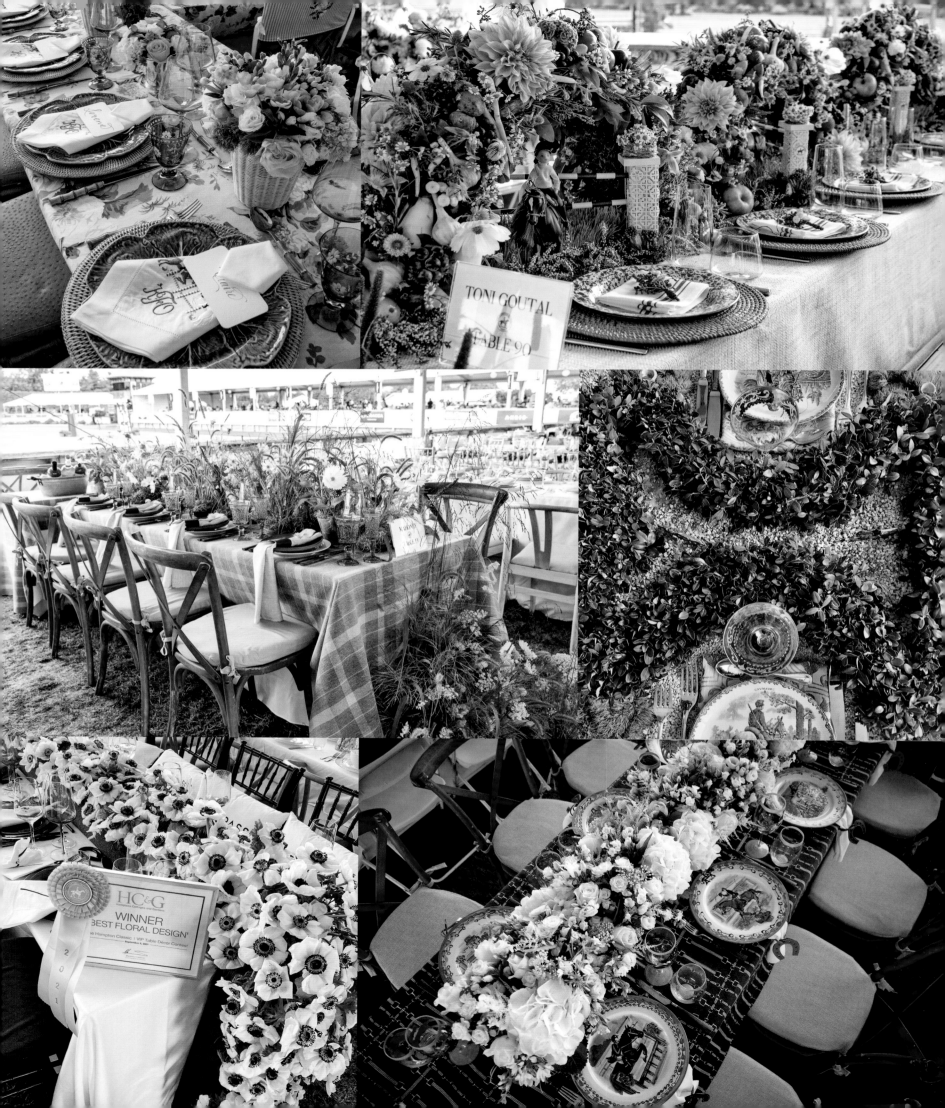

and private individuals for the coveted Best in Show blue ribbon. "When The Colony Palm Beach invites you to the Hamptons, you bring monkeys to the horse show. And pink pineapples and hot pink toile and juicy citrus," described florist and event designer Lewis Miller of the table he orchestrated for the Florida hotel.

Kelli Delaney, a Hamptonite and woman about town, has in the past been asked to judge to the table competition. "I chose my ribbon winners based on creativity in terms of how they incorporated an equestrian theme into their tablescapes, as well as overall originality in floral design, linens, and tableware. This is a maximalist design competition for sure. Many of the table hosts bring in interior designers from Manhattan to create their tabletops. From vintage Gucci horsebits fashioned into napkin rings, to linens embroidered with the crest of the horse farm, every detail matters," Kelli explains.

This is the Hamptons after all, where no expense is spared.

New York–based interior designer Sasha Bikoff has been designing her family's table at the Hampton Classic for a few years. She's done variations on the equestrian theme but often in unexpected ways as in the case when she did an Arabian Nights theme or unicorn fantasy wonderland, or when she turned her table into a Versailles garden, replete with petite boxwood parterres, gravel, statuary, and chairs covered entirely in faux grass. "The Hampton Classic tables vary from classical to modern; some pay homage to the equestrian lifestyle, and more recently contestants have really started to think outside the box. For myself, I always like to stay on a horse theme but with a twist. I think

it takes creativity and a beautiful execution to win. I have been successful in the past because of my attention to every single little detail on the table, from the custom napkins and tablecloths to the little figurines that adorn my tablescape. For me it's not a basic approach where I only consider the floral arrangements," says Sasha Bikoff.

One of the Best in Show winners of recent years was a table designed by event floral designer Christy Doramus. It was in all shades of pink owing to the table's rosé wine sponsor. She describes, "I was determined to create a fun, friendly, and highly detailed destination for the winemaker's esteemed guests. From beautifully illustrated menus and personalized horse show ribbons featuring guests' names to handmade napkins, seat cushions and pillows made from carefully selected fabrics. Every element of my table was customized to delight all who dined or simply pass by for a glass of rosé. I always enjoy incorporating a few pieces of china from my personal collection or roses from my garden because every tablescape is truly a labor of love for me."

The awards for Best in Show and two runners-up plus special citations for floral design, theme, and innovation are handed out before the ringmaster Alan Keeley, in his red, blue, and gold livery, steps into the arena to sound off his trumpet to announce the most anticipated and final show-jumping competition of the week. Ribbons are met with squeals of joy and rousing applause by table hosts and their guests. Clinks of champagne flutes and cheers all around ensues, just in time for the first Grand Prix competitor to make an entrance in the ring.

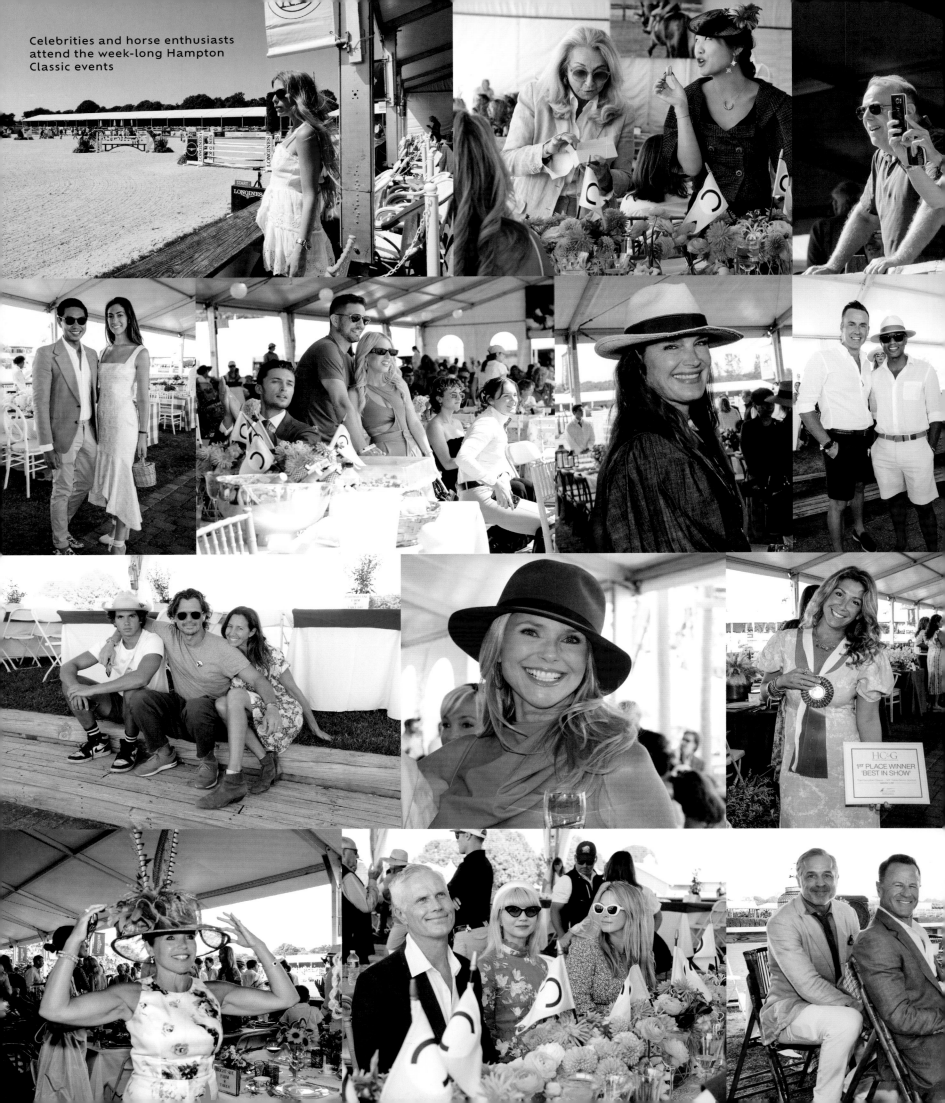

Celebrities and horse enthusiasts attend the week-long Hampton Classic events

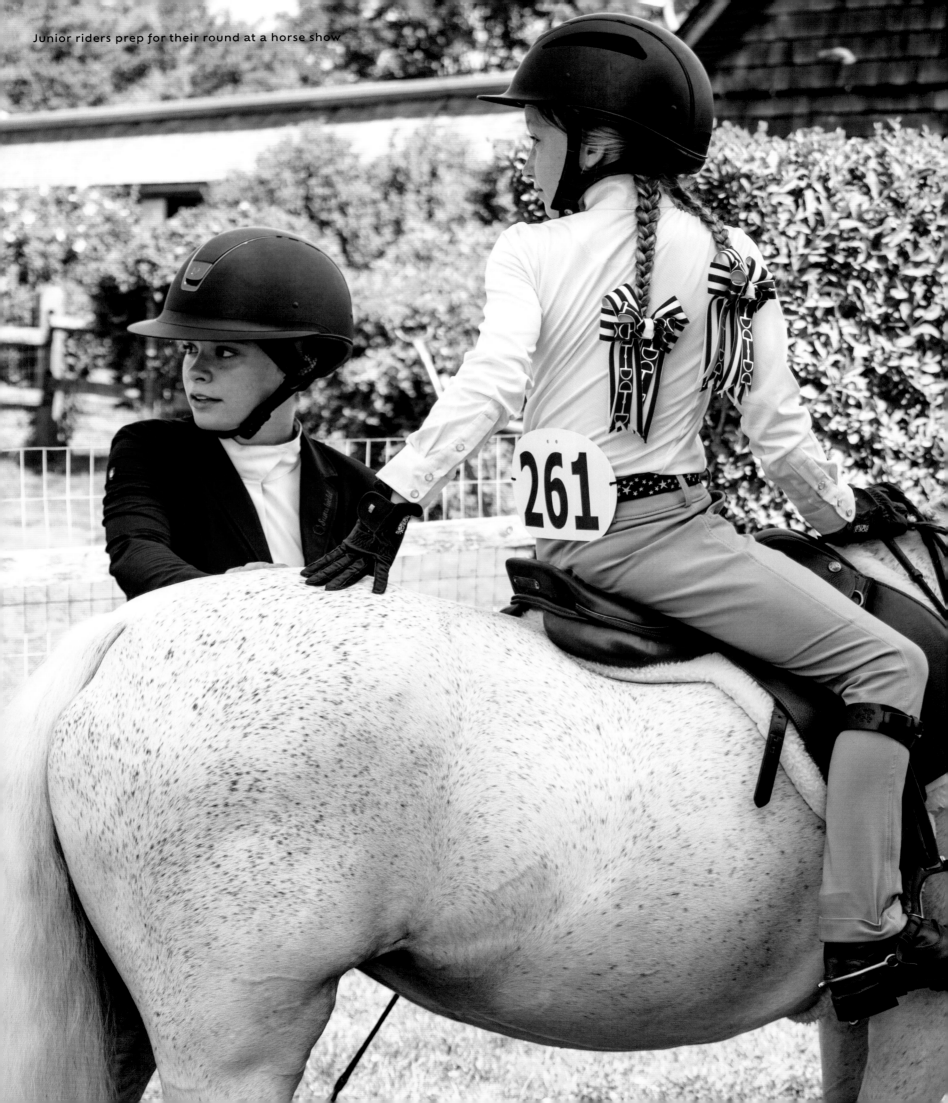

A breeding ground for would-be Hampton Classic competitors and winners is the Sagaponack Horse Show at the Topping Riding Club. It is held twice a year in the summer, often three weeks apart, in mid-July and early August.

The club's farm manager, Mercedes Olivieri says: "It is one of the oldest shows at this end of Long Island, having been started in 1968 by Tinka Topping as a fundraiser for the Hampton Day School. We keep it going because it is fun and rewarding. We start planning in February with a meeting at the Hampton Classic office to go over judges and crew to make the show safe and in keeping with USEF [United States Equestrian Federation] guidelines. Then starting in May, it's all about keeping the footing in both the grass ring and the hunt field in good shape. All the jumps have to be cleaned and repaired or repainted." Mercedes adds, "My favorite memory from the show was when I was in my thirties and I was a gatekeeper for the grass ring. We practically had to shine the car headlights onto the field to finish the last flat class because there were so many entries."

Jenno Topping, whose family started the Topping Riding Club and who lived on the premises as a child says in jest of the Sagaponack Horse Show: "It was nice to roll out of bed and get on a horse and compete, because you usually have to wake up early to get to a horse show."

She was the rider to beat in her teenage years, winning almost all the top prizes in the competitions she entered. "It's such a mental, emotional sport because it is not just your headspace. It's also whatever was going on with your horse. I remember loving the focus and feeling of everything falling away except competing in the ring. It wasn't zen because you're competing in a really intense way, but because of that focus there was nothing else that occupied your mind," adds Jenno of the mindset she had when she was top competitor.

While there are a few adult classes at the Sagaponack Horse Show, it is largely a venue for children and teen equestrians. As such, you can find scenes of little girls and boys with their haul of ribbons tied to their belts and high school students giving each other confidence boosts and loud cheers from the sidelines. Siblings Juliette (twelve) and Jilliana Jimenez (ten) have been showing at the Sagaponack Horse Show since they were each three years old. Together they have amassed the top prizes and boxes full of ribbons. (They also appear on the cover of this book.)

In her childhood and teen years, Paige Allardice competed numerous times at the Sagaponack Horse Show. "It's one of my favorite horse shows because it feels like home. I grew up down the street on Parsonage Lane and our horses lived in a barn in our backyard. From ponies to horses, I remember always getting good ribbons because it was a relaxing environment. The horse show would also usually be on my birthday, August 10, so it was always a good time with lots of horse show friends and family," recalls Paige.

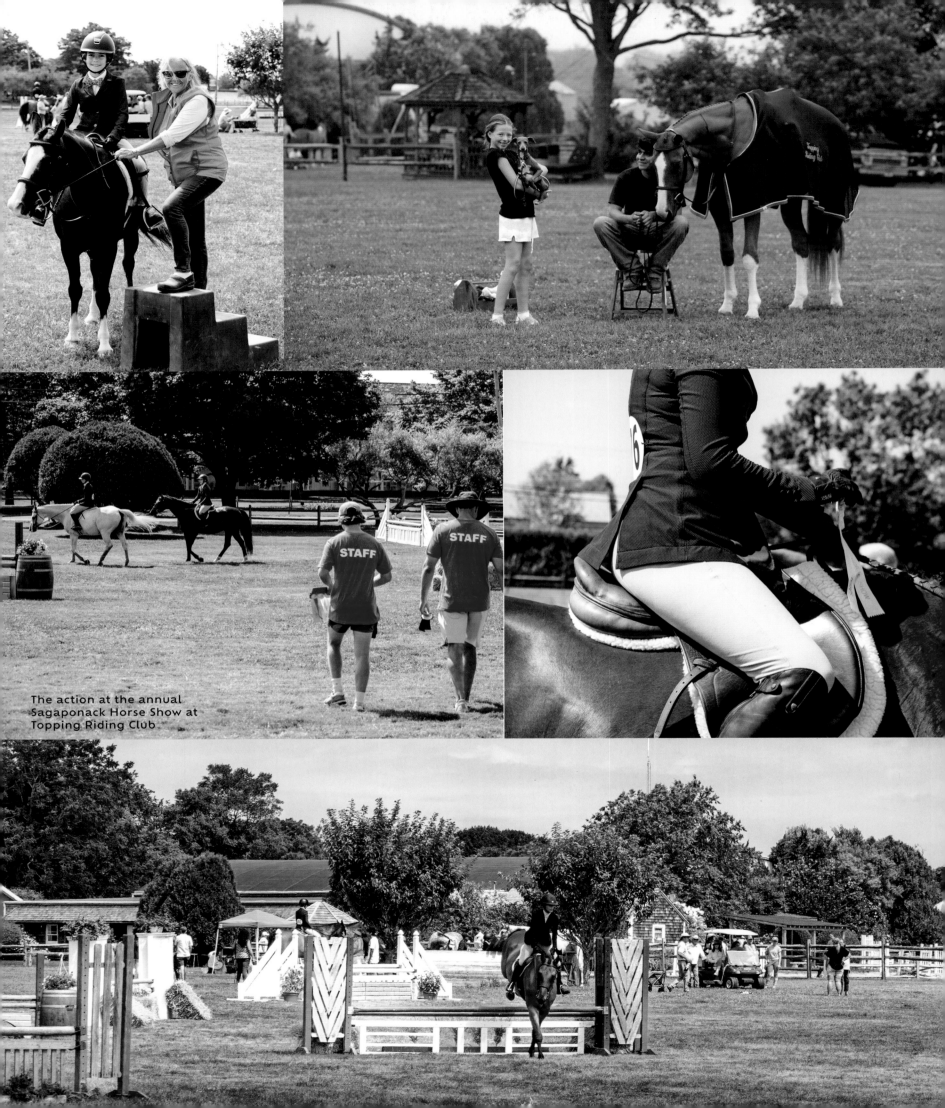

The action at the annual Sagaponack Horse Show at Topping Riding Club

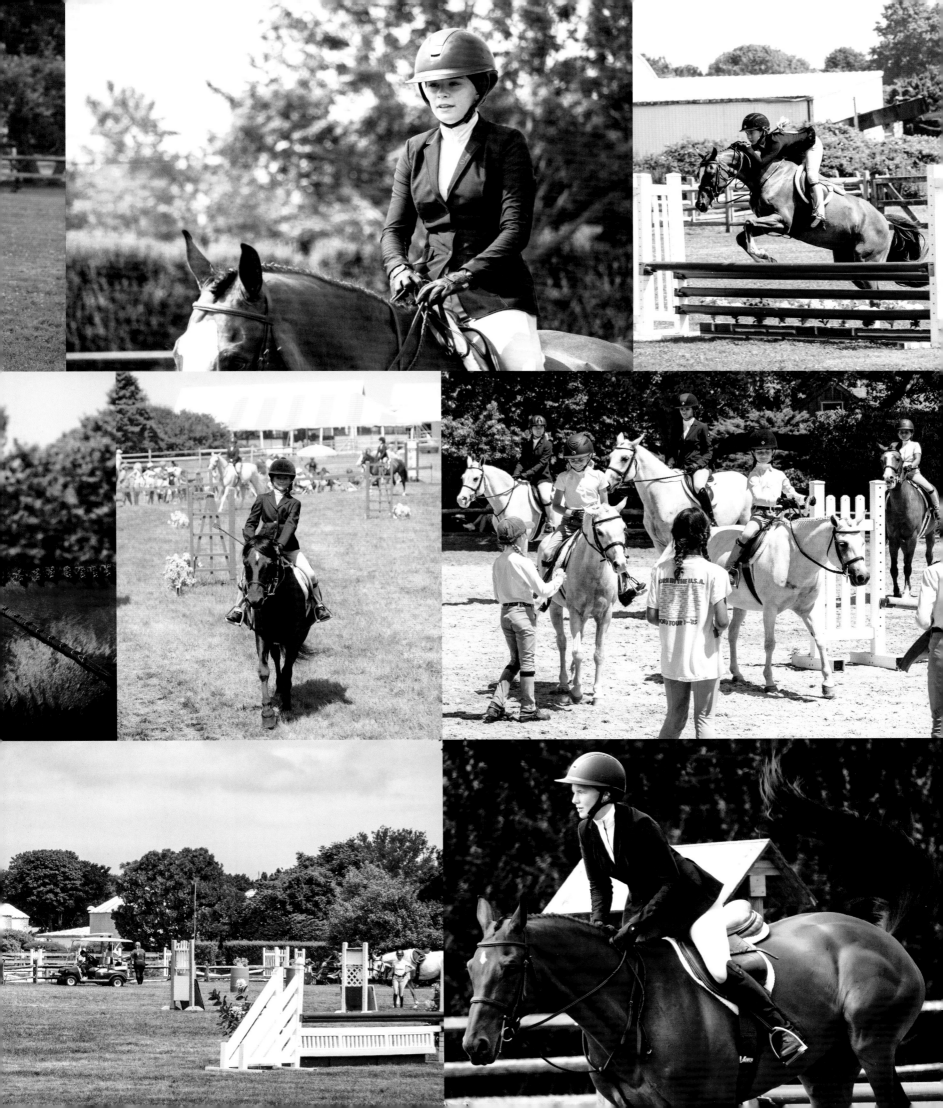

In 2022, Paige Allardice was at the Sagaponack Horse Show. Not as a competitor but this time as a parent. She was there to watch her four-year-old daughter, Sienna Rose Pepa, compete in the lead line class. Like her mother, Sienna bested all the other children in the class and won the blue ribbon. "It was such an incredible moment and filled my heart with so much joy," remembers Paige. "I was so proud of her and there is nothing better than seeing your child smile as big as she did. It brought back so many wonderful childhood memories. I finally understand how nerve-wracking it must have been for my mother to watch me in the ring, and [it] reminded me how much time and effort goes into prepping for a show day. It's a dream of mine to see this all come full circle." A few weeks later, Sienna Rose would go on to win the biggest prize of her age group, the Blue Ribbon at the lead line class at the Hampton Classic.

The other local horse show in the Hamptons is the Long Island Professional Horsemen's Association (LIPHA) Horse Show, held over two days at the very beginning of the Hamptons season in mid-May. For the past few years, it has been staged at Wölffer Estate Stables in Sagaponack and is attended by riders from the Hamptons as well as other parts of Long Island. The LIPHA Horse Show is held to raise funds for the organization's missions. "The LIPHA is there to aid and educate professional horsemen. We have an academic scholarship program. We have a fund to aid members in case of injuries, death, and other times of need. A lot people in this industry do not have health insurance so if something happens we are there for them to help through the hard times," says Harriet deLeyer. The LIPHA Horse Show is a reunion of sorts for riders and trainers who have been hibernating during the winter months. It is also a great warm-up event for competitors before the bigger shows in Upstate New York and Princeton, New Jersey.

The horse show season in the Hamptons ends with the Fall Derby at Topping Riding Club in mid-October. Riders of all ages compete in the grass arena with obstacles that replicate what one would have seen from traditional hunts of the past. The riders go through the courses surrounded by the glowing fall foliage and seasonal décor of mums and pumpkins. All around is the spirit of friendly competition.

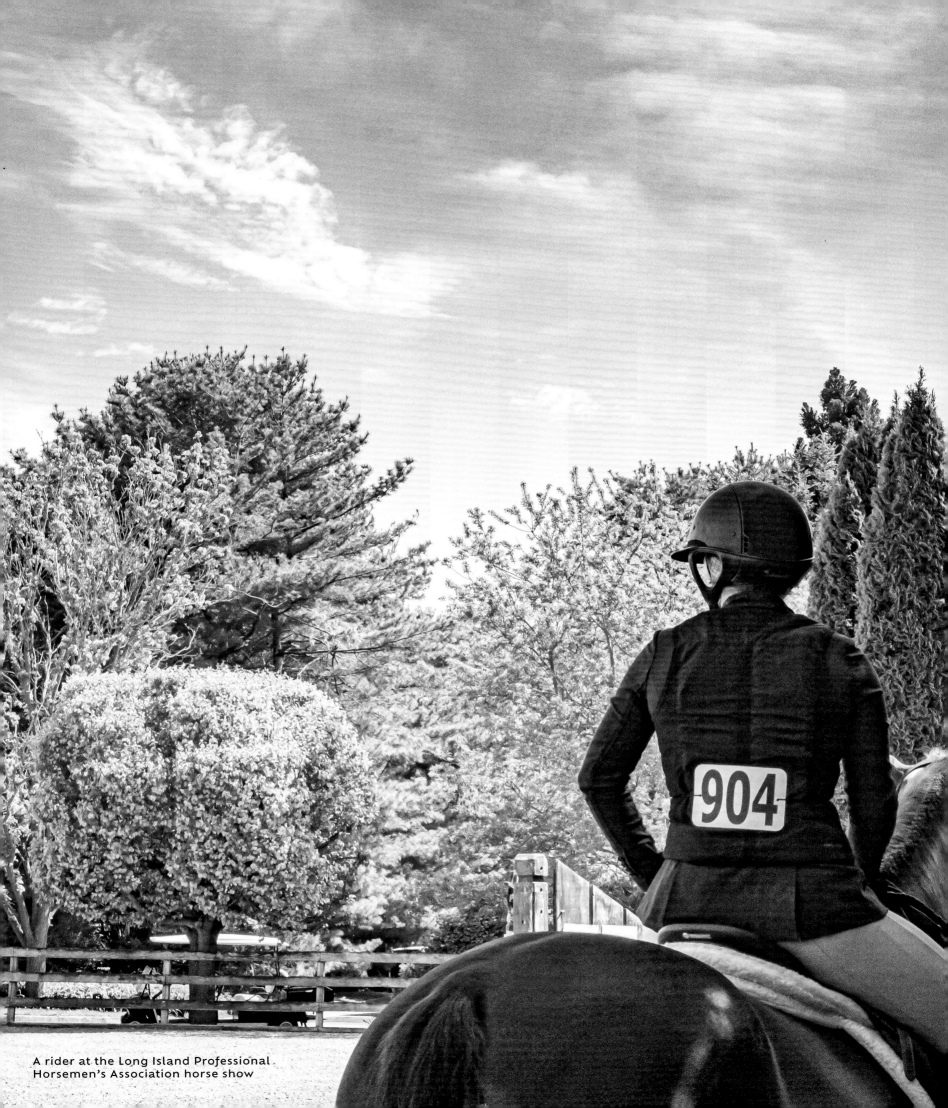

A rider at the Long Island Professional
Horsemen's Association horse show

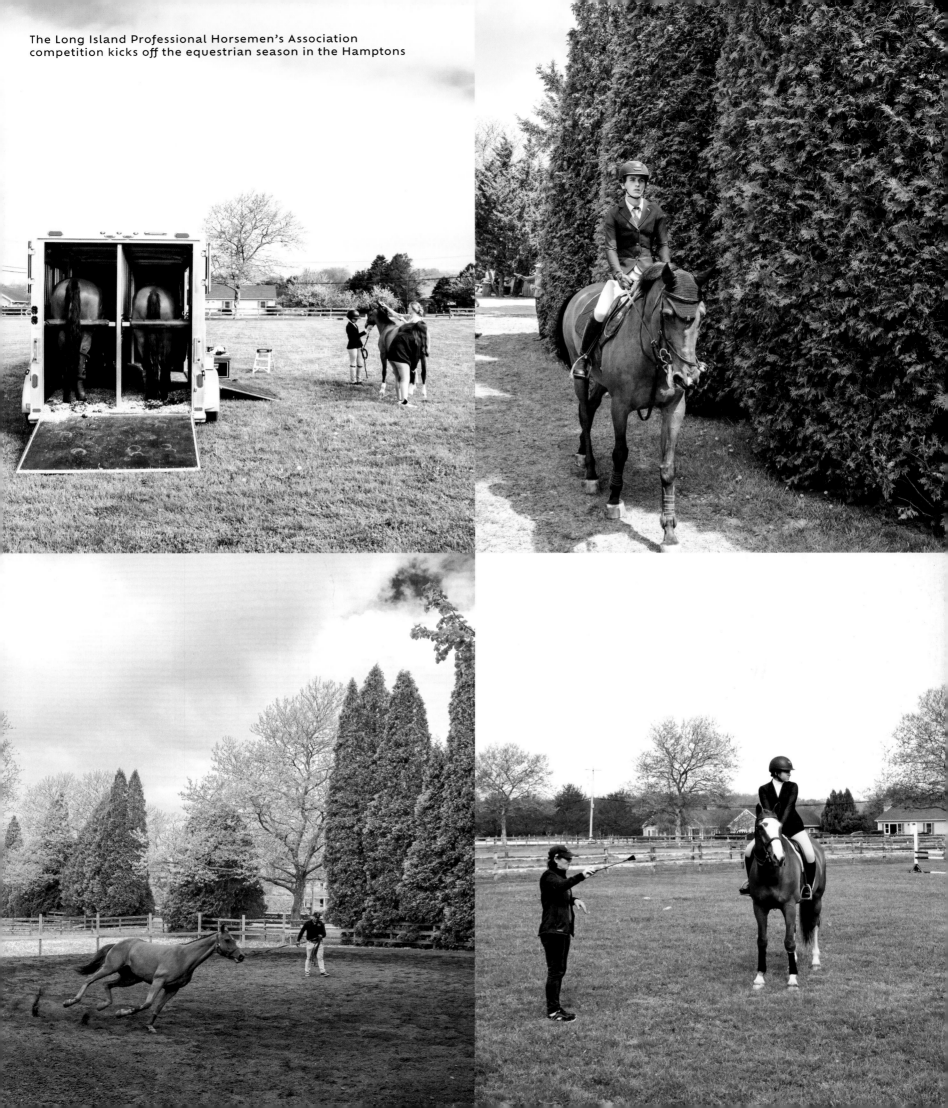

The Long Island Professional Horsemen's Association competition kicks off the equestrian season in the Hamptons

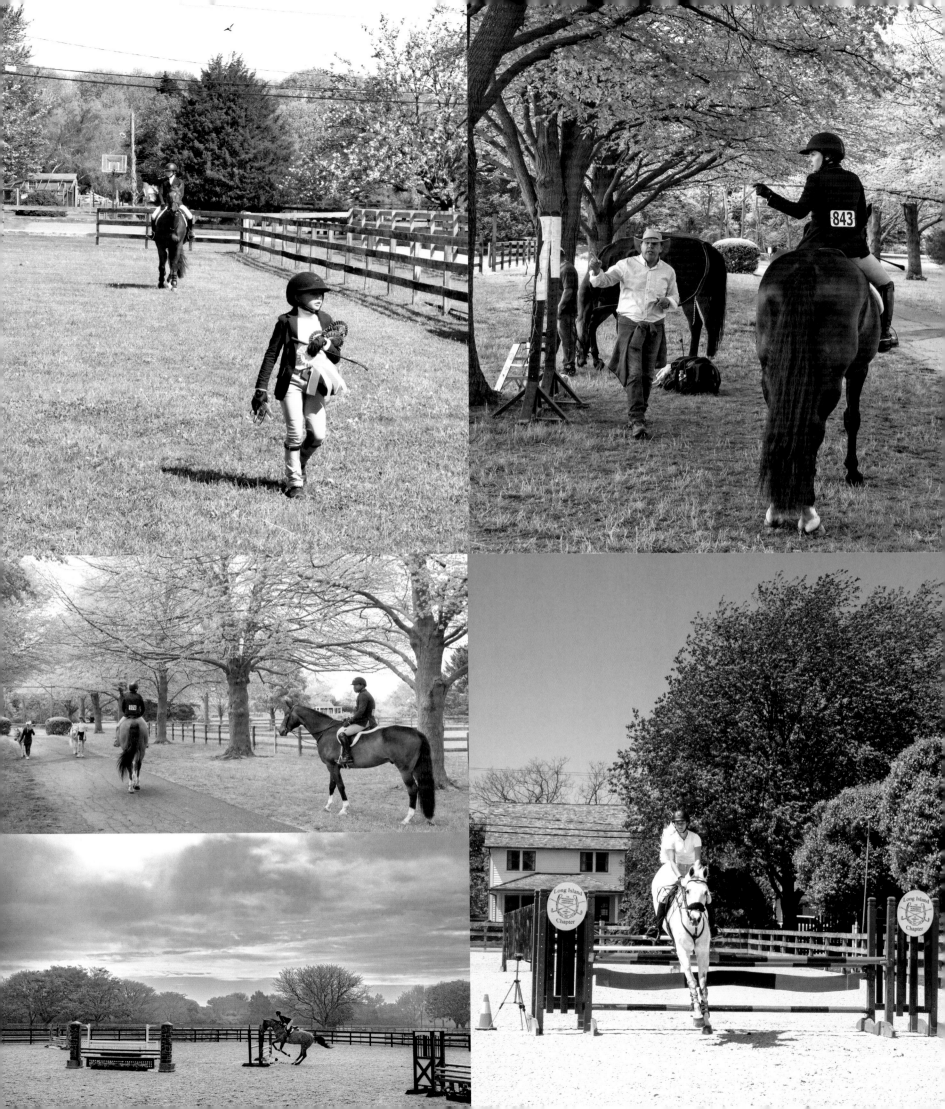

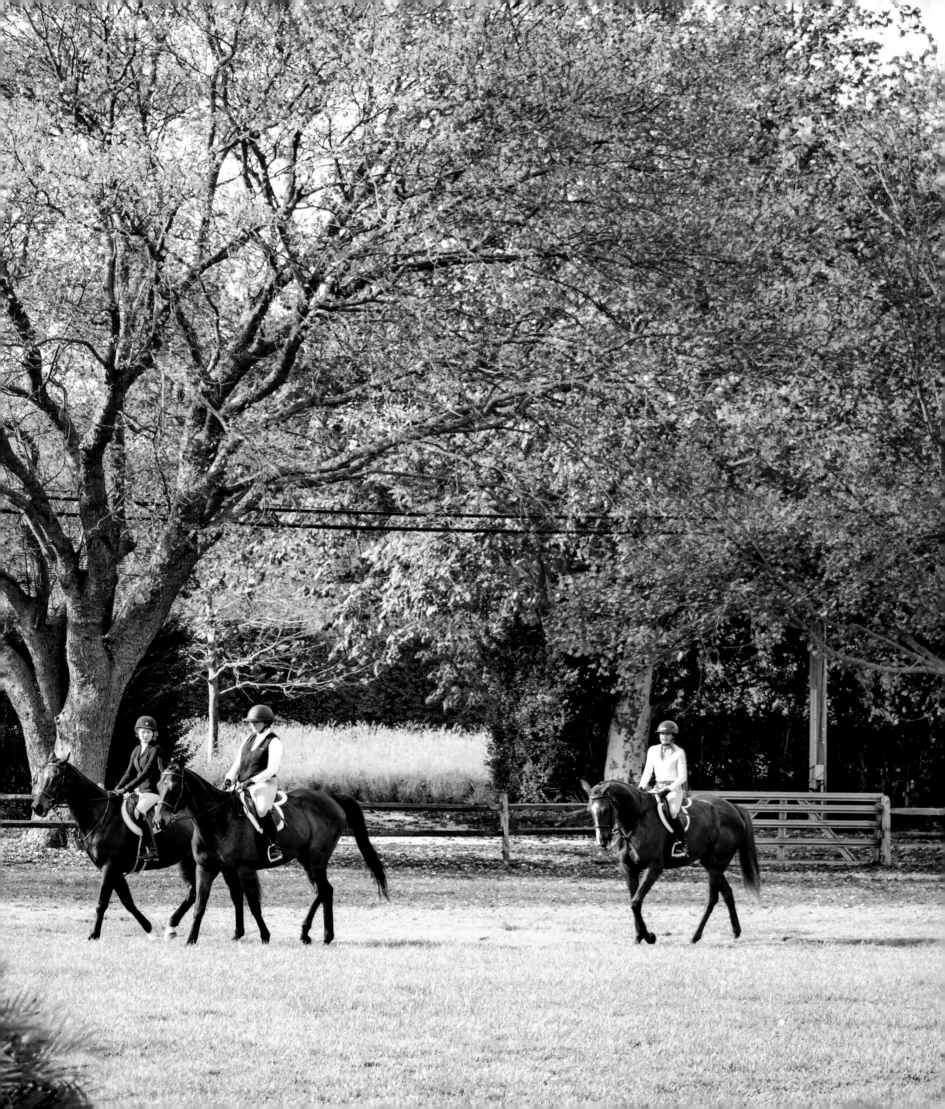

Black da Prata

"Every horse is beautiful, courageous, and intelligent. Photographing these animals in a minimalist environment has always helped me to see their beauty and oftentimes their personality in the most transparent of ways. We ask so much of these animals, and the most that I can offer in return is to capture them in the most beautiful light possible."

—Shelli Breidenbach

Image Credits

All photographs are courtesy of Blue Carreon, with exceptions noted below.

Endpapers: Solo, Arielle, Serenity Now, Carrusel, Tucan, and MonaLisa (horses owned by Lisa and Justine Ryan); Shelli Breidenbach

Pages 4–5: Bespoke Real Estate

Pages 6–7: Chuck Baker/Wölffer Estate Stables

Page 8: Doug Young

Introduction:
A Love Affair with Horses in the Hamptons

Pages 12, 15: Matthew Donahue

Pages 16–17: Doug Young

Pages 18–19: Elena Lusenti

Page 20: Emanuele Fiore/Fiore Productions *(top left)*; Balarama Heller *(middle right)*; Oliver Campbell *(bottom right)*; David Prutting *(middle left)*

Page 22: Juan Lamarca

Page 23: Elena Lusenti

Page 26: Rob Rich/Society Allure

Page 30: Diane Lee Photography/The Tack Trunk *(top right)*

Page 34: Bruce Bromberg *(top right)*; Jaime Lopez *(middle right)*

Page 35: Marsin Mogielski *(top right)*

Page 38: Emanuele Fiore/Fiore Productions

Pages 40–41: Emanuele Fiore/Fiore Productions

Galloping Through Time:
A Historic Overview

Page 46: Morgan Collection/Getty Images

Page 49: Bert Morgan/Getty Images

Page 50: Arnold Genthe Collection at the Library of Congress

Page 51: Arnold Genthe Collection at the Library of Congress

Page 52: Robert Appleton *(top left)*; Harvey Ginsberg Postcard Collection/East Hampton Library's Long Island Collection *(top right, middle left)*; Robert Hefner/East Hampton Library's Long Island Collection *(bottom)*

Page 53: Harvey Ginsberg Postcard Collection/East Hampton Library's Long Island Collection *(top right, middle)*; *The East Hampton Star* *(bottom right)*; Arnold Genthe Collection at the Library of Congress *(bottom left)*

Pages 54–55: Jason Stalvey

Page 56: Arnold Genthe Collection at the Library of Congress

Pages 58–59: Arnold Genthe Collection at the Library of Congress

Pages 60–61: Dave Edwardes/Montauk Library *(top left, middle, and right; middle right; bottom center; bottom right)*; Francis Shields/Brook Shields Archives *(bottom left)*

Page 62: East Hampton Library's Long Island Collection *(top left, middle right)*; Dave Edwardes/Montauk Library *(top right, middle left)*; Stony Hill Stables Archives *(bottom)*

Page 66: Topping Family Archives

Page 68: Bill Ray/deLeyer Family Archives *(top left)*; East Hampton Library Long Island Collection *(top right)*; deLeyer Family Archives *(middle right)*; Hotchkiss Family Archives *(bottom right)*; Isabel J. Kurek Photography *(bottom left)*; deLeyer Family Archives *(middle left)*

Page 69: Hotchkiss Family Archives *(top left, bottom left)*; Topping Family Archives *(top center)*; Brennan Family Archives *(top right, bottom right)*

Page 71: Suzy Drasnin

Page 72: The East Hampton Library Long Island Collection

Page 73: Cal Norris and Jack Graves/*The East Hampton Star*

Page 74: Hampton Classic *(top)*; Liz Soroka *(bottom)*

Page 75: Madeline Grebow *(bottom center)*

Page 76: Max Rohn

Page 77: Courtesy Wölffer Family Archives

Pages 78–79: Suzy Drasnin *(top from left: photos 1, 3, 5; middle from left: photos 2, 4; bottom from left: photos 1, 3, 5)*; Cal Norris and Jack Graves/ *The East Hampton Star* *(top from left: photo 4; middle from left: photos 1, 3, 5; bottom from left: photos 2, 4)*; Topping Family Archives *(top from left: photo 2)*

Page 80: Jaime Lopez *(top left)*

Page 81: Kristin L. Gray Photography *(top left)*; Suskind Family Archives *(top right, middle)*; Lisa Tamburini Photography *(bottom left, right)*

Published in Australia in 2023 by
The Images Publishing Group Pty Ltd
ABN 89 059 734 431

Offices

Melbourne
Waterman Business Centre
Suite 64, Level 2 UL40
1341 Dandenong Road, Chadstone, VIC
3148
Australia
Tel: +61 3 8564 8122

New York
6 West 18th Street 4B
New York, NY 10011
United States
Tel: +1 212 645 1111

Shanghai
6F, Building C, 838 Guangji Road
Hongkou District, Shanghai 200434
China
Tel: +86 021 31260822

books@imagespublishing.com
www.imagespublishing.com

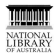 A catalogue record for this
book is available from the
National Library of Australia

Title: Equestrian Life in the Hamptons // Blue Carreon
ISBN: 9781864709452

This title was commissioned in IMAGES' Melbourne office and produced as follows:
Editorial Georgia (Gina) Tsarouhas, *Graphic design and Production* Nicole Boehringer

Printed by Artron Art Group, China, on 157gsm Chinese OJI matt art paper

IMAGES has included on its website a page for special notices in relation to this and its other publications.
Please visit www.imagespublishing.com

Every effort has been made to trace the original source of copyright material contained in this book.
The publishers would be pleased to hear from copyright holders to rectify any errors or omissions.
The information and illustrations in this publication have been prepared and supplied by Blue Carreon and the participants. While all reasonable efforts have been made to ensure accuracy, the publishers do not, under any circumstances, accept responsibility for errors, omissions and representations express or implied.

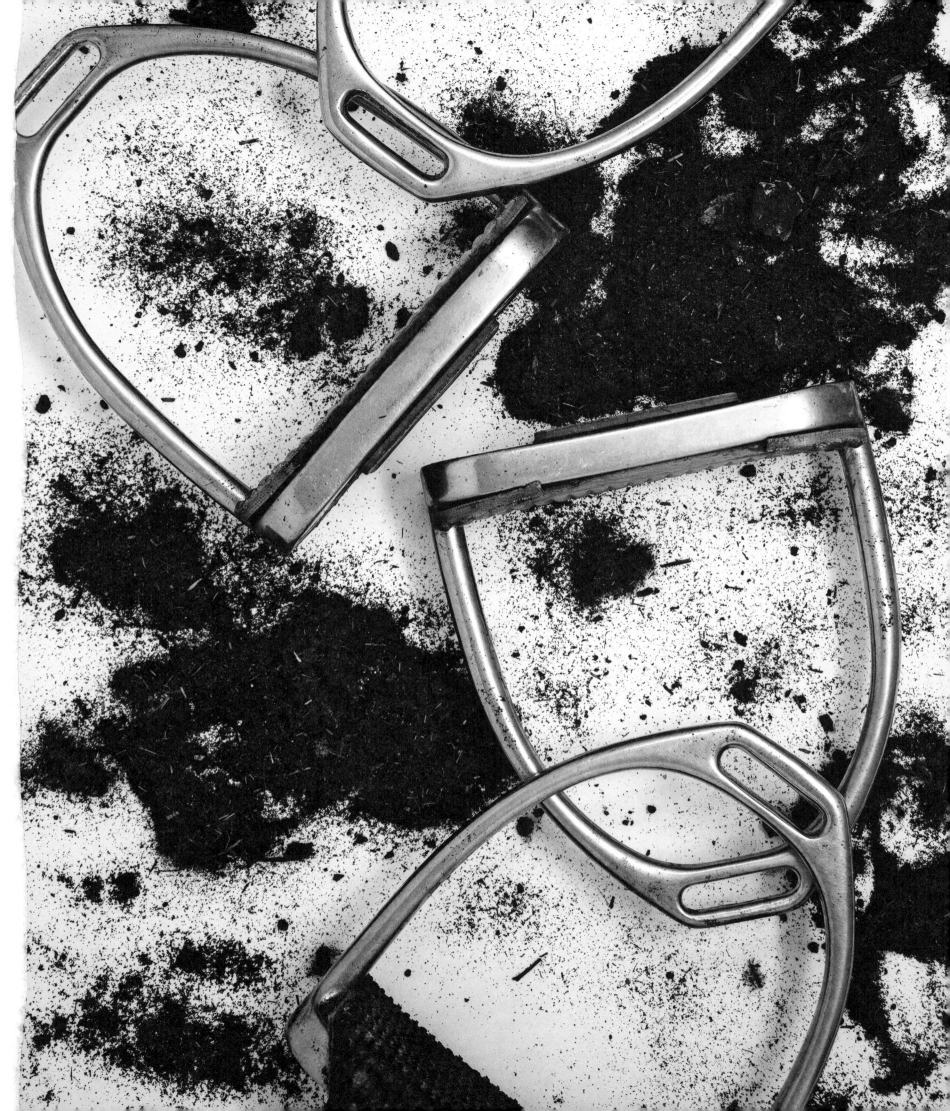

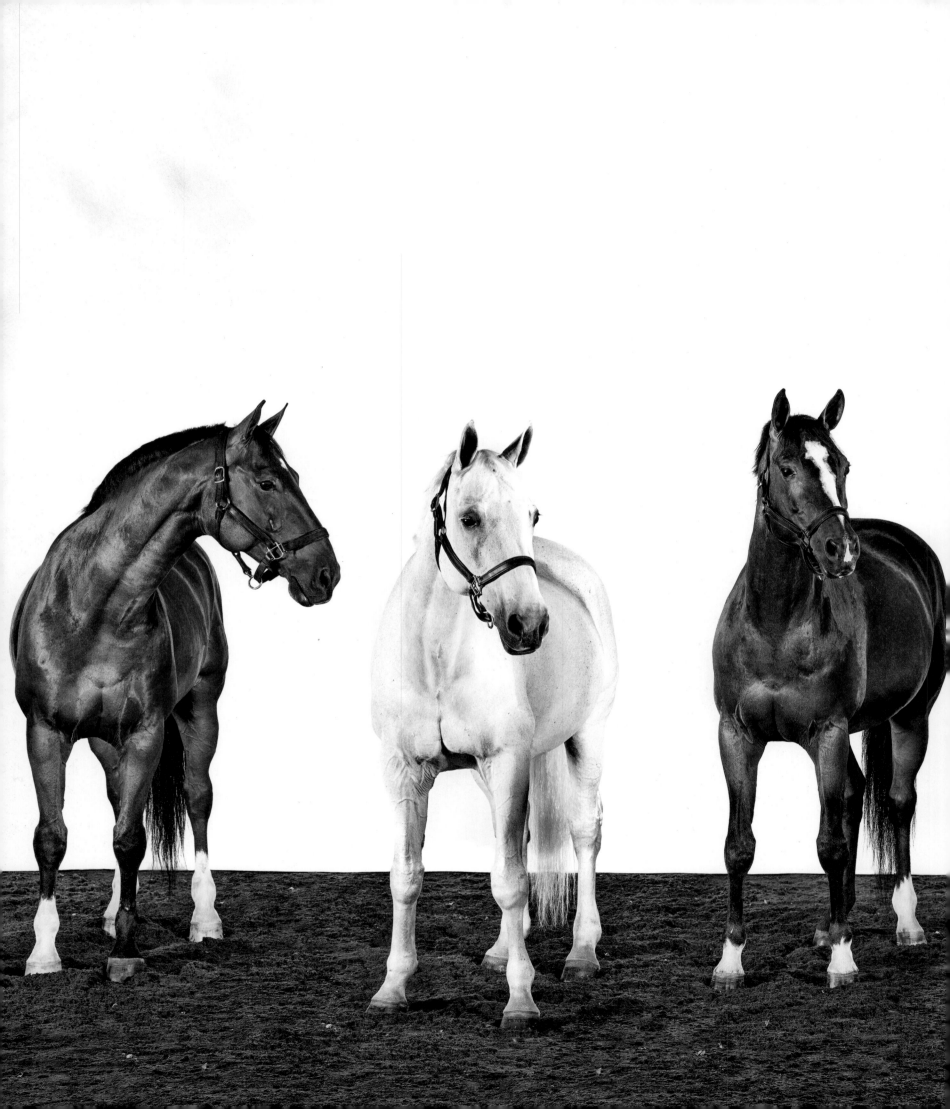

Acknowledgments

Creating this book was a collaborative process and it wouldn't be in your hands right now without these people.

I owe a debt of gratitude to Jason Stalvey who patiently, meticulously, and with great dedication worked on the images to give them polish and finesse.

Thank you to all the photographers who have entrusted me with their work: Doug Young, Shelli Breidenbach, Richard Phibbs, Emanuele Fiore, Sophie Elgort, Matthew Donahue, Elena Lusenti, Lisa Tamburini, Suzy Drasnin, Isabel Kurek, Greg Kessler, Juan Lamarca, Max Rohn, Marsin Mogielski, Jaime Lopez, Cadence Kennedy, Rob Rich, and those I may have missed in this roll call. I cannot thank you all enough.

A special appreciation goes to Gretchen Topping and Justine Ryan for pointing me in the right direction and giving me their insider information on the world of horses and riders in the Hamptons.

Thank you also to David Rattray and Jack Graves of the *East Hampton Star* for opening up their archives and lending me some wonderful images, as well as the team and archivists at the East Hampton Library and the Montauk Library. Shanette Barth Cohen, Marty Baumann and the entire team of the Hampton Classic, your assistance has been a tremendous help.

The cover of this book would not be possible without the generosity of Joanne Comber-Jimenez and John Paul Jimenez and their daughters, Juliette and Jilliana, and their well-behaved gray ponies. Cody Vichinsky and his wife, my dear friend Lauren, and the team at Bespoke Real Estate and homeowner Andrea Karambelas, a very special thank you.

To my publisher Images Publishing and the creative and editorial team, Honorine Le Fleur, Nicole Boehringer, and Georgia (Gina) Tsarouhas for believing in me and this project.

And of course, all the riders, grooms, barn owners, and managers and—not to be missed—all the amazing and majestic horses that patiently stood for photographs.

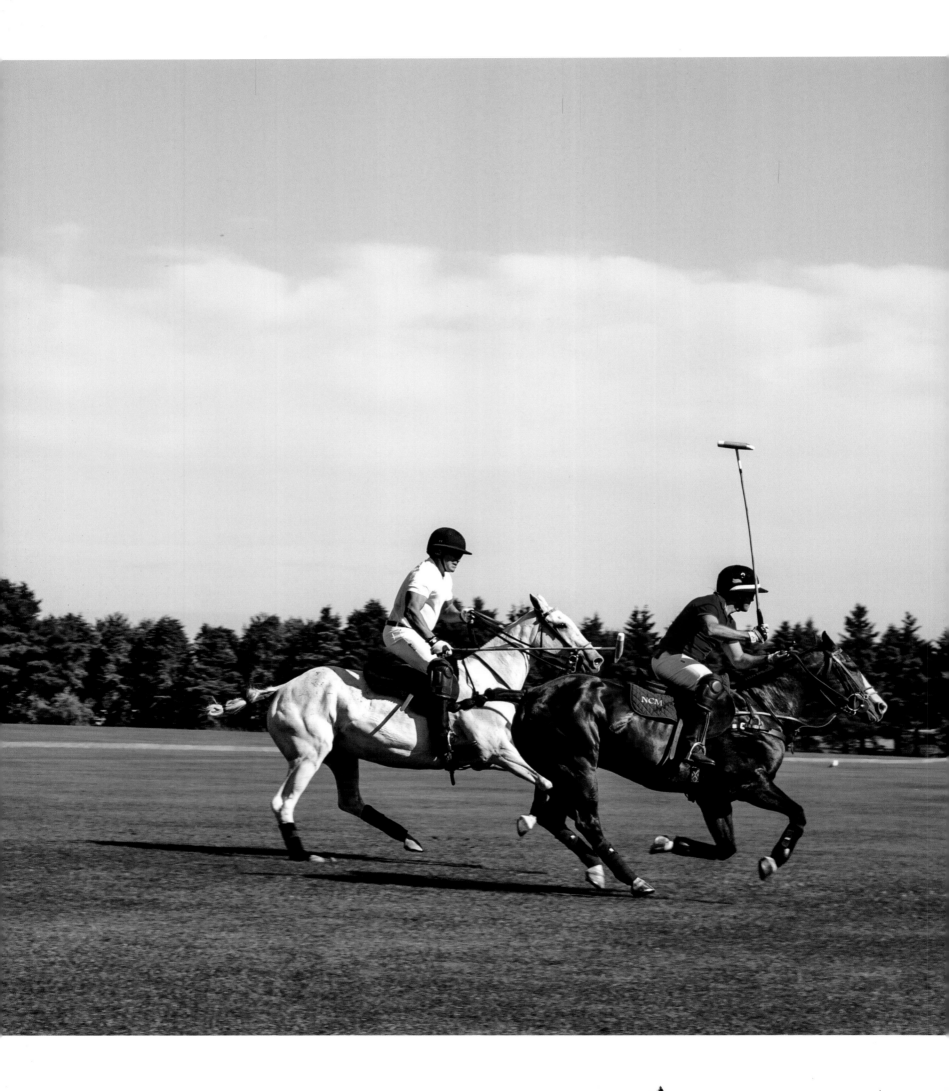

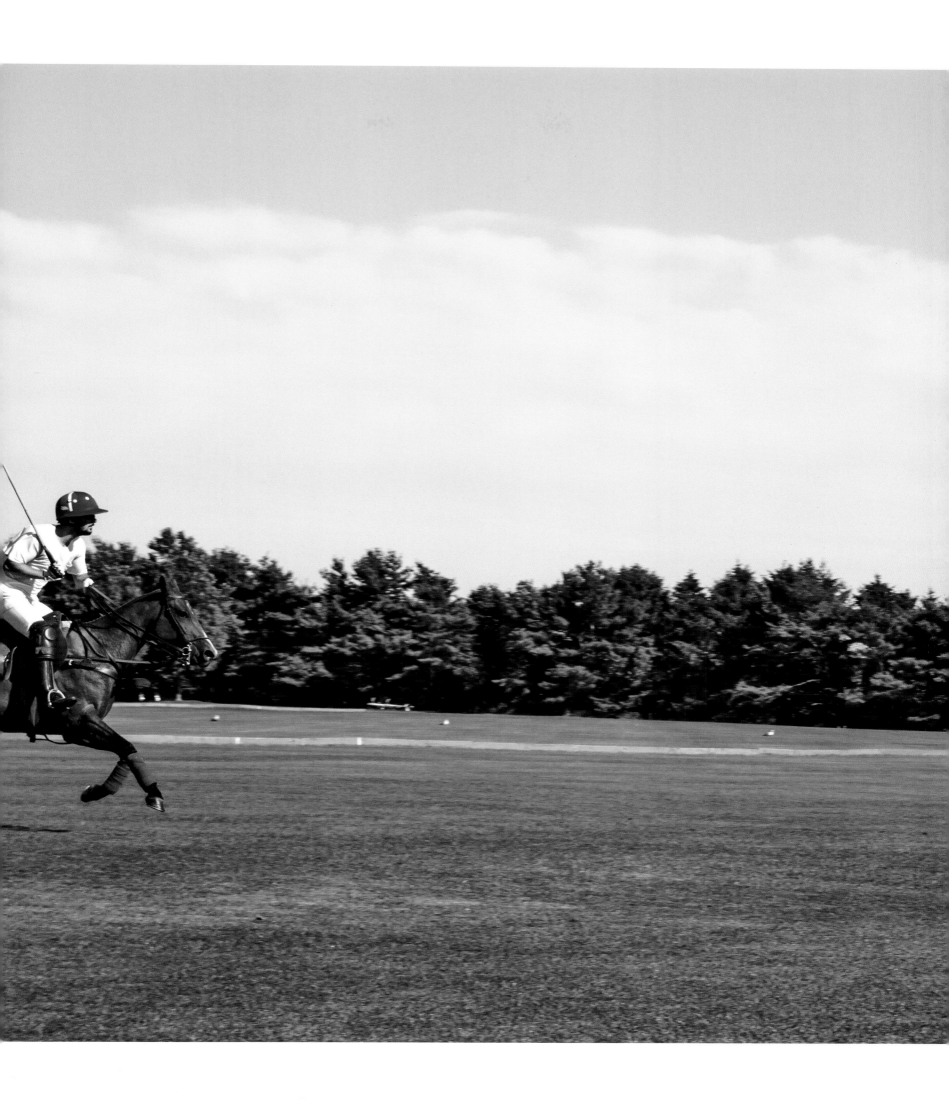

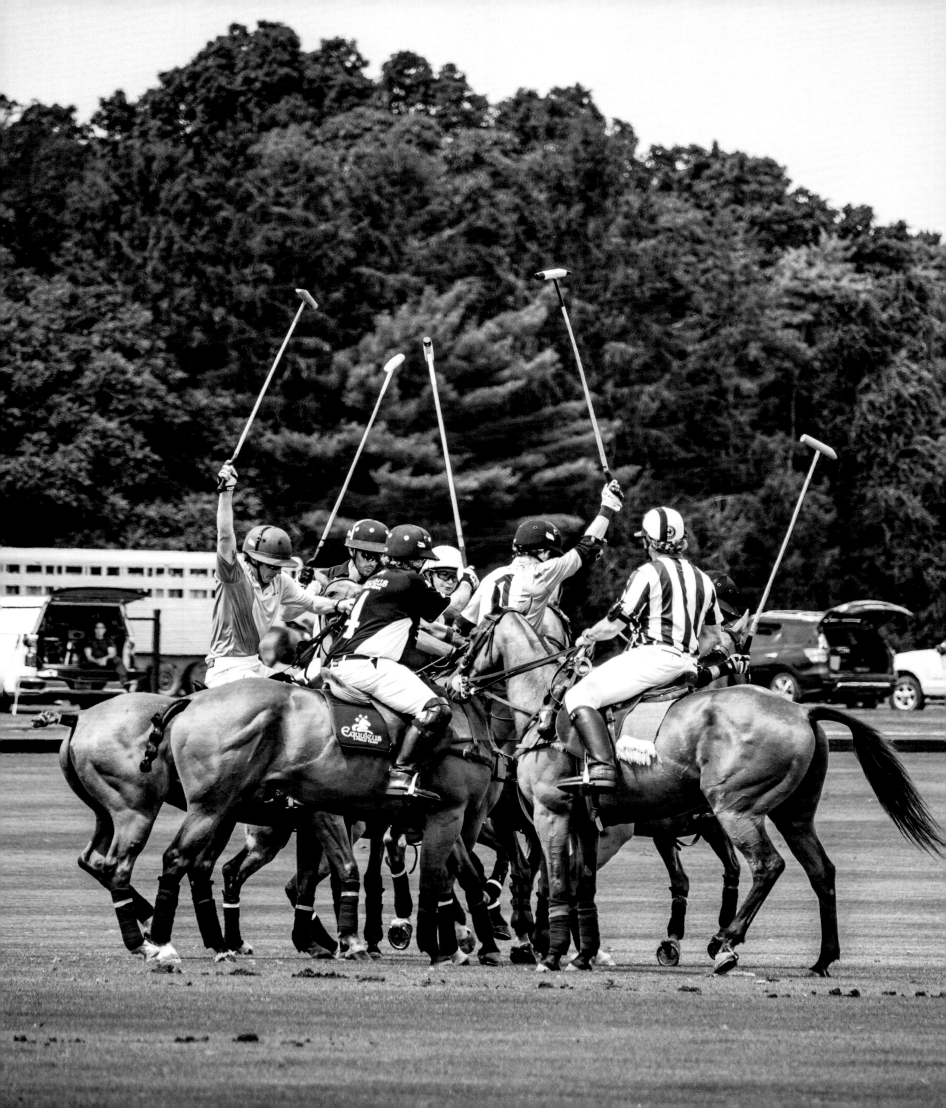

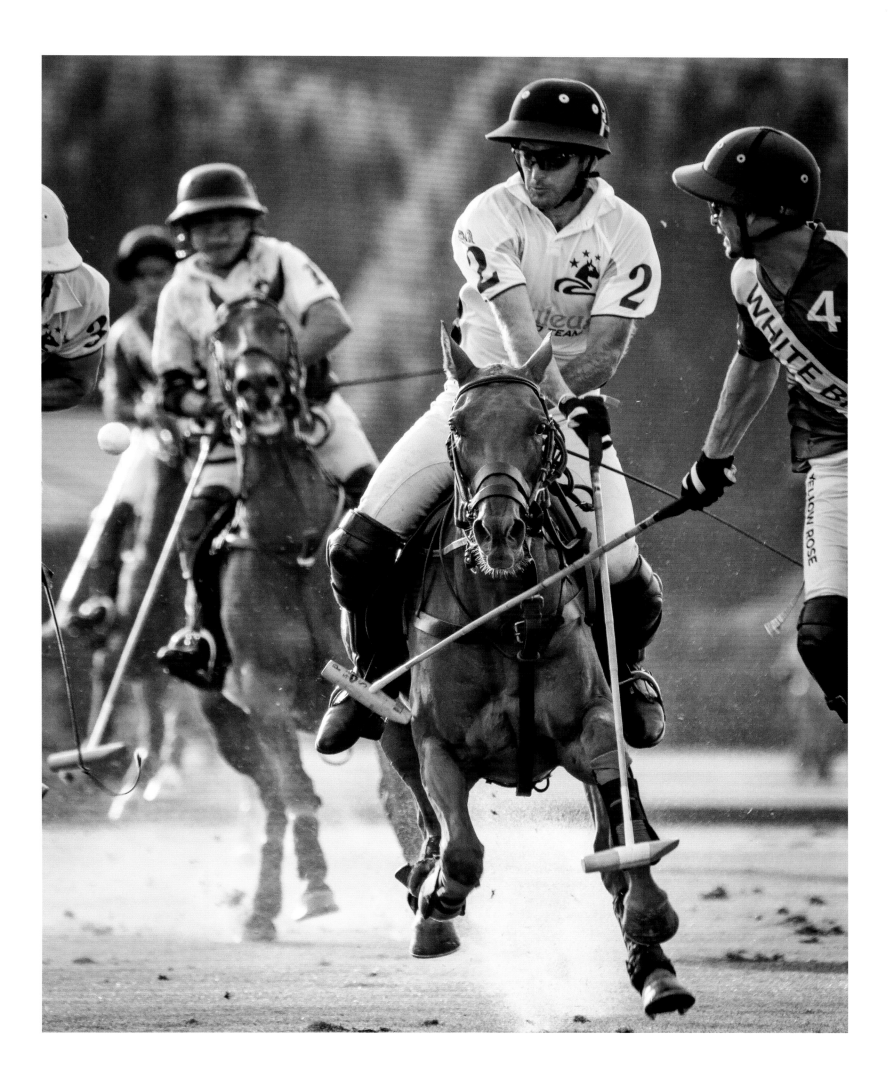

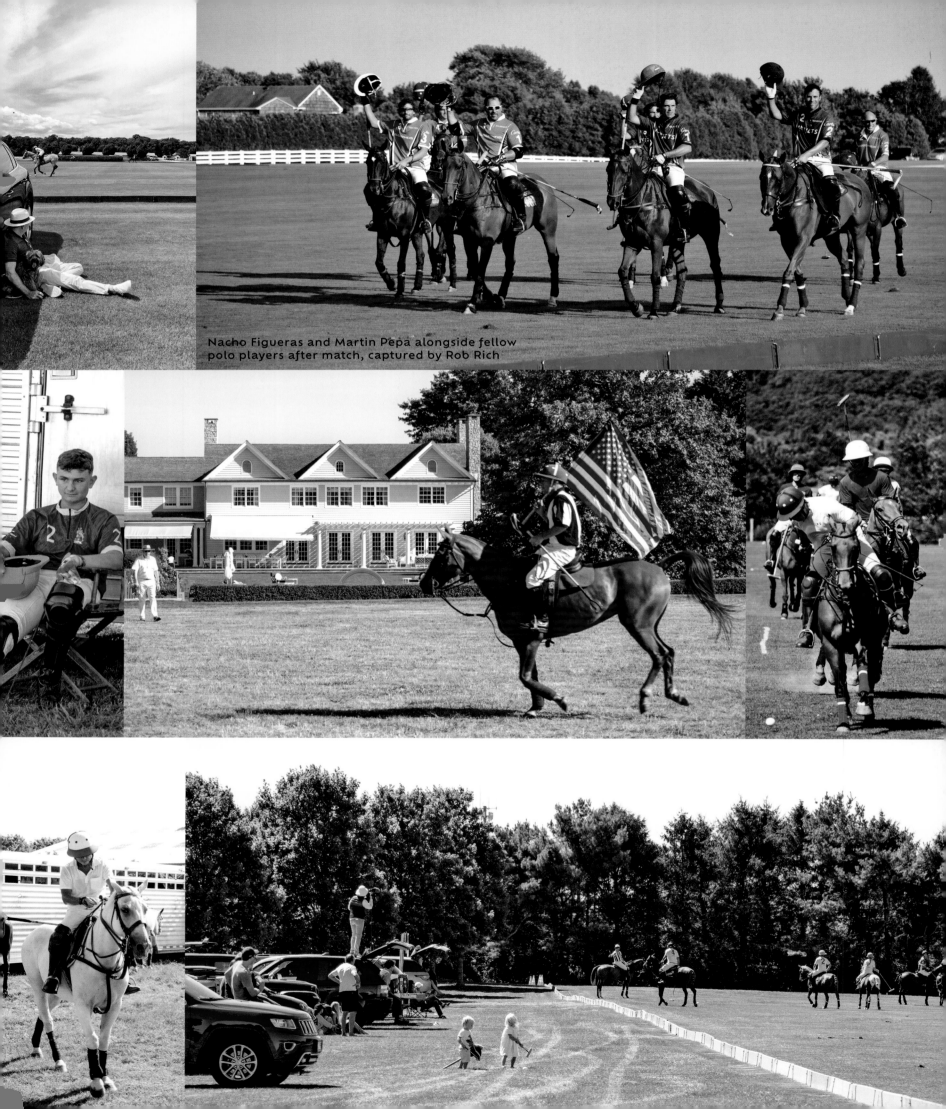

Nacho Figueras and Martin Pepa alongside fellow
polo players after match, captured by Rob Rich

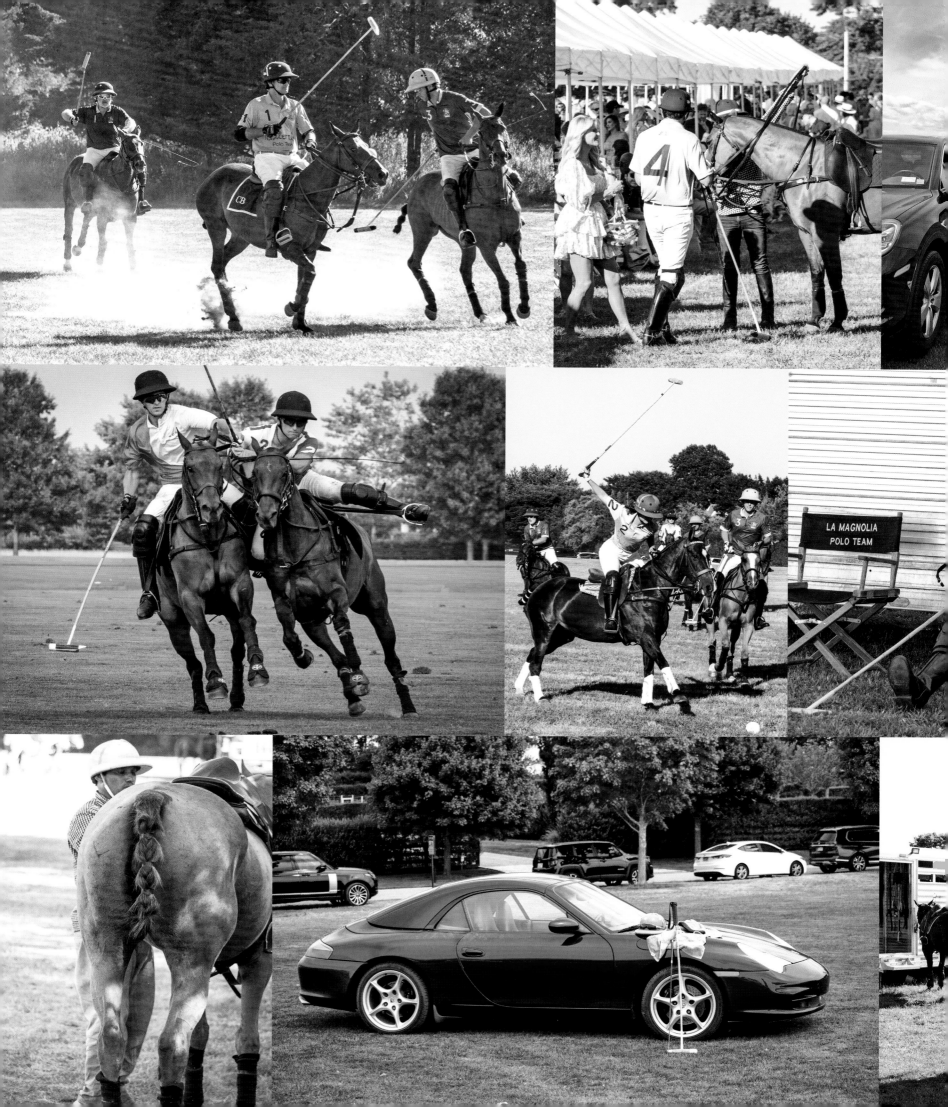

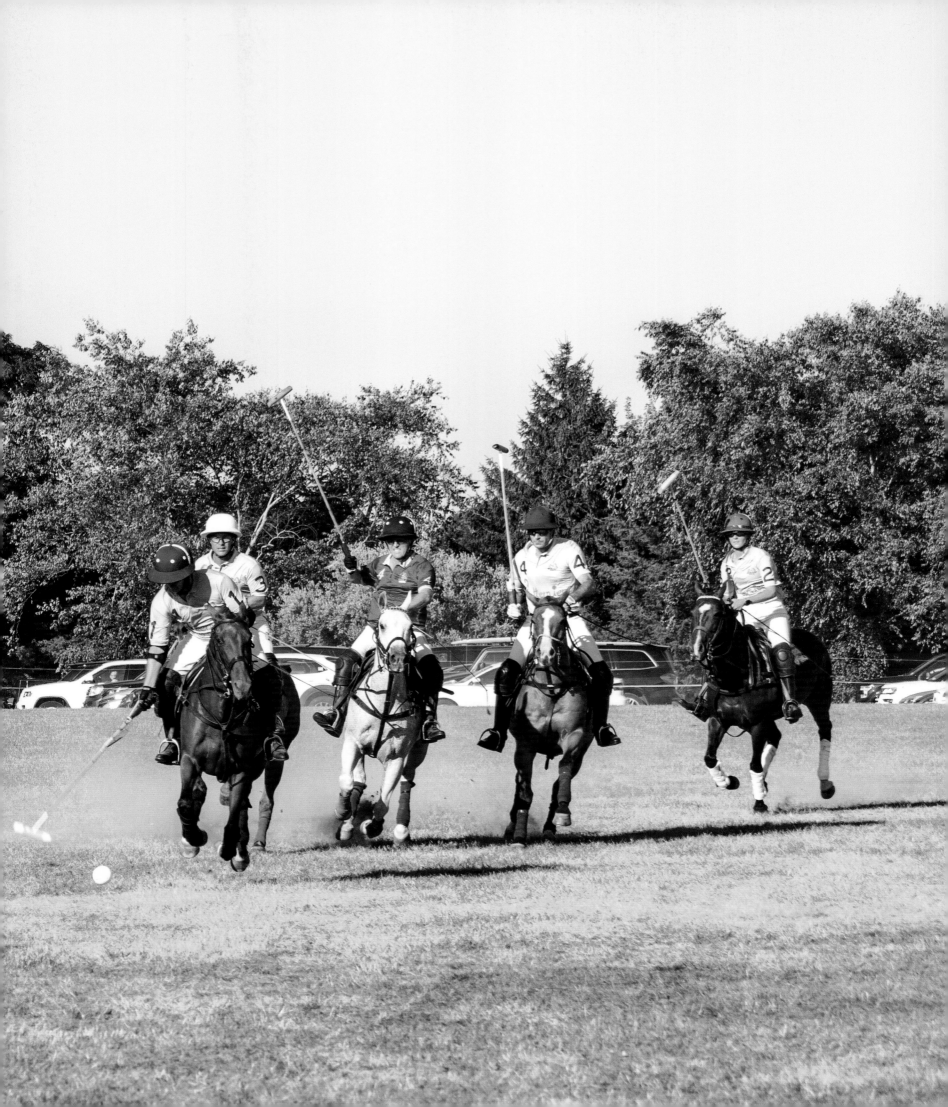

This spread and following pages: Galloping horses, competitive frenzy, and sportsmanship on display at different polo matches in the Hamptons throughout the summer, including Christie Brinkley co-hosting a match with the Fishels

Outside the horse shows and show jumpers are the polo players. Patrons of the sport and local polo players invite teams from Connecticut, Florida, and sometimes Argentina to play in competitive and exhibition matches. The recently formed Wainscott Polo Club hosts six- and sixteen-goal tournaments between Hamptons home teams like Equuleus Polo Team or Martin Pepa's La Magnolia Team versus visiting teams like White Birch and Bellamar at the meticulously manicured private polo field of Equuleus, or on the grounds of Two Trees Stables in Bridgehampton. Not far from both polo fields is the Southampton Polo Club, where various players take part in lessons or practice games with the towering and colorful outdoor sculptures of Nova's Ark Project as the backdrop.

In the summer, if you are lucky enough to be invited to a match at a private polo field, or are willing to fork out a few hundred dollars for a ticket, you can witness this rarefied world of ponies, good-looking polo players, private gardens, and colorful fashion. You get to be so close to the action that sometimes that polo ball may just land on your lap just as you are about to sip your rosé. If you have a penchant for spotting celebrities, you may just catch a sight of model Christie Brinkley or fashion designer Rachel Zoe or a coterie of socialites and social media personalities when the cloud of dust from the galloping horses on the field has settled. Luxury watch and beverage companies like Cartier, Piaget and Veuve Clicquot have sponsored matches in the East End.

Perhaps one of the most popular of these games is Polo Hamptons, held twice in late July at the residence of philanthropists Kenneth and Maria Fishel. The Fishels state, "The Polo Hamptons matches are the most anticipated events in the Hamptons. Our beautiful Bridgehampton estate is breathtaking in its natural beauty, and seeing the magnificent horses and players on it is a sight to behold.

"It is our pleasure to host this event in order to bring the Hamptons community together for a spirited day of healthy competition, while making new friends and treating them to first-class service, food, and drink. The day is perfection, and it is our pleasure to share it with our friends and neighbors. We always immensely enjoy the day and local charities benefit from the philanthropic nature of the event," they conclude.

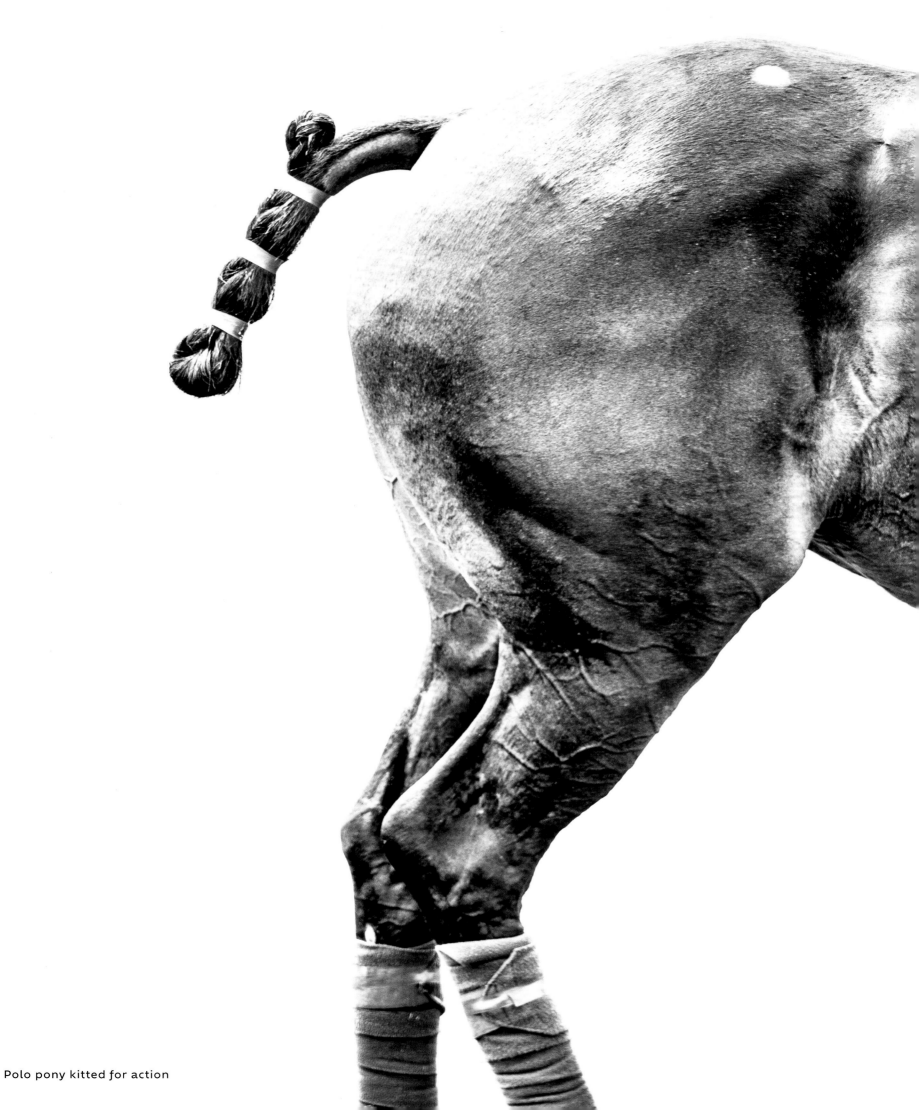

Polo pony kitted for action

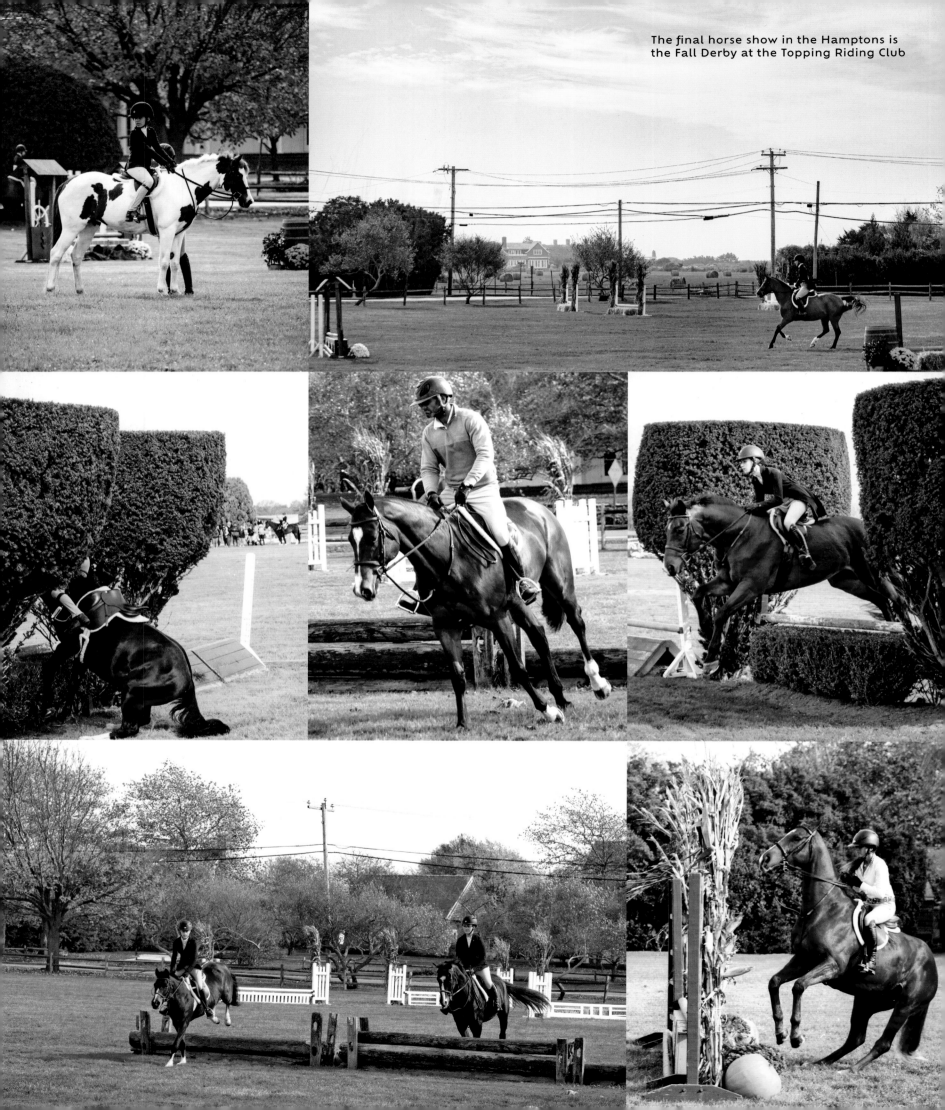